THE ARTIST'S GUIDE

THE
ARTIST'S
GUIDE

How to Make
a Living Doing
What You Love

BY JACKIE BATTENFIELD

DA CAPO PRESS
A Member of the Perseus Books Group

Designed by Timm Bryson
Set in 11 point Dante

Library of Congress Cataloging-in-Publication Data
Battenfield, Jackie.
 The artist's career guide : how to make a living doing what you love / by
Jackie Battenfield.
 p. cm.
 ISBN 978-0-306-81652-9 (alk. paper)
 1. Art—Vocational guidance. I. Title.
 N8350.B38 2009
 702.3—dc22

 2009009635

First Da Capo Press edition 2009
Published by Da Capo Press
A Member of the Perseus Books Group
www.dacapopress.com

Da Capo Press books are available at special discounts for bulk purchases
in the U.S. by corporations, institutions, and other organizations. For more
information, please contact the Special Markets Department at the Perseus
Books Group, 2300 Chestnut Street, Suite 200, Philadelphia, PA 19103, or
call (800) 810-4145 extension 5000, or e-mail
special.markets@perseusbooks.com.

10 9 8 7 6 5 4

This book is dedicated to my sons, Drew and Ian,
as they begin their professional lives.

CONTENTS

Introduction: Why Read This Book? ix

Section One
TAKING CHARGE OF YOUR PROFESSIONAL LIFE

ONE *How to Assess, Plan, and Take Action 3*

TWO *How to Assemble the Essential
Tools to Support Your Work 24*

Section Two
CIRCULATING YOUR WORK

THREE *How to Get Started: Peer Networking,
Readiness, and Creating Your
Own Opportunities 73*

FOUR *How to Introduce Your Work to the
Professional Community: Researching
and Exhibiting in Nonprofit Spaces 95*

FIVE *How to Build Long-Term
Professional Relationships 123*

Section Three
SUPPORTING YOUR WORK

SIX *How to Earn and Manage Money* *159*

SEVEN *How to Find Even More Support:
Grants, Residencies, Gifts* *197*

EIGHT *How to Read and Work with the
Fine Print: Contracts, Legal Issues,
and the Art of Negotiation* *241*

Section Four
MAINTAINING YOUR PRACTICE

NINE *How to Structure Your Day-to-Day Operations* *283*

TEN *How to Build Community to Survive Being Alone* *311*

Epilogue 341

Acknowledgments 347

Biographies 349

Index 363

INTRODUCTION: WHY READ THIS BOOK?

An artist's life embraces every job description of a small business: creative director, marketing director, bookkeeper, construction manager, secretary, janitor, technician, and publicist. It is a self-directed life run by a committee of one. Being an artist is a *profession*. It is not a vow of poverty. If you ask artists to define success, most will say that it's having the time, space, and money to make art. However, many of the skills needed to succeed are acquired only through painful trial and error. This book is designed for emerging to mid-career artists and provides guidelines on setting and achieving career goals that reflect a wide range of artistic values.

Since 1991, I have supported myself and my share of family expenses primarily from sales of my art. My husband is also an artist and self-employed. Together we are raising two sons. The elder just graduated from college, his education entirely funded by art, and our younger son just started. Every time a tuition bill arrives, so does art income. We buy our own health insurance, fund our own pension plans, take vacations, and—most important of all—still create art. We have reached this enviable position not through lottery winnings, a trust fund, or being "discovered," but through diligently planning and pursuing available opportunities. This book is my chance to share how I've built a satisfying career from the ground up and show you how to do the same.

To begin, I need to go back in time to January 1989. I was married to an artist, seven months pregnant, and the mother of a four-year-old. I had a challenging job directing a nonprofit art gallery and unfinished paintings beckoning me in my studio. When my first child was born, I

had taken only two weeks off from work. I had divided child care with my husband, and he had learned how to look after an infant. I pared down my hours at the gallery and brought home work to do in the evenings and early mornings. But now with two children, these dynamics would be more complicated. Just imagining coordinating their different schedules made my head spin; we would have to hire additional child care. I knew deep in my heart that these new demands on my time would make it impossible to continue any serious studio work. No matter how carefully I managed my time, there simply weren't enough hours in the day. A deepening despair came over me, and I felt trapped between the needs of my job and my desire to care for my children and build my art career. I feared that I was destined to go the way of other friends whose artistic practice had slowly disappeared, squeezed out by increasingly complicated personal lives. Were the necessary choices I made in my life going to eliminate my artistic career? I realized this moment was an important turning point in my life.

Eight years earlier, I had founded the Rotunda Gallery, a nonprofit exhibition space in Brooklyn, New York. At the beginning, I thrived on the excitement of developing and managing all the aspects of the gallery program. Interacting with the art community as gallery director and curator was thrilling. I had access to any artist's studio in the New York metropolitan area simply by making an appointment. I discovered new talent as I scoured the slide registries at leading nonprofits like Artists Space, White Columns, and the Drawing Center. By curating exhibitions that placed well-known artists alongside emerging artists, I was ushered into the back rooms of Soho and 57th Street galleries to select works of art that were worth ten times my salary. My job allowed me to take an idea percolating in two or three artists' work and create a new dialogue between them within the gallery's walls. These experiences were deeply rewarding. I had something to offer other artists and the art community. Running the gallery allowed me to overcome my normally shy personality, as I continually sought financial support for the program and ways to connect with new audiences. In spite of all this public activity, I was able to quietly continue my own painting practice.

Introduction

Driving the Rotunda Gallery to success required a steep learning curve, since I had come into it without any background in arts administration. During my first three months on the job, I visited over two hundred artists' studios, curated half of the first season's exhibitions, and set up an artist registry. I even met my future husband on one of those studio visits. Suddenly, my phone was ringing with artist inquiries, and packages of slides began piling up on my desk. As a result, I had to change from being a private person to being a public one. By then, I had run through the initial $5,000 seed money from a New York State Arts Council grant. One of the gallery's board members gently suggested that I had better start looking for more. Through trial and error, I rapidly acquired skills in fundraising and management. I found that colleagues were generous with their advice. I'll never forget writing the gallery's first grant application to the National Endowment for the Arts. Susan Wyatt, the director of Artists Space, sat me down next to her desk. While her busy staff swirled in and out of her office, she walked me through it step-by-step, answered my three hundred questions, and handed me tissues when I broke out in tears of frustration over the looming deadline.

Year by year the Rotunda Gallery grew, added staff, expanded its programming, and attracted new audiences. With that growth, I found myself turning over more of the "fun" tasks—studio visits and curating shows—to focus on supervising staff, fundraising, and promotion. I was proud of my accomplishments at the gallery, but as it grew in stature and I became known in the art community, I felt more and more out of place and removed from the artist within. The title "gallery director" never fit my core identity. I felt torn between two lives.

My professional life involved visiting studios, finding new artists, writing exhibition and grant proposals, hiring guest curators, and promoting the gallery. My other life was that of a "secret artist," always searching for precious chunks of time to paint. It felt awkward managing these two identities, and the artist was getting short shrift. I didn't feel comfortable promoting my own work among my colleagues. The few times I invited them over to my studio, I wondered if they only came out of professional courtesy. No matter how enthusiastic or stimulating the

conversation, I was still riddled with doubt. Any time I had an opportunity to meet other art professionals, I felt compelled to talk up the gallery's program and not my own artwork. After all, that was why I was being paid. It seemed that with each passing year I was building a brick wall higher and higher, separating the two parts of my life. It now towered between my art and my job, with my family balanced precariously on top. I also realized that in order for the Rotunda Gallery to continue to grow, it needed an infusion of new energy and ideas. I had nothing more to give as an administrator and wanted to rearrange my life so that my art career took center stage. I was proud of what I had accomplished at the gallery and knew it was time to turn it over to a new director.

In January 1989, as I sat at my gallery desk and thought about the baby due in March, I was filled with an overwhelming desire to go home and never come back. I wanted to toss out all my administrative clothes, pull on my paint-smeared jeans and T-shirts, and work on my unfinished painting. I wanted to savor every moment of a new baby. I didn't want to hire full-time child care. Just the thought of the added expense made me weary. My older son was growing up so quickly, and he was about to start school. I wanted to be the person walking him home every day.

How could I leave the gallery, stay home with my kids, and paint? My husband was working hard on building his career. Raising a family had interrupted his studio practice as well. How could I live without the security of my steady salary? My mind churned incessantly, turning the problem over and over. What could I do? It wasn't as if I had been stashing all my paintings in a dark closet for eight years. A year before I started the Rotunda Gallery, I had attracted the attention of a private art dealer on the Upper East Side of Manhattan. To my good fortune, she was enthusiastic about my work and started to make regular sales. This relationship was enough incentive to keep me pushing my work in the studio. There was an audience for my paintings, and there were collectors who wanted to own them. I made sure to save a little money out of each sale to build up a nest egg for emergencies.

Then, I had an epiphany: managing a nonprofit gallery was just like running a small business. Maybe it was even harder. Each year, the

gallery started out with an ever growing budget for the salaries of staff and programming, but very little in the bank. New funding had to be found, and old grants had to be renewed, in order to make the numbers balance. No one had handed me my salary; I had raised it. My paychecks were directly related to my activities. I also realized that I had learned a lot about the art business. For eight years, I had been working with artists who were at all stages of their careers. I had been on the receiving end of thousands of slide packets, served on exhibition juries, visited hundreds of studios, and written press releases and grant proposals. I had watched some artists skillfully navigate the rapids of their professional lives and seen others sadly crash and burn. I had encountered artists who were quietly and consistently earning a good living from their art and others whose work appeared regularly in art magazines but were still as poor as church mice. I asked myself: What if I took all this knowledge and insight and applied it to my career? I was sure I could figure out how to make a living from my studio. I had six months of living expenses stashed away, and I could teach one or two studio classes to stretch it out. That realization gave me the courage to send my resignation to the gallery's board of directors. My accountant groaned and said, "You can't quit. I do your taxes; I know you can't quit." "Don't worry," I replied. "I've got a plan."

Of all the skills I learned while developing the Rotunda Gallery, the most important and valuable was planning. Everything I did for the gallery had to be considered from a long-term point of view. So why not apply the same principles to my own art career? I imagined how I wanted my life to look. That image was clear as a bell; I pictured being at home caring for my kids and painting in my studio. The next hurdle I had to tackle was how to make that happen. The answer to that was more challenging and truly scary. I needed to earn a living from my studio. As I had done many times for the Rotunda Gallery, I steadied myself by setting a specific long-range goal. My new goal was that in five years I would be making enough money to support my half of family expenses and my studio practice from regular sales of my work. I wrote down a figure that represented my family living a comfortable lifestyle. I then determined short-term financial objectives and career goals for

each year leading to the fifth. I confess that when I wrote down this plan, it scared me half to death. I tried to shake off the fear by laughing and saying, "Jackie, you are insane. You don't even know anyone who makes this kind of money. Who do you think you are?" My inner critic was having a field day, ridiculing my audacity. It took a while to quiet that nagging voice. I reminded myself that I had started the Rotunda Gallery on a shoestring and had made it grow far beyond anything I could have imagined. What I had done for the gallery I could do for myself. Even though I was full of doubt, I trusted that this first plan would provide a structure to help me take action, and that this action would lead me to a new place.

My next focus was determining how I was going to find dealers and agents to represent my work. I lived in a studio loft in lower Manhattan, near Soho, which at that time was the hottest gallery district in the world. It was 1989, and the '80s booming art market was over. The galleries were deathly quiet, and many were destined to close. Like the stock market in 1987, the art market had also contracted. Even so, I found that all the artists I knew were still seeking the few meager opportunities Soho had to offer. This route didn't seem promising to me, especially since my paintings didn't fit the conceptual aesthetics of the moment. The collectors who were purchasing my work weren't following that part of the art market. I knew that there must be other collectors and galleries out there; I just needed to find them. I unrolled a map of the United States and noticed Soho wasn't even large enough to be a tiny pinprick. There were so many other cities and areas to be explored. It was at that moment that I decided to let go of prospects in Soho. I was going to look for representation in the rest of the United States. Suddenly, my world seemed full of opportunities, and I was eager to find them.

Shortly after our baby was born, I took my first step. I was scheduled to attend a board meeting for the National Association of Artists' Organizations (NAAO) in Washington, D.C. I decided that this would be my starting point. I researched galleries and dealers in *Art in America: Annual Guide to Museums, Galleries, Artists* and interviewed an artist friend from college who lived in the D.C. area. She gave me names of

more venues and provided background information. From my research I made a list of possibilities, sent out letters of introduction, and requested an appointment to show my portfolio. To my dismay, not a single dealer responded to make an appointment. So I followed up my letters with phone calls to introduce myself and schedule a time to meet. A few weeks later, I boarded the train to Washington, D.C., with a list of five meetings, a three-month-old baby in a Snugli, a backpack full of diapers, and my portfolio, and carrying a small painting under each arm. While my older son stayed home with his dad, the baby went with me to the appointments. There I introduced my work and began nurturing a relationship with three of the five dealers. When I returned to New York, I sent any information they had requested and thank-you notes. Within three months, one of the private dealers offered me a $10,000 painting commission. That figure had been my first year's financial goal. To my astonishment, I had accomplished it in only six months. I continued to follow up with all the contacts I had made. Eighteen months later, Addison/Ripley, one of the galleries I had met with on that first trip, began to show my work. They continue to represent me to this day.

I started to look for representation in other parts of the country and began reading the financial section of the newspaper. Was the economy doing poorly everywhere? Not quite. It was still strong the further west I looked. Nine months later, I flew to Los Angeles to explore its opportunities. Again, I did my homework, contacted dealers, and made appointments. Thrilled to have just learned to walk, the baby spent nearly the entire flight toddling up and down the aisle with me in tow. I felt as if I were walking across America in search of my goals, even if it were from thirty thousand feet up in the air. In LA, my childhood friend Felice gave me a place to stay, buckled up her two kids and mine in car seats, and dropped me off at my appointments. She then drove in circles around the block until I came out, because if she stopped driving, the kids started crying. Again, several new relationships were initiated, and a year later I was offered representation and a show. Unfortunately the gallery closed two months before my show opened. I learned that even my best-laid plans would always be subject to forces out of my control.

Undaunted, I continued to look for other opportunities. That same year, I was awarded a Pollock-Krasner grant, which was perfectly timed support to continue my plan. Each year, I brought new art dealers into my sphere and met my financial and artistic goals. By the third year I had far surpassed my original goals. Things were moving faster than I had ever thought possible. I was juggling studio time with child care, and although the schedule was tight, I was enjoying every minute of it. My painting had expanded to include collage and printmaking. As I continued to look for other opportunities, I experienced defeats as well as triumphs. Many nights I tossed and turned, too anxious to settle down and sleep. Every little victory—a positive response to my work or a check in the mail—helped me manage my fears and fortified my goals.

A studio practice is a lonely endeavor. To combat that isolation, I've always sought to interact and maintain relationships with a larger community of artists. It was one of the reasons why I had started the gallery. Before that I had connected with other artists by teaching at the Rhode Island School of Design and Syracuse University. During the early days of my plan, I supplemented my painting income with adjunct teaching at LaGuardia Community College and Empire State College. This work kept me in contact with other artists and introduced me to faculty members and students. In 1992, I was invited to teach the business of art seminars in the Artist in the Marketplace (AIM) program at the Bronx Museum of the Arts. This job prospect was immediately appealing and offered the perfect balance to the solitude of my studio practice.

Organizing and teaching the AIM seminars was a dream come true. I could take all the information, experience, and skills I had developed for my own work and share it with a larger community of artists. AIM sessions became my favorite night of the week. Through the AIM program I have had the privilege to mentor over five hundred artists.

As the AIM program became better known, I was offered other opportunities. In 2002, as head of a team at the New York Foundation for the Arts, I helped draft a semester-long curriculum, *Full-Time Artist*, for the Emily Hall Tremaine Foundation. As a result, I now teach this class in the Master of Fine Arts program at Columbia University's School of the Arts. I have helped design and deliver professional development

workshops for the Creative Capital Foundation, which awards grants for innovative project-based work in all disciplines and provides grantees with professional development assistance such as fundraising, promotion, and strategic planning. As part of a team of art professionals, I teach skill-building workshops to artists all over the country. Since 2003, we have led intensive weekend retreats for over two thousand artists in California, Florida, Oklahoma, North Carolina, South Dakota, Maryland, New York, Arizona, New Mexico, and the United Kingdom. I have worked with artists from all over the world, at all stages of their careers, and in all media. I have seen how they struggle to fit making art into their lives. Helping artists solve their professional dilemmas has been as deeply rewarding as my studio practice.

While writing this book, I have interviewed dozens of gallerists, curators, art administrators, critics, intellectual property attorneys, public art administrators, and artists. We discussed their role in the art world and their relationship to others in the field. As our conversations explored issues relevant to the profession, the interviewees provided valuable tips to artists for improving their practice and their relationships with art professionals. These interviews are quoted throughout the book and highlight essential advice. Transcripts of these "reality check" interviews can be read on the book's website: http://www.artistcareerguide.com.

I have found that basic business skills are difficult to incorporate in an artist's daily practice, since, more often than not, one acquires them haphazardly through mistakes, missed opportunities, bad planning, or financial and emotional crises. The administrative responsibilities of an active career can be overwhelming. It is important to know what tools and systems to have in place when exciting opportunities start appearing. If your career unexpectedly slows down, you need to know how to revise and revitalize it. My teaching has offered practical insights into the art world as well as information and exercises on organization, management, and promotion. I want to help you transform your uncertainty into productive activity and define and evaluate your accomplishments and needs in order to develop an ever evolving plan to move ahead.

I've witnessed the art world change, and I've experienced its cycles of prosperity and decline. Suddenly installation art is hot, and painting is not, while the following season the reverse is true. The art market devours new talent and anoints its selected superstars only to become infatuated with others soon after. I have watched artists continue to fill thousands of exhibition spaces with new work, usually at great expense to themselves. I have had to learn how to stay focused on my creative vision to keep steady in a market that is constantly swaying. I have kept abreast of new technology, expanded my studio practice, and researched new venues. You too will need to find your own ways to navigate the ups and downs and the shifting currents of the art world.

This book asks you to confront issues you have avoided until now. You may not want to face them; you might not even know why you should be confronting them in the first place, or you might wish someone else could do this work for you. You might think that once you "make it," you'll never have to do these tasks anyway, so why bother learning them in the first place? I have heard all these excuses from artists, and I sympathize with your desire to avoid these issues, as I've felt the same way. But taking responsibility for those parts of your practice that don't readily correlate to your creative process—documenting the work, writing a compelling artist statement, making professional contacts, managing time and finances—will have a huge impact on your success and satisfaction as an artist.

I offer this book because, like me, you are committed to living a personally satisfying life making art and want fresh insights into the difficulties artists face. No matter where you are—currently in art school and beginning to wonder about life after graduation, a couple of years out of school and pondering what your next move is, or mid- to late-career and resuscitating a stalled or dormant practice—this book will present tools and techniques you can begin applying immediately.

This book is a compendium of advice and answers to the questions that have come up in my own practice and in the classes and workshops I have taught. It is my chance to share with you the ways I have achieved career satisfaction and how you can do the same. It represents the accumulated wisdom and experience of all the artists with whom I have

worked and shares with you insights from many art professionals. It addresses the doubts and fears you and other creative people face, and provides information to help you overcome those crippling feelings. It dares you to challenge the myth of the starving, disorganized artist and surmount any self-defeating habits that are holding you back. Each chapter illustrates a different aspect of an artistic practice that you can begin to work with on a daily basis to build a supportive environment to create your finest work.

TAKING CHARGE OF YOUR PROFESSIONAL LIFE

It's hard to take control of your professional life when you aren't sure where you're headed and are responding to opportunities with inadequate tools. In this section you will be led through a series of exercises to uncover and develop a vision of your life that fits perfectly with your needs and values. You are challenged to create your own definition of success and map out a path. Planning is the foundation for you to start shaping your world as you want it to be.

Next you will be shown how to develop the essential tools and techniques to support your work. You will learn how to develop and effectively use images of your work and your artist statement to enhance nearly every aspect of your professional life. It's not easy to put into words the subtle and elusive ideas of your art or show its nuanced details in a digital image, but these tools are your links to the rest of the art world and need your careful attention.

Embracing a vision for your career and using the essential tools will allow you to begin moving in a positive direction. Addressing these issues will get you up and running and lay the framework for the rest of the book.

chapter one

How to Assess, Plan, and Take Action

This chapter asks you to stop and reflect on what you wish to accomplish in your career. The fact is that no one is coming to "save" you, but you *can* save yourself, if you know which way you are headed. You seldom get into a car, hop on a train, or board an airplane without a destination in mind. The same should apply to your professional life, whether you are just beginning a career or are somewhere in the middle. This chapter introduces long- and short-range planning as a means to organize, structure, and sustain your artistic and personal life. Even if you are doubtful that a process like this will work for you, the information covered in this section lays the groundwork for the rest of the book. Don't skip this chapter.

An art career comes in all shapes and sizes.

Almost everything you do as an artist is self-generated. There is no boss impatiently stamping his or her foot, demanding overtime to get a job done. There are no classroom assignments or end-of-semester critiques to pace you. It is a challenge to continue pushing yourself creatively as an artist year after year. Unfortunately, many of us tumble into the dark vortex of less and less art making as time goes by. Even if you do manage to remain resolute and self-motivated, your day job and personal life compete for meaningful time with your art practice. When life gets complicated and squeezing in more hours at the studio feels impossible, having an overall vision and a plan for the immediate future will help steady the chaos and sustain you in a more productive manner. You have already beaten incredible odds by committing to a life as an artist. You have developed your own process to generate ideas and have made the works of art that surround you in your studio. *You have a vision of*

what you wish to create; now you need to pair it with an equally powerful vision of how you will proceed with your professional life.

During the first year of the Rotunda Gallery, I was so focused on getting through eight exhibitions that there wasn't a moment to think further than the next show. But once I had installed the last show of the season, I realized with rising panic that another one was only two months away. This meant coming up with a new round of exhibition ideas, artists, fundraising, and promotion *while* tending to daily gallery tasks. I realized that I couldn't continue to work on such an ad hoc basis. I needed to get better organized and make a plan in order to manage the gallery's program over a longer time span. I started by assembling a list of all the deadlines the gallery faced: grant due dates; financial and program reports for quarterly board meetings; development, selection, promotion, and installation dates for each exhibition. There were so many of them! Every deadline had a host of tasks leading to it. For example, to submit a grant application required doing research, creating a project budget and proposal drafts, editing and assembling support materials, and—if we got the grant—writing regular reports. Looking at these lists was overwhelming. I pinned a year-long calendar on my office wall and began filling in all the deadlines. I color coded each exhibition, major grant, and report. Seeing everything visually laid out helped me feel more comfortable with what needed to be done. It was a lot of work to put the calendar together, but its stabilizing structure helped me manage different tasks and deadlines. Every morning I could glance at the calendar to see what had to be done that day.

As the gallery's programming became more ambitious, with added staff and a bigger budget, my planning had to encompass more variables and longer time spans. I had to execute fundraising proposals that not only gave regular reports of the gallery's current activities but also covered programs we expected to present two to three years in advance. I had to make time to assess the gallery's accomplishments, identify areas needing attention, and reflect on where the program was headed. I had to reach out to the board, gallery staff, and community to make sure we were on track and our plans were relevant. As I juggled more chores and deadlines, I relied more and more on the planning process.

Even on those days when the task list looked endless, I could see how my daily actions directly related to deadlines and reinforced short-term goals and how all actions and goals supported the gallery's future plans. I could focus on what had to be done today because my calendar listed tomorrow's tasks. I began to apply the planning process to my studio work, so I could get the most out of the little bits of time available at home. It helped me hang on to my painting practice despite a demanding job. Little did I know that, eight years later, this planning process would prove to be indispensable, giving me the confidence to leave the gallery and pursue my art career.

The Rotunda Gallery benefited and grew through planning. I was always looking at the overall picture, envisioning what needed to be accomplished long-term, setting specific goals, and assigning tasks that needed to be done in the short-term. Everything had to fit within the gallery's overall mission.

Planning isn't just for organizations. You do it all the time, although you might not be aware of the process. Think of all the steps you go through to show up on time at your dentist's office for a regular check-up. Or consider a more complex goal, such as enjoying a relaxed vacation. You begin by considering your needs and desires, ask for advice, do some research, determine how much you can spend, save money, organize your schedule for time off, make reservations, and travel—all this activity just to lie on the beach. Whether the goal is big or little, the process is similar in each case: there's a specific goal to be achieved, it's based on something you value (the health of your teeth, stress reduction, or pleasure), there's a series of actions to be undertaken, and you encounter some deadlines on the way to reaching it.

My career path took a 180-degree turn the day that I realized the planning process I had practiced to develop and manage the Rotunda Gallery could be applied to my art career. For the first time, I allowed myself to dream about *the life I wanted to live*. I envisioned what it would look like in five years' time, filling that picture full of details. That life appeared both tantalizingly wonderful *and* impossible to achieve. I didn't know exactly how I was going to make it happen. In spite of my fear, I clung to the vision and, as I did each year for the gallery, made

myself map out a series of interim goals and tasks that I would need to complete in order to build that life. Knowing what I wanted to accomplish in five years gave me a framework from which I could take action. I had a reason to take specific steps I wouldn't have done otherwise, such as realizing an upcoming scheduled trip to a board meeting in Washington, D.C., was *also* an opportunity to make contact with art dealers in that area. In the past, I had only attended the board meeting and a show or two at the National Gallery. This time, because my long-term goal was to connect with art professionals who would support my work, I took different actions. I researched and made appointments to introduce my work to art dealers, adding half a day to my trip. I packed my portfolio in my overnight bag and didn't let the fact I had a three-month-old baby stop me. He came along too. At the end of the Washington weekend, the baby and I rode Amtrak home with board meeting notes as well as new connections with potential art partners. That's the awesome power of planning. Lots of little actions can eventually add up to bigger things. Some of those appointments developed into art partnerships that continue to support my work twenty years later.

Why Should You Make a Plan?

Planning helps you address the daily question "What needs to be done now?" within the framework of your larger goals. Following a plan counters the passivity of waiting for something to happen by directing you to take meaningful action now. It provides clarity to help you create, assess, and pursue opportunities. Taking action within a plan helps you calm down when feeling overwhelmed or paralyzed by what needs to be accomplished. Moving toward the career you desire will no longer seem an amorphous, haphazard, or formidable undertaking. Most importantly, planning is the foundation for shaping the world as *you want it* instead of trying to fit into what *you have been told* is possible. Each one of us has a different view of what makes a successful career, and we will achieve it in our own way. There are no cookie-cutter approaches—go to this party, meet this person, make this kind of art, or be included in this show—that guarantee success. If that were true, you wouldn't need to read this

Planning can be applied to anything—creative, artistic, personal, and criminal.
—Colleen Keegan, creator, Creative Capital Strategic Planning Program for Artists

book, and we would all be showing up at the same party. There are as many definitions of success as there are artists. What's yours?

Whether you are just starting out or farther along in your career, making a plan will give you the insight to determine what you want to develop or revitalize in your professional life. *The planning process will help you understand where you are now and reveal where you wish to go. Planning provides a path to connect the two.* As an artist you are already process-oriented, for without a system, no matter how intuitive or haphazard it may feel at times, you couldn't create works of art. The planning process operates in tandem with the one you use for your artistic practice. It may feel like an awkward partnership at the beginning, but in time and with a little patience, you will discover how to manage the two.

The next section will take you through a series of steps to begin the planning process. These steps are:

1. Dream big: Create a vision of what you want to achieve.
2. Write your obituary: What do you value most in life?
3. Set your goals: Generate long- and short-term goals.
4. Establish your action plan: Determine what you need to do and a timeline for it.
5. Take action.

Each step includes exercises to help you flesh out your ideas. You don't need to do them all at once. Spend some time each day, week, or month working through the exercises until you have gradually completed them. This is an opportunity to be as open and honest with yourself as you can be. Listen to yourself without judgment. I realize that can be difficult to do. Try to tone down the inner critic and the skeptic.

Have fun with these steps. Don't feel the need to rush through the process. Seek out a place where you can work on each one. It may be in your peaceful studio or a noisy coffee shop. It is okay to draw pictures, doodle in the margins, or gaze out the window. Don't censor your thoughts. In the spirit of discovery, enjoy whatever ideas come to mind. Laugh out loud. Allow for surprises. If you get stuck somewhere, move on, and return to that step later. Make this process your own.

Success isn't something that happens to you, it's something you create.
—Joanne Mattera, artist

Success is to be part of the [art] conversation.
—Ellen Harvey, artist

You will need to write everything down to lay a solid foundation for your plan. There is a lot of power in putting things in writing. Most of your thinking is unconscious, a flowing stream of thoughts from which you consciously harvest only a few. Good ideas are too easily lost if you rely only on your ability to recall them later. How many times have you regretted not jotting down that flash of inspiration? At that moment the thought will seem so real and vivid that you're sure you will never forget it. Yet hours later, when you try to recall it, it's gone. Writing things down activates the process and preserves your ideas. You have something tangible to work with—to examine, question, revise, and follow later on. Writing down your plan puts your unconscious on notice and imposes a sense of entitlement to what you desire. You will be more motivated to follow through.

Write in a sketchbook, on legal pads, on sheets of cheap drawing paper you pin up around the studio, or in a secret folder on your computer. Throughout the process, allow yourself to write without judgment. Try to open up a clear channel from your thoughts to your hand to the words that flow out onto the paper or computer screen. Do not edit your writing. Allow yourself to be surprised, amused, and even confused. This is your opportunity to explore the unknown, the unacknowledged you.

Remember, there is no right or wrong response to any of these exercises, only *your* answers. Take your time. Allow your thinking to develop and grow.

The writing you do for these steps is for your eyes only. Find a safe place to store it so you can be as honest with yourself as possible. Just as you would when making a new work of art, don't ask for help or seek the judgment of others. You don't want to be subjected to another person's limitations or expectations. When I wrote my first plan, I didn't share it with anyone, not even my husband. I was afraid my friends and family would laugh and tell me my plan was ridiculous, a waste of my time and meager resources, and impossible to achieve. I was already scared to death about what I had envisioned. I couldn't have coped with other people's doubts and fears. I only shared tiny bits and pieces of my plan with those closest to me on a need-to-know basis. When I began achieving some of my goals, I was able to open up and reveal more.

Once you have finished the following steps, you'll have established an overview of what you want to accomplish and a series of immediate actions to get you started. Think of this as a new beginning. Try to do the steps in the order listed here. As you proceed, there will be lots of opportunities to refine, reevaluate, and tweak your plan to better suit your needs.

All my decisions come from wanting to make art for the rest of my life.
—Janine Antoni, artist

Step 1: Dream Big

CREATE A VISION OF WHAT YOU WANT TO ACHIEVE.

Yes, dreams can come true, but only if you allow yourself to have them. I realize that at this point you may be feeling skeptical. That's okay and perfectly normal. The concept of planning seems counter-intuitive to an artist's life. So many factors are out of your control. How can you predict the future? How can having a dream help your career? Isn't it all about talent and knowing the right people? Right now you'll just have to trust that entering into this process will quell some of your doubts and help you move ahead. Let your natural curiosity take over. It's similar to the questioning process you use to make your art: a willingness to explore unknown territory, engage multiple possibilities, and follow a line of thinking to see what happens. Now is the time to be equally curious about yourself.

One of the features of planning is that you'll never achieve more than the vision that guides you. For example, no athlete is ever selected for the Olympics by sheer accident. To prepare to compete at that level, Olympic athletes begin with an innate interest in a sport and some natural abilities that they hone through years of hard training motivated by a compelling vision of their future gold-medal performance. *Your* vision is comprised of your needs, desires, and abilities all working together to shape *your* destiny. Now is the time to imagine how you would like your artistic life to unfold.

For this exercise, let go and freely imagine what you want. Remember, you don't need to broadcast your vision to the rest of the world, but you *do* need to write it down and acknowledge it to yourself. Begin by quieting your mind, and allow the fuzzy images and stray

How to Assess, Plan, and Take Action

thoughts to gradually come into focus by asking yourself the following questions:

- What would make me feel successful as an artist?
- What would make me feel successful in my relationships with my partner/spouse/children/family/community?
- What kind of life would make me truly happy?

As you envision the answers to these questions, write down what you see. How does it feel? Who is around you? Where are you located? What are you doing? Try to make your answers rich with details. Allow yourself to dream as big and as colorfully as you can. Write in a stream of consciousness without worrying about grammar, spelling, or even coherence. Don't forget to include your life outside the studio. What is your relationship with your family/partner/spouse/children? Let this be an honest assessment of what you want for your life in a global sense, not only your art career. Be as honest as you can to reveal *what you want, not what you have been told you should want*. Again, do not edit. Allow it to flow. Make it as expressive and detailed as you can. Try to cover two to three pages, but if you're going strong, don't stop until you're finished. You have a complex life; there are no short answers.

If you are having trouble imagining what you want, try to think about what brings you pleasure. Draw a picture if that works better. Collect a stack of images, and assemble them into a collage. Walk around with a camera, and find your own images. Remind yourself that you have the right to be happy and this is what it would look like. Pretend you won $40 million in the lottery, and money was no longer a barrier. What would you be doing? Save everything you have written and collected.

Step 2: Write Your Obituary
WHAT DO YOU VALUE MOST IN LIFE?
Your vision needs to be aligned with your values. You cannot pursue a goal that works against a deeply held belief. For help in defining what is

THE ARTIST'S GUIDE

most significant for you, one of the best exercises is to write your own obituary. I know this may seem morbid, but your plan will be better informed if you have an ultimate destination in mind, and there is no end like death. How do you want to be remembered? Who will speak at your memorial service (friends, family, lovers, neighbors, colleagues, etc.)? What will each one say about you? What will you have accomplished? When I wrote my obituary, I imagined myself very old and resting peacefully on my deathbed. I visualized who would be standing around me and what thoughts or regrets might be going through my head. If your death is too gruesome for you to imagine, pretend that it's your seventy-fifth-birthday party or a taping of an episode of *This Is Your Life* and everyone special has gathered to celebrate it with you. Who are they, and what would you like them to say about you? What impact have you had on their lives?

> *In terms of building a career, I think one of the most important things to start with is to understand with as much clarity as you can muster at the moment, what it is that you really want. What exactly is the kind of career you want? Artists will very quickly say, "Well I want a great career," but does that mean a career that has gotten significant curatorial attention, a career that's significant in a museum context, or a career that's significant because it's paying your bills and supporting your family? Does that mean . . . you're an art star? There are all these different levels. Be specific about it, because the clearer you are about what you want, the more you can understand what approach is going to fit that. Also, I think you need to understand as a young artist, this is going to change. That what you want today and what you want tomorrow might alter.*
>
> —Kurt Perschke, artist

Writing my obituary made me reassess the kind of parent I wanted to be to my children and the kind of partner I wanted to be with my husband. When my children were small, it helped me choose to stay home at night reading and tucking them in rather than heading out to art openings. I would need to find another way to promote myself. In writing my obituary, I was also surprised to discover how important it was to me that I continue to play a role in strengthening my artist community. At the time I wasn't sure how I'd do this. I put the thought away for later. As I came to understand who and what was most important in my life, my obituary helped me prioritize my time and goals. It helped me understand my motivations and clarify my objectives so I made better choices at forks in the road. It showed up in hundreds of tiny decisions I made each day.

Writing your obituary is a similar process to revealing your vision. Allow yourself to enter into a state of active imagination, enjoy the details that emerge, and *write it all down*. You could format it like a *New York Times* obituary, as an entry in a daily journal, or as a long newsy letter to a good friend who couldn't attend your seventy-fifth-birthday party. You

could bring friends into the exercise by videotaping their fond remembrances of you. You don't have to complete this step in one session. Let it sit over time, and add or revise it as needed.

When you are finished, find a quiet place, and read through all you have written in "Dream Big" and "Write Your Obituary." Ask yourself if the person described in the obituary matches up with the life imagined in "Dream Big." Notice any discrepancies between the two. Are they both articulating the same values? What have you left out? Have you missed something significant in your vision? (e.g., Where's my travel lust in this picture?) Comparing the two is a way to see where your vision may be limited, unrealistic, or off track based on your deepest desires.

These two steps contain a vision of your life comprised of your deepest desires *and* your values. Planning books refer to this combination as your life's mission. Like a compass, they will keep you pointed in the right direction. They provide the reason why you do certain tasks and help you understand how those actions fit into the bigger picture of your life. Don't let the magnitude of your vision overwhelm you. Much of it will seem impossible to obtain, but who knows? In five, ten, twenty years' time, anything can happen. In a few years you might find that your life looks amazingly like what you imagined, or you might find that your goals have changed along the way. Your vision can always be rewritten.

Step 3: Set Your Goals

GENERATE LONG- AND SHORT-TERM GOALS.

Goals are those things you wish to accomplish. They are generated from your dreams and an understanding of what you value, making them the third step in this process. A goal identifies where you want to be at a later date and is comprised of the many small steps you need to take to accomplish it. Some goals will take years or a lifetime to be realized, while others will be completed in just a few months.

The first part of this step is to brainstorm a list of goals. What are all the things you wish to accomplish over a period of time? I like to break it down into five-year chunks. For me, five years is far enough into the future to project ambitious accomplishments, yet not too far away that I

Putting your subconscious thoughts into words does control the agenda and makes one proactive rather than reactive. . . . It becomes the story that you tell yourself. It is your essential truth, and you can build everything else from that.

—Colleen Keegan, creator, Creative Capital Strategic Planning Program for Artists

THE ARTIST'S GUIDE

feel snowed under by the possibilities. You can select a shorter or longer time frame if you prefer—three, ten, or fifteen years. Don't make it shorter than three, because you need to allow some time to let your plan develop and mature.

Pull out a blank sheet of paper, write at the top "IN FIVE (or whatever) YEARS I HAVE," and begin listing all the things you have accomplished during that period of time. Do not censor yourself. Write down *all* of your ideas, no matter how farfetched, dumb, frivolous, or impossible they may sound. *There is no such thing as too many items on this list.* Write them down as if they have actually happened; use action verbs: completed, awarded, secured, created, won, etc. The best goals are concrete—they state a specific action or event. Go through your list, and make whatever adjustments necessary to change vaguely worded goals into specific actions and events. Finally, make sure you have listed goals for your personal life as well as the artistic.

You may find this to be a difficult exercise, as helpless feelings arise when your list gets longer and longer. The expression of your desires feels insurmountable. How can you get to all of them? You may also start wondering if you are worthy of some goals. Don't panic and shut down the process. When I brainstormed my first set of art career goals, I remember thinking to myself, "Who do you think you are?" I ignored those doubts, and for now you should too. If you are doing this exercise well, you will generate far more goals than it's possible for any human being to realize. You are still in the brainstorming phase, and more is good. Later there will be plenty of time to sort, evaluate, and prioritize.

The second part of this step is to sort everything into long-term and short-term goals. Look through your lengthy brainstormed list, and next to each item indicate whether it is a short-term goal (SG)—something to be accomplished within the next year—or a long-term goal (LG), to be accomplished in two to five years. Some of your short-term goals may be achieved in a week or two; others will need to gestate longer or require interim steps before they are completed. On new sheets of paper, separate your goal list by writing long-term goals on one page and short-term goals on the other. Read through the long-term goal list, and

Listen to what you are telling yourself. Accept who you are. Pay attention to what you have been telling yourself since you were a child, because all the seeds you need for your work are right there.

—Morgan O'Hara, artist

We found with strategic planning that bigger plans are always easier to reach than smaller plans.

—Colleen Keegan, creator, Creative Capital Strategic Planning Program for Artists

see what smaller tasks need to be accomplished this year; add them to the short-term list. If you end up with too many items on the short-term list, don't worry—there's always next year.

Look over the two lists. How do they compare with your imagined life from "Dream Big"? Are any goals in conflict with your values expressed in your obituary? Have you forgotten something important? Add or adjust where necessary.

Goals exist to serve *you* and make *you* happy. You don't exist to serve them. Just like your art practice, your goals need to be generated from your needs and desires. What makes you happy and satisfied with your life is personal and cannot be determined by anyone else. As you pursue a goal, if it doesn't make you happy or add to your sense of accomplishment, modify it. Your list of goals will include tasks you don't enjoy and ones that challenge your abilities. I have found that identifying the reason why I have to do something motivates me to do it in spite of my dislike. It's like balancing your checking account or sending a thank-you note. These tasks may be bothersome, but they support your other efforts.

At this point, you can file away your long-term goals. They have been instrumental in getting you to this point and can be reviewed once a year. Our next step will be working exclusively with your short-term goals.

Step 4: *Establish Your Action Plan*
DETERMINE WHAT YOU NEED TO DO
AND A TIMELINE FOR IT.

Planning is an opportunity to think systematically about opportunities and assess what you need to do as determined by your goals. An action plan establishes a timeline of activities that need to be accomplished on the way to achieving your goal. It is an integrated series of small steps that helps structure your life so you can accomplish more. Think of it as a roadmap that guides you from point A to point B, the travel directions you get online, or the navigation system in your car. Following its step-by-step directions helps you complete one constructive task after an-

THE ARTIST'S GUIDE

other. *Your anxiety about the outcome of your goal will be replaced by directed activity.* As you are pulled into a course of action you will have less time to fret about its result.

Practice developing an action plan for one short-term goal. Go through the following steps to get you started:

1. Look over your short-term goal list, and choose one to accomplish in a month or two.
2. On a sheet of paper or on your computer, write the goal at the top of the page. Underneath, list the actions you will take over the next few days or weeks to complete the goal. List specific actions, such as researching information, making a phone call, or taking a digital image of a recently completed work. List them consecutively.
3. Next to each action write in the date you plan to complete it. Think practically and be realistic about how much time you have to devote to it.
4. Do the actions as planned, by either writing up a weekly to-do list or posting this sheet of paper where you will refer to it daily.

Practicing on one short-term goal will help you understand how easily something can be achieved when you keep your focus on it. By listing a date next to each action you have committed yourself to doing it and can monitor your progress. You can also assess how much you can take on and still juggle the rest of your life. Working toward your goals is easier if you can sustain minimal effort over a long time rather than loading yourself up with an unrealistic number of tasks all at once. Your initial enthusiasm will be maintained if you don't allow yourself to get bogged down by trying to do too much.

Make yourself write it all down until you have established a few new habits, such as breaking big steps down into smaller ones, making a task list, and regularly reviewing and evaluating your progress. As you internalize this process, your own system will emerge, and you'll create shortcuts. In time this process will feel less cumbersome. Mastering

how you go about achieving one short-term goal provides a model to tackle multiple goals with a yearly action plan.

Mapping Out Your Yearly Action Plan

Strategic planning at its core is simple. It sees that all information is good information. It is an honest assessment of exactly where you are. It is an eyes-open opportunity to not only deal with your present reality but also [to look] at how you shape your reality.

—Colleen Keegan, creator, Creative Capital Strategic Planning Program for Artists

You have spent time identifying your dreams and the long-term goals that will help you make them come true. Each long-term goal will take years to accomplish and is composed of many short-term goals. A yearly action plan will help you organize these short-term goals. Planning always works *back* from your goal by identifying the actions you need to take to move *forward* to your goal. This rule applies whether it is a long-term goal or a short-term goal; the only difference is the timeline. For this next exercise you will refer to your list of short-term goals. These are the tasks you need to accomplish this year. Your yearly action plan will help you figure out how and in what order you'll tackle them.

You can start with any date that works well for you. Schedule a few hours all to yourself. For years, I used the September to August academic/gallery season, but a few years ago I switched to the calendar year. I found early January an ideal time for me to curl up with a notepad and a fresh new calendar to make a yearly action plan. If you are reading this book mid-year, you don't have to wait for New Year's Eve or September to get started; apply this exercise to the months remaining.

I begin by first reflecting on what happened to me last year. I'll refer to my list of long-term goals to see which ones still resonate and which ones need updating or elimination. Then I'll make a new list of short-term goals for the upcoming year. I see this time as a wonderful gift to myself. I take a lot of pleasure in crossing off completed goals from last year's list. It's easy for me to forget about what I accomplished and only fuss over what I didn't do or still need to do. Use this time to enjoy what you have achieved, no matter how minor it may seem. Don't berate yourself for those goals you haven't completed; use it as an opportunity to assess where you are and what you need to do. If you aren't making any headway with a strongly desired goal, this is the time to rethink it. You may need to approach it differently, modify it, get help, or give it more time than you had expected. Maybe you need to discuss it with

someone else to get outside feedback. If this goal still feels vital to you, roll it over to the coming year's list. As I begin to brainstorm my short-term goals, I get excited. Taking this time to think about the totality of your life is healthy, so make sure your list includes your professional *and* personal life.

When you create your yearly action plan, you may find that some of your original goals no longer seem relevant. Changing life conditions precipitate different goals. Each decade of my life I have thought differently about my art practice. What were once burning dreams and desires have gone cold, and new ones have replaced them. I remember feeling certain I would never relinquish my studio work to write a book. Just the thought of it terrified me. Writing this book was a goal that slowly crept up on me over several years until I could no longer deny its importance. I wrestled with the idea, as I knew it would have an impact on my time and energy to make art. I made my living from the studio—what would happen to me if I let it go for a book project? What would happen to the partnerships I had cultivated over the years? Would I be forgotten as an artist? Would the art world let me back in? I couldn't answer those questions. As I debated with myself, however, I began to talk with other people about writing the book. I noticed my energy and excitement for this project grew. I was as interested in talking about it as I was about my painting. That surprised me; I usually loved talking about what was going on in the studio. Finally I embraced the book as a new long-term goal and generated a new list of short-term goals to make it happen.

Every year we set new goals in January. We actually go to Puerto Rico to visit [my wife] Rossana's family for the holidays. So for two to three weeks we are on a beach in Puerto Rico super far from our studios and the rest of the art universe. And we are thinking, what would be the next step? Where do we want to take it? What would be the strategic way to move this project? Where are we getting the most resistance? Where are we getting the least resistance? And a lot of times you move in the path of least resistance for obvious reasons, but we evaluate every year. We actually do it on a regular basis, but that's our big [moment to] figure out where we want to take the project the next year. . . . That's the same time we evaluate our work too. We sort of envision what we want to focus on in the next year. The kind of work we want to make, what we want to think about.

—Matthew Deleget,
artist and cofounder, MINUS SPACE

Artists Matthew Deleget and Rossana Martínez manage a busy studio practice and an online curatorial project, MINUS SPACE. The sidebar describes how they do their planning and have fun at the same time.

Doing my yearly evaluation, I always uncover a few neglected goals. For some reason they never get done. I take some time to explore why I am stuck or procrastinating. Is this goal still really important to me? Is it being stopped by something else that needs to be done first? Am I scared

of it? If I am, what can I do to make it less intimidating? I try to come up with one small step to get engaged in it. Sometimes, I realize that this goal is no longer of interest to me. Other times, I see that my plan is developing differently from what I had originally imagined, and my long-term goals need to be modified. If you get stuck spinning your wheels on some task, analyze what help or support you might need to pull yourself out and move forward and whom you could ask for assistance.

To help you figure out a system for organizing the year's work, complete your yearly action plan by transferring your short-term goals to a calendar. First, fill in important deadlines such as paying taxes, grant due dates, freelance or job commitments, commissions, and exhibition schedules. When I first began doing this, I took my twelve-month calendar apart, laying it out on a large table so I could see the whole year when I filled things in. When I was done, I would hang the current month and the upcoming month above my desk and keep the rest nearby. Now I do it on my computer and print out any month as needed. It's up to you to figure out what works best.

Chapter 9 will discuss organizational systems in the time management section. For now, begin with your calendar: take a little time each week, go through what needs to be done, and make a plan for the next five to seven days, tweaking it as you go along. No matter how intuitively you work, it's helpful to have a short to-do list somewhere in a visible place so you will be reminded of the actions you need to take. Get to know what you can realistically accomplish in seven days. Review your action plan at the end of the month. Are there more steps, and do you need more time than you initially projected? Have you uncovered information that shifts your goal? Modify, and move on. You will eventually discover the appropriate amount of time you need for detailed planning: monthly, quarterly, or semi-annually.

Step 5: Take Action

All this planning is of no use unless you follow through by taking action. You have invested a lot of time identifying your goals and creating these lists. Don't put off doing them. I find it fascinating that some of

my students who have readily engaged in all the planning exercises find this step the hardest part of the process. I've noticed that they love dreaming and scheming, but neglect following through with action. Their plan is comfortable as an imagined possibility, but their anxiety brings up the paralyzing fear of failure. Yes, a plan may look daunting, but taking the first steps will relieve some of the anxiety you feel. If getting started is hard, find one concrete action you can take. As you become engaged, your actions will replace your anxiety. Even if the results are not exactly what you expected or don't work out at all, they will produce new information to help determine your next move. Good luck, being in the right place at the right time, and being prepared are more likely to happen when you are actively engaged in your plan.

It will take many small steps to accomplish a big goal. The sooner you start taking responsibility for your life, the more energy you'll generate to propel yourself forward. Even doing something minor—making a new contact, organizing your desk, downloading an application—should be seen as a step forward. Set up rewards to release good energy into your plan by celebrating completed actions. When I met my first year's financial goal in just six months' time, I immediately felt empowered and successful, even though I still had much more that needed to be done. I took a moment to really savor how good I felt. As I sat on a bench by the Hudson River and watched the sun go down, I could feel a huge grin spread across my face as the thought kept flashing through my head, "Maybe I *can* do this." Nothing feels better than beginning to make progress on what you want.

If you are reading this book, you have already beaten the odds and are willing to try something new. I know getting to this point hasn't been easy. Take a moment to acknowledge what you have achieved so far, ignore the negative messages that hold you back, and allow yourself to begin thinking differently. Like any profession, achievement takes talent, hard work, and yes, a little luck. You will face moments of suffering—that's the human condition—but they don't have to be what defines you.

An art career is different from other businesses and professions. What you are creating is deeply personal; you are challenged to remain

Right now, I am preparing for a show. Because my work is fabricated and made in different ways, [these sheets] on the wall are like the map of the show: the ideas, images, calendar, and dates. I can look at the date and what has to happen so that everything is done on time. I can work backwards. I can just sit here and see the whole show and think about it.

—Janine Antoni, artist

How to Assess, Plan, and Take Action

vulnerable and open to the creative spark. The concept of planning can feel contrary to the creative process. Yet being an artist isn't just about making art. You have many other responsibilities—managing a studio, looking for opportunities, identifying an audience for your work, caring for and protecting what you have created, and securing money, time, and space, in addition to whatever is happening in your personal life. All of this will be accomplished better if tackled in a strategic and focused manner. Whatever has happened to you in the past does not have to predict your future. Planning is your opportunity to assess, take positive action, and begin producing results.

Initially, it may feel awkward and cumbersome to write things down and follow a weekly, monthly, yearly, or lifelong plan. But don't let that stop you. Planning gives you permission to ask for what you want and design a path to achieve it. You already understand process; your art comes out of one you've spent years developing. Think about your first drawing class: how awkward a piece of vine charcoal felt in your fingers and the struggle it took to manage the complex relationship between your eyes, your hand movements, and a crumbly line. After a few weeks, as you grasped concepts of positive and negative space, composition, and shading, your confidence grew. Becoming comfortable with planning will be a similar experience. It takes practice to make it work for you. In time, you will internalize many of the steps outlined here and find your own ways to do planning quickly and efficiently.

Bookstores offer shelves of books dedicated to mastering the planning process. Ambitious people everywhere are looking for ways to be more productive and manage their lives. You may wish to browse through them to explore other planning methods and pick up new tips.

You are committed in that you have told people what your plans are. You have written them down. You are constantly keeping that in [the] forefront. Your vision of your career is always there up front. So when opportunities present themselves, wherever they are, at a meeting, an event, or somewhere there are networking opportunities, you are able to take advantage of them, because you have said in your mind this is what you are doing. It isn't a matter of "What if I can do it?" but "How can I do it? What steps can I take? What things can I take advantage of?" The business plan and structure, your legal issues, and your marketing are all important tools, but they are meaningless without your vision and drive to accomplish your dream.

—Jeff Becker, artist and executive director of Arts Incubator, Kansas City

Counter the Van Gogh Myth

Our culture promotes a skewed view of artists. It's much more interesting to make a movie about Jackson Pollock's unruly life than Hans

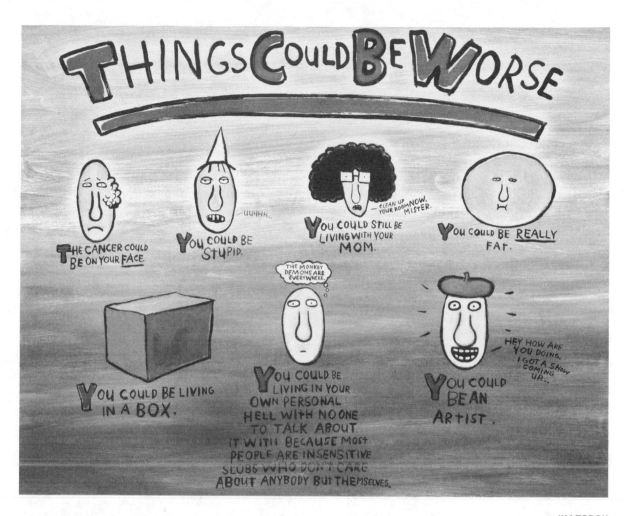

JIM TOROK

Things Could Be Worse, 2007

Acrylic on panel

37 x 48 inches

Private collection, courtesy of the artist and Pierogi

Hoffman's more balanced existence. To make my students aware of these pervasive messages, I do the following exercise:

On a chalkboard or large sheet of paper, I write "A VISUAL ARTIST IS" and ask them to complete the sentence. Words and phrases come flying: creative, starving, disorganized, bad at math, dyslexic, poor, struggling, visionary, crazy, insane, on the fringes, free, nomadic, bad at following rules, antisocial. You may have a few words and phrases of your own to add. As the class looks over the list, they notice immediately that most of the words and phrases are negative. Their preconceived idea is that being an artist automatically makes a person crazy,

How to Assess, Plan, and Take Action

poor, and disorganized. I refer to this association as the "Van Gogh Myth," because these negative terms reflect the public misperception of the artist as madman. Many artists' earliest visions of pursuing a career are merged with the impossible task of living a good life. They are defeated before they have even begun. I have found that all too often artists are conditioned not to ask for what they want because they have decided that it is impossible to achieve. Doing this simple yet revealing exercise with my students helps to get those unconscious associations out in the open, where they can be challenged and overcome.

There is no single way to proceed with an artistic career. It is your job to individualize your direction and make a plan based on your own needs and values. To begin, you must first identify what you want to achieve. Once you have done that, you will be able to break it down and create manageable tasks to get you rolling. Only by having the big picture in mind can you work toward fulfilling your goals.

Start here. This chapter is about spending time with the most important artist in your universe—YOU. Get to know what you really want. Hold on and treasure your vision. Acknowledge that your life is a work in progress and that your goals will change and develop over time. Knowing deeply what you want to accomplish shores up doubt, builds fortitude, and pushes you to take more action. This awareness changes how you hear and use information. Your senses will be sharpened. You begin to listen to everything differently; you interpret what you read, what you do, and whom you meet with your goals in mind. You will ask better questions of those around you and seek more meaningful help. All of this will produce a subtle yet profound shift in how you proceed and the actions you take. It will reshape your life and have major consequences for your career.

You may feel burdened with counterproductive beliefs that keep you from succeeding. In spite of the things that have gone well in my life, I still struggle with mine. My demons and my inner critic make me feel unworthy and incapable of reaching ambitious goals. Sometimes I feel as if I have one foot on the gas *and* one foot on the brake at the same time. I have learned to listen to my unpleasant critical inner voice to help me understand how it influences my behavior. Through planning

and taking action I have learned to override and silence it. For a delirious moment, my foot is completely off the brake, and I'm gleefully shooting ahead.

Try it. You have nothing to lose and everything to gain.

Resources

Covey, Steven R. *Seven Habits of Highly Effective People*. Anniversary edition. New York: Free Press, 2004.

- I picked up this book twenty-five years ago to help me develop strategies for setting goals. I especially appreciated Covey's emphasis on the importance of aligning your goals with your values.

Gelb, Michael J. *How to Think Like Leonardo da Vinci*. New York: Dell, 1998.

- This book contains some great exercises to enhance your thinking and a system of goal setting and mind mapping that appeals to visual thinkers.

Sher, Barbara, with Annie Gottleib. *Wishcraft: How to Get What You Really Want*. 2nd edition. New York: Ballantine Books, 2003.

- I read the first edition of this book years ago when I first began setting goals. It is filled with fun exercises to help you identify your strengths, skills, and interests. It also has a great chapter on handling the fears that come up when you reach for ambitious goals.

How to Assemble the Essential Tools to Support Your Work

Assembling a great set of promotional tools develops confidence and enriches your creative practice.

This chapter explores the crucial links between work samples, artists' statements, and the intended audience—curators, dealers, critics, collectors, other artists, and the general public. It shows how work samples and a written statement can become part of your creative process and inspire new studio work. When done well, these tools are an intimate and revealing glimpse into your practice, references, and intentions. They are the most important tools you will use to promote your work over a lifetime.

More people in the world will see your work through some visual reproduction of it than will ever see it in person. Think about it. If you want to see the *Mona Lisa*, you don't have to travel to Paris. You don't need to fly to Spain to see Picasso's *Guernica*. You can simply open up one of the hundreds of books in which these works appear. For well over a hundred and fifty years, images of great works of art have been readily available worldwide. From painted and incised animals depicted in the deep interiors of French caves to the latest installation currently on view in Seoul, South Korea, art is readily accessible to us through many streams of reproduction.

You studied art history via projected images on screens in darkened lecture halls and pored over tiny black-and-white and color reproductions in textbooks and magazines. You made your initial judgments based on these images. I vividly remember my introduction to post-Impressionism in college. Looking at Cezanne's painting *The Large Bathers* (page 26) in my textbook, I thought, what was the big deal about this work? Why had my art history professor talked so ecstati-

cally about it? I only saw some lumpy naked women leaning in toward each other. Yes, I noted the classic triangular composition, but I didn't get much more than that from the illustration. A year later, as I entered a gallery in the Philadelphia Museum of Art, *The Large Bathers* suddenly popped up in front of me.

I was astonished by its power as the painting pushed me back against a wall. Then, I finally got it. You may have had similar experiences. Whenever I am introduced to a work of art, whether through an image, or in person, I immediately begin to make judgments and assumptions about what I am seeing. I ask myself questions about the work and its creator. What is it about? What was the artist's intention? How was it made? How does it relate to other artists' work? I look around to see if I can find some information to begin answering my questions. This is why your work samples and artist statements are so important. Together, they form a more complete record that documents your past and present achievements. They are the two most essential tools you will use to promote your work throughout your career. They are the tools that art professionals will use to understand and support your work.

As artists, we want everyone to encounter our work in person. We know an image of our art, no matter how outstanding its quality, is less satisfying than seeing it in real life. I wish I had a penny for every artist

How to Assemble the Essential Tools to Support Your Work

PAUL CEZANNE

The Large Bathers, c.1900–05

Oil on canvas

Philadelphia Museum of Art, Pennsylvania, PA, USA/ The Bridgeman Art Library

who sighs, "But these images don't really represent my work. You've got to come and see it in person." I know how frustrating it feels when trying to explain my work as pictured on a computer screen or postcard. No matter how good the image, many elements cannot be fully captured in a reproduction. It is difficult to convey the relative relationship of scale, minute details, tactile sense of surface, and—most of all—the intimacy of the viewing experience. Sadly, it's impossible these days for anyone to keep up with new ideas and current exhibitions without relying on the reproduced images we see in art publications, advertising, TV, and the Internet.

Viewing a work of art in person is often not enough to satisfy your curiosity. In your excursions into galleries and museums you may have found yourself fascinated, puzzled, or curious about a particular work of art. Your interest may make you search around for the wall text, exhibition brochure, or press release because you want to gain a deeper insight into what you are seeing or to confirm what you are thinking.

Your work sample and artist statement represent a vital line of communication between you and the rest of the world. Images of your work appear on exhibition announcements, websites, advertisements, catalogues, and art reviews. They are projected in competitive situations such as juried shows and job interviews as well as panels deciding on grants, awards, and residencies. Your artist statement will appear as a handout in an exhibition, a paragraph in a press release or brochure,

THE ARTIST'S GUIDE

and a page on websites, portfolios, and grant proposals. Assumptions, judgments, and decisions about your work are made based on what the viewer gleans from these two tools. It puts your efforts at a real disadvantage if you send out poor quality images of your work and obtuse or badly written artist statements. It's a cop-out to take the position that "My work speaks for itself," or "If they can't get my work by looking at it, that's their problem." Actually, it's your problem, not theirs; the viewer, curator, or panelist moves on to someone else.

As you create your work, documenting it through words and images needs to become part of your creative process. No one else in the world will ever be as committed as you are to your work. It is *your responsibility* to discover what images represent it best and what words need to accompany them to enhance the viewing experience.

To get started, ask yourself the following questions:

- What information do I want the world to know about my work?
- What kinds of images show my work to its best advantage?
- What do I need to say or write to assist the viewer when looking at my work?

The first step is to acknowledge that *you* are the expert on *your* own work, not the curator, critic, or gallery director. You are the one most intimately involved in its genesis and execution, making you the best source of insider information. Others may help provide insights and food for thought, but first you need to be clear about the meaning of your own work. As you may enter into a dialogue about it during studio visits and exhibitions, you don't want to be completely swayed by another's interpretation.

With practice and thoughtful attention you can develop the capacity to capture images that show your work to its best advantage and to find the words that authentically describe your intentions. It's a skill-building process, just like the one you developed to make your art. You will need to set aside time to do it, which will be easier to manage if you can incorporate it as an integral part of your creative practice. The reward

will be that as you become better at getting great images and articulating your ideas, the resulting clarity and insight will function as an important feedback mechanism for developing your next body of work. The key is to make these activities as engaging as making your art.

The next section, "The How-to's," outlines a process to assist you in developing your visual and written tools. This chapter, along with "How to Introduce Your Work to the Professional Community" (chapter 4), helps you become comfortable showing and talking about your work in a variety of situations, even under pressure. It helps you evaluate the quality of the images that you send out to the world. Then it walks you through the steps of composing an artist statement that conveys just the right amount of information your audience needs to become more involved with your work. Throughout I will show you how these vital tools are seen and used by others.

The How-to's

TOOL #1: WORK SAMPLES

A work sample is a visual image of your work as captured on digital files, color transparencies, photographs, or video.

The quality of your work sample is of supreme importance for the promotion of your art. This is true whether you are promoting it yourself or through a gallery, curator, or agent. I can't stress this enough. Remember, the only relationship most viewers will *ever* have with your art will be through a reproduction of it. You have only a few seconds to impress the panel, juror, curator, art dealer, agent, or web surfer with your work. These are decisive moments! You want them to count. *It is important that you become the person in control of the quality of your images.*

A great work sample shows off your work to its best advantage. You should be able to say to yourself when you look at it, "Yes! That looks great!"

Work Sample Basics

- Place the art on a neutral background—white, black, or grey, depending on the needs of your work.

- Arrange even lighting over the entire picture plane—get rid of dark areas or hot spots.
- Eliminate glare on framed works or glossy surfaces.
- Establish the proper contrast so the whites are white, not dingy grey, and blacks are fully black. Learn how to use the white-balance feature on your digital camera.
- Capture the full intensity or subtlety of the colors and textures.
- Fill the picture frame as completely as possible with the artwork—without cropping off the edges of the painting, drawing, or sculpture (except in detail views). The viewers need to know they are seeing the whole work versus a detail.
- Take detail shots to show specific areas and alternate views.
- Remove distracting elements or extraneous things from the picture frame, unless they are necessary to reference scale or the architectural setting for an installation or performance.

Make sure you have great images of your work *before* it leaves your studio. Once the art leaves your hands, the opportunity to document it is gone or becomes more complicated. If your work is lost or damaged in transit, your studio documentation is the only record of its pristine state or even of its existence. Should a conservator need to be hired to repair the damage, that image would be crucial in helping with the restoration process.

For installations where the work is finished on site, documenting it thoroughly needs to be part of your production schedule. You may think you can rely on the gallery or museum to document the work, but their staff will never do as thoughtful or thorough a job as you would. Their interests are different from yours. For them, documenting your work is more about preserving a record of the exhibition rather than focusing on concepts and themes. It's typically done by either someone on staff or a freelance photographer who is given only the most

I've always documented my work in video and still photography. The couple things that I've learned about documentation are that whenever I've handed it over to other people, I've regretted it. I had a professional film crew that shot commercials for Nike and were all on board to do the video documentation for the project. They had resources I couldn't dream of and I could never afford. Two days before the project started, they got a different gig. Because of that, only half the sites were filmed, and I only have the backup video, which I shot. So I've learned that you can't rely on other people, but I've also learned that their footage wasn't as good as mine. . . . Finding collaborators who you really trust that are going to be great is actually quite hard.

—Kurt Perschke, artist

[Handwritten note: Need #1 — I will need a better process for photographing finished work.]

CHRISTIAN MARCLAY
Boneyard, 1990
Dimensions variable
750 hydrostone casts of phone receivers
Courtesy of the Dakis Joannou Collection, Athens

basic instructions. These people can't read your mind to know what aspects of an individual piece need to be captured. They are interested in satisfying the needs of their client—the museum or gallery—not you.

Examples of the difference between an institution's documentation and the artist's appear in the two illustrations above. Artist Christian Marclay exhibits his work internationally at important museum and gallery venues. Compare the two images of his sculpture installation *Boneyard*. The one on the left was taken by a photographer under the directions of the artist when it was first shown in a commercial gallery in Europe; the one on the right was taken by the exhibition photographer at the Whitney Museum of American Art in the 2002 Biennial Exhibition.

While the Whitney Museum image adequately documented the entire sculpture as installed during the show, the piece feels removed from the viewer, and it is difficult to identify the white objects on the floor. In fact, the art occupies only the bottom half of the image; the other half is empty museum walls. Contrast that with the other photo, shot from a ladder, high up and over the piece. The image manages to capture a close-up of the scattered objects while providing a long depth of field alluding to the scale of the piece. We can easily see that the cast objects

JULIANNE SWARTZ
How Deep Is Your, 2003
Site specific installation
with sound
P.S. 1/MoMa, Queens, NY

scattered on the floor are old-fashioned telephone receivers, which fulfill the meaning of the title's metaphor.

A work sample is not the work; it *represents* it. You need to plan *now* for work samples that meet a variety of future needs—exhibition announcements, press photos, and advertising. *To capture an image that reflects the ideas, materials, or concepts behind the work, you will need to get creative with your work samples.* Don't be hesitant to move your work around or set up different camera angles to capture a more compelling shot.

Installations may require rearranging some of the elements, moving them closer together, or pulling some into the foreground to make a more dramatic image for the work sample.

If the work is interactive or has a performance component, including action shots is crucial. You may need to bring a friend along to the photo shoot to stage the viewer's participation yourself. In Julianne Swartz's installation *How Deep Is Your,* two pop songs, "How Deep Is Your Love" by the Bee Gees and "Love" by John Lennon, emanate from the basement's defunct boiler unit into a tubing system that runs through the hallways and stairwell of the P.S. 1 Contemporary Art Center. The songs travel through the museum via hundreds of feet of plastic tubing and eventually emit from a funnel that hangs in the gallery space two floors above. Viewers can hear a mixture of the two songs by placing their head in the funnel. Two images capture the essence of the installation. The one on

I've often been unhappy with the results when institutions have documented my work—either the resolution isn't high enough, or they've picked an angle that I dislike.

—Ellen Harvey, artist

DIRK RATHKE
Wall Objects, 2001–05
Oil on canvas/cotton
Each approx. 24 x 8 x 2–4 in.
View of installation Gallery
Stefanie Seidl in Atelierhaus
Hermann Rosa, Munich,
2005/06

the left is a detail of the sculpture as it emerges from the hallway and into the gallery space to its end point. On the right is an arresting shot of a gallery visitor listening to the emanating sound. Although we can't hear the songs, these two images provide the information needed to understand the participatory aspects of this installation.

Arrange several works together into one shot. While a single piece provides the viewer with one level of meaning, the concepts, scale, or serial nature of your work may be better demonstrated by including an image of several works grouped together. Above is a work sample that includes a number of shaped paintings from the *Curved Canvas* series by Dirk Rathke. This view shows us the repetitive nature of the series, the range of variation, and a view of the painting's edge to show the dimensionality and shaping of the canvas as an object on the wall.

A great way to expand your thinking about your work samples is to take the time to look critically at images in art magazines, catalogues,

exhibition announcements and on websites. Ask yourself what makes one picture more successful than another. If it is an artist's work you know, think about how well the essence of the person's work has or has not been captured through this image. Maybe a detail shot has been chosen over an image of an entire piece. Would that work for you? Make note of what captures your attention, and think about why it does. If you work in video, performance, and installation, carefully consider the difficulties of presenting complicated and time-based projects in a single image.

As you look critically, think of ways you could apply some of these tactics to your own work. Can you arrange a similar setup? Would a working process or studio shot provide crucial information and scale? Keep a picture file of these images for reference and inspiration.

For installations and performances, images are sometimes needed months before the work is in its final form or publicly exhibited. Rather than send out an exhibition announcement with only your name on it, capture preliminary work samples that represent elements or ideas of the unfinished piece. You can start building an audience for the show long before the work is installed.

If your work is process-based, you may want to document those actions. Remember Hans Namuth's striking image of Jackson Pollock flinging paint (page 34)? It perfectly reflected the concept of "action painting." You might not find your tools or method all that interesting, but your audience will. Being able to see your creative process invites them into the studio and clarifies usually hidden aspects of the work.

Producing great work samples requires taking the time to learn how to do it yourself or hiring a professional photographer. Based on my own experience, I advise you to learn how to shoot images of your work that rival those taken by a professional. Why? Because if you can't take good photographs of your work, you will often not have the right work samples when needed. Sometimes a slide or a digital image must be sent quickly, and you don't have the time to wait for an appointment with a professional photographer. Taking a picture with your cell phone on the way out the door to an appointment isn't going to cut it. Instead of talking about your ideas, you'll spend more time explaining why the

color isn't right and why those unintentional dark spots aren't a new direction in your work. Unless your work is small and easily portable, you will need to produce a certain amount of finished pieces before it's cost effective to have a professional photographer come to your studio. Your art production should be based on your own process, not timed for a photographer's appointments. Waiting for six months to finally have great images of your most recent work is counterproductive to your promotional efforts. You will not be able to respond to a curator or gallerist's request in a timely fashion. Images of your current work will not be available when quick action is needed to react to an unforeseen opportunity or last-minute deadline. Teach yourself to produce images of your work that are almost as good as those of a professional, so you won't be caught off guard.

Playfully practice documenting your work in different ways to see what makes it look best. If documenting your work is a new skill for you, or you aren't happy with the work samples you currently have, experiment

a bit. Have some fun. Set up a photo shoot. Click away; try different camera angles and lighting arrangements. Purchase a roll of photo backdrop paper, and take photographs with a black, grey, or buff background instead of white. Capture a variety of details; let intuition be your guide. Look over the images critically, and assess what looks best. Ask friends who know your work which images they like and why. Even if you end up using a professional photographer to do the final work documentation, having done your homework will help you direct her to the best angles and alert her to potential issues. Professional photographers are expensive. If you know what shots and camera angles you want, it will save you money.

Hiring a Photographer versus Doing It Yourself

If you hire a photographer to document your work, ask for samples of other artists' work he has shot in your medium. Get suggestions from art professionals in your community. If you notice another artist's fantastic work sample, ask her for the name of the photographer. Don't forget that photographers are professionals with their own strengths and weaknesses. Some are excellent with paintings, but don't do as well documenting installations or sculpture and vice versa. Don't think that just because you have hired a professional you can leave him alone. Until you have worked together several times, you should remain an active part of the process to insure that your needs are understood. Think of it as a collaborative partnership. You can explain what you're looking for, and he will in turn make suggestions and give advice based on his experience. Here's where your picture file of wonderful work samples can come in handy.

Learning to document your work by yourself will require that you make an investment in some basic equipment, get some instruction, and take the time to practice. I learned how to photograph my work by hiring a photographer to walk me through the process. She showed me how to properly set up the lights. Then she taught me how to use a handheld light meter, suggested filters that applied to the issues of my work, and discussed slide film versus digital. She also introduced me to the necessity of a tripod, which I had thought was an extraneous piece

I think each artist should learn how to photograph their work properly. Whether they are doing it themselves or they're hiring someone, they need to learn how to do it well. That's very important. Because it's such a visual business clearly, and the wrong color in a jpeg or any of that kind of stuff can really change the whole thing.

—Julie Baker, president of
Julie Baker Fine Art
and partner of
Garson Baker Fine Art

of equipment. In no way would I call myself a professional, nor would I feel confident documenting someone else's work, but I learned to be competent with my own. If you need to find out how to get better images of your work, take a workshop or hire a photographer, as I did, to teach you the basics. Acquire the essential equipment, and then practice until you are consistently getting great images. You may still want to hire a photographer to document important pieces or works that will be used for exhibition announcements and press photos. I assure you, doing it yourself is a great skill to develop.

Whether you document your work yourself or hire a photographer, always *evaluate all images to determine their overall quality and effectiveness.* To do this you need to look at the images as they will be viewed by others and how they will be used. Will they be part of a grant proposal and digitally projected before a panel? Are you including them on websites, burning them to CDs or DVDs, or printing them on your inkjet or laser printer? Sometimes a seemingly perfect image, when projected or printed, is washed out, dingy, or slightly out of focus. If you have used a professional photographer, explain the problem and ask him to reshoot the work. If you are doing it yourself, go back and shoot it again.

View all digital files full-screen on your computer monitor. I am often surprised to see that the great thumbnail image on my digital camera viewer turns out to be slightly out of focus on my computer screen. You can't correct that problem in a photo imaging program. The work must be photographed again. Before I break down the lights and put away the work, I'll download the files to the computer and carefully inspect them. The photo setup is standing by if I need to reshoot.

You need to be satisfied with how your images appear on your computer screen and printer. Once your work samples go out into the world, you no longer control how they are viewed. Every slide projector, computer monitor, and digital projector has its individual quirks, color balance, and light intensity. Every inkjet or laser printer will produce a slightly different version of your digital file. Ever walk through a large electronics store? Check out the wall of flat screen TVs and computer monitors. Although they are all tuned to the same channel or dis-

play the same wallpaper, each one looks slightly different—richer, paler, softer, harder, warmer, or cooler. Your images will be subjected to the same variations as well.

Digital media has overtaken film stock for documenting work in the last few years. A good quality digital camera is a necessity. It is easier to use than a manual film camera, and images can be cleaned up with a photo editing program. Most organizations now ask for digital submissions rather than 35 mm slides. In spite of the recent advances in digital technology, many art professionals still argue that photographic film stock produces better quality images than even the highest resolution digital cameras. *Documenting your work has two main purposes—to create a long-lasting archive of your art and to promote it.* Whether you document it with both color transparencies and digital files or only digitally, the crucial step is to make sure these images are safely stored in more than one location. Color 35 mm slides and larger format transparencies (4 by 5 inches), when stored correctly in archival sleeves and in a dark cool place, have a longer shelf life than CDs and DVDs. Digital images should be backed up to external hard drives or an online image-hosting site. Your responsibility to your work is to stay informed and capture the finest images currently possible. It is important for you to keep up with any new technology that changes these standards.

Digital images should be saved as "raw" files (no compression) and then downloaded as tiff files (minimum compression) that can later be converted into jpegs. If you are working with a professional photographer, they can provide you with images that are adjusted to the proper color balance and contrast. If you are shooting your own work, you will need to do this yourself or hire someone to do it for you. I recommend that you learn the basics of a photo editing software program such as Photoshop. Have someone teach you how to properly calibrate your computer screen, clean up your images, save them at different resolutions and formats, and print them out. Depending on someone else to do this for you will only mean you won't have the images you want when you need them. Learn how to create a PowerPoint or other digital slide presentation on a CD, DVD, or flash drive; make sure the images are correctly

sized so that they properly fill the screen and will open on both Macintosh and PC platforms. It always pays to double-check what format is needed before sending out digital files.

As your work is photographed, create a list with the *title, date, medium, size,* and any other information that should be noted. This saves enormous time later when you are labeling the images. All the information needed is at your fingertips with no guessing about the dimensions of a piece that may be back at your studio, wrapped up, or shipped away. If you are dropping off a portfolio of work to be shot at the photographer's studio, create this list in advance, and provide written instructions on how you want the work to be shot (background color, amount of space around the image, etc.).

. . . good color correction, a clear image, straight-on shots, and being lined up: As easy as that sounds, you would be amazed by how bad some of the images [from artists submitting to competitions] are; they're really dark, or you can't see what's going on.

—Letha Wilson, artist and associate curator emeritus at Artists Space

Labeling Your Work Samples

- Digital files are rotated to their correct orientation and saved with, at minimum, the title and your name. Avoid any punctuation marks in the saved file title, as it may make it impossible for another server to upload the image.
- Digital printouts and laser prints should be labeled on the front with small print running along the bottom edge: your name, title, date, size, and medium. If appropriate, include your website URL.
- Size is always listed as: height x width x depth (HWD). Use the mnemonic "Helpful Work Dimensions" to remember the correct order.
- On slides and color transparencies always indicate the top of the image, even if you think the orientation is obvious, as in a portrait or landscape. Draw an arrow indicating up or write the word "top" along the upper edge.
- On a photograph, print "top" on the top margin of the image, or affix a label to the back with it clearly indicated. All other information should be on permanent labels affixed to the back. Do not label directly on the back with a permanent marker, since that might bleed through.

THE ARTIST'S GUIDE

- Label both the CD or DVD and the box or sleeve it is sent in with your name, phone number, and website and/or email address.

The best time to label the work is *now,* as you are working with the images on the computer or when they first arrive from the photo developer. The information is fresh, your commitment is strongest, and it saves you time later on. This is where the list you developed while photographing the work comes in handy. Although each organization will have its own formatting and labeling guidelines for submissions, you need to create your own labels to keep all your work samples in good order and easily accessed. Having well-labeled work samples will save you enormous amounts of time later on. Below are general guidelines as well as those for specific media.

Media-Specific Work Sample Tips

Installation/performance: The most important role of an installation photograph is to give context to the artwork. It is crucial to have images of the actual piece isolated from its surroundings so that the viewer is provided with a clear understanding of the artwork itself. The full installation shot sets the stage and presents the piece in its exhibition environment. Detail shots illustrate important ideas and specific aspects of the work that are hard to see in a full installation view. Including a person standing to the side of the work or interacting with it shows the

ROSSANA MARTÍNEZ

Glow, 2006

Performance and site-specific installation at Hunter College/Times Square Galleries, New York

Fluorescent orange spray paint on wall

Edition of 1,000, fluorescent orange spray paint on white paper, 4 x 6 inches each

scale and scope of the installation. If it is relevant, you can document the piece at different times of the day or in different seasonal situations (like earthworks or time-based works).

If your installation has a performative element, make sure you have someone document that aspect as well. Remember, you'll have only one chance to capture the images you'll need.

In addition to the four images above documenting her performance, Rossana Martínez also adds an excellent description to complete our understanding of the piece.

> *Glow* is a hybrid project where performance and architecture are transformed into painting. To create *Glow*, I wore a black dress and

THE ARTIST'S GUIDE

heels. Starting in one corner of the space, I walked around the perimeter of the room holding a can of spray paint while continuously spraying paint on the wall until the can of paint was completely empty.

The visual result was an installation consisting of undulating and overlapping orange lines. The intention of the work was to question what is considered a contemporary painting or what is a painted object. As part of the project, I created an edition of 1,000 works on paper consisting of fluorescent orange spray paint on white paper. The edition was stacked in the center of the space and made available free of charge to all visitors.

Video: In addition to the complete work, select a brief portion of it, generally no more than two or three minutes, to be viewed first. Create a separate chapter on your DVD, and label it as an excerpt. It could be one crucial scene or a few short sections from different parts of the piece. You don't want to waste precious time and the limited attention of the awards panel or art professional on all the opening credits or a lengthy introduction. Instead, your goal is to keep their hands off of "fast forward," which creates an erratic viewing of your work. You want to capture the viewer's attention and curiosity, so choose the excerpt wisely. Make sure it represents the overall concept or a compelling part of the story line or action. Think of this excerpt like a movie preview promoting an upcoming attraction, which whets the appetite of the viewer to watch the entire work. Include a brief, written summary of the entire piece or performance to help orient the viewer. (See below, "Written Documentation Accompanying Work Samples.") Also include the title, year it was produced, a list of funders, organizational affiliations, and the appropriate credits for key personnel and key actors. The information does not have to be a fancy design, just neat and easy to read. With any media submission, where you have a case or a cover for a CD, DVD, or VHS tape, you have an extra opportunity to include an image of one of the works or a dynamic still shot on the packaging that will convey a sense of what's "hidden" in the box and will distinguish your work from others.

If it's a complicated installation, then maybe include one shot of the overall layout to give you an idea of what it is as a whole. I really find it helpful to place a person in a shot to give the viewer some sense of scale. Then a few really specific detail shots that communicate what that piece is in a really clear way.

—Letha Wilson, artist and associate curator emeritus at Artists Space

LETHA WILSON

Still from *Double Western (Transcriptions of Walks through the Visual Arts Center of New Jersey onto the Wilderness and Vice Versa)*, 2007

12 minutes, color video on DVD

Still images from film and video: You will need still images from your film or video work for websites and publicity and to apply for competitions in which the jury will not view DVDs on the first round of elimination. Still images of a time-based work should document various aspects of the narrative or concept and must be accompanied by a description of the story line or action. Capturing good still images should take place during shooting and needs to be programmed into the filming schedule. Have a digital camera ready to shoot stills during the process. It is more challenging to find a decent still image in all the footage once the shoot is over.

Digital images: Individually, list all images on the CD or DVD by title. Each image when accessed should contain discreet text along the bottom edge: name, title, date, size, medium, materials, and a brief description (if needed). I know this may sound superfluous, but should the image get printed or sent to others, you always want your name to be attached. The only exception to this rule is when the guidelines for submission specifically state this information cannot appear on the image. The images need to be jpegs (not tiff files) and for most uses not larger than 4 by 6 inches, 300 pixels per inch. Jpeg files to be sent through email should not be larger than 600 by 800 pixels. I always save the unedited raw file as well; sometimes I need to go back to prepare it differently for a particular submission.

Keep an archive copy of all work samples. This is a record of your history as an artist! Even if you are mainly using digital images when sending out for opportunities and grants, you may still want to keep an archive set of slides. Even better, keep two archive sets, one stored in a separate place from your office or studio, so if there is a fire or flood, one set is safe. Many artists in New Orleans were horrified to lose all their work samples in addition to a lifetime of art to the flood waters of Hurricane Katrina. Archiving images is extremely important. Your archive copy should never be sent out to competitions, opportunities, or grants where it may be lost or damaged. If a work gets sold or lost and you have sent out the last work sample, you could lose the only record of that piece or performance. Label the archive image as usual, and then write "ARCHIVE" in big red letters on the slide, videotape, or master, so you won't be tempted to use it for any purpose other than making duplicate work samples when needed. All digital files need to be backed up and stored on an external hard drive or in an online account. You'll find more information about archiving your work in chapter 9.

Straightforward language and some sort of side script or something like "This is a sculpture" and "Documentation of this piece that happened here" is really helpful because artists get really caught up in their own work and don't realize that the person looking at it isn't as familiar with it. So when introducing new work to someone who hasn't seen it before, it is good to really use clear language when explaining and describing it. I like it when slide scripts have info about the piece and three or four short sentences about them.

—Letha Wilson, artist and associate curator emeritus at Artists Space

Written Description Accompanying the Work Sample

A picture may be worth a thousand words, but for visual art, sometimes the image just isn't enough. Remember that the most important part of presenting your work is offering concise information so it is readily comprehensible to the viewer. The best way to achieve this is to include a brief explanation with your work sample. This description varies depending on the complexity of the work. It may be as simple as the basic facts (date, size, medium) or a more detailed account. This is your chance to convey any information about the content, materials, and process of a specific piece not readily apparent in the work sample. Depending on the purpose, it can be included on the projected or printed digital image or as a numbered list corresponding to the work samples on a separate sheet of paper.

Go back to Rossana Martínez's work sample on page 40, and notice how the viewing experience is enriched by the information she has included about her performance and installation. Work sample descriptions aren't only useful for time-based pieces and complex installations. Here is an example of a work sample description for a suite of my prints:

> In my meditation practice, I picture myself sitting beside a stream of my thoughts which are like an ever changing body of water. This suite of two large-scale woodblock prints reflects this contemplation, and the laborious process of carving the wood becomes a labor of love. The woodcuts explore similarities of the wood grain to the subtle gesture and geometry of water ripples. The images capture an arrested moment, and the resonating effects of a stone dropped into still water.

Valerie Hegarty's image description list provides an example of an installation artist's work sample description with comments. A short (one-paragraph) artist statement could be included at the top of the

VALERIE HEGARTY
Phone/Address/Email

Image Description List

Image #1: Threshold, 2002
Paper, paste, paint, fabric; 28″ x 54″
The Stray Show, MN Gallery, Chicago

A mosaic threshold pattern was constructed completely of paper, paste, and paint on the floor of a gallery space and was an approximation of the mosaic patterning that existed on many front steps in my Chicago neighborhood. The mosaics were disappearing as buildings were torn down or renovated. At the opening, most people didn't notice the paper threshold glued to the floor, and stood on it while they looked at other work.

Image #2-3: The Yellow Wallpaper, 2003
Paper, paste, paint, fabric; approx. 9′ x 6′ x 18′
Really Real, Gallery 312, Chicago (semi-permanent installation)

Strips of paper were painted with a yellow wallpaper pattern based on the descriptions in the short story "The Yellow Wallpaper" by Charlotte Perkins Gillman. The piece highlights the obsessive act of the peeling of the wallpaper in the story and the character's desire for transformation.

Image #4-7: Hotel Lobby Column, West Loop, 2002
Paper, paste, paint, fabric, cardboard; 16′ x 30′ x 100′
Solo Exhibition: At the Edge—Innovative Art in Chicago, Gallery 400, Chicago
Artist Council Special Assistance Grant

Based on the lobby of an apartment building I used to live in, the back of Gallery 400 was transformed into an aging hotel lobby constructed from painted paper and cardboard. The viewers could enter the space and wander until they were lost in what was in effect a still life painting. Both nostalgic and ironic, the space questioned the erasure of the past in the path of progress and also the validity of the ideas of authenticity.

Image #8-10: Green Bathroom, MCA Chicago, 2003
Medium: Paper, paint, paste, fabric, masonite; 10′ x 26′ x 26′
Solo Exhibition: 12x12 Room, Chicago Museum of Contemporary Art

The green institutional bathroom I used at my art studio was transposed into the corner of an MCA gallery. A decrepit public bathroom that normally would be repressed in such a modern blank space (both aesthetically and psychologically) caused viewers to do a double-take. Upon closer inspection, the illusion of the disintegration also disintegrated as the tiles and plumbing revealed themselves to be paper-thin.

The artist's name and contact information are included here.

The list is numbered to match the order of the slides or digital images. Basic facts such as title, date, medium, and size are listed first.

Notice that the artist included where the work was installed and the kind of show.

Often it takes several images of an installation to accurately portray it. In some cases the artist uses two, three, or four images.

Each group of images provides interesting descriptive information that discusses both the process and specific features that are difficult to see from the images on their own. These details add clarity to her presentation.

VALERIE HEGARTY
Hotel Lobby Column, West Loop,
2002

Paper, paste, paint, fabric,
cardboard

16 x 30 x 100 feet

At the Edge—Innovative Art in
Chicago, Gallery 400, Chicago

Courtesy of Guild & Greyshkul

page to provide an overview for the enclosed work samples. This eliminates the need to provide a separate artist statement.

TOOL # 2: ARTIST STATEMENT

An artist statement is a two- or three-paragraph description about your work that provides the reader with information about your sources, ideas, and inspiration.

Your artist statement presents insightful information about your process and answers questions viewers might have when looking at your work. Remember, 99 percent of the time your art will be viewed without you nearby. You won't be available to answer viewers' questions, offer fascinating background information about where the ideas came from, or describe your working process. A well-written artist statement is a good place for them to find these answers. It is a valuable tool providing an additional connection between you and your audience. And in doing so, it creates the opportunity for your work to be more fully considered and appreciated. These days you can't run away from the task of expressing what you are doing in your work with words. Your artist statement will become a page of text on your website or accompany an exhibition of your work. It can be dropped into your artist package and grant proposal or included in a press release.

When I was curating exhibitions, most of the artist statements I encountered did not provide me with pertinent insights into the work. They were too general, too theoretical, or too badly written to be of any use. More often, reading an artist statement evoked my sympathy for the artist struggling to express herself. So, I usually ignored them. Over the years, I've surveyed many art professionals, and they report having the same issues with artists writing about their own work. Now is your opportunity to change their perceptions. Producing a well-written, informative artist

THE ARTIST'S GUIDE

statement will make your packet, press release, or proposal stand out from the rest of the crowd.

I know how painful a process it can be. As easy as it was for me to identify deficiencies in others' statements, I have struggled to write my own. My intuitive and nonlinear art practice didn't address political or conceptual issues, or involve a compelling narrative. Writing about my formal concerns and process felt boring. The more I worked on my statement, the more depressed I felt. I concluded that my work was meaningless because I couldn't figure out how to express what it was about. Maybe I just pushed paint around a surface until it felt right. Was I really that shallow? Dismissing my work like that was a cop-out, and deep down I knew it. My curatorial experience with other artists' work had shown me the enlightening power of a great statement. Yet I had so much resistance to writing about my own work. I was afraid to reveal too much information. I felt that if I demystified my art practice, it would diminish my work in the eyes of the viewer or limit multiple readings of it. Worse than that, I feared that writing would interfere with the tentative and delicate process of creating new work. So my artist statement remained a distanced generalization about my practice and of little benefit to me or my audience.

Composing a thoughtful statement about my work has been a struggle between what to say and how to develop a decent piece of writing. Because my major was visual art I blew off any opportunity to become a more competent writer during undergraduate and graduate school. Running the Rotunda Gallery forced me to work harder on my writing skills, but I still found the process difficult when I had to apply it to myself. In my seminars and lectures, I work with many fellow artists who also struggle with writing their statements. To help them and to help myself, I have given a lot of thought to how you can identify the most valuable information about your work and compose a meaningful artist statement.

Less than 10 percent of the packages I receive are any good, but every now and then you get a gem. . . . A gem package is really about the work. . . . An artist should know how the viewer needs to see their work. . . . Not only that, but you need to give the information, name, title, year, dimensions, media. If that information isn't there, I'm swimming blindly. So it's all about the information.
—Camilo Alvarez, owner, director, curator, and preparator of Samson Projects

[Artists] are not taught how to write artists statements. . . . When we are considering future exhibitions for the museum and we're reading through them, they are a discourse of rambling that has no visible connection to the work. You've got to be able to describe your work. You've got to be able to do all the work for the critic. We want one paragraph maybe.
—Susan Moldenhauer, artist and director/chief curator, University of Wyoming Art Museum

ALLYSON STRAFELLA
Untitled 4/19, 1993
Typewriter on paper
11 x 8.5 inches

A few years ago, while viewing a group exhibition of works by emerging artists at the Drawing Center in New York, I had my first flash of insight about what information to include in an artist statement. I was intrigued by one particular group of drawings by Allyson Strafella. Curious to learn more, I read what she had written about her work in the exhibition brochure:

> I began using a typewriter for its obvious function—to record my thoughts and ideas. Communicating is a crucial yet constant struggle for me. The more I typed, the more the letters and words on the pages began to take on a new function, a new language. My discovery of this new language created with my typewriter and paper was one made up of patterns and grids formed by punctuation marks: commas, colons, apostrophes, and brackets. It was as if the typewriter was experiencing a breakdown, and this breakdown was my breakthrough. I had discovered a new way to communicate. There is an endless source of information that can be created through a limited use of materials: paper and a typewriter. I became, and am still, intrigued by this process.

Many of the questions I had running through my mind as I looked at Allyson's work were beautifully answered in her statement—questions such as: How did she come to produce these pieces? Why is she doing it this way? Is it done on a computer or a typewriter? What does it mean? Reading the statement, I felt as if I were engaged in an intimate conversation with the artist. Notice that Allyson was able to do this in one short paragraph. With simple but precise language that was fun to read, her statement gracefully led me through her process. Although I didn't know her, I felt connected to her and her work, and the experience remains a vivid memory. It was at that moment that I truly understood

how an artist's few well-chosen words had the potential to intimately link a viewer to her art.

You may feel more at home solving the pictorial issues of a good work sample—composition, color, and layout. You have more experience taking something visual (the art) and interpreting it in another image-based form (the work sample), so it's an activity that feels natural. Writing well about your work is an entirely different process. Your writing skills may have never been strong, or they might be a little rusty. Your college term paper on the symbolism of angels in Renaissance painting may have been your last written analysis of art. But just because you don't feel as accomplished a writer as you are a visual artist doesn't mean you are off the hook. It does mean you need to be more patient and methodical with the process of extracting information about your work and putting it down on paper. A good artist statement is too important a tool for you to ignore or neglect. Like work samples, an artist statement is just another way to convey information about your work to the world. It doesn't replace your art; it *supports* it.

ALLYSON STRAFELLA
Untitled 10/2, 1993
Braille, typewriter on paper
11 x 8.5 inches

To begin identifying what should be included in your artist statement, you need to listen. If your statement is going to help you connect with viewers, what might they want to know about your art? You need to listen carefully and be aware of the kinds of questions and comments that naturally arise about your work during studio visits, lectures, critiques, and appointments. Jot them down, and look them over. Are some questions asked more often than others? These are the aspects of your work people want to know more about. They'll point you to the most intriguing or compelling parts. It is your answers to these questions that should be included in your statement.

A good artist statement informs viewers about the work but doesn't overly explain it. What you reveal reflects a delicate balance between expressing your ideas and providing just enough information for view-

ers so they can start their own process of engagement. Your artist statement is specific and poetic at the same time.

Having to produce a well-written, informative statement can make you feel as if you're about to fall into a deep dark hole. To avoid tumbling into the murky process as long as possible, you just hover at the edge. You then rush through it and write your artist statement at the very last minute under the pressure of a deadline. I've done this many times. I've written something in a hurry because it was required. I've skipped proofreading because I didn't have the time to make corrections or because I didn't want to face my bad writing. I've crossed my fingers and sealed the envelope or pushed "send" on an email and hoped for the best. It's at times like those when I prayed that the images of my work would be sufficient and no one would bother reading my statement.

If writing a statement feels like an overwhelming or agonizing task for you, there are ways to get started. First of all, understand that all writing is a process, just like making your art. It takes time to find your voice. Think of the years it took for you to develop as an artist. Ask any professional writer how much he struggles to find the right turn of a phrase or to clarify an idea and how many drafts it took to get there. Why should it be any easier for you? Also ask him about how good it feels when he has found those few choice words. Writing this book has opened my eyes to the struggle and to the elation experienced during the writing process. I have no trouble standing before a group of artists and presenting a lot of information in professional skill-building workshops, but to get that same material into a written form has been hard. I've thrown myself quite a few "pity parties" and wondered why I ever got started on this project. I've also learned that when my efforts produce a well-written line of text and I hear my voice loud and clear on the page, the delight I feel at that moment is the payoff for all my labors.

A skillfully written statement doesn't magically appear on your first try. It takes a lot of messy writing, which is then edited to isolate the best parts into the beginning of a concise statement. You may produce ten or more pages of writing to get less than one page or even a paragraph of a finished statement. You may need to go through five, six,

seven, or more drafts before coming up with a finished product. Let yourself off the hook, and put aside any preconceived ideas about your writing abilities or the difficulty of this process. Begin collecting your thoughts, and pay attention to viewers' questions and comments about your work. Preserve these observations by writing them down. This is a good habit to develop long before a statement is needed. It provides the framework for the information you will want to cover.

Any way you can figure out how to make the writing process more enjoyable will be a blessing. You may find it easier to write at a certain time of day, such as early morning. You may keep a studio journal, assigning yourself a page of thoughts before starting any work or just before you leave. You may find a window seat in your local coffee shop a more welcoming place to think and write. Carry around a journal of ideas and thoughts that are jotted down whenever and wherever you are, or have a link to your unfinished draft visible on your computer desktop so you regularly spend a little time adding and editing.

Getting Started: Collecting Information and Composing the First Draft

If you currently don't have an artist statement or need to revise and improve the one you have, here's a way to get started. Describe one or two recent works. Do it quickly, and don't worry about grammar, jargon, or finding the exact word. Don't think about a format or structure. You should write down everything on paper that comes to mind about the piece. Below are some questions to get you started. Not all of them will apply to your work, but start with those that are the easiest to answer.

- What does your work look like? (Think about size, colors, shapes, textures, light, objects, relationships, etc.) Make your description visual.
- Why do you do it? What is your inspiration? Where does the impetus for making it come from within you?
- Write about the work from different points of view, such as conceptual, thematic, and emotional.
- Is there a central image or idea in the work?

- What are its different elements, and how do they interact within the work?
- What kind of materials are you using? Why?
- How is it made? What is your process?
- How does it use space? How does it relate to the surrounding space?
- Where does this work fit into your development as an artist?
- How does it relate to other artists' work? Who inspires you?
- What questions are you asked about this work?

To make the writing experience as real as possible, sit in front of your work as you write to make sure you capture specific details. Don't try to answer all the questions above in one sitting, but write as long as the words flow, and then put it aside. Don't reread or criticize what you have written. Allow negative, silly, weird, and even pretentious thoughts to be expressed. Give yourself over to the process. Understand that this is just a way to generate the raw material that will shape your statement. Trust that somewhere on these pages will appear a few gems or phrases you will use later.

Broaden your writing to include other works that may precede the current pieces. Continue with this exercise until you have covered a range of your work and as many of the questions above that apply. Allow this process to take several days or weeks. Don't rush it. This early messy phase is important. It allows you to be playful without the harsh critic sitting on your shoulder reminding you what a lousy writer you are. You want to engage the deepest part of your unconscious thought. On some days the words will flow, and on others they won't. You may find yourself waking up in the middle of the night with an interesting thought or idea about your work. Keep paper close at hand to write down any ideas that pop up unexpectedly.

Get Help from Others.

Remember what I said before about learning to listen carefully to viewers as they look at your work? The questions they ask will often reveal

important information to cover in your statement. Invite friends to your studio to talk about your work. You'll get the liveliest conversation and can reference specifics and details if you have this discussion in front of the actual work. Try to include someone in the group who is not overly familiar with your practice. This could be the start of a critique group, and you could provide this service for others in return.

Think of it as an interview, and allow the discussion to build naturally as a give and take between their response to your work and your explanation. Allow yourself to be open to their questions and differing points of view. If at all possible, record the conversation. You can also take notes or ask someone in the group to be the scribe, but often the best phrases and ideas get lost in the heat of the discussion. Suddenly someone will exclaim, "Wow, that says it perfectly! Write that down! Wait a moment—how did we say it?" Alas, no one recalls exactly what was said. A tape or digital recorder will capture every possible tidbit and nuance. You can even buy a voice recorder for your MP3 player that will temporarily convert it for this use. A few days later, listen to the discussion, and write down the questions asked about your work and any descriptive phrases. What did this conversation reveal about your strongest, most compelling ideas? Is there a pattern? Have you been asked similar questions during studio visits, critiques, and exhibitions?

Once you have collected many pages of writing about your work, schedule some time to read over everything you have written. Read it out loud. As you go, use a highlighter to mark the most interesting ideas, phrases, stories, and concepts—anything that interests you. Save all this early writing; you may want to refer to it later.

On a clean sheet of paper, copy the highlighted text as a list of phrases. Read through it carefully. What does this condensed information tell you about your work? Does it cover all the important aspects of it? Is there anything missing? Are certain words or phrases or concepts repeated? Is this significant? Are there any thoughts that should be expanded? Add more information, or revisit some of the questions on page 51, to fill in any apparent holes.

Write a First Draft Statement.

This is your opportunity to string together the most important ideas you wish to convey about your work, incorporating the strongest words and phrases from your list. The writing will still look rambling, messy, and disorganized. That's okay. You'll have lots of time and opportunity to work on your draft during the editing phase.

Edit, Edit, Edit.

After you have written your first draft, look it over, and ask yourself the following questions to begin the editing process.

Am I writing in the first person? Write your statement as if you were talking about your work directly, using "I," "my," or "me" instead of "she" (or "he") or "the artist." Writing in the first person makes your statement more personal and intimate.

Where is the most important information? Pull out your highlighter, and go through what you have written. If you could only mark one sentence, what would it be? Is it in the first paragraph, buried somewhere in the middle, or tacked on at the end? If it's in the middle or at the end, bring that information up to the top, and start again from there. Develop a strong first sentence. It may be why you make art, your intentions, or what materials you use. Another way to start is to tell a short story about something that inspired you into making a specific body of work. This is your chance to draw readers into your world. You want to grab them with the most essential and compelling ideas first, so even if they only read the first few sentences, they can still walk away with important information about your art.

Is my language accessible to the average reader? If your statement is difficult to read, it will *not* be read. Good writing is clear writing. Keep it simple. Even if your work encompasses complex theoretical ideas, you need to find a way to express them clearly so they will be understood by the wide audience encountering your statement. Refrain from hiding your ideas

THE ARTIST'S GUIDE

behind jargon-laced theory or lofty poetic wording. Theoretical writing does have its place in academic journals, some proposals, and situations in which it will be understood and appreciated. In general, allow discussions that reflect your extensive knowledge of art criticism or academic vocabulary to arise naturally during studio visits, job interviews, or passionate debates in coffee shops. Leave them out of your artist statement.

> The works deal with a fragmentary corporeality which seeks its stimulation in the natural sciences, such as botany and neurology. The drawings construct and illustrate an intellectual model of deconstruction of corporeality and the search for unity.

This artist statement begins with important sounding words, but what do they mean? Not only is it difficult to read, but there is no payoff—no better understanding of the artist's intention in the work. Readers may feel stupid or ignorant because they don't understand the text. Or they may wonder if the artist understands what she is doing. It is much better to write simply about what you know and use words and phrases from everyday language.

Is the writing specific to my work, or could this statement be applied to many other artists?

> My work investigates contemporary scientific, social, and political issues filtered through a visual medium.

> My paintings are a constant exploration of the human experience involved in the act of creation.

> My installations aspire to enter into a free-flowing exchange of ideas between the present and the past. They question our relationship to the nature of time and the meaning of progress.

> I like to see things as the camera sees them.

HEESEOP YOON

Dad's Basement, 2004

White masking tape on black canvas

105 x 162 inches

These statements are so general they could apply to many other artists' work. They do not contribute to a more intimate understanding of these particular artists' work. You need to rewrite broad generalizations that could apply to many other artists working with the same media, subject, or style. Take the time to identify what in your work is particular to you alone. What is it that sets your work apart from other artists using similar ideas, style, imagery, or issues? Remember: out there in the world is a blizzard of artwork. What sets your snowflake apart from all the others? Identify what is specific or special about your work or process. It might be an experience you have had or a particular way you are using the materials. What is your source of inspiration? Think back to how you arrived at the ideas you convey in your work.

Below is an example of a statement that successfully addresses both the specific ideas behind the art and the artistic process, in this case the process by which the artist Heeseop Yoon constructs her wall drawings and installations.

> My work deals with memory and perception within cluttered spaces. I begin by photographing interiors such as basements, workshops, and storage spaces. From these photographs I construct a view and then I draw freehand without erasing. As I correct "mistakes," the work results in double or multiple lines, which reflect how my perception has changed over time and makes me question my initial view. Paradoxically, greater concentration and more lines make the drawn objects less clear. The more I see, the less I believe in the accuracy or reality of the images I draw.

Does my statement come off as overly aggressive or passive? Eliminate words and phrases like "unique" (all works of art are unique—it's a given); "first" (you may be wrong); and "only" (probably not and hard to prove). Challenging readers in this way will work against you. Let them discover your unique and fresh vision on their own. Also try to avoid using words like "aspire," "hope," and "attempt." They are weak and may reflect your unresolved feelings, or make it appear that you are hedging your bets as to whether you have accomplished what you wanted in your art. Write assertively, using active verbs and strong phrases. State what your work is doing, not what you hope to do. Change "In this series of paintings I hope to investigate . . ." to "This series of paintings investigates . . ." Notice how much stronger and more active the phrase is without the word "hope."

Do I tell readers what their response will be to my work? This is a subtle but important point. Refrain from informing viewers how they should feel, be moved, challenged, or changed by experiencing your work.

The viewer will confront their own sense of isolation and dislocation.

These paintings challenge our perceptions about . . .

These images will allow us to move toward the delight and wonder we naturally feel for nature.

You can't predict how anyone will react to your work. What if viewers don't experience what you expected? You have set up a situation that allows viewers to disagree with your work rather than simply participate in their own experience of it. You are better off stating what you are doing, what you perceive, or what your experience is and allowing viewers room to develop their own responses.

Does my writing sound defensive? Some statements anticipate an unfriendly reader and are already prepared for an attack.

This installation is not about conceptual art.

I do not feel as if I am limited to production within the medium of photography.

Compose your statement with a sympathetic friend in mind who is genuinely interested in the work and wants to know more about it. Instead of defining your work by what it is *not*, simply state what it *is*.

Have I used the spelling and grammar checker installed on my computer? These tools are free writing help. They do not replace a thorough word-by-word edit. Spell check has its limitations and won't flag easily mistyped words, such as "shoe" for "show" or "who" for "how." The computer's grammatical suggestions can be comical or just wrong, but they will point out problem areas. In the end, it never hurts to get a second opinion from another reader you trust or to have a copy of Strunk and White's *The Elements of Style* nearby.

Make the reader feel that they know something special about you after reading your statement.

The Wrap Up: Testing, Testing, One, Two, Three

Once you have finished your first draft, have several friends who know your work, including some who are not artists, read your statement and respond. They may have good ideas about your work to add or might be able to catch phrases that don't make sense. Your non-artist friends will be the best at flagging art jargon—those words frequently used within the art community but not well understood outside of it, which should be avoided.

Even professional writers depend upon editors and copy editors to catch incomplete thoughts and correct verb tenses. If possible, ask a writer to proofread your written materials to check for grammatical errors and evaluate the overall structure. Good writers are merciless in deleting repetitive or extraneous phrases and straightening out twisted run-on sentences. It's worth it to pay or barter to get their expert advice.

People who write regularly know that writing is a physical act. Nabokov wrote standing; other writers need specific dimensions of desk space; others compose orally and record what they say onto the page later. Find out where, when, and how you write best. Sometimes when we are stuck it means we need a good walk, a deep breath, or a snack. As you edit your work, try printing it out to get a better view of it before your next edit. Try reading it aloud in your best newscaster voice. Really. Newscasters have to read a lot of text clearly, in a short time. Putting yourself in their shoes vocally might help you see where your writing trips up a reader. Wherever you stumble or stutter, see if there isn't a small problem with usage, punctuation, or grammar.

—Aaron Landsman, theater artist

THE ARTIST'S GUIDE

Make the Writing and Editing Process Physical.
Another way to experience your statement is to have other people read it out loud to you. Close your eyes, and imagine that you are hearing it for the first time. How does it sound? Where do they stumble in their reading? Does it represent your art well?

Your finished statement should be no more than one page long, double-spaced. This is about 350 words. The art world will appreciate your brevity. Even if you have more to say, ultimately you want viewers to spend more time looking at your work instead of plowing through a long statement. There is nothing that can't be said in one page. That includes summarizing a lifetime of work, discussing different series or media, or describing a single group of paintings. There is a fine line between presenting just enough engaging information to satisfy readers' interest and burdening them with your life story.

A one-page statement can address a large body of work or different media that embrace the same idea. It becomes an important item to include in all your submissions for exhibitions and grants. It will be used as a valuable reference for describing, promoting, or selling your work for gallerists, curators, publicists, critics, and journalists.

For other uses, the longer statement can be shortened to one or two paragraphs that are no more than half a page. This condensed statement addresses the most pertinent information about your work or a particular series. A shorter statement can be incorporated into the heading of a work sample description sheet accompanying a portfolio or grant application. It can be the leading paragraph to a longer description of a specific project. It can be integrated into the body of a press release, an exhibition announcement, or the opening page of your website.

Work on a version that is twenty-five to fifty words. This brief statement contains the central idea of your work to grab the reader's attention. It gets inserted into cover letters, letters of intent, and your artist biography. When you have memorized it, you can use it as a verbal business card to introduce your work to someone new. Artist Dread Scott has managed to slim his statement down to five powerful words:

It has to tell me what you are thinking, tell me your concept. What is the idea behind it? And if they're just great abstract paintings, say that. You know, that's fine. Or tell me who your influences are. I mean, you don't have to explain the work because it should speak for itself on some levels, but you need to be able to explain where you are coming from.

—Julie Baker, president of Julie Baker Fine Art and partner of Garson Baker Fine Art

"Revolutionary art propelling history forward." It succinctly sums up his mission of over twenty-five years and serves as a tagline on his résumé, business card, stationary, and website.

Once you have nailed down a good statement, you will find it necessary to revise and make changes as your ideas develop. This will become a natural part of your creative process. If you continue the practice of listening carefully, keeping a studio journal to record ideas as you are working, and taking notes during or after studio conversations, the revisions won't be so overwhelming. You will have plenty of material to start with when you sit down to rewrite your statement.

When I was organizing the seminars for the Artist in the Marketplace (AIM) program at the Bronx Museum of the Arts, I worked for many years with Senior Curator Lydia Yee. I admired the thoughtful consideration she gave to the hundreds of submissions the museum would receive for the AIM program. Lydia also frequently serves on selection panels for other highly competitive opportunities. Here's what she looks for in an artist's submission; she nicely sums up the importance of your work samples, descriptions, and artist statements.

> In an artist's package, I look for a well-organized presentation and good quality images. Artists need to take advantage of every opportunity to document their work, particularly when it is installed in a proper exhibition space. Often times, more than one image is necessary to represent a particular work. When I am reviewing documentation and there are multiple views of a work or several artworks from a series, I will take the extra time to get to know the work a little better. If I can't tell what I am looking at; if the images are not focused properly, overexposed or underexposed; or if they look like they were done with a snapshot camera with inadequate lighting, it reflects negatively on the artist, and I am unlikely to give it a second chance. Each artist is competing against dozens, perhaps even hundreds, of others, so those with good documentation have an advantage—they are able to communicate more clearly with their viewers.

I never take what I'm looking at for granted. I often ask myself: What am I looking at here? Is this a painting? Is this a print? What materials is the artist using? What is the scale of the work? What seem like very basic questions about the artwork may not be readily apparent in a photograph. I want to see an image list or script that identifies each piece: the title, date, medium, and dimensions. A resourceful artist will also use this as an opportunity to convey a bit more about the work by adding a sentence or two about where it was installed or about the choice of subject or materials. It's incumbent on the artist to make that basic information available to the curator, critic, gallerist, or whoever might be looking at the work.

An artist statement not only provides some context for the work, but also gives the artist an opportunity to tell a story. It leaves the person who is reviewing the materials with something memorable that will stay with them a little longer. It doesn't have to be overtly biographical, but can simply be what motivates the artist. A vague or generic statement won't help the viewer understand the work. It's useful for artists to get feedback on their written materials from a friend who isn't an artist or involved in the art world. All of this material should work together to make a big impact.

As an artist, it's important to be as articulate as you can about what your point of view is, what you are looking to do, and what you want your work to project.

—Nicole Straus, public relations consultant

TOOL #3: ARTIST RÉSUMÉ AND BIOGRAPHY

A résumé is a brief listing of one's educational and professional qualifications and experience. It is also referred to as a "curriculum vitae." An artist biography is a one- or two-paragraph summary of an artist's major accomplishments written as a narrative.

Including an up-to-date document highlighting your professional accomplishments is a necessary accompaniment to your work samples and artist statement. Scanning it quickly, a reader will learn what you have done in your career so far, and it provides clues as to where you are headed.

Here is something to remember: your résumé and biography are not the main reason you'll get opportunities. No gallerist, curator, or

awards panel uninterested in your work samples and confused by your artist statement will proclaim, "I want to do something with this artist," based on your résumé. In fact, your résumé is generally the last thing they scan, after making their first impressions about you and your work from your other materials. Too often artists get unnecessarily stressed out over their résumé. They worry about its length: Is more than one page too long? Are three, five, twenty too many? They worry about including their birth year: no one will take them seriously if they are under thirty, or they will be seen as failures if they are over forty and haven't "made it" yet. They place too much importance on securing multiple exhibitions every year and freak out if there is a gap of one or more years in their listings. When faced with their anxiety in my classes and workshops, I often wish these artists were more worried about the quality of their work samples and producing a good artist statement than they are about their résumés. Your résumé is just *information* that either confirms or contradicts any first impressions someone has made about you and your work.

The Résumé

So what's the purpose of your résumé? It's a listing of facts that place you in the art world. A résumé with listings for the last year or two announces your emerging status. One that goes back for decades signifies a mature, seasoned artist. Where you received your education may provide an art professional with clues about your work, especially if it reflects a style or a conceptual line of thought for which the school is well-known. Your résumé reflects in what arenas you have already received support: nonprofit exhibition spaces or commercial galleries; local, national, or international venues; lesser- or well-known curators, critics, and journalists. Competitive grants and awards reveal the validation of your work by peers and art professionals.

Your résumé is a fluid document that can and should be tailored for a particular opportunity. You want the art dealer, curator, critic, search committee, grant panel, or exhibition visitor to easily scan the information listed. You will have different résumés: one will be shaped for exhibition opportunities, while another will be formatted to apply for teaching

positions or freelance situations, or to stress your activities as an independent curator or critic. You will select your listings accordingly.

The basic headings on an artist's résumé are as follows:

- **Name and Contact Information:** List your name, mailing address, studio address, home phone, and cell phone, along with your website and email address. When you exhibit with a commercial gallery, the gallery will often remove much of this information, so other art professionals will need to go through them to contact you.
- **Education:** List undergraduate and graduate degrees, institutions, years granted. Don't fill up this category with every workshop and seminar you have attended or every master artist with whom you have studied. This category is right after your contact information if you are a recent graduate. Once you have five or more years of experience outside of school, move it to the end of your résumé.
- **Exhibitions:** List the title of the show, venue, city, and state. Group them by year, and begin with the most recent and work backwards. Do not include the month or dates of the exhibition; it clutters up your résumé. Combine group, solo, and two-person exhibitions together when you are starting out and highlight the solo shows with an asterisk. Once you have had three or more solo and two-person exhibitions, pull them out, and give them their own category; put everything else under "Group Exhibitions." If information about the exhibition is posted on a website, include the complete URL.
- **Awards/Grants/Residencies:** Include the names of the organizations, and group them by year received, beginning with the most recent.
- **Bibliography:** This category includes exhibition reviews and catalogues that discuss your work. Both print and online media count. If a group show you are in is reviewed and your work is not mentioned, do not include this listing. Again,

group them by year, beginning with the most recent first. Standard formatting is as follows:

- Book and catalogue entries: author's name (last name, first name), *full title of the book* (including subtitle, if any), city of publication, publisher's name, publication date.

- Periodical entries (reviews or articles in art magazines, in newspapers, or online): author's name (last name, first name), "full title of the article," *periodical/online newsletter name,* volume or issue number (date): pages occupied by article or URL for the article.

- Consult a style book to get additional help for this section.

- **Collections:** Limit this list to public collections and well-known corporate and private collections. If you don't have any, don't break out in a sweat, just don't include this category. It will look better than if you scraped together a bunch of unknown collections.

- **Other Professional Activities:** On your exhibition résumé list only those activities that apply to your studio practice. Freelancing, jobs (even college teaching jobs), curating, writing, and professional memberships are of lesser importance here, so limit what you report in this category. Instead of listing every show you have curated, you may summarize the activity in one or two lines. You will develop separate résumés that focus on your teaching credentials, independent curatorial projects, work experience, or freelance activity.

- **Public Commissions, Film Festivals/Screenings, Performances:** Depending upon your practice, you may wish to include these categories as well.

Keep the format clean and neat, so it is easy to read. You want to be sure all the information in your résumé is up-to-date, accurate, and free of grammatical and spelling errors. Exchange your résumé with a friend, and carefully proofread each other's. It is easier to find a mistake on your friend's résumé than on your own.

JOAN LINDER

SELECTED SOLO AND TWO PERSON EXHIBITIONS
2008 *more fun in the new world*, Judi Rotenberg, Boston, MA
2007 *the pink*, Mixed Greens, New York, NY and Hallwalls, Buffalo, NY
2006 *death, sex, war*, Rowland Contemporary, Chicago, IL
 118-60 Metropolitan Ave, American Jewish Museum, Pittsburgh, PA
2004 *making money out of nothing, running up debt, trusting in God*,
 Mixed Greens Gallery, New York, NY
2003 *White Room*, White Columns, New York, NY
2000 *When?/Now.*, Queens Museum of Art at Bulova Corporate Center, NY

SELECTED GROUP EXHIBITIONS
2008 *Opportunity as Community: Artists Select Artists*, Dieu Donne, NYC, NY
2007 *PED.Rio*, File Rio, Rio de Janeiro, Brazil
2006 *home for lost ideas*, General Public, Berlin, Germany
 prevailing climate, Sara Meltzer, New York, NY
 2 Bieniale der Zeichnung, Kunsterein Eislingen, Germany
2005 *Five Projects*, Glyndor Gallery at Wave Hill, Bronx
 759 Running Feet, Gwangju Art Museum, Gwangju, South Korea
 Erotic Drawing, Aldrich Museum, Ridgefield, CT.& Diverse Works,
 Houston, TX
2004 *Bush League*, Roebling Hall, Brooklyn, NY
2002 *Four Brooklyn Artists*, Saito Tomayo Gallery, Tokyo, Japan
2001 *Traveling Scholars*, Museum of Fine Arts, Boston, MA
2000 *Private Worlds*, Art In General, New York, NY
 Public Culture, Private Nature, Sommer Contemporary, Tel Aviv, Israel

AWARDS
2007 Smack Mellon, Artist Residency Studio Fellowship, Brooklyn, NY
2005 Lucas Artist Residency Fellowship at Villa Montalvo, Saratoga, CA
2004 MacDowell Colony, Residency Fellowship, Peterborough, NH
2003 Yaddo, Residency Fellowship, Saratoga Springs, NY
 ArtOmi, Residency, Ghent, NY
2001 Pollock Krasner Foundation Grant, New York, NY

BIBLIOGRAPHY
McQuaid, Cate, *Compelling the Eye of the Beholder*, Boston Globe, July 16, 2008
Genocchio, Benjamin, *The Power of the Pen*, New York Times, November 25, 2007
Cotter, Holland, *Art in Review, Prevailing Climate*, New York Times, August 11, 2006
Kerr, Merrily, *Joan Linder at Mixed Greens*, Art on Paper, March, 2006
Leibowitz, Cathy, *Joan Linder at White Columns and Mixed Greens* Art in America, Nov. 2004
Smith, Roberta, *Caution: Angry Artists at Work*, New York Times, August 27, 2004
Landi, Ann, *The Many Faces of Realism*, ARTnews, June 2002

EDUCATION
1999 Skowhegan; 1996 MFA Columbia University; 1993 BFA Tufts University

WWW.MIXEDGREENS.COM mixed greens 531 WEST 26 TH STREET|1ST FLOOR|NEW YORK|NY|10001| T: 212 331 8888|F:212343 2134

As you accumulate exhibitions and other professional distinctions, begin to eliminate lesser listings. You don't want the reader to get buried in the details of each and every exhibition, grant, and review. Selecting the most important and titling the category "Selected Exhibitions" or "Selected Bibliography" alerts the reader to the fact that you have done much more than what's listed here.

Artist Joan Linder has a series of drawings in which she painstakingly renders artist's résumés. On page 65 is a drawing of her one-page résumé of selected listings.

Don't be too concerned with the length of your résumé. Generally one to three pages is sufficient to provide an overview of your career. Somewhere in your archive files will be a complete listing of everything. If your résumé is more than a page, make sure your most recent listings and strongest categories are on the first one. Avoid bloating your résumé with benefit auctions where you have donated work; exhibitions in restaurants, bowling alleys, and bars; or too many juried exhibitions. Most art professionals are not impressed with long lists of juried exhibitions, or that you have been included in the local annual arts festival every year for the last decade. They may have been important milestones in your professional development, but allow them to remain your personal history. (Chapter 4 has a longer discussion on the pros and cons of juried exhibitions.)

The Artist Biography

Your artist biography (or bio) summarizes your résumé in a narrative form. It will be incorporated into written programs, flyers, and press releases. It will be read out loud by a moderator to introduce you on a panel or at a lecture. To create this document, you will need to go through your résumé and summarize your most significant accomplishments. Your bio is also a nice opportunity to include one or two pieces of personal information that may not be included on your résumé such as where you were born, your interest in environmental issues, the many languages you speak, or the fact that you lived on four different continents before the age of twenty. You can also include a sentence or

JOAN LINDER
Detail, *front bar*, 2007
Ballpoint on paper
From "the pink"
60 x 164 inches
Courtesy of the artist and
mixed greens gallery

two from your artist statement. Below is Joan Linder's résumé from the previous illustration transformed into her bio.

Joan Linder is best known for her labor-intensive drawings that transform mundane subjects into conceptually rich images. Life size representation of figures and objects explore themes such as the banality of mass produced domestic artifacts; the politics of war; sexual identity and power. Linder has exhibited throughout the US and in Brazil, Germany, Israel, Japan and Korea, at venues including White Columns, NY; the Queens Museum of Art; the Museum of Fine Arts, Boston and the Gwanjgu Art Museum, Korea. Awards include the Lucas Fellowship at Montalvo, CA; Mac-Dowell Colony Residency; the Foundation of Jewish Culture's Ronnie Heyman Award; and a grant from the Pollock Krasner Foundation. Born in New York, Linder attended the Skowhegan School of Painting and Sculpture in 1999 and received a MFA from Columbia University and a BFA from Tufts University. Linder is an Assistant Professor of Visual Studies at the University of Buffalo. She lives and works in Buffalo and New York City.

How to Assemble the Essential Tools to Support Your Work

It's easy to feel insecure about your résumé and bio. Seeing your efforts as a few lines of black and white text can be deflating. Remember that it is just a document someone will scan after they have reviewed your far more important tools: your work samples, descriptions, and artist statement.

The Payoff

The benefits of producing great promotional tools are enormous. As you incorporate these tools into your art practice, the clarity and insight they provide are an important feedback mechanism that will help push and lead you to develop your next body of work. Looking dispassionately at your résumé will help you ascertain if you are challenging yourself with new opportunities or settling for the same juried show each year. Comparing your goals to your résumé will help you decide which new opportunities you should seek out next.

Your ability to thoughtfully discuss the ideas and issues in your work is a powerful skill. These words become the nucleus of all written information about you and your projects. Yes, it is difficult to discover what to say and write about your work. The more you capture illusive information through taking notes, keeping a journal, and listening to yourself and others, the more ease you will feel expressing yourself and the fundamentals of your work. Images of your art will be your only reference after the work has been sold, dismantled, or stored away. They are important records of your achievement. Your artist statement and work samples will help you prepare for a studio visit or a public lecture.

You shouldn't settle for anything less than the best promotional tools. The confidence you feel having great work samples and a well-written artist statement will motivate you to seek out more opportunities with those people who will help your career—artists, writers, friends, art dealers, curators, and critics. As you will see, these contacts and relationships are essential to your career development.

Resources

College Art Association. "Standards and Guidelines." 2008. http://www
.collegeart.org/guidelines.

- CAA offers guidelines for artist résumés and artist teaching résumés.

Lamott, Anne. *Bird by Bird: Some Instructions on Writing and Life*. New York: Anchor Books, 1994.

- When I struggled with my writing, many writer friends recommended I read this book. It provided me with insight, inspiration, and laughter.

Strunk, William, and E. B. White. *The Elements of Style*. New York: Dover Publications, 2006.

- This short book will help you master the basics of writing.

Winkleman, Edward. "Bio Camp Open Thread." June 29, 2006. http://edward winkleman.blogspot.com/2006/06/bio-camp-open-thread.html.

- Chelsea gallerist Edward Winkleman provides a frank discussion of the do's and don'ts of an artist résumé from an art dealer's point of view.

CIRCULATING YOUR WORK

This section is about circulating your work. It could be a short section that describes the mythic cycle of "making it"—go to famous art school, create notable work, graduate, start showing at nonprofits, get reviewed by influential critic, be picked up by high-profile art gallery, have your work acquired by significant collections, raise your prices, show in museums, live happily ever after. The truth is there are few artists for whom this narrative describes the arc of their career. There is no single point of entry, nor one path to success.

There are different art worlds with diverse interests, and each supports many kinds of art. The next three chapters embrace numerous ways you can get your work in front of a responsive audience while building community and a core group of support. Once you understand the different resources and options available, you can apply that information to your personal goals and action plan. Knowing who all the players are, their expectations, and the ways they work with artists is key to figuring out where you want your art to be, how to get in front of a receptive audience, and how to marshal your resources to access them.

Making work is fantastic, but it can't stay in your studio forever. There comes a day when you will have to take it out of the safe cocoon of your workspace and expose it to a larger audience than your cat, family, or studio mates. To build a career, you need to have your art seen and your ideas made public, allowing a larger dialogue to develop around it. Going public connects you to new people and other opportunities.

"No one is coming to save you." These were words I heard early on in my career by more experienced artists. No matter what stage of your career, it is ultimately your responsibility to promote your work and seek out a variety of venues and art professionals for support.

chapter 3

How to Get Started: Peer Networking, Readiness, and Creating Your Own Opportunities

This chapter discusses how to assess your readiness to share your work with the wider world and suggests some ways to get started within your community. Often, just seeing your work displayed in a different context offers important insight for developing new ideas back in the studio. As you begin to get your work seen and discussed, you will understand how to branch out into other opportunities.

Building a career depends on who you know.

As an artist, I know how overwhelming it feels to even *think* about getting your work shown. It's hard to know where to begin or where your work fits in. All you need to do is browse through the cascading download of exhibition announcements and art newsletters arriving daily in your inbox to see the awesome amount of activity in the art world. Sometimes as I scan them, I imagine everyone is getting their work shown but me. With rising levels of panic and despair, I look over the list and wonder why I wasn't included in one of these shows. What's wrong with my work? I feel forgotten, like a wallflower standing at the edges of an incredible party hoping that someone will ask me to dance. With a sigh, I exit my email program and head back to my studio, hoping the art world will come looking for me.

Waiting for someone to finally notice what a fabulous artist you are and exhibit your work is one way to go about building a career, but that can take a frustratingly long time. Taking even the smallest step toward increasing the visibility of your art can change your whole point of

view. Whether you are just starting out, have taken some time off, are smarting from the latest round of rejections, or are mired in mid-career malaise, you need to put your doubts behind you and plan a way to get yourself back into the game.

But wait. Are you ready for all of this? It may seem strange to ask yourself if you are ready to share your work with others. The first two chapters of the book were designed to rev you up by addressing your dreams and goals and helping you sharpen your promotional tools. You don't want to miss out on a perfect opportunity by holding back now. However, taking the time to figure out if you are ready to launch your work is not a step backwards, but a necessary stage in your preparations before plunging into the exhibition community. You need to protect the delicate balance between nurturing your artistic voice and inviting outside opinions, comments, and criticism. Determining when to keep your work to yourself and when to share it with the rest of the world is a question that will engage you throughout your professional life.

There is no magical protection from criticism, and you will encounter it throughout your career. When it is well-timed and thoughtfully delivered, it can propel your thinking forward in spite of its sting. If you are unprepared for it, even the well-meaning advice of good friends can derail your process. Harsher criticism will set you back for months or even years.

What do I mean by readiness? Readiness is when you have developed a body of work that shows consistency of ideas and control of the medium. It could be your thesis show from art school, but just as likely it will be the work and artistic voice you develop on your own in the years afterward. If you are self-taught, have switched media, or have taken your work in a new direction, readiness comes after you have passed through the early exploratory phases and have begun to feel fluent with its connections to your other work. After graduate school, my practice evolved from sculptural installations to painting over a three-year period. It took another two years of painting to finally feel I was ready to send that work out. You too may find your work follows a steadily unfolding idea or abruptly splinters into diverse tangents.

The best gauge of readiness is your eagerness to share your work with others. You have reached some of your own conclusions about it, look forward to discussing it, and are curious about others' reactions. After you've arrived at this stage of preparedness, the ensuing dialogue will be richer and more fruitful. You will be standing on solid ground. If the earth below shakes a bit from the tremors of outside analysis and advice, you will be in a healthier position to withstand them and act accordingly.

Timing is a factor in determining readiness. Allow yourself to experiment and let the creative excitement build—play, fail, resolve, and rethink. If you are going through a period when you feel blocked or unsure of what you are doing, you may need to sort it out on your own. Continue to follow your ideas in the work, and document your process and thoughts in a studio journal. Inviting comment and criticism about a nascent body of work too early can upset and influence your fragile line of thought. I've experienced creative blocks lasting nearly a year. I've spent months working on a series of paintings only to throw them away. I've followed dead ends and tried ideas that didn't work. I had to push myself to show up at my studio and continue working. It was hard to turn down studio visits and ignore potential opportunities. I desperately wished someone would show up with just the right solution to resolve my block, but I knew it was better for me to work through it on my own until my cloudy vision cleared. I looked at a lot of other art and happily visited other artists' studios and took a rain check on their visiting mine. I postponed visits from art professionals whom I had been eager to see my work. Until I saw my way through the worst patch of my creative block, I laid low. Only when that series of paintings finally jelled was I ready to open my studio door again.

The final ingredient of readiness is to understand where you are in your development rather than define your practice by where you think you should be. Readiness is based on judicious assessment of your body of work. It's not based on the reputation of your art school, how many degrees you have earned, or how many years you have been out of school. It's not based on what your peers are doing. Your work will develop and mature on its own schedule. It is painful to feel left behind, if your practice and its ideas are percolating slower than others. You fear

you'll never, ever catch up. It isn't easy to steady yourself and dispassionately consider what serves your work and your process best. For now your challenge may be to allow your work to unfold in private.

Your Best Allies: Your Network of Peers

You have got to be making stuff. I had a friend of mine who was teaching, and she said that her students who were undergrad second year were going, "How do you get into galleries?" And she's like, "Hang on a minute. You've got to make some work first." Sometimes people jump the gun, and they just think about the career before they've actually got anything going.

—Jaq Chartier, artist and cofounder of Aqua Art Miami

Once you are at the place where you are ready to discuss your work with others, start with your peers and colleagues. They may be art school buddies, former teachers, studio mates, an interested work colleague, or someone you met at an opening. Calling upon trusted friends and artists to exchange studio visits allows you to engage in regular discussions about the work as well as a range of topics.

Studio visits are primarily opportunities to foster a dialogue about your practice. They are helpful when you have come to an interesting juncture, are stuck in a rut needing a push, or seeking responses to new work. They range from the laid-back drop-ins with friends to more formally scheduled meetings. Studio visits introduce your work to professionals in the art community. It is a chance to present your work on your own turf, get feedback, and lay the foundation for a future working partnership.

Your studio is a personal place where you have spent many hours wrestling with your ideas and materials. No matter how eager you are to share your work, for many reasons allowing someone else in can be dicey. You feel vulnerable in the studio; therefore it can be hard to hear suggestions or even well-meaning criticism. The memory of those comments lingers and may haunt you for weeks afterwards, as you struggle with feeling unsure of yourself and become reclusive. Whereas, if someone is effusive and excited by your work, you feel high for days. You'll want to throw open the doors and invite everyone in. You never know which way it's going to go. That's why your readiness and preparation are important. It takes practice to learn how to elicit productive information and steer a conversation for your own benefit without controlling it. With experience you will learn when to talk, when to be quiet, and how to listen without becoming defensive. Studio visits build on each other. A comment in one may determine your series of ques-

tions in another. You discover whom to rely on for certain kinds of feedback and advice and when to call someone back for another visit.

Regularly swapping studio visits with your peers will help you prepare for more formal meetings with an art professional. Consider the circumstances: if this is a curator, art dealer, or friend's first visit, you may want to present a chronological overview of your work. If it is a repeat visit or the person is already familiar with your work, you might show only recent developments. If your practice is installation-based, you may want to build a model of the project and show your visitor sketches, video clips, and sample materials. You should also have documentation of other projects handy, either as prints or as video clips or jpegs on your laptop. Visit the studios of other artists working in your media, and notice how they present their work. You will pick up do's and don'ts to apply to your presentations. Because I have several series of works going on at once, I will often ask an art professional what he or she wants to see when we are setting up the appointment. Usually the person has already looked at my website and has a good idea of where he or she wants to begin. I put away unfinished work I'm not ready to discuss and hang a few of the pieces the visitor has requested. I have others nearby, ready to pull out.

An artist's studio is a fascinating place to the rest of the world. Sculptor Joe Fig has explored his curiosity about this subject through a remarkable series of highly detailed portraits of artists in their studios. He writes:

> In 2000, as a study on artistic process and the sacred studio space, I began creating miniature sculptures of historical artists in their studios. Two years later my interest turned from historical to contemporary mostly because I wanted first hand source material, rather than reference through books. I began a letter writing campaign to artists, requesting to visit them in their studios. My intention was to

I actually had a number of opportunities to show my work and I chose not to until 1968 and that was a very conscious decision that had to do with the work. I had a very strong—I still do—strong belief that the act of going public is a very important decision and everything you do from the point in which you go public is part of the public record and is out there and you cannot get it back. Anything before the time you go public is nobody's business and you don't have to talk about it, you don't have to show it, you're not responsible, you can destroy it all or whatever. But there is something about that decision, "OK, I think I can put my neck on the line for this work and I feel strongly enough about it that I will live with however I feel about it later. This is now part of the public realm."

—Chuck Close, quoted in Joe Fig, *In the Painter's Studio: Artist Joe Fig Interviews 25 Contemporary Artists* (Princeton, NJ: Princeton Architectural Press, 2009)

JOE FIG

Detail & full: *Chuck Close
Summer 2004*, 2005

Mixed media

24 x 31 x 42 inches

Collection Jon and Mary Shirley,
Seattle

get a clearer understanding of the real, day-to-day practicalities of being an artist; how they lived, worked and supported themselves.

My most memorable studio visits were those where the conversation developed naturally and there was a lively exchange of information. We talked about individual pieces and new ideas. The discussion wasn't just about me and my work, but also included the visitor's. I learned more about them personally, about projects they were developing or suggestions of artists and shows to see. My positive memory of these visits was based on their insights and points of view, not how wildly enthusiastic they were about my art. The best part was that after they left, I was raring to go back to work.

My worst studio visits were conversations that felt forced, like a bad blind date. The artist, curator, or art dealer didn't "get" my work. Their questions hit me like an unannounced pop quiz for which I was ill-prepared. Their suggestions and criticisms were infuriating or, even worse, made me feel self-conscious about some aspect of my work. I remember one art dealer excoriating me over how I was using cadmium yellow in my painting. He expanded his personal distaste into a generalized dismissal of my entire year's production. Afterwards, his criticism reverberated every time I reached for a tube of yellow paint. It took me nearly a year to work that color back into my palette. I was aghast that his irrelevant comment had such a negative effect on me. When visitors toss out zinger remarks during a studio visit, it's nearly impossible not to feel hurt and dejected. When it happens to you, take solace in the knowledge that every artist has four or five similar stories. Take in and use the productive comments, and do your best to throw the others away. Remind yourself it's just one person's opinion.

If an art professional is coming to your studio, you can't help but hope that this visit will result in future exhibitions, sales, representation, or any manner of new possibilities. You are eager to please. You'll want immediate results and feel a huge letdown if something you want

If I'm in [an artist's] studio, I want to get a sense of what other things they are working on right now. You know, besides the thing that we're there to talk about. There are always little things, like what other little doodads do they have on the wall? How do they use their space? It's always curious. . . . People have done really effective slide shows in their studio when they are showing me documentation of installations. And when we are doing that, I also like to be able to see if they have some materials from those projects or something that's tactile. If it's audio, just something that will give me a better understanding of the project. Otherwise, I could just be looking at images in my office.

—Jennifer McGregor, director of arts and senior curator, Wave Hill, and former director, NYC Percent for Art Program

isn't offered right away. Studio visits are a lot like dating. They start out tentatively, and you never know what will happen. You can get along like a house on fire or want it to be over in ten minutes. They can also be disorienting, as someone is often seeing your work in this context for the first time. You can help minimize your uneasiness by preparing yourself with a clear idea of what you want to say. Remember: this is your space and your work. You are the expert. Don't be surprised if it takes many visits before relationships are solidified and commitments are made. The art world can sometimes move at a snail's pace. Let go of your expectations, and focus on the best possible presentation.

Listen carefully to the questions visitors ask, and pay attention to what sparks their curiosity. Do they want more information about your process, how you achieved certain effects, or how you have used the medium? Are they interested in the source of your imagery or how one work connects to another? Do they linger over the reference materials you have pinned on the side walls? Keep a notebook handy, and take notes during the visit. Their questions may provide valuable clues to what you may need to add to your artist statement and work sample descriptions. A lively discussion will prompt suggestions of books, articles, websites, exhibitions, and other artists you may want to check out.

If your visitor asks a question or makes a suggestion that stumps you, temporarily store it as food for thought. Maybe, in time, that strange idea will bear fruit. Your viewer may have noticed something in your work that you weren't yet aware of or ready to acknowledge. Regular studio visits are opportunities to practice evaluating responses to your work. Ultimately, you sift through the information and sort the relevant and helpful remarks from the unrelated and destructive ones. In the end, as good or as grueling as they may be, studio visits allow you to practice sharing information about your art. They need to be a regular part of your professional life.

Engage in studio visits with old and new friends to gather different reactions to your work. When you return the favor by visiting their studios, the conversations continue and deepen. I have artist friends with whom I have been exchanging studio visits for over twenty years. One

Studio visits are incredibly important. Of course you want to get dealers, gallerists, and curators in there, but also get other artists to visit you. It's all about the dialogue. Art doesn't exist without a dialogue.
—Camilo Alvarez, owner, director, curator, and preparator of Samson Projects

long-term friendship began in the playground sandbox with another artist and mother of a toddler. For years the kids played in the studio corners as we discussed developments in our work. Eventually the kids started school, and our studio visits continued with less distraction. The intimate knowledge and history of my practice that she brings to our studio conversation is deeply satisfying. She can reference pieces I created over two decades ago and put my work in a context few others can. I am also just as interested in how new visitors respond to seeing my work for the first time. What do they look at first? As they explore the visual material in the studio, what holds their interest? Afterwards, I may jot down the questions they asked and a summary of the discussion. Taking notes during and after studio visits is a good habit.

Good friends and peers will provide you with thoughtful, honest feedback that will help you assess your strengths. They will share information about other opportunities and give tips based on their own experience. These studio visits will help you practice presenting and talking about your work and other artists' work with increasing self-assurance. You can test out a new idea and see how it flies. When I'm really unsure of something I'm working on or have just completed, I'll prop it up in a corner of the studio during a visit. I may not refer to it at all, but I'll see if my visitor is drawn to it or asks about it. I may wait to see how the conversation is going and introduce the work when I feel ready. This is my system for testing work in progress.

It is essential that you maintain a solid connection with your peers. As they develop their own opportunities and connections within the art community, they bring you with them. Your name may be on the tip of their tongues if they are asked by the dealer, critic, or curator to recommend other artists to see. I can trace many of my opportunities to a fellow artist who helped connect me. Nurture and support your peers. They will sustain you in the long run.

Generating Your Own Opportunities

The easiest way to expand the intimate audience you have developed among your peers is to make your own opportunities. Self-generated

venues are ones you create for yourself or organize with other artists. They provide you with the most flexibility: you design it, you fund it, you promote it, and you host it. Instead of waiting to be asked in, you invite others to join you. These are terrific opportunities for community building. Banding together to organize and promote the event brings new friendships into your life.

OPEN STUDIO EVENTS

Plan an Open Studio event for friends, family, and acquaintances. This is an extended studio visit with a whole group of people. Clean up your space, select the art, install it, haul in some refreshments, and invite all of your friends and family. A special energy is created by the party-like atmosphere when many people mill around, meet each other, and engage with your work. Open studios are appropriate at any stage of your career. I've hosted open studios to introduce a new series of work, present a recently completed project, preview an exhibition about to travel thousands of miles away, celebrate a new studio space, or just have a party. I've also participated in studio tours in which a group of artists agrees to open their spaces to the public during a designated day or weekend. We printed announcements with maps and directions, sent press releases, and waited for the public to arrive.

There is nothing to be embarrassed or shy about when creating your own opportunity through an open studio event. Even well-known artists host private studio parties to preview an exhibition of work opening out of town or abroad. People are always curious about the artist's mysterious place of creative alchemy, so don't feel obligated to hide the brushes and the power tools, or feel compelled to dismantle your inspiration altar. Let the open studio be a "straightened-up" view of your artistic practice. Invite the viewer's curiosity.

Once you have cleaned up your space and arranged your work, stage an open studio for a week or two. Design your own creative and personalized announcement for postal mail and email. (For more information about your contact list, see chapter 5.) Make the perfect guest list, and send out the invites. If someone important doesn't come to the opening

Put yourself in your own show. There are empty spaces that you or your friends might be able to use. Then invite everyone you know. . . . Get your work out there, and start networking with these people.

—David A. Dorsky, attorney and director of Dorsky Gallery Curatorial Programs

party, follow up by inviting him or her for a private visit. I have found it is easier to get an art professional I have been courting to schedule an appointment during an open studio. Your open studio event announces your readiness to have your work seen and discussed.

Assign six friends the task of bringing someone you don't know to the open studio so you can enlarge your field of contacts. If your art is for sale, don't be shy about it! Print out several copies of the price list, and place them where they can be easily found. This clearly signals your intentions, and attendees can check the prices without asking you.

The open studio announces your eagerness to have the work seen by a larger audience. Listen carefully to the suggestions that are offered, ask for referrals, and, afterwards, follow up!

I think it is really important to figure out a way to protect that studio time, and for me it is by having deadlines. Even now that I have galleries, getting a show on a calendar is what keeps me in my studio when I could get pulled away by the art fair. . . . If you're working out of your house and you just plan, "Okay this date I am having a party. I am having people over to see my work" . . . you have a deadline of some sort.

—Jaq Chartier, artist and cofounder of
Aqua Art Miami

FREE ARTIST REGISTRIES

Add your work to free artist registries. These are vast image files of artists' work samples that are often sponsored by a nonprofit organization. They are frequently consulted by art professionals and the public. Before the Internet, many nonprofits established artist registries to help serve the artists in their community by creating an in-house resource of images for future programming. When I started the Rotunda Gallery, establishing an artist registry was one of my first tasks. It was invaluable for developing programming and helped me promote artists to other art professionals. Formerly housed in slide carousels, filing cabinets, or three-ring binders, today's registries are digitized versions on the web. Even if you have your own website, it pays to have work included in the organizations' registries you support and respect. Research what artist registries are available to you, and assess which ones you might want to join. Look for organizations that have a mission or present ideas that are similar to yours. This research will begin to connect you to a network of artists who share a common ground with

your work. Being part of an artist registry can lead to exhibition opportunities all over the world.

Artists Space, one of the oldest alternative art spaces in New York City, sponsors a registry open to all and contains work by thousands of artists. Others, like White Columns, another venerable New York City–based alternative art space, are curated to include only a few artists out of hundreds of applications. Curated registries put your work in a specific context that is aligned with the organization's point of view, and are more coveted opportunities than open-admission sites. Many art professionals will consult a curated registry first, so they don't need to wade through too many files to find what they need.

Other registries specialize in regional artists, specific media, or genres. There are also registries that are open only to members of the organization or are sponsored by State Arts Councils for their resident artists or grant recipients. Some art programs and art schools maintain registries of their alumni. Others have specific criteria for submission, such as the registry at the National Museum of Women in the Arts, which admits only women artists who have had at least one solo show in a museum or gallery.

Participating in an artist registry is a way to announce your readiness to engage in a wider discussion about your work. It places you in a larger network of artists. With the number of free registries available, there is no need to join those that charge fees. As with anything you do to promote yourself, make sure you are comfortable with the context and respect the organization hosting the site. Keep track of where you have registered your work, and make a point of updating your page with new pieces often—at least once a year. You can put the tools from chapter 2 to good use in these registries. Remember, an image is often not enough. If you have space to include more information about yourself, use it. Add work sample descriptions, an artist statement, résumé, contact information, and links to your website whenever possible. Allow the viewers to fully experience your achievements, and give them a reason to pause on your space/site and the opportunity to learn more about your work.

[Artists Space's] slide registry lets visitors search for specific words. So the more descriptive words you have in your artist statement about your work, the better chance someone that is looking for you will find you. . . . In addition to the pre-set categories they provide you such as "color field," "geometric," or "abstract," you can get really specific in your statement, which opens the door for people finding you, for example: "works about Colombia," "political works," "works about the sublime in the Western landscape."

—Letha Wilson, artist and associate curator emeritus at Artists Space

THE ARTIST'S GUIDE

CREATE YOUR OWN WEBSITE.

Your website is like an extended exhibition of your work. As your own little corner of the World Wide Web, it allows you to curate and organize a selection of your work for global view. Think about it as an exhibition and a catalogue of your work all in one. It can include announcements of upcoming events, short video clips, published reviews and catalogue essays of your work, interviews, press photos, and your artist biography. It is one of your most valuable promotional tools. Even if your work is so esoteric that there are only a handful of dealers, curators, or collectors in the world interested in what you do, this is your connection to them.

Your website needs to be aligned with your goals and should provide enough information to introduce or update the viewer about you and your work. When designing it, ask yourself some questions. Where am I headed? Who are the most important people I want to reach with this information? What do they need to know? What do I want them to remember? Your answers will determine the information and organization of your site. Decide if you will hire a web designer or create it yourself with one of the easy-to-follow programs available online. If you hire someone, make sure the designer gives you the basic information about the server and program platform, and have him or her provide a way for you to upload images and text yourself. I've learned the hard way that wonderful web designers can be unavailable or disappear completely when needed. You don't want to have to start all over with a new web design.

Make the process fun and expansive, as you did when figuring out your goals in chapter 1. Be creative, and think of it as an extension of your art practice. You want it to look *professional*, but that does not mean it should feel *impersonal*. This is an important distinction. Allow the layout, images, and words to provide the viewer with an intimate experience of your work and your aesthetics. This means it should be easy to navigate and have a design that does not get in the way of viewing the visual information. Spend some time looking at other websites of artists in your discipline, and use their successful tactics when creating your site.

All the curators are doing a lot of their research online. . . . It's becoming one of the primary modes of looking at work, for better or for worse.

—Letha Wilson, artist and associate curator emeritus at Artists Space

The beauty of the web is that once you put something online, it's instantly accessible everywhere. We put this thing up there as a [curatorial project with a] local group of artists, and it instantly spread everywhere.

—Matthew Deleget, artist and cofounder, MINUS SPACE

Apply to your website the same standard of image quality and written material as outlined in chapter 2. Think of it as a studio visit, but one in which you aren't in the room to guide the viewer or answer their questions. Deepen the viewers' understanding of your accomplishments by providing great work samples and enticing descriptive language. Unlike an artist registry, you are not limited by a set number of images or the amount of information accompanying them.

You want to create a *sticky* website, one that viewers enjoy visiting and return to often. That means in addition to easy navigation, there is fresh content added every three to six months. You can draw new traffic to your site by exchanging links with venues that have exhibited your work, publications that have written reviews, organizations you support, other artists, and blogs. Include brief descriptions of each site, and regularly check these links to make sure they are active. Have a link to your website posted on any artist registries or galleries containing your work.

On your website, there should always be a way for viewers to get in touch with you. You can even include options for posted comments or ways visitors can be added to your email list. Use your website to expand your contact list and connections globally.

CREATE A BLOG.

A blog is a collection of postings of your thoughts and art images generally hosted by a blogging site such as Blogger (http://www.blogger.com). It can substitute for a website or complement one you have already developed. If you are engaged in a lengthy project, it can provide diary-like status updates for your community on your progress. You can post images and text as frequently as you wish, and they will appear chronologically. With a blog you have fewer options on design layout than you do with a website, but a beautiful image with descriptive information

My website is a static tool. Visitors can see recent work and read my statement about it, but the content doesn't change very often—maybe once in six months to a year. I have someone maintain my website, so I have to provide the new information in a way that will be clear to her, review the material with her, and then tweak the changes before she posts the new version. That could take a week. The blog, on the other hand, is an easier and much more dynamic tool for me. I can make changes every day or several times a day if I choose.

My blog is as much visual as it is textual. It is me being a commentator. I like looking at art and connecting the dots. I want to show people what I am seeing and how that relates to what else I have seen. So the blog has lots of pictures, and because it's easy to post, there are usually two posts a week. The thing I love is that this kind of publishing allows a lot of cross-referencing. If I like an artist's work, I can put a link to their blog, their website, their gallery, shows they've been in. So you could read my blog and go off in ten different directions just from that post alone. Before the Internet we had—what—footnotes? The live sharing of information, credit, pictures, and ideas is a good way for all of us who are working alone in our studios to be out in the world and have a larger presence in the world.

—Joanne Mattera, artist

doesn't need much more than to look good on a computer screen. Viewers can sign up for RSS feeds, which will deposit new posts into a blog tracker such as Google Reader or Bloglines, or send a message to their email account. Blogging can be an excellent way to engage and develop community.

COLLABORATE WITH OTHER ARTISTS ON A SHOW.

Collaborative multi-artist shows often take place in an empty commercial building rented or donated for a week, a month, or longer. They range from impromptu group exhibitions of artists to tightly organized shows with catalogues requiring months of planning. A group show can quickly extend your network of peers. You can experiment with how to present, install, and document your work. You can learn the fundamentals of organizing and promoting an exhibition, all good information that can be applied to your next show.

There are many examples of ambitious artist-organized group shows that have captured public attention. One that challenged the staid formalist New York art establishment in 1980 was the raucous Times Square Show, organized by the artists' collective Colab and including more than 250 artists.

Colab took over an entire building, which was a former massage parlor in the then-seedy Times Square section of New York City, for a month. They invited other artists to join them to display socially themed artworks. I remember the excitement I felt touring the show, seeing work displayed outside the usual clinical white box of the galleries and in a gritty urban environment. It introduced me to graffiti artists and a handful of others whose careers I have followed ever since. Across the ocean, the 1988 Freeze exhibition in an empty Port Authority Building in East London, organized by Damien Hirst and other art students at Goldsmiths College, launched his career and many of the other artists who participated. It was a breakthrough moment for the yBAs (young British Artists) as they were referred to in the press, and it put the world on notice that something new and exciting was happening in the United Kingdom.

A second-floor room at the *Times Square Show*

Produced in 1980 by Collaborative Projects, Inc (COLAB)

Photo: Andrea Callard

The theme of the room was money, sex, and death. Coleen Fitzgibbons, Robin Winters, and Christof Kohlhoffer made web offset prints that were used as wallpaper. John Ahearn presented a bust of Rigoberto Torres, and Tom Otterness showed a sign painted on metal, Caution/Coition. Ahearn and Otterness found the building and negotiated with the landlord to initiate the *Times Square Show*.

Organizing a large group show of artists isn't limited to busy urban areas. Susan Moldenhauer and Wendy Bredehoft organized their local community of artists in rural Laramie, Wyoming. They had been attending Art Basel Miami Beach for years, visiting the numerous hotel fairs that had sprung up around the main event. In these satellite fairs, galleries showcase their artists' work by installing mini exhibitions in hotel rooms. Susan and Wendy decided to apply the same idea to their community, where there were few opportunities for local artists to show their work. They secured a wing of a Laramie hotel and invited twenty-six local artists to each claim a room and install a "solo" exhibition. To jointly handle publicity, fundraising, refreshments, and administrative jobs, committees were formed and the details hammered out. The fair was such a resounding success that it grew the following year to forty artists.

When organizing a show, make a plan, find a space, and, if it's roomy enough, invite other artists to join you. Divide up the expenses and the tasks of organizing, installing, publicizing, promoting, and gallery sitting among the group. Just be mindful that the bigger the group, the harder it will be to coordinate everyone—but the potential rewards are worth it. With each participating artist reaching out to his or her contacts, the show will attract a larger crowd and is more likely to garner publicity in the local press. The pooling of resources creates a must-see atmosphere. It's been my experience that art professionals respect the time and effort that artists put into organizing their own show, and they will go out of their way to visit and see what all the excitement is about.

EXPLORE YOUR COMMUNITY ORGANIZATIONS AND NOVEL VENUES.

Look around, and perceive your neighborhood and community with "art" eyes. Begin to collect all the possible places for exhibiting your work. There are many diverse municipal art spaces, artist societies, art centers, arts festivals, park departments, libraries, and state and local arts councils with exhibition programs. These are good places to practice introducing your work and start meeting artists. Consider other kinds of venues, spaces where people conduct business, entertain, or hang out, such as restaurants, bookstores, nail salons, fitness centers, and coffee bars.

When I moved to a new town after college, my very first exhibition was in the lobby of the local bank where I had my account. Because it wasn't a typical art space, it felt like a safe space for me to get started. I was pleasantly surprised when that show led to an invitation to install a larger body of work at a nearby university and a summer job teaching classes at a local arts center. These activities introduced me to local artists

We were all involved in the processes of organizing, assembling, installing, and promoting. We talked about pooling our regional mailing list, so that everybody shares it. . . . One of the interesting things was that this was not juried. It was a community exhibition. . . . We felt it had to be inclusive. Inclusive doesn't mean that the quality of work diminishes or that it isn't professionally presented. You have to be willing to put up the money, the time to be there for the weekend, and do everything that has to be done. You're not going to put that much work into something and then just throw your work up on the wall without framing it. There is too much peer pressure.

The artists did not handle the sales. We devised a system where we had two people set up in a different room who did all the sales for everybody, so the artists were not worried about dealing with that. We removed the money part from them, so they could just talk about the work.

—Wendy Bredehoft, artist and education curator, University of Wyoming Art Museum

Exhibition poster
Touchstone Laramie, 2006
Courtesy of the Laramie Artists
Project, design by Snowy Range
Graphics, Laramie, WY

and a new community of people. I never listed my first show on my résumé, but it led me to others I could.

If you aren't ready to approach a community gallery, you can start at the local cafés, restaurants, and venues where you do business. Practice putting your work on display and documenting it. While these shows may not strengthen your résumé, they can be confidence builders. Invite another artist to share the space with you. Join local art organizations, network with other artists, get advice, and share opportunities. Evaluate how your work stacks up against others in a group exhibition. Build your self-confidence, and test your readiness, by starting at less intimidating venues.

TAKE YOUR ART DIRECTLY TO THE PEOPLE

You may find that you have ideas and work that do not fit into even the most informal exhibition space, or you may want to engage different communities with your projects. Many artists are mixing environmental awareness with public art projects, such as Eve Mosher's *HighWaterLine* (see chapter 7) and her current *Green Roof Module*, which will create a network of green roofs in neighborhoods throughout New York City.

Three organizations have teamed up to work with artists on public art projects. Art & Community Landscapes (ACL) is a partnership of New England Foundation for the Arts (NEFA), the National Endowment for the Arts (NEA), and National Park Service (NPS). ACL is a national program that supports site-based public art as a catalyst for increased environmental awareness and stewardship. The program addresses the natural environment through site-specific art projects that may include temporary or permanent art installations, exhibitions, interpretive media, festivals, or other works informed by the site and community in which the project is located. Project sites and partner organizations are selected to work closely with an artist or artist team for

one year or longer. Together, the artist and partner organization develop and implement a publicly accessible project that inspires greater community involvement in protecting and enhancing the natural environment. To find out more about this program, check with the New England Foundation for the Arts.

Robyn Love is another artist who would rather engage widely diverse audiences in her work than make objects for exhibition spaces. Robyn currently spends half the year on The House Museum project, which takes place in a remote area of Newfoundland and uses the physical structure of an ordinary house, where she and her family live, and all its contents as the basis for exploring ideas related to culture and how it is shaped by tourism. Through her ongoing project, Robyn captures elements of the local culture before it is irretrievably shaped and molded into a typical tourist attraction. The House Museum includes video and audio components, collaborative projects with neighbors, and a series of free public events. Robyn uses both a website and a blog to document what happens there.

Many artists take their paintings, sculpture, performances, and video projections directly to the public in outdoor spaces. Street art or guerilla art is a broad category of work covering surreptitious, ephemeral, and unauthorized art, and it is placed outside, often with the purpose of making a political statement. My introduction to some now well-known artists was through their street art. In the early '80s, I remember catching

ROBYN LOVE (image left)
Accentuate the Positive, 2008
From the *Antimacassar Sutra Series*
Crocheted cotton
5.5 inch diameter
Photo courtesy of the artist

(image right)
Two visitors to the House Museum listen to an audio tour created by Robyn Love for *Step Out of The Room*, a special exhibition of photographic installations in the museum created in 2007 by twelve local residents in collaboration with artist Marlene MacCallum.

I had this idea for a project which played on the local culture, architecture, and people . . . so I had to figure out how to make it possible. That is how The House Museum came about. We found this house in Newfoundland, bought it, lived in it, and it became my artwork.

—Robyn Love, artist

a glimpse of Keith Haring making one of his subway chalk drawings and walking by Jean-Michael Basquiat's SAMO graffiti in Soho. You may choose to work solely in the street, or combine it with gallery exhibitions. The British graffiti artist known as Banksy sums up the power of street art: "If you have a statue in the city centre you could go past it every day on your way to school and never even notice it, right. But as soon as someone puts a traffic cone on its head, you've made your own sculpture" (from the *Independent*, September 23, 2006).

A great example of an artist who has seamlessly moved between both worlds is Jenny Holzer. Artist and political activist, Jenny Holzer began over twenty years ago printing her *Truisms*, such as "a little knowledge goes a long way," on posters pasted anonymously on buildings around New York City. They later appeared in formal art contexts, such as electronic signage spiraling up the museum ramps for her 1989 Guggenheim retrospective exhibition. Today, they also live on the Internet on her Truisms website, which invites users to view them all and even contribute their own. A more recent project, *For the City*, involved light projections on the facade of the New York Public Library and the Elmer Holmes Bobst Library at New York University in 2005. Along with these light projections, Holzer completed a series of oil paintings based on the declassified U.S. government documents she had projected on the NYU library. These paintings were exhibited at her gallery, Cheim and Read, and at the 2007 Venice Biennale.

Not all street art is overtly political. Even charming landscape painting found a surprising public presence in Ellen Harvey's *The New York Beautification Project*. Over the course of eighteen months, Harvey completed forty oval oil paintings directly on existing graffiti throughout New York City. Utilizing a process opposite to that of the quickly spray-painted tags of graffiti artists, each piece was based on a particular European landscape painting and took days to complete. Harvey worked through bitter cold and sweltering heat. Each painting brought a different cast of characters to her sidewalk studio. To help publicize the project, Harvey created a series of postcards and a map of the painting sites, so that people could take a tour of her paintings. She distributed these maps and postcards to local restaurants, stores, and people in the art world to draw a di-

verse audience to it. A complete catalogue of the project with the accompanying stories was later published in the book *Ellen Harvey: New York Beautification Project*. Ellen describes her project below:

> I started looking at all the graffiti [in the park], and I thought, "Well, that's painting also. Why don't I make some graffiti for the park?" So I thought about what kind of graffiti the park might like—something pastoral and romantic. That's how it started. And then, once I'd painted the first one, I knew I wanted to keep going, because it raised so many interesting issues for me, like, "Who gets to make public art?" "What makes one thing art and another graffiti?" Because the oil painting is obviously illegal pigment just as much as any sprayed image. . . . I also wanted something that people would see as being "art" even if they weren't in the art world. The landscapes are all either direct quotes from paintings or very directly reference that cliché.
>
> I was going for enchanting, because I wanted to see if I could get the aesthetics to trump the illegality of the thing. In some ways the project was an experiment in creating a social consensus. Each painting took several days, so they had to be sufficiently appealing to the largest possible number of people for me to be allowed to do them. I didn't ask permission, but I did get caught all the time.

Guerilla projects are limited only by your imagination and your comfort level. They allow you to bring your work and your message to a wide audience not usually engaged in viewing art. You can witness an incredible variety of projects on the Internet. Street art photographs are avidly posted on Flickr and YouTube sites. The Wooster Collective website (woostercollective.com) is dedicated to documenting work like this world wide.

Build a space for your art in the world outside of your studio. Once your work leaves your space, it will have a life of its own and a place

JENNY HOLZER
For the City, 2005
Light projection
The New York Public Library,
New York

Text (pictured): "The Fires Have Begun," from *E-mails from Scheherazad* by Mohja Kahf. © 2003 by Mohja Kahf. Reprinted with permission of the University Press of Florida and the author. Presented by Creative Time © 2008 Jenny Holzer, member Artists Rights Society (ARS), New York. Photograph by Attilio Maranzano.

ELLEN HARVEY

New York Beautification Project
(details), 1998–2001

Oil on graffiti sites in
New York City

Each 5 x 7 inches

Abandoned house on the north
side of 231 Front Street, south
side of Peck Slip

Photos: Jan Baracz

among other works of art. As a conversation grows around it, you can take the information and feed it back into new work. Develop a core community to provide you with support, advice, and referrals. Beginning with your peers affirms your readiness to share your work with a wider audience. Close friends will give you a much-needed kick in the pants to move forward, or they will hold your hand when you have to venture into new territory. Your core community will facilitate your ability to extend yourself to greater challenges and support of your goals.

Resources

Artist Registries
Artists Space Registry (a registry open to all): http://afonline.artistsspace.org
White Columns Registry (a curated registry): http://registry.whitecolumns.org

Blog and Web Resources
Free blog publishing tool: http://www.blogger.com
Edward Winkleman's blog: http://edwardwinkleman.blogspot.com/
Wooster Collective: http://www.woostercollective.com.
 • This site has images of street art from the world over.

Other Resources
Tracy, Charles, and Valerie Bianchi. *Art and Community Landscapes: A Partnership Project.* National Park Service, Rivers, Trails and Conservation Assistance Program, Northeast Region. Art & Community Landscapes Publication No. 1, 2008.
 • This is the report on the joint project of the New England Foundation for the Arts, the National Endowment for the Arts, and the National Park Service. http://www.nefa.org/grantprog/publicart/acl.html.

chapter 4

How to Introduce Your Work to the Professional Community: Researching and Exhibiting in Nonprofit Spaces

This chapter discusses networking and how to approach nonprofit organizations, a varied group of venues that welcome and support the work of thousands of artists each year. It will show you how to organize your promotional materials and establish connections. It will help you make a plan to begin locally and to spread out to venues farther away.

Doing your homework means you won't attempt to fit your round art into their square space.

The art world is no longer held captive by a few dealers, critics, curators, or patrons. The good news is that there are more options today than ever before to have your work seen. Open up the most recent edition of *Art in America: Annual Guide to Museums, Galleries, Artists* (it comes out every August), and you will find over 4,500 listings of galleries, museums, university spaces, nonprofit exhibition spaces, corporate consultants, private dealers, and print dealers covering all fifty states. Turn to the art section of your local newspaper, and you will find even more exhibition listings of spaces not covered in the annual guide. Add to this list over three hundred public art commissioning agencies on the national, state, and local level. A few searches on the Internet will yield a plethora of web-based galleries and sales sites as well as the vast communities of people connecting through Facebook, YouTube, MySpace, and even the ecumenical collector's paradise of eBay.

In the beginning you should try out a variety of these venues to determine where your work belongs and to attract the audience you desire. There are many kinds of opportunities; not all of them will be

suited to your work or your professional goals. Working with a sense of what you want to accomplish will help you consider your options more systematically. You also need to develop a working knowledge of different organizations to explore whether your motivations and needs are aligned with theirs. Narrowing your choices allows you to spend the necessary time and attention to pursue the most viable situations instead of heedlessly running in circles. Over the years, I have watched too many artists chase any and all opportunities just because they exist. Blinded by excitement, they approach the wrong prospects because they haven't done enough investigation beforehand. This scattershot approach is a waste of time and a surefire recipe for rejection. Whether you are just finishing art school or reinvigorating your career, taking your work public should not be a frustrating pursuit but a focused and strategic plan to move forward.

Branching out from friends, family, peers, and colleagues to the professional art community requires you to introduce your work to a wider network outside of this cozy group. It's called "promoting yourself," or in the business world it is referred to as "marketing." Many artists find this task the single most difficult part of their job. The kind of effort needed to promote yourself is completely different from the solitary creative energy you experience in the studio. It demands that you practice and develop a different set of muscles. In the studio you are in command of any situation. Outside of it you are more dependent on the decisions and opinions of others. It is easy to feel that too many judgments are out of your control and to be puzzled about how they are made.

Promoting yourself also requires coming face to face with your own self-esteem and issues of entitlement. It can quickly stir up feelings of inadequacy about your work and yourself as an artist. I know how hard it is to introduce your work to someone new with this conflicting cocktail of emotions. I am never comfortable with this process, but it has become easier the more I do it. I have found that concentrating on what I want to accomplish has enabled me to reach beyond my fear and carry out the actions necessary to promote my work. I remind myself that this is my responsibility to what I have created. If I don't get behind it,

how can I convince others to support it? The sooner you make your peace with promotion, the sooner you can begin honing your skills. It's a necessary part of your practice and will propel your work from the privacy of your studio to the world beyond it. This chapter will provide you with some easy ways to stretch your comfort zone and develop your own promotion style.

Let's start with what you already have in place. You have identified goals for your practice, have great promotional tools (work samples and written materials), and have been regularly discussing your work with peers and colleagues. You are aware of the issues in your art and feel prepared to talk about them. You feel ready to engage a new audience with your work and are eager to see their reaction. These are the main ingredients you will use to promote yourself—and you already have them.

At the same time you've been exploring your local art landscape— researching venues, opportunities, and art professionals with whom you want to be connected. While doing this research, you need to consider who will be most receptive to your work. There are both obvious and subtle differences between exhibition venues, and audiences gravitate to them based on their programming. Most likely you are already drawn to some spaces regularly and visit others only once in a while. You need to keep this in mind as you do your research.

If you want to be a part of the art world, you need to survey the landscape and imagine your place within it. Reflect on who would be interested in the content of your work or your approach. Outside of your peers, consider whom you want to see your work and why. What spaces feel like a natural fit? Who is their audience? Most artists operate with only the vaguest notion of their viewer or supporter. They imagine an amorphous group of collectors, artists, or the general public. I realize you can never predict exactly who will be interested in what you do. Discussing different audiences and venues with others will help spark productive conversations about who might be most receptive to your work. These conversations could trigger referrals to certain critics, curators, or organizations. Learn to decipher the distinctions among different spaces and the diverse interests of art professionals. Venues you

approach for support will analyze your work based on their tastes and programming needs.

Making potential supporters—curators, art administrators, critics, collectors, gallery directors—aware of your work is essential to connecting with new opportunities and expanding your career. Promoting your work introduces it to someone who will do something on your behalf. There are many ways they can benefit you. They will come and see what you have created, visit your website, show your work, collect it, or support it with grants and services. They will help spread the word about what you are doing. They promote your work to others when they write about it or review it. The best way to cultivate these promotional partners is through relationships you develop one at a time.

I get hundreds of proposals from artists over the course of a year. The exhibitions we present at Diverse Works are the result of lots of research, and mutual research is critical. I research artists to find work that suits the nature of our programming, and, in turn, artists need to be researching appropriate venues for the work that they are doing. It is so frustrating to get proposals day in and day out from people who clearly don't know the first thing about the organization, people who haven't set foot in the door, don't know what we do, and haven't looked at our history of exhibitions. That's a waste of that artist's time, my time, money, and everything else. I can't stress enough how important it is to do your research, know your community, and know your field.

—Diane Barber, codirector and visual arts curator of DiverseWorks Artspace

Promotion is a necessary ingredient in your artistic practice. You want to develop ways to promote your work that maintain your personal integrity. If you view it as an uncomfortable suit of clothing you must don a few weeks out of the year, it will always feel stiff and unnatural. Instead, you need to incorporate a few actions every day toward this goal, as uncomfortable as it can be. This allows you to practice and hone your skills. It's unfortunate that the pervasive notion in the art community is that "good work will be recognized." It sends the message that if your work is worthy, you don't need to actively promote it. If you have to promote it, then it must not be creditable. It's no wonder many artists are straitjacketed by these conflicted feelings and would rather completely avoid making an effort.

Promoting your work needs to arise organically from your creative practice and personality. The way you go about it depends on what kind of a person you are. You may relish the opportunity to gleefully introduce yourself and throw your arms around people at openings and events. You may be the opposite, standing off to the side and viewing the art world with bemused detachment. You may not even like attending openings and art events and avoid crowds as much as possible. I'm

painfully shy when it comes to making my way through an opening. In fact, I have perfected the ability to become invisible, scooting around the outside edges and out the front door without interacting with anyone. To overcome my instinct to flee, I've made a rule for openings. I am not allowed to leave until I have spoken with three people in the room. That rule forces me away from the outer walls and into the crowd. Often my first conversation is with the gallery assistant pouring wine. Then I look around to find someone standing alone whom I can approach with a friendly greeting such as, "Hi, do you know the artist? Can you point him (her) out to me?" By this time I've managed to quell my initial fright-and-flight mechanism, and other conversations follow. Attending events with a friend or two increases the likelihood of meeting people. Friends can help facilitate an introduction to someone you want to meet and keep you from chickening out. It helps to look at promoting yourself as a fact-finding mission. The people you meet and the tidbits of information you gather are all pieces of a puzzle you are on your way to solving.

Artists often worry about how to be assertive without being seen as "too pushy." Pushiness is another negative connotation attached to the idea of promotion that needs to be dismissed. Promoting your work *requires* that you be assertive. It does not mean you are impolite, disrespectful of others, or inappropriately aggressive. At an opening, it's the difference between saying a few words about the show to the curator and imploring them to visit your studio. It's the difference between mailing a card for your upcoming show to the curator followed by an email and sending daily missives throughout the run of the exhibition. You need to untangle promotion from your feelings of self-worth, set those feelings aside, and proceed as if it is just another part of your artistic practice.

Networking isn't limited to the relationships you have with your peers and art events you attend. In fact, there are simple things you can do each day that comfortably fall into the category of promoting your work. Seize any opportunity to build your community. Networking can take place anywhere—in airports, elevators, coffee shops, the gym, and riding mass transit. A friend of mine was introduced to his gallery by

If you have a notion of the audience that you would like to reach, that affects all of your decisions—from where to show, to what you make, and so on. There is another way of looking at it. You put something out in the world, certain kinds of people respond to it, and you then have to understand why. . . . And then, there is the issue of venue. There is a gallery audience, there is a museum audience, and there is a public audience. . . . It's good to be aware of what you have to offer.

—Janine Antoni, Artist

the guy at the deli counter who made his sandwich each day. It turns out he also made sandwiches for the gallery staff. Remember: people enjoy meeting artists. We are exotic. We may think that our process is mostly prosaic, but the rest of the world doesn't agree and wants to know more.

Basic Guidelines for Self-Promotion

DEVELOP A BRIEF DESCRIPTIVE STATEMENT ABOUT YOURSELF AND YOUR WORK.

In advertising, it's called an elevator pitch. What would you say to someone about yourself and your work in a thirty-second elevator ride? Look at your artist statement, and find a few sentences that visually describe your work. Practice saying them out loud. You don't need to memorize them, but you want to become comfortable with the essence of what you wish to convey. It's easy to become tongue-tied when suddenly faced with the question "What's your work like?" To respond, you want to give just enough information so that the listener might want to follow up with another question, which can be the start of a longer conversation. It is important that you incorporate descriptive language that will help them form a visual image in their mind about your work. Introducing yourself and your work in a friendly way is a skill that anyone can develop. Practice on your friends and family, and ask for feedback. They'll point out important ideas or interesting information you missed. Then try out your verbal statement in less stressful situations before tackling the really difficult ones.

CARRY BUSINESS CARDS WITH YOU, AND USE THEM.

When I hand my business card to someone I've met and get his or hers in return, I am deepening our connection. Exchanging business cards is a good way to foster a relationship. You can leave the recipient with a tantalizing impression of your practice through a clever design or including an image of your work. I know artists who have made this process fun by creating business cards with a variety of images. When

You have to find a balance between getting yourself out there—networking, meeting and greeting people—and not letting that distract you too much from the work that you're doing. Your job is to be in the studio from at least 9 till 5, if not more. If you don't want to do that, then you shouldn't be an artist in the first place. But networking is a big part of it. When you're not in the studio, you've got to get out there.

—Cristin Tierney, art advisor

I have met artists that I know will be successful because they are aggressive and very polite. "Aggressive" means being out there. I love it when I meet artists who really like to talk about art other than their own.

—Andrea Kirsh, art historian, art critic, and writer

asked for their card, they fan them out and allow the recipient to choose one. This act can spark a longer conversation about their work.

On my business cards, besides including the usual contact information, I list my website but not my email address. If someone wishes to get in touch with me, I want to drive them to the opening page of my website to see my work before they click on the contact tab to email me. It is also helpful to make brief notations about the person on the back of business cards you receive. Include a few key words about the conversation, a mutual acquaintance, or a note regarding following up. I have a terrible memory for names, so I constantly rely on business cards to help me out.

Don't be an art snob! Don't hang only with artists. Make friends in all areas. Make friends with business people, with lawyers, with people who run businesses, who are entrepreneurial, who like to organize things. You need to know a lot about different kinds of people and how they think—What matters to them? What are their personalities? What kinds of books and magazines do they read? What Web sites do they visit? . . . It's always good to have people from your past whom you can trust—even for different kinds of advice. Build a brain trust for yourself.
—Anna Deavere Smith, *Letters to a Young Artist: Straight-up Advice on Making a Life in the Arts: For Actors, Performers, Writers, and Artists of Every Kind* (New York: Anchor Books, 2006), 73–74

BEFORE YOU GO TO AN ART EVENT, DO SOME PRELIMINARY RESEARCH.

You will be better informed about the art space, exhibition, curator, panelist, collector, or artist if you learn more about them beforehand. You can often learn a lot by searching the Internet and asking other artists what they know. Learning more about the organization and the people involved will help you identify those individuals you want to meet at the event. Having some background knowledge about them can help break the ice when introducing yourself. The conversation is richer when you can include comments or questions about their recent projects, and they will appreciate that you did your homework.

KNOW THAT DEVELOPING GOOD RELATIONSHIPS TAKES TIME.

Being open to—and staying in touch with—those who cross your path is how your community of support grows. Follow up introductions with an email or note if appropriate; then add that person to your contact list. Allow stronger relationships to evolve naturally. At all times, just be yourself. People appreciate honesty and sincerity, and they have

You should know about everything going on in your immediate community, and if you forge relationships with the curators—well, like I already said, we talk about stuff. If I am working on a show, I talk to every colleague I know about that show: "I'm looking for work like this. Let me know if you see anything." Fifty percent of exhibition development happens in conversations. Think of the arts community as your professional network. If you really know your field, you'll have opportunities to get information that would otherwise be flying under the radar.

—Diane Barber, codirector and visual arts curator, DiverseWorks Artspace

amazingly delicate antennas for phoniness. Allow your networking style to emerge naturally from your own personality. If you are soft-spoken, don't try to be boisterous or aggressive. Turn your shyness into an asset by being an attentive listener and asking questions. Being prepared by following the previous suggestions will help you overcome your initial shyness.

What matters most is the quality of your relationships, not the quantity. Make it part of your practice to build connections with people you respect and admire. Good relationships are a two-way street. There will be times when you will need to call on them for help and occasions when they will need yours. Foster the bond by generously sharing information and connections. Call up a friend or two, and let them know about something you discovered in your research that might be of benefit to them. They will direct information and contacts back to you. It takes less effort to keep a good relationship than to begin a new one.

Although there is no single path to engaging the audience that will be most responsive to your work, many artists find their first opportunity comes through art professionals working in nonprofit organizations. The rest of this chapter outlines your options in the nonprofit arts community and provides information on how to connect and work with them. Chapter 5 will discuss the commercial galleries, art dealers, consultants, museums, and public commissioning agencies. Knowing who the different players are and how they fit into your plan is crucial to establishing yourself. You can then employ a variety of entrance strategies to get your art shown.

Nonprofit Organizations

Nonprofit (or not-for-profit) organizations support a specific issue or concern, which is identified as their mission. They are often created to respond to a need, such as providing a permanent home and public access for a collection of art, exhibiting and promoting contemporary

MORGAN O'HARA

Site-specific wall drawing:

FORM AND CONTENT: Amiri Baraka reading his poetry, Ishioka Toyomi carving cedar, 2003

Wall drawings: flat black acrylic on white wall

19.5 x 48.75 feet

Aomori Contemporary Art Center, Aomori, Japan

Morgan O'Hara's *Live Transmission* drawings are done as both private and public performances. Done in real time with both hands, they render visible normally invisible or fleeting movement patterns through seismograph-like drawing. The direction of the line as well as the quality of its intensity is transmitted by closely following each segment of an activity.

artists or artistic ideas, offering a community service, or educating and informing the public. They are not concerned with making a monetary profit from their activities, and they are primarily supported through grants, donations, and endowments.

Nonprofits usually work with an individual artist on a limited basis—on a single project or show. Their program decisions reflect their mission and funding. Collecting this information is an essential part of careful research and will determine which organizations are the best matches for you. Since most nonprofit organizations receive grants from local, state, and national sources, they have a responsibility to be open and accessible to the public. The public includes you, the artist. Organizations that work with contemporary artists must develop criteria for selection and publicly post submission guidelines to their programs. Carefully reviewing these guidelines is your responsibility.

The exhibition space I started in Brooklyn, the Rotunda Gallery, was set up as a nonprofit. I worked with a board of directors who oversaw my activities and the fiscal management of the gallery. Because we received grants from state and city agencies, as well as foundations and individuals, I felt it was my responsibility to be open to a range of art

ideas and projects that fit the mission of the gallery. Although I was concerned with the overall quality of the arts programming, I never gave a thought to whether the work on exhibition would sell. Sales weren't part of our mission. The gallery thus functioned as a showcase for a wide variety of ideas in contemporary art practice. Since we presented mainly thematic group exhibitions, each year we worked with dozens of different artists and hired independent curators to bring in a variety of viewpoints. I was always interested in new artists who approached me and curious about their work. I took every opportunity to encourage artists to send me information and often asked other art professionals for artist recommendations. It was also part of my job to be informed about the rest of the art community, so I regularly visited other galleries to see whose work they were showing.

Sometimes, it takes a while to find out what people are really interested in. Sometimes, you don't even know that when they are asking a question, they might have something in mind for you two years down the road or that you might be able to do something for that person. It's a mistake to go around thinking that every opportunity is something to work. People like to be appreciated and enjoyed, and that is an important factor in working together. One has to be careful not to move into situations only to use them. There exist radical differences in approach in America, Europe, and Asia, and major differences run along these lines.

—Morgan O'Hara, artist

There is an incredible network of nonprofits throughout the nation. Organizations like the Rotunda Gallery are often referred to as "alternative" spaces or "artist-run" spaces. Many were founded by artists in the '70s and '80s in response to the lack of exhibition opportunities for contemporary living artists and as an alternative to the market-driven commercial galleries. These spaces provide programs based on their mission, such as supporting artists who are emerging, underrepresented, of color, local, or working within a specific genre or medium. These organizations periodically review their missions to make sure their programs are relevant to the needs of the community they pledge to serve. They do not have a permanent art collection but present frequently changing exhibitions. Many spaces are still mainly staffed by artists. In the larger and more established spaces it is not unusual for the directors and curators to go on to new positions in museums and commercial galleries. There are long-standing relationships in the art world between these spaces. They talk to each other often.

Alternative spaces are constantly looking for new talent and quickly respond to fresh ideas percolating in the art world. They were the first to support installation, video, animation, and performance work, pro-

viding artists the opportunity to show how these media could be incorporated into an organization's programming. Nowadays, many commercial galleries, museums, and even collectors have established project rooms and are comfortable commissioning installations and working with ephemeral art objects.

Alternative spaces are often the first to embrace difficult, issue-based work or politically sensitive material. During the "culture wars" between the National Endowment for the Arts (NEA) and the arts community in the late '80s and early '90s, it was the artist-run alternative space Washington Project for the Arts that immediately agreed to host the controversial Robert Mapplethorpe retrospective *A Perfect Moment*. The show had been cancelled at the last minute by the Corcoran Gallery of Art under political pressure. Another alternative space, Artists Space, had its NEA funding withdrawn for the AIDS show *Witnesses: Against Our Vanishing,* to be reinstated only after the arts community furiously erupted in protest. I lived a block away from Artists Space and volunteered to help with the media circus that descended on it during this perilous time. I watched with pride as my friend Susan Wyatt, the director of Artists Space, admirably defended the show, free speech, and the importance of nonpolitical government funding for the arts in the national news media.

Artists have to think about their own specific community. I mean, in St. Louis I was actually really fortunate to be in a community that wasn't Manhattan right out of graduate school. Because it wasn't Manhattan, everybody would answer my phone calls, I was on grant review panels, and I learned all these things that I could apply later. So it's not like you have to immediately go someplace big, but you have to understand what different places have to offer and understand that people move around. I think that's something that's obvious in retrospect, but every curator I knew ten years ago is now someplace else.

—Kurt Perschke, artist

Because alternative spaces function as art laboratories and embrace a wide variety of work, they are great places for emerging artists to get started and for mid-career artists to experiment with new ideas. In fact, most of them make it easy for you to get involved. Guidelines for submitting work or applying for projects and requests for exhibition ideas are either posted on the organization's website or available as a handout at the admissions desk. If it has an artist registry, make sure your work is included. All nonprofits regularly review the work of artists in their registries when curating exhibitions and developing new ideas.

It's also true that quite often the budget of an alternative space is limited and the staff overworked. This means that resources available for a

DIVERSEWORKS ARTSPACE

From the exhibition *Run for Your Lives!* curated by Diane Barber and presented at DiverseWorks Artspace in Houston, Texas, 2006.

Mushroom cloud: Dietrich Wegner (www.dietrichwegner.com)

Tornado: Matias Duville (http://www.matiasduville.com)

Small paintings: Katherine Taylor, Marcia Wood Gallery (www.marciawoodgallery.com)

show will vary from space to space. Most require the artist to fund some exhibition expenses, such as shipping, framing, flat-screen monitors, projectors, etc.

While the funds may be meager, the conversation can be fruitful. Being selected for a group show allows you to measure your work against others'. Being offered a project space may be your only chance to see that installation or video project fully realized as you intended. The great documentation you take of your installation may help you land your next project grant or exhibition. Any chance you have to place your art in a different context provides you new information about the work and how different viewers respond to it.

Many nonprofit organizations don't have an exhibition venue but produce cultural programs consisting of temporary shows and installations in public spaces. These projects can range from a one-day light

projection, installation, or performance to placing work in a public square or building lobby for six months or more. The organization functions as the liaison between an artist's project and the community, securing necessary permissions from the local municipalities to safely and legally install and maintain the work in a public space. They also underwrite many of the expenses, help fundraise, and publicize the project. For example, Jenny Holzer's outdoor projections, discussed in the previous chapter, were sponsored by a New York City–based presenting organization, Creative Time.

Many municipalities have discovered that placing art in public places is good for the local economy, so they welcome these projects. For example, New York City Mayor Michael Bloomberg estimated that Christo and Jeanne-Claude's monumental outdoor installation throughout Central Park, *The Gates*, brought in 4 million visitors and $254 million in economic activity to New York City for a project that was on view for only sixteen winter days.

Public art projects can take place on any scale. Arizona-based artist Gregory Sale has been doing text-based studio work for years and recently began a project, *Love Buttons*, which was inspired by Robert Indiana's *Love* sculpture installed at the Scottsdale Civic Center Mall. He created a series of poetic text-based buttons, commissioned by Scottsdale Public Art; these were distributed to participants at local arts festivals. "*Love Buttons* is a participatory event which employs poetic language and evocative text fragments to disperse a sea of poetry into the crowd of festival-goers. The participants connect through chance encounters and linguistic associations to spark a collective contemplation on love." Larger versions of the buttons were spread throughout festivals as signs mounted to lampposts around the grounds. Sale has also created a Love Buttons website (http://www.love-buttons.com), where viewers are encouraged to make their own love poems without using the word "love."

A different kind of participatory project is Kurt Perschke's *RedBall*. Originally commissioned in 2001 by the St. Louis Arts in Transit program, the *RedBall* project is a temporary sculptural performance that becomes a public art event. It's a fifteen-foot inflatable ball that gets

It was great for me to begin my career at the nonprofits because I didn't have to deal with the commercial world. I could concentrate on learning to install my work and watch how it was being received before having to deal with the commercial side of things.
—Janine Antoni, artist

We do a lot of commissioned works. . . . We have "affairs" with artists.
—Diane Barber, codirector and visual arts curator of DiverseWorks Artspace

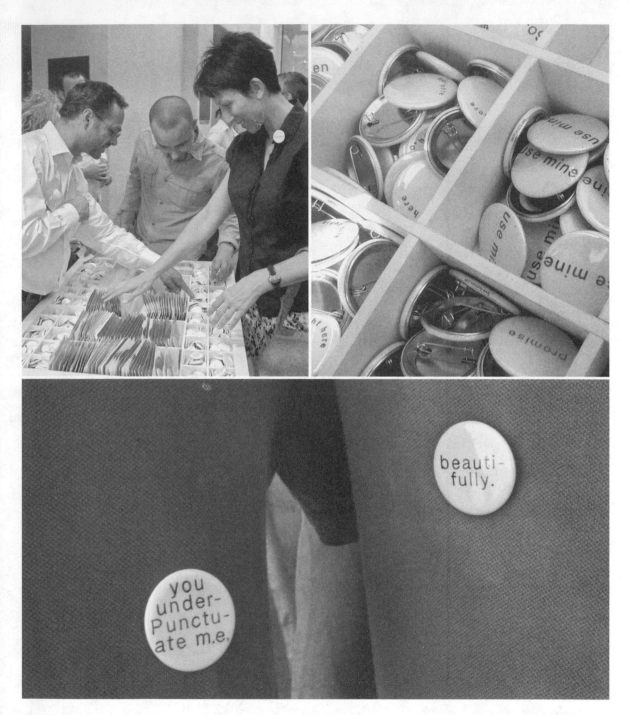

GREGORY SALE

Love Buttons, 2008

Participants engaging with *Love Buttons* during a rhythm-and-blues festival and a summer art walk. Co-sponsored by Scottsdale Public Art and Lisa Sette Gallery, Scottsdale

Photos: Marilyn Murphy (top left and right)

Photo: C. Warden (bottom)

squished into architectural locations throughout a city in archways, between alleyways, and so on (image next page). It moves throughout the city in a choreographed suite of installations over two or three weeks but is only at each specific site for one day. Viewers quickly grasp that the sculpture is mobile and, in a sense, exploring the city. Everyone begins suggesting ideas of where it should go next and becomes engaged in the "artistic process." For Perschke, that transference of the imaginative process is a core aspect of the piece. After completing the project in St. Louis, Perschke was interested in seeing how it functioned in other urban environments. With his own funds he brought the *RedBall* project the following year to an artist's residency in Barcelona, Spain, where he installed it throughout the city and at the Museum of Contemporary Art. The project attracted an article in *Sculpture* magazine, and other invitations to host the work followed, from Sydney, Australia; Portland, Oregon; Scottsdale, Arizona; and Chicago, Illinois; as well at the Busan Biennale in Korea.

Because the budgets for projects in public spaces can be large, organizations are more likely to work with experienced artists rather than those fresh out of art school. Check out whom they have recently supported to gauge whether you should apply to their programs. Challenge yourself, but also be realistically attuned when doing your research to decide if this is a good match for you at this time in your career.

COLLEGE AND UNIVERSITY ART GALLERIES

These are exhibition spaces created to enhance the educational mission of the academic institution and provide cultural programs for the surrounding community. College and university art galleries provide training, curatorial, and exhibition opportunities for the students, alumni, and staff and bring the work of invited artists into the academic environment. They may have their own separate building that houses a permanent art collection and engages in the same activities as a museum. They can also encompass gallery spaces within the art department or school library or, more informally, be a lobby and hallway designated as exhibition space. Support is provided by a combination of funds and services,

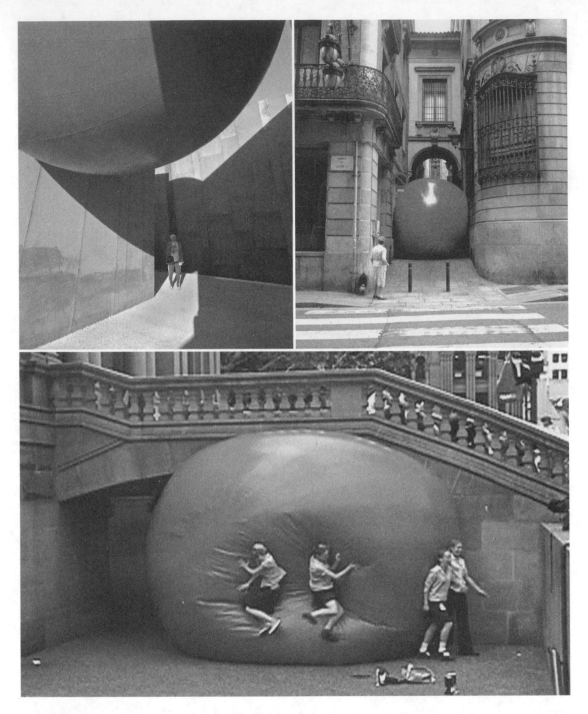

KURT PERSCHKE

Clockwise, from top left:

RedBall: Arizona, 2008, Arabian Library Site

RedBall: Barcelona, 2002, Jaume Street in
 Gothic Quarter

RedBall: Sydney, 2003, Old Town Hall

The RedBall Project is a sculptural
installation traveling around the globe.

including a yearly budget within the institution, solicited grants, and donations. They maintain a year-round program of rotating exhibitions, talks, and lectures. Others function as art incubators, commissioning project-based work that pushes the envelope of artistic practice. In many rural communities they are the primary exhibition sites available. For example, the University of Wyoming Art Museum is one of only five art museums in the entire state.

Just as with alternative space galleries, there is fluid movement between curators and directors in university and college spaces. They may come from or move on to national art publications, museums, galleries, and other nonprofits. These professionals are developing their careers too. Don't be surprised if your paths cross in another context later on. Connections forged with art professionals at any stage of your career have the potential to last a lifetime.

I have noticed that many artists don't take advantage of the opportunities available at these venues. From local community colleges to large universities, there are a plethora of spaces available that could be a part of your career plan. They are an opportunity to exhibit your work and engage in a stimulating dialogue about it. Many spaces combine solo exhibitions with an invitation to lecture publicly about your work, give a workshop or demonstration, or engage in studio critiques with their art majors. If they don't have such a program, you should volunteer to give a gallery talk or to speak with their students. It's a good opportunity to practice discussing your work with a receptive audience.

Some university and college galleries may operate on a strictly do-it-yourself basis. Others, depending on their size and budget, will professionally cover all your exhibition needs, including a catalogue or brochure of the show, which you can use in the future as supplementary material when applying for opportunities in other venues. If you are working on complex, labor-intensive installations, there are often plenty of free student interns available to assist you. In return, the interns get valuable experience and insight into an artist's process.

The project now exists parallel to my studio work and takes me away to travel once or twice a year. From the first time someone contacts me, or says that they are interested, to an actual installation, it can take six months or a year, so there's a lot of work that happens before those two or three weeks of actual installation. I have to go out, visit a city, and select the site six months in advance.

When you stop envisioning this stuff as public art and you think about it as cultural programming, you ask different questions. Public art people are making monuments to go in front of buildings, but if you are talking to somebody who is used to doing operas and film festivals, nobody is concerned about those things. They are concerned about exposure and impact.

—Kurt Perschke, artist

CO-OP GALLERIES

These are exhibition spaces started by a group of artists who agree to jointly share the financing, duties, and responsibilities of running the organization. In addition to paying startup costs and a monthly fee, it may mean taking your turn gallery sitting, preparing the space, helping to install an exhibition, sending out announcements, bookkeeping, and other administrative tasks. The artist members regularly receive a solo show and thus have a stable, long-term base from which to operate. Some co-op galleries were started by groups of artists who felt shut out of the commercial venues, such as the A.I.R. Gallery in New York City, which is dedicated to women artists. Others have been formed to add additional exhibition opportunities in a small town or city. Many of them are organized as nonprofits so they can apply for grants to provide programming for artists outside of their membership and offset their members' fees.

The quality of programming at a co-op gallery is defined by the participation and ambition of its artist membership. Sharing responsibilities allows for a pooling of talents that can benefit the whole. One member may be better at promotion, another experienced at bookkeeping or fundraising. You must be willing to be active and carry your share of the tasks. For many artists, co-op membership is a good alternative to commercial gallery representation or is a way to get started exhibiting. It provides you with a community of peers and a stable platform from which to engage your audience.

I am on a campus with some 17,000 students and . . . it's a challenge to get huge chunks of that population through the door; so we are constantly looking for ways to attract students. We want them to feel welcome and part of this institution, which is important for a lot of different reasons. It secures our place as a vital part of the university and is important in terms of future fundraising efforts. Alumni provide a huge base of support for any university or college. The opportunity to connect with students is when they are here. It also drives a pedagogical approach to the exhibition and the interpretive programs that happen here in the museum. I think that's something that we are aware of at every step of the exhibition planning and implementation.

I think every university museum addresses multiple and varied audiences. Not every show will resonate with all of those audiences. Our aim is to create a mix of programming that's exciting and challenging, that engages different segments of our audience, and gets them involved in the program and the institution.

—Janet Riker, director, University Art Museum, University at Albany

JURIED EXHIBITIONS

Many nonprofit organizations sponsor juried exhibitions as part of their program. If you are applying to "national" or "international" juried exhibitions, be extremely selective. In many cases, these shows are the means by which an organization collects easy money from the entry

fees of hundreds of artists eager to get their work seen by a "prestigious" juror. They are seldom career-building opportunities, even if your art is selected for exhibition and given an award. A better way to introduce your work to an important curator or critic is to send your information directly.

If you want to apply to juried exhibitions, here are some selection criteria to keep in mind:

- Look for shows that don't charge entry fees to enter. You may need to pay shipping if selected, but the jury process should be free.
- Select shows with a specific theme that applies to your work.
- Consider shows open only to regional artists; these can be a good way to expand your connections to your community.
- Most of all, apply only to those juried exhibitions sponsored by an organization you value and trust.

Being accepted into a juried show can help build confidence in your work when you are starting out. But be careful: don't depend solely on these venues, and make sure you are exploring *all* your other exhibition options as well.

PROMOTING YOURSELF TO REGIONAL NONPROFITS

The easiest place to start promoting yourself is in your surrounding area. Connect with nonprofit opportunities within a few hours' drive or a short train or bus ride. Even if you have lived in the same place for a while, and have been exhibiting your work locally, periodically reacquainting yourself with what is available nearby is a good exercise. If you are just out of school or new to the area, doing this first is the best way for you to begin establishing yourself. Remember your goals. What do you wish to accomplish? Introduce your work to a new audience? Find a project room for your new installation or video project? Expose your work in a new context or in relation to others in a group show?

Experience how a different audience responds to your work? Next, compile a list of venues that will be the best fit for your work and your goals.

Here's your homework:

1. Take out a map of your area, and draw a circle encompassing fifty to a hundred miles from where you live. (The size of the circle will depend on how densely populated your community is. In urban areas fifty miles may be plenty, while in rural areas the circle may need to be larger.)

2. Compile a list of nonprofit venues within the circle on your map. Consult the *Art in America: Annual Guide to Museums, Galleries, Artists*, local newspapers, magazines, and the Internet.

3. Research each of the venues. Start with those with websites, and begin to collect information about them.

 a. What is their mission? Is it a good fit for you and your work?

 b. Do they have guidelines for submitting work?

 c. Do they have a registry of artists?

 d. What is the full range of their programs? Which ones are appropriate for you?

 e. What is their exhibition history? Do they repeat certain themes that relate to your work?

4. Compile a short list of those venues that are the best matches, and make a plan to visit them over the next few months. You could take one Saturday afternoon a month and make the rounds of one geographic area within your circle. Add to your list those venues that did not have a web presence or enough information for you to make an initial decision about them.

5. At each site you visit, make sure to connect with someone in the organization, even if it is just an intern sitting at the front desk. Ask questions about their programs, collect any written information available, and sign up for their mailing list or

email list to be informed of upcoming events and opportunities.

6. When you return home, sift through the information you have collected, and narrow down your list by answering the following questions:
 a. Do they support work like mine?
 b. Do I respect what they are doing?
 c. What are their submission guidelines?
 d. Who's in charge of making decisions? How can they be contacted?
7. Make a plan to follow through on the information. Take out your calendar or to-do list, and pencil in any deadlines for artist submissions and proposals. If they don't have deadlines, make them for yourself.

No matter how much information an organization has on its website, a visit is always illuminating. Some organizations don't have the staff to keep their website updated. A new program may be in place that is not yet listed online. Because of the relentlessness of spam, many organizations no longer keep a staff list on their website. You can collect that information with a phone call or site visit. Visiting the organization often brings surprises. The spacious gallery spaces that caught your eye on their website may appear much smaller in person. The current exhibition may be much more exciting than you expected from the short description provided. You may bump into someone you know who introduces you to the staff. You'll have to schedule some significant time for this activity, but I guarantee that it will be time well spent.

Site visits are a great opportunity to begin a connection with the organization. If the intern or staff person at the front desk can't answer some of your questions, he or she may ask the curator or director to come to speak with you. Being curious about their organization and asking a few questions that clarify their guidelines and programming decisions shows your genuine interest in their space. A curator or director will appreciate that you have done some basic research and aren't asking about information that's already posted. You may pick

up an inside tip or two about submitting work, or advance notice about an upcoming exhibition she is organizing. Your questions may lead her to suggest other venues, independent curators, or opportunities you should check out. You may be able to send her to a friend of yours whose work is just right for a show they are organizing. During this conversation, you don't need to provide too much information about yourself. Introducing yourself with your first and last name and a sentence or two about your work is plenty. Keep the conversation friendly and to the point. Always follow up any conversations like this with a brief thank-you note, postcard, or email saying you appreciated their time. It puts your name in front of the director or curator again, and if your note or postcard has an image of your recent work, all the better.

Once you have determined a few places to contact, carefully review their published guidelines, and *follow the instructions*. I can't emphasize this enough. More artists are rejected simply because they didn't do their research or follow directions. It is a common complaint among art professionals. Don't assume they will make an exception for you. Send your images in the format they request. Most organizations will view digital files, but some still want slides. Have your digital files converted to slides if that is what they need, or give them a call to see if they will look at digital printouts; don't berate them for their backwardness. Only send in as much information as they have requested, and format it according to their specifications, following their file size and labeling guidelines. Include work sample descriptions of the images (at the minimum, title, date, materials, and year), artist statement, and résumé. If you are proposing project-based work, include a description and a budget (if requested).

What if the organization does not have guidelines for submitting work? If you wish to introduce your work to the director or curator, then put together a package. The artist package is a promotional tool that allows you to initiate contact, follow up with more information after an introduction, or keep already-established relationships informed of your latest body of work or project. Return to the tools in chapter 2. Their quality is crucial. The all-important first impression an art profes-

sional has of you is contained in your package. *Before* you send it out, remember to run it by an artist friend for feedback and corrections.

THE ARTIST PACKAGE

The contents of an artist package are as follows and in order of importance:

- cover letter
- work samples: three to four digital printouts (necessary) and CD or DVD with more images (optional)
- work sample descriptions
- artist statement
- résumé
- business card
- one or two exhibition reviews, postcards of past exhibitions, catalogues (optional)

Slip these materials into an inexpensive two-pocket folder with your name printed on the cover. Add a self-addressed, stamped envelope if you wish your materials returned. Make sure your name and contact information are on every page of the package, especially your work samples. Should they get separated from your package, they can be later identified. Review the guidelines for formatting your work samples, work sample descriptions, artist statement, and résumé (see chapter 2).

A cover letter should always be included in your package. It is a general greeting that identifies why this material has been sent to the recipient and provides a short overview of what is included. It is seldom more than one page long. You should always make an effort to address it to a specific person rather than a generic "Dear Curator" or "Dear Gallery Director." Take a few extra minutes to call and get this information along with the person's exact title and spelling of his or her name.

Your cover letter will reveal your personality through your choice of words and tone. The first sentence states the letter's purpose and sets a professional and courteous tone. Think about why you are sending this

package: Is it to introduce your work? Does it follow up on previous correspondence or conversation? Are you writing at the suggestion of a third party? *Get directly to the point.* Do not begin with a long story about a related topic or try to be artificially intimate or ingratiating. Demonstrate you have done your homework and know something about the organization, person, or opportunity.

You can also include another paragraph containing more detailed information about the enclosed body of work, your short twenty-five-word artist statement, or news of something important that is currently happening in your career, such as a grant, a commission, or an exhibition. Keep this information brief. A one-sentence summary of your artist statement or a salient line from your résumé is okay, but don't repeat sentences or paragraphs from your artist statement, project proposal, or large portions of your résumé.

A final paragraph includes language to motivate the reader to take action, such as making an appointment to review a portfolio, scheduling a studio visit, retaining information for future reference, or reviewing and returning the materials. I usually say that I'll contact them either by phone or by email in a week's time to follow up with any questions they may have. And then I do it. Making those phone calls can be daunting, but if you say you will follow up, then you must go through with the action.

At the bottom of each cover letter, list what enclosures are included in the package. I'll note on my copy exactly what images I've sent them, so if I follow up later, I know what they have seen.

Think of your artist packet as a studio visit but without you there to explain your work. This means that the information needs to be well-organized and self-explanatory. Make sure your cover letter has a strong opening sentence and is personalized and carefully proofread. The work samples with descriptions and artist statement should provide enough information to answer the reader's initial questions about the work, like the following: Are these video stills, installation documentation, or a series of photographs? What has inspired this work? What are those weird

I think one thing [cover letters should] say is something specifically about [the gallery]. I've sold many different types of things in my life, and when I would go into a sales meeting, I would do my homework, so it sounded like I knew everything about their company. I didn't know everything about their company—there's no way I could have—but I had enough tidbits that that person thought, "Wow, she knows what she's talking about. I want to work with her." Same concept. You know—write me a letter that says, "I really like this person's art," or "I saw you here, and I really appreciated _____." You have to not only talk about yourself. You have to talk about them.

—Julie Baker, president of Julie Baker Fine Art
and partner of Garson Baker Fine Art

materials, and why are they being used? The work samples, descriptions, and artist statement are always the most important elements of your package. The rest of your materials—résumé, reviews, catalogues—are of lesser importance. They provide a quick scan to see where you are, where you've been, and who has supported your efforts.

If you have been showing your work for some time and have collected reviews and critical essays about your work, *consider adding a page of press quotes to your packet.* These are brief excerpts of writing about your work and provide information you may not be able to say easily about yourself, such as "Artist X's sculptures project tremendous power." It is a device that has been used advantageously for years within the performing arts, literary, and film communities and can be just as useful for visual artists. A list of press quotes is similar to the advertising that accompanies the release of a movie or the blurbs printed on a book jacket. Instead of filling up your package with pages of reviews and articles no one will read, pull out the best sentences and paragraphs about your work, and arrange them on one page. If there is a review of a group show, include only the sentences or paragraph that discusses your work. Select the most compelling statement from the curator's catalogue essay, instead of the whole thing. Always identify the publication and author of the passage. Never change the meaning of the writing. If you need to shorten a sentence, use an ellipsis (. . .) to indicate words have been removed. Make sure the excerpt accurately represents the tone of the critic or curator. Don't remove words to change a negative review into a positive one, such as editing "stupendous failure" to just "stupendous." The quote sheet is a useful tool in that it can provide a fresh interpretation of your work that expands on your own statement

Here is an example of two press quotes about Santa Fe artist Susan York:

> [Susan York's] striking body of work and systematic methods—
> influenced by the Constructivist and De Stijl movements as well as

Typically, I sent out packages around the same time that I was doing a show. It allowed the dealer that I was contacting to see that I was currently in a show. Something about the currency of that . . . seemed to make a difference. It's like anything, once you are in one gallery it's like dating: the most popular people are the ones that have the most dates. When you are wanted, everyone wants you.

—Joanne Mattera, artist

SUSAN YORK
3 columns, 2008
14' 10" x 10" x 10" x 9 5/8"
corner columns:
6' 10" x 10" x 10" x 9 5/8"
Lannan Foundation
Photograph by Jayme Stillings

ancient Greek premises of geometry—adroitly provoke tensions between space and form. . . . Ultimately, through witty and poetic compromises, York's works negotiate a delicate balance between the conceptual and the material, between control and impulse, between order and chaos.—Sarah S. King, *Art in America*

Although repetitive labor is the subtext of York's installations, its residue can only be sensed as a consequence of slight visual unevenness and other related imperfections. She describes the way she applied graphite to the walls of her room-scaled pieces as follows: "Repetition and labor are my benchmarks. I am transfixed by the constant circling of my hand across the graphite and the gradual silvering of the surface as my hand rubs across it again and again, hour after hour."—Kathleen Whitney, *Sculpture* magazine

Don't allow other artists into your package. This is one place where you don't need to be generous. This package is all about you. Do not in-

clude group show exhibition announcements, catalogues, and reviews. This information is listed on your résumé, and any great quotes from critics and curators are on your press quotes sheet. You want the viewer's attention to be focused only on you and your work, not distracted by images and writing about other artists.

If you are making your contact through email, the same rules apply. Like a cover letter, the email should include a short, one-paragraph artist statement, and the first sentence of the email should state its purpose. You should attach no more than four low-resolution work samples. Incorporate the work sample description as text below the image, so the viewer can see both at once. Include the link to your website, MySpace page, or entry in an artist's registry, so the recipient can click on it if he or she wishes to see more work. Always offer to set up a studio visit, schedule an appointment, or drop off a portfolio at the recipient's convenience.

How do you know you are ready? It is part of the reason that there are artists that go from local to regional, to the nearest big city and work their way out. What I tell artists when I work with them is: think of it like [when] you throw a pebble into the pond and those ripples go out from the center. The artist is the center, obviously, and those ripples are the forays that we make out into the art world. And obviously the pond is the art world itself. So, in the process of rippling outward, we learn how to do all the things that we need to do.

—Joanne Mattera, artist

CONNECT THE DOTS

You should always be on the lookout for opportunities to connect your work with a receptive audience, whether it is just a single art professional or a thousand visitors to your exhibition. Make sure you are challenging yourself to move up to more competitive opportunities. I have watched artists get stuck in exhibition ruts. They have found success getting into juried shows or working with grassroots exhibition spaces. Instead of expanding their research and promotion to seek out new venues, they continue working in similar arenas because they feel safe and comfortable. Their résumé lengthens, but they aren't challenging themselves or their work to move into higher levels of opportunity.

I think nonprofit alternative art spaces are incredibly important. Gallerists and dealers go to nonprofits to see what's next.

—Camilo Alvarez, owner, director, curator, preparator of Samson Projects

No matter what stage of your career you are in, keep track of the nonprofit opportunities available to you. Get on their contact list, and put them on yours. Attend openings, and introduce yourself to the staff whenever possible. Art professionals of all kinds make regular visits to these sites, view their new exhibitions, and share information about

artists. Turn these organizations from gatekeepers into partners to help you move forward with your career.

Resources

Art in America: Annual Guide to Galleries, Museums, Artists.
- Published annually each August, this is a comprehensive listing of museums, galleries, university galleries, nonprofit exhibition spaces, corporate consultants, private dealers, and print dealers throughout the United States.

Smith, Anna Deavere. *Letters to a Young Artist: Straight-up Advice on Making a Life in the Arts: For Actors, Performers, Writers, and Artists of Every Kind.* New York: Anchor Books, 2006.
- This book is a series of letters to an imaginary young artist "into painting." There are nuggets of wisdom for artists of all ages.

How to Build Long-Term Professional Relationships

This chapter discusses commercial venues—galleries, private dealers, corporate consultants, and the more exclusive nonprofit venues, museums, and public commissioning agencies. It will offer advice on how to be a good partner with your venues and show you how to build long-term relationships. It provides exercises that will strengthen your ability to make and manage your contacts.

Put your best foot forward. First impressions count, and follow-up is important. This could be the beginning of a long relationship.

When you are just beginning your career, it is difficult to visualize the intricate relationships that will develop between the people you know and the ones you will meet in the future. As you move on with your professional life, it is even harder to imagine how to use these connections to your benefit. You must begin to envision the artist in the studio next to yours, the art history friend from grad school, or the young man perched behind the gallery desk as a potential ally. Just like you, art professionals—artists, gallery directors, curators, critics—get their start somewhere small, gain experience, and use their contacts to promote themselves and move up to more powerful positions. Each has the potential to take you with them, and that is why they are your connection to new opportunities.

Throughout your career, it is to your advantage to develop and maintain relationships with all levels of the art community—from the receptionist on up to the director, from the art historian including your work in her first exhibition, to the senior curator at the museum. The art world is an extremely fluid society. Art professionals change positions all the time, moving between commercial galleries, museums, alternative spaces, and editorial jobs. The failed gallerist may find redemption as an

innovative director of a nonprofit; the Renaissance art history major may develop into an enthusiastic curator of new media. Many artists discover in the first decade out of school that they have more passion for curating, writing, or selling art than they had for making it. It's quite possible that your best friend from drawing class may show up years later as the director of a contemporary art museum. A good example of this is the career of Olga Viso, director of the Walker Art Center in Minneapolis. Viso graduated from Rollins College in Florida as a studio art major. Her first job wasn't in the arts but in marketing for real estate developers. Later, while doing graduate work in art history at Emory University, she volunteered at the High Museum in Atlanta, which turned into an internship, then a job at the registrar's office, followed by an administrative position in the director's office, and then finally curatorial assistant. She moved to Washington, DC, for a job as curator at the Hirshhorn Museum. After seven years in curatorial, Viso became deputy director and then finally director of the museum. Now she is director of the Walker Art Center (see *ARTnews,* December 2007). Viso's story illustrates how the art student intern assisting with your installation today may someday be a curator, gallerist, or critic. As he establishes his career, your connection to him will continue. Most ambitious art professionals begin their careers at entry-level positions in the art world and gradually achieve positions of power.

For the last two chapters we have been exploring different ways you can develop more support for your work. Chapter 3 explored self-generated opportunities, and chapter 4 discussed those organizations most welcoming to artists, the nonprofits. Before we look further into leveraging your relationships to help promote your work, the next section explores another area of the art world, commercial venues and the more exclusive nonprofits. They are a mixed bag: these organizations often require that you have achieved a higher level of achievement before they work with you. Once I have outlined the opportunities in this area, the final section of this chapter returns to relationship building and solidifying the partnerships you create as you navigate the art community.

Commercial Venues

Commercial art organizations are businesses created and run to make a profit for their owner(s). Just like any other business, they need to make enough money to pay their expenses in order to keep their doors open. Their need to make a profit is a significant factor in their decision making. However, owners, directors, and staff of commercial art organizations are also deeply committed to the art they sell and the artists they represent.

And let's be blunt, an art gallery is a retail business. We can pretend it's something else and that art is not a product, but it is.
—Julie Baker, president of Julie Baker Fine Art and partner of Garson Baker Fine Art

ART GALLERIES

An *art gallery* is a business engaged in the sale of art through representation of a select number of artists, generally twelve to thirty-six. The represented artists, often referred to as the gallery's "stable," are provided regular exhibitions, and a selection of their work is available on site. Galleries make their income from sales commissions, which are generally 50 percent of the works' selling price. They are responsible for providing most or all of the costs of mounting an exhibition: shipping, installing, insuring, publicizing, creating an exhibition announcement, and holding an opening party. They may also partially fund production costs. This is especially true for one-of-a-kind installations or the creation of an edition of photographs.

Your relationship with a gallery ranges from the length of an exhibition to multiple shows over many years to a lifelong partnership. Some galleries have represented me for over a decade, and I have worked with others for only one show. Gallery representation is a long-term relationship with an organization committed to promoting your work to collectors, critics, curators, and other art professionals. This continuing partnership is the advantage of working with a commercial gallery.

A *gallerist* is the owner of a commercial gallery with an ongoing commitment to a small group of select artists. The term has come into usage in the last few years to distinguish an art professional dedicated to building an artist's career as opposed to an art dealer, who simply sells

an artist's work. You will find the terms "gallerist" and "art dealer" are still often used interchangeably.

Gallery representation means that you have a place to show your work regularly, usually a solo show every two to three years, depending on your productivity. The gallery will have an inventory of your work between shows, to promote and sell it. They may also showcase your work at art fairs (see page 133) and help place your work in exhibitions elsewhere. There are many forms of gallery representation; the most common is a commitment to an exclusive relationship within a geographic territory. Anyone in that community wanting access to your work would go through the gallery.

A good gallerist will be your sounding board. She discusses your work as it evolves, helps you evaluate and select other opportunities, protects you from bad choices, and is a buffer between you and the rest of the world. She works hard to build your career, placing your work in private and public collections and in time creating a demand and higher prices.

Most of my gallery relationships are long distance, but even though I'm not able to attend all the openings or have frequent studio visits, there are many ways I feel connected to them. I know how they like to do business— who calls me right after a sale and who likes to wait until he or she has received full payment before telling me the details. Even though they are located hundreds of miles away, I feel that I can pick up the phone and have a long talk with any of the staff about what I'm doing in the studio, or the jpeg I've sent of a work in progress. They carry my history, and our conversations expand to news of our families, what's happening in the world, and our respective art communities. Although I'm not able to drop in and visit whenever I want, I feel connected to the other artists in the gallery and to the galleries' business health and well-being, and they to mine. I remember the elated call I got from my Seattle art dealer when she sold one of my

A gallerist takes care of the artist. There's a long-term relationship involved. A dealer will not care where or to what collection a work goes, but a gallerist definitely cares. A gallerist will follow up with a collector every time the artist has a show, and a collector gets that. For a dealer, it's a one shot deal maybe, and then that's it. A gallerist will send a collector the artist's bio, whereas a dealer sends them an invoice.

—Camilo Alvarez, Samson Projects

A dealer is dealing with canvases, objects, videos, or whatever the case may be. A gallerist is dealing with a career. A gallerist is concerned with not just selling the work but contacting the right people and getting these artists' names in the press.

—Cristin Tierney, Art Advisor

paintings a few days after 9/11. My family had to leave our home near Ground Zero to stay with friends in midtown Manhattan. In the midst of those terrible weeks, she was especially thrilled to be able to bring me some good news.

The gallerist expects a level of exclusivity with the artists they represent. They often want to control access to your work within a specific area—a town, city, region, country, or the world. When you are just starting out, most galleries will "try out" your work on their audience in group and solo shows before making a longer commitment. They want to be sure you are a good fit with the other artists and want to see how your ideas are developing. Should an agreement for representation be forthcoming, you need to consider it carefully and negotiate your options and responsibilities. This is true for any contract and especially before agreeing to worldwide or nationwide exclusive representation. It is a complicated decision that should not be made at the onset of your relationship with the gallery. Allow the details of your relationship to develop over time.

I use what they do for me as an opportunity to learn about how the commercial world works, but they are privy to my thinking from the beginnings of a project. So, I don't just hand them an object at the end. I make sure that they have followed my creative process from the beginning. By the time they get the object, they understand it on all levels.

—Janine Antoni, Artist

Many artists judge success solely by getting gallery representation. A long-term partnership with a gallerist can validate your career to the outside world. You should always make sure, however, that you are working with someone with whom you feel a connection. It's a longer commitment, unlike working with a nonprofit, where a bad situation or a difficult staff person is annoying only

[Artists] are my clients. I have to take care of them. I can't do it without them. I don't make art. So I wear two different hats. I have a hat that is managing artists and the other that is managing the collectors. My job is to bridge the two.

—Julie Baker, president of Julie Baker Fine Art and partner of Garson Baker Fine Art

for the life of the show. You need to be discerning when committing yourself to work with a gallery. The following are some questions you should ask yourself as you begin your association with them. Do you like the gallery's program? Do you share similar values and goals? Are you comfortable with the relationship? Do you like the way they represent your work to others? Are they open to listening to your concerns and needs? Be honest with yourself; your answers to these questions are important. Many artists jump at any offer of representation just to feel supported and legitimized, only later to agonize over the relationship

*Each gallery has a vision and a
way they think things should
operate. It's really about
finding two visions that
somewhat align.*

—Janine Antoni, artist

when it proves difficult and unrewarding. Accepting an offer to join a
gallery is a big step. Representation does not mean all your worries are
solved and you can hand off all the business aspects of your career to
someone else. You still need to be in the driver's seat. What you have
gained is a skilled copilot.

I can't predict what your relationship with your gallery will be like.
Besides expecting that gallery representation will solve your career chal-
lenges, another mistake artists make is to misunderstand the complex
interactions that will arise among themselves, their gallery, and other
art professionals. Artists often enter into sales and exhibition agree-
ments without considering if it is in the best interests of their gallery
partnership. What may seem like an innocent mistake can have far-
reaching consequences. I often get S.O.S. calls from artists confused
about these gray areas of the commercial art world. Here are a few
guidelines to get you started.

Even if you aren't officially represented by a gallery, but they have ex-
hibited your work, you need to respect the fact that their promotional

efforts have introduced it to a wider audience. They should have the opportunity to follow through with any potential sales, not just when the show is hung, but for a period of time afterwards—at least six months. Many galleries will ask to keep your work in their back room during that time. Few art sales are made on impulse. Collectors may consider a purchase long after the show is over. Besides, it gives the gallery a chance to continue thinking about your work and showing it to those who missed the exhibition. If you are represented by the gallery, make sure to clarify whom you can work with directly, what they consider their territory, and how studio sales should be handled. It's not unusual for collectors or art dealers to approach an artist directly, hoping to buy work without the galleries' commission. At my last exhibition opening, an art consultant handed me her business card and said she was interested in my work. I thanked her and said I would add her to my mailing list, but made it clear that any work she wanted would need to be purchased directly from the gallery. You too need to be wary of such offers. They may seem like quick and easy money for you, but nothing ruptures the artist-gallerist partnership faster than going around the gallery.

Every gallery has their notion of what encompasses their territory, and you won't know what it is until you discuss it with them. During this conversation you have the opportunity to bring up any prior relationships you have with art professionals that you want to maintain on your own. It is surprising how small and insular the art world is. If word of your dealings with someone else other than your gallery comes out, you will have damaged an important relationship. Here's a good rule of thumb when navigating this gray area: keep everything out in the open, and ask yourself, "Is this sale or exhibition one I can discuss with my dealer?" If the answer is yes, then you're on solid ground and aren't disrespecting the partnership.

Introducing your work to a gallery can feel like an extended courtship. The director of a gallery wants to find or discover artists on

The one thing I realized as an artist is that art dealers are just people like everyone else. Some of them are really doing a good job, some are doing a mediocre job, and some of them are very approachable and great businesspeople. Others are very aloof and secretive. . . . [My husband] Ben and I always talk about the gallery relationship with artists being like a marriage, and it's got to be an equal relationship. It's got to be one where you feel like you are going into business with a partner where you are on the same page and interested in what they're doing. Not every gallery is the right fit for an artist. . . . Sometimes artists just want to show anywhere, and they don't even think about what the long-term consequences might be.

—Jaq Chartier, artist and cofounder of Aqua Art Miami

her own schedule. She alone carries a singular vision of what she is looking for in her gallery's program. That's why her response to how she knows she wants to show an artist's work is: "I just know it when I see it." I understand your frustration at that vague response, but it's the truth. Gallerists are always looking for a good match for their programs to keep them fresh and exciting. They don't want to plow through piles of unsolicited packages or extensive email submissions, even if the submitting artists think they are a perfect fit. This is where your assertiveness comes in handy. Attending gallery functions and developing a cordial relationship are a better approach. Continue to exhibit at other venues whenever possible. Art dealers gather information by visiting other shows, doing research, and talking with curators, critics, and artists. This means that your visibility in the art community and your relationships with a variety of art professionals are crucial. A studio visit with an independent curator could lead to gallery representation. Allow art dealers to become aware of you by including them on your contact list and attending their events. Don't forget to develop relationships with all levels of gallery staff. The young man sitting at the desk could be your future fabulous gallerist.

The fact that commercial galleries work year after year with the same group of artists means they are some of the hardest venues to access. An established gallery will add one or two artists to those they represent every few years, generally choosing ones whose work they have been following for some time or artists recommended to them by art professionals. They may do group exhibitions of other artists to shape their program and to audition new ones.

When looking for opportunities in this area, keep track of commercial galleries just starting out. Many gallerists get their start working for other art dealers. As they learn the business, meet collectors, and develop financing, they make plans to open their own space. Mary Boone

[My relationship with my galleries] is very good. I'm working with three galleries right now, and they all bring very different things to the table. Some of them have more access to very large art fairs, other ones are very gifted salespeople, some are better at press relationships, but the important thing is that they all believe in and support the work. They're very individual relationships—both on a personal and a business level. I'm enjoying working with all of them. For a long time, I didn't have a gallery. I went through three galleries in rapid succession, two of which disappeared on me, and then it took a couple of years before I found someone I wanted to work with again.

—Ellen Harvey, Artist

There's no way I could just pick somebody off the street, or someone that I've seen in a newspaper article and say I want to represent this person, because it takes time to build a confidence, to know the breadth of work, to know that you can talk about this work, and know somebody that wants to live with this work. You know where the work should be seen and who needs to see it.

—Camilo Alvarez, owner, director, curator, and preparator of Samson Projects

once sat at the front desk at Bykert Gallery, an influential New York gallery run by Klaus Kertess in the late '60s and early '70s. When a gallery is brand new, they are developing their program and haven't solidified their relationships with a group of artists. This is the period of time when they are most approachable. Some even post on their websites guidelines for submitting work.

Beware of vanity galleries. These are spaces that charge the artist for all the costs of mounting an exhibition. The fees are often calculated by the linear feet of wall or floor space given to your work. Funded by artists desperate to have their work shown, these galleries make little to no effort to sell the art or build the artists' career. They have already made their money before the show has opened. The quality of art shown is uneven, since their main criterion for selection is the artist's ability to pay. They advertise in the back of national art magazines with the message "Chelsea Gallery seeks new artists" or some other hot art spot, preying upon artists trying to get a toe hold in New York. Don't support these vultures. It is like throwing your money away. They are not career builders. Reputable galleries do not charge the artist for shows. Your art will be better served if you spend your time and money looking elsewhere.

PRIVATE DEALERS

These art dealers buy and sell art without maintaining an exhibition space. They work by appointment from a suite of offices or their home or bring collectors directly to your studio. Many private dealers are also certified to provide fine art appraisals, insurance, and estate evaluations of fine art collections. They may specialize in one area, such as the resale of contemporary masterworks (also referred to as Blue Chip), Latin American artists, or twentieth-century works on paper, while others may be interested in emerging artists. Sometimes an art

Finding an artist is as nuanced as meeting anyone that you meet in your life. . . . If someone who knows us mutually introduces us, I am much more likely to look at your portfolio. . . . I don't look at packages that come to me unsolicited. I need some sort of introduction. . . . I am much more likely to visit with someone that says they are coming to Dallas, they have sent me their information, and they know that I am incredibly busy, but would like me to take fifteen minutes to talk to them. . . . Sometimes, I will take on an artist that comes to me, but honestly most of the time we go out and find them. . . . But what does turn me on is follow-up.

—Cris Worley, director of PanAmerican ArtProjects, Dallas

So do your homework; find the gallery that's the right fit. I would say develop a relationship if you can. [Artists are] selling themselves to try and get someone who wants to represent them. Sales are based on relationships. So go to the opening. Hang out at the gallery that you like the most. Get to know the people that are part of it, so that when you finally do get into that conversation, they already like you and respect you.

—Julie Baker, president of Julie Baker Fine Art and partner of Garson Baker Fine Art

dealer will begin working privately to build up a collector base of support before opening a public gallery.

With a private dealer, your work can be sold into a collection without ever being publicly exhibited. Not every piece of art you make needs to be shown, but you should consider how you feel about this before turning work over in these situations. There may be certain pieces that you hold in reserve for the opportunity to exhibit before you offer them to a private dealer for sale. It is also important that you get accurate information for your records about where the sold work has gone in case you ever wish to borrow it later for exhibition. My first painting sales were through a private dealer. She placed my work in collections in New York and Europe and, because her business overhead was low, immediately paid me for any sales. Working with her was a pleasure, and the experience was an auspicious beginning that helped assure me there were collectors eager to have my art.

You're mindful of the idea that these people [collectors] have certain tastes, certain philosophical ideas, or particular attitudes about the world around them. That comes out in the art that they buy and collect. So, it's partly our role to identify that or to discover these things. For example, a client who is really partial to text-based conceptual art is a PhD in genetics and a scientist by training. This client's professional identity informs his interest in art, and thus conceptual or pseudoscientific art is exactly the right kind of work to seek out on behalf of this particular collector.

We also want to make sure that the collector is buying artwork that has a sort of "good housekeeping seal of approval." That the artist or the gallery isn't going to disappear next year. It is our job to understand not just [the artist's] commercial success, but his or her critical and institutional success. . . . The work should be strong, have meaning, and be connected to essential issues in the art theatre today. I'm also interested in the reputation of the gallery that represents that artist. Is the artist also represented overseas and by whom? Those things really matter.

—Cristin Tierney, art advisor

ART ADVISORS

Art advisors provide professional guidance to art collectors on the acquisition, installations, and maintenance of works of art. They are often paid monthly retainers by collectors, and their allegiance is to their clients, not the artist. With collectors' interests in mind, they stay current with artists and exhibitions worldwide. An advisor handles all the administrative details of acquiring work for a collector: negotiating the sale; preparing the proper paperwork; arranging for insurance, framing, shipping, delivery, and installation; and finally cataloguing it into the collection. Their clients will have a wide range of tastes, so art advisors must have an extensive knowledge of art history and the current art market. They follow the art auctions and often bid on behalf of their clients. They are less likely to buy directly from an artist, preferring to work with galleries they trust. Remember, art advi-

sors are charged with building art collections for their clients. They are most interested in artists whose art will retain value over time and who have attracted serious support for their work.

ART FAIRS

An art fair is a gathering of art dealers who temporarily set up shop by renting booths in a large public arena, often a convention center in a large city. Art fairs are like huge temporary shopping malls of art. Visitors can check out galleries, private dealers, print dealers, and independent curators from all over the world. For a long weekend they converge on a city such as Miami, New York, Chicago, London, or Basel and set up mini exhibitions in their booths. Art collectors, critics, curators, art advisors, artists, and the curious fly in from everywhere to check out the art scene, buy art, meet with colleagues, and party. By competing for and securing space in art fairs taking place all over the world, art dealers can promote themselves and their artists to a much wider audience than their home base. Some art fairs are organized around specific groups, such as young art dealers (NADA, Pulse) or members of the Art Dealers Association (Armory Show, NYC). They can be structured around a concept such as the Affordable Art Fair (AAF), with art priced under $10,000. Others are media specific, exhibiting only fine art prints, works on paper, or functional art like the International Expositions of Sculptural Objects and Functional Art (SOFA). Many of the smaller fairs are held at hotels. The organizers reserve several floors of a hotel and offer their exhibitors a room for their exhibit rather than a booth in a large convention center.

As an artist, an art fair was one very great way to see a whole bunch of art galleries in a real big quick swoop and figure out if there was anybody I was interested in approaching. . . . Don't try to talk to the dealers about your work [at art fairs]. . . . You are looking at the artwork to get inspired. What are you seeing that you find exciting, that makes you want to go back into your own studio and make work? Not because you are trying to copy it, but because you find it reinvigorating. Sometimes an art fair can be depressing. You go, and you find the commercialized aspect of the art world heightened.

—Jaq Chartier, artist and cofounder of Aqua Art Miami

Art fairs have been a feature of the art world for over thirty years, but recently their number and importance in the art world have exploded. They are a huge social market and the way many galleries earn a significant percentage of their annual income. For the art dealer, art fairs are expensive, competitive, high-pressure situations with the potential to enhance their reputation and sales capacity. Their focus is on selling the

JAQ CHARTIER
Infusion w/Magenta & Red,
2008
Acrylic, stains, and paint
on wood panel
20 x 24 inches

art and promoting the artists they represent, renewing old contacts, and meeting new collectors.

Like Jaq Chartier, I go to art fairs to browse, research, network, and size up an array of venues. I especially like to see international art dealers and those from other parts of the United States. Strolling through Art Basel/Miami Beach, one of the largest and most intense fairs, drives home the point that there is an incredible variety of artistic practices. My mind spins with new ideas for my own work—make it smaller, bigger, weirder, playful, formal; fill it up; pare it down—the possibilities are endless. However, just like after eating too many sweets, my initial excitement usually turns to queasiness by the time I've reached the end of the labyrinthine maze of art booths. By then, the unrelenting commerce makes the art seem beside the point. I've learned to stop and take a break before I get oversaturated.

When you take a client to an art fair, they've bought a plane ticket; they've got a hotel reservation; there's a commitment that "I'm going, and my whole focus is going to be looking at contemporary art." They are in "buy mode." Art fairs are terrible places to see art, but [they are] the best way to get an unfiltered view of what's going on and what's new.

—Cristin Tierney, art advisor

Art fairs are currently an important vehicle of promotion and business for the art world, so you shouldn't ignore them. Even if they aren't always comfortable places for the individual artist, they are potential networking arenas and great places for you to ingest a lot of new information. You can practice talking with a variety of art professionals, not about your work, but about what they are showing. You can see fresh ideas, materials, and techniques that may carry over to your practice. Figure out your best approach to the fairs. Team up with a buddy who is better at starting conversations with strangers, make plans to hook up with out of town friends, or plow through on your own.

ART CONSULTANTS

These are also referred to as corporate art consultants. These are art professionals who assemble collections for the interior and exterior office spaces for a wide range of commercial and nonprofit businesses: huge Fortune 500 corporations, hospitals and health care facilities, legal offices, and financial service institutions. Like art advisors, they represent the corporations' interests and not those of individual artists. They are art-world generalists. As each job has different requirements, they need—at their fingertips or on their computer screen—a wide variety of art to offer their clients. The corporation may wish to have a collection of landscapes by local artists, minimalist abstract art, vintage photography, or images of some product related to their company. Often the final selection of the art is up to a committee assembled by the corporation. That means your work needs to please a number of people, not just one collector. Art consultants purchase work from galleries, nonprofit spaces, print publishers, and poster distributors, as well as directly from the artist. They make their money from sales commissions, which are generally between 10 and 20 percent when working with a gallery and 35 to 50 percent when dealing directly with individual artists. It's not unusual for corporate art consultants to establish good

Part of the reason we bring students to Art Basel Miami Beach is not only so they can experience the art world, but also so they can begin to place their own art-making process within the creative context of the world. They come, respond, and look at the work. They are certainly wowed and overwhelmed by much of the work, but they begin looking with a critical eye and understand that the work they are making is just as important and just as well made. That's an important part for them to discover: they do have a place in the greater realm of the art world, even though they come from Wyoming. In fact, one of the students that we brought last year has come back this year entirely on his own, recognizing that it's good for him to be here to mix and mingle and to help inspire him to go back to his studio in Wyoming and continue to create the work that he does.

—Wendy Bredehoft, artist and education curator, University of Wyoming Art Museum

connections to individual private collectors through these jobs and place the artists' work there as well.

In my experience, many art consultants are just as passionate about art and their artists as any gallerist, curator, or dealer. While some get so many requests for "something to go over the sofa" that their views resemble that of interior decorators, most are seriously interested in helping their clients upgrade their collections. Art consultants work hard to educate non–art-savvy buyers to expand their tastes and aesthetics. While these sales may not be your biggest career builder, they can be a valuable source of income.

Art consultants are very easy to approach. Most of them have websites describing their services and completed projects. They also include guidelines on what information artists can send them to be included in their future presentations.

Museums and Permanent Public Art Projects

Museums house permanent collections of work by dead and living artists that are acquired, conserved, researched, and publicly exhibited. The professionally trained curatorial staff organizes exhibitions from their permanent collection and borrowed work. These exhibitions highlight specific artists and art movements, and address some aspect of the museum's mission.

To most of us, museums are the imposing granite edifices with hundreds of employees, international reputations, and noteworthy collections. But museums are also modest venues staffed by one harried person and the collection of one eccentric individual. Some museums are regionally centered institutions that focus on artists from that locality. Then there are ones with a specific topic or medium, such as the Museum of American Folk Art, the Museum of Glass, or the intriguing Museum of Sex.

Museums welcome artist visitors but tend to be more exclusive when considering them for exhibition. Most position themselves to be the pinnacle of exhibition opportunity and art world authority, signifying an important level of achievement for the artists they support. Many will

only consider contemporary artists with a significant track record of critical attention and career stature.

Don't automatically cross all museum venues off your list. Yes, the biggest are waiting for you to become famous before offering you a retrospective, but opportunities in thematic group shows, project spaces, and print, photo, and new media galleries may be more readily available. Across the country there are plenty of smaller museums that are more receptive than the few large ones that dominate the art world. Regional and local museums are often more responsive to up-and-coming artists in their area. A good example is the nine small art museums that circle the New York tristate area: the Bronx Museum of the Arts, the Queens Museum of Art, Hudson River Museum, Katonah Museum, Nassau County Museum, the Jersey City Museum, the Newark Museum, Montclair Art Museum, and the Aldrich in Connecticut. They regularly show emerging and mid-career artists in both group and solo exhibitions.

Take time to explore opportunities at the smaller museums in your area. Just like you did with the other nonprofits, research their missions and exhibition histories. Find out if there are any guidelines for submitting your work for projects or regional survey exhibitions. Include the staff on your contact list so they can be informed of what's happening with your career. They want to know about the artists and cultural events in their region, even if they don't have much space for them in their programming. They may be able to assist your career in many other ways, so attend their events, and invite them to yours. Museum professionals are often asked to serve on grants and awards panels and to nominate artists from their region for other opportunities. They will suggest to visiting curators and critics which local artists' studios and exhibition spaces to see. You want to be on their radar when these opportunities arise.

PUBLIC ART COMMISSIONING AGENCIES

These are federal, state, and city agencies and nonprofit organizations that commission and/or buy art for public spaces. Many operate under

I think that a lot of public art is problem-solving. More and more, percent commissions are asking for artists to look at a space, look at a situation, and come up with an idea. So rather than just "we're looking for a sculpture in front of this building, and you either have a sculpture that's the right size or want to do a sculpture," it's "we have an airport; we want to move people from one place to another; we want an artist to think about this." So there's a problem-solving element to conceptualizing your idea that I think is very interesting to a lot of artists. And then once you get the commission there's also a huge problem-solving aspect to figuring out how to do it and how you're going to take this idea from a proposal to a completed, finished work of art.

It's important that artists really look at what the project is when they put their submission together. If there's anything in your repertoire, even if it's something that you did ten years ago, that somehow has some kind of connection to this project, it might be appropriate to submit it here. Public art isn't necessarily so interested in the things you did last year. I've just seen so many times where one image will just trigger some kind of connection. Sometimes there's just one image that's like, "Oh my God. There's something about this, and we can see how this would work." So trying to get a sense of the variety and the breadth of your work is important in a public art submission.

—Jennifer McGregor, director of arts and senior curator, Wave Hill, and former director, NYC Percent for Art Program

"percent for art" guidelines, which are municipal ordinances that require a percentage of a construction budget be used for the commission and acquisition of art. A plethora of opportunities exist here, including site-specific temporary or permanent art in airports, landfills, outdoor plazas, municipal buildings, public schools, parks, and mass transit. Many programs also purchase paintings, sculpture, works on paper, and prints to install in the reception rooms of public hospitals and government offices. Some artists operate almost solely in the public art field arena, but most combine it with their regular art practice.

If you're interested in exploring how your ideas might fit in with permanent public art projects, a good way to start doing your research is by joining the Public Art Network, a program of the arts advocacy group Americans for the Arts. They have a public art database of national resources for organizations and individual artists with directories, guides, and planning tools. They also publish *A Year in Review*, which is a curated selection of the best public projects of the past year. The most recent editions are only available by purchasing a CD, but their website (www.artsusa.org) provides free viewer access to selections from earlier years. It is worth your time to look at this collection of public works and check out the incredible variety of ideas, materials, and approaches. It will quickly expand your notion about what's possible.

Public art projects require certain skills from the artist not necessary to a private studio practice. The nature of public art requires a collaborative process, with the commissioning agency, the community, and other disciplines (architects, engineers, designers, fabricators), so many decisions won't be yours alone. You need to be comfortable working as a team player and have good communication skills. Most public art projects take three to five years to execute, so they also require the ability to manage long-term construction and a project budget.

JEAN SHIN
Dress Code, 2008

Cut fabric (military uniforms and citizens' clothes)

Beva adhesive on eighteen painted aluminum composite panels

Overall: 14.25 ft x 58.5 ft

Installation in the lobby of the George H. Fallon Federal Building, Baltimore, Maryland

Commissioned for the U.S. government by the General Services Administration Art in Architecture Program

Photograph by Seong Kwon

Sculptor Jean Shin is best known for her labor-intensive process of transforming exhaustive accumulations of cast-off objects such as donated clothing, losing lottery cards, emptied prescription bottles, and broken umbrellas into visually alluring, conceptually rich works. *Dress Code* is a good example of how Jean transformed concepts from her temporary site-specific installations into a successful permanent project. She describes the commission as follows:

> When making my first public art commissions, it was absolutely crucial to maintain the integrity of my temporary public art works in the process of translating them into permanent forms. The accumulation of everyday materials from specific communities is at the root of much of my work, and so I typically involve the commissioning agent in this process. In the case of the U.S. General Services Administration project, the Art in Architecture coordinator facilitated my collaborations with other federal agencies, including the Veterans Administration and U.S. Citizenship and Immigration Services. With these exclusive resources, I was able to work with communities that I would otherwise not have had access to. Although the use of such nontraditional materials as donated clothing initially presented challenges and concerns for a permanent commission, I worked in consultation with a textile conservator

Dress Code is made up of the deconstructed military uniforms of veterans and recently naturalized citizens' clothing arranged into a mosaic-like, fabric mural. The project reflects the diverse community of people—be they recent immigrants, government workers, or veterans—who pass through the federal building on a daily basis and, in the process, reveal the many faces of American identity.

who was able to provide guidelines on specific materials and techniques, as well as methods for altering the existing environment to better preserve the life of the work. I also work in close collaboration with a building's designers and engineers, as I aim to create public works that are in direct dialogue with their surrounding environment and architecture. These site-specific factors play an integral role throughout the process, starting with the initial conception of the piece. Taking on the challenge of planning and creating these large permanent commissions has certainly strengthened the vision of my work. Although the process is very long, intense and involved, it is a positive experience that makes me constantly examine what is really essential to my art and art-making practice. It also gives me great satisfaction to create works that are truly in public, non-art spaces where a diverse audience will experience the work for many generations.

Check out the programs that exist in your community and state. A state with a model program is Arizona. It seems that almost every bridge, highway overpass, bus stop, and public building has commissioned art as an integral part of its structure, and the program works with a wide range of artists. In Philadelphia, the Mural Arts Program has produced over 2,700 murals—more murals than any other city in the world. The U.S. General Services Administration (GSA) has a commissioning program called Art in Architecture (as Jean mentioned). Another example is the Metropolitan Transit Authority (MTA) Arts for Transit program in New York City. In a system over a hundred years old, each subway station is slowly undergoing renovation, and commissioning art is an integral part of this process. Well-known artists such as Tom Otterness, Eric Fischl, Elizabeth Murray, and Vito Acconci, as well as lesser-known and emerging artists, have designed permanent works for this program. Thousands of daily commuters and tourists come into contact with mosaics, sculpture, and even conceptual works of art during their ride. Your art may not be best suited to the white box of the gallery but better served in public arenas.

Most of the public art agencies maintain registries of artists whose work can be considered for upcoming projects. You can also get on their email or mailing lists to be sent requests for proposals (RFPs). For more information about creating art on commission, responding to an RFP, the selection process, and managing a project, consult the comprehensive resource *The Artist's Guide to Public Art: How to Find and Win Commissions* by Lynn Basa (New York: Allworth Press, 2008).

I spend a lot of time trying to figure out who might be interested in what I am doing, following up with people.
—Ellen Harvey, artist

Working with Multiple Venues

Don't look at the venues outlined in chapters 3, 4, and 5 as mutually exclusive. You can work with different spaces and programs at the same time. For example, in the space of a few months, you may have a site-specific installation in the project room of an alternative space, a series of your works on paper in a group show at a commercial gallery, and another piece acquired for a corporation thousands of miles away through an art consultant who finds it on your website. There are no hard and fast rules as to the right order of opportunities that will develop your career. Your work might be embraced by a commercial gallery right out of art school, or you may exhibit at nonprofit spaces for years and then land gallery representation.

An artist who has navigated the commercial sector in a unique way is Christo. He and his wife and partner, Jeanne-Claude, have put together multimillion dollar public projects by themselves. For over sixty years, they have assiduously built up a collector and support base without any gallery representation or grants and have funded huge public art projects from direct sales of their work.

Now that you have a summary of the opportunities available, continue developing your artistic goals. Having an overview of all levels of the art world and the advantages they afford will help you make informed decisions on how to proceed. The next step is to match up all these potential opportunities with your goals as an artist. To help sort out how to think about what venues you wish to pursue, you need to return to some self-assessment. On the following page are some questions

you need to ask yourself. Just as in chapter 1, write down your answers so you can refer to them later.

- What is my plan? What is it I am looking for and why?
 - Is it to present a new body of work?
 - Is it to get sales or commissions?
 - Do I want to connect with a particular audience?
 - Is it to attract critical attention?
- What are my resources?
- Do I have a body of work or a project ready for exhibition?
- Is my practice site-specific or community-based?
- How productive am I? How long does it take for me to complete a body of work or an installation/video/site-specific/community-based project?
- How hard is it to install my work? Do I need to travel with it? Can it be easily shipped?
- What is an ideal number of venues I can work with at the same time?
- How will these decisions affect my life, my family, and my other responsibilities?

Every artist will have different goals for the exposure of his or her work. Matching your goals with your studio practice will help you to figure out the best way to start. Not every artist has a practice that can support the needs of several art galleries at once or wants more exposure than a solo exhibition or installation every eighteen months. It may be that your work is labor-intensive or you have family responsibilities that make your output relatively low. Conversely, your ideas may engage both large-scale community projects and studio work that is of interest to a variety of nonprofit and commercial venues. The ultimate purpose of exhibiting your work is to connect with the audience you desire. There are no easy answers or shortcuts to discovering who this audience will be. If you skipped the "Promote Yourself to Regional Nonprofits" exercise in chapter 4, go

Every artist has to determine on their own how they want to participate in the for-profit market, the non-profit world, the academic world, the curatorial world, the collector world, art fairs, you name it. There are a million worlds you can occupy.

—Matthew Deleget, artist and cofounder, MINUS SPACE

back, and begin now to research and connect with the best options in your community. Once you have started there, you can begin expanding to others.

Building Long-Term Relationships

As I've said more than once, most of your opportunities will come through someone with whom you are already connected. This diagram is a way to picture the rings of relationships radiating out from your art.

THE UNIVERSE OF PROFESSIONAL RELATIONSHIPS

Unexposed: The outside ring is comprised of all those who have not been exposed to you or your work. These individuals have no relationship with you at all, although you may know of them. Until you become a household name like Picasso, this will always be the largest number of people.

Exposed: These are individuals who have had some brief exposure to you or your work. This exposure may be a fleeting glance at your exhibition announcement, viewing your work in a show or as a panelist, looking through your artist packet or grant proposal, reading a review of your work, hearing others mention your work, or a visit to your website, My-Space page, or blog. If they come in brief contact with you in more than one of the above ways, they begin to feel familiar with your work. It is the next largest category of people.

Connected: These individuals have moved from merely being exposed to your work to feeling connected. This category includes nonprofit organizations and galleries that exhibit your work, panelists who select you for a grant or opportunity, art consultants who purchase your work for a collection, art critics who mention your work in a review, your friends on Facebook, and almost anyone who has visited your studio. It also includes peers, family, and friends who have an interest in you and your work.

Core Support: These individuals are your most valuable relationships. They include art professionals who have an active, ongoing interest in your work. Besides galleries that represent you, they include art administrators, curators, critics, collectors, grant makers, and artists who stay current with what you are doing and take every chance afforded them to see your work and lend their support to your career.

Building long-term relationships revolves around the actions you take to move individuals from the colder, outer-relationship circles to the warm, inner core. Over the space of a lifetime, you will be consistently working to move art professionals not yet familiar with you (Unexposed) into an awareness of you and your work (Exposed), to helping you in some way (Connected), finally to an ongoing partnership with you and your career (Core Support).

You currently have artists and art professionals in your life who would fit every category above. To prove it, take a moment, and try this exercise:

1. Divide a piece of paper into four columns, and title the top of each with one of the circle headings above: Unexposed, Exposed, Connected, and Core Support.

2. Take your address book or email list, and write the names of the artists and art professionals in the appropriate columns.

3. Look over the columns. You probably don't have many names in the Unexposed, as these are the people who don't know you, so they aren't in your address book. For the other categories, you will most likely find that Core Support has the smallest number. That's normal. Don't fret if your Core Support circle is only close friends and family; having anyone at all in that group is a start.

4. Identify five to ten art professionals who are currently in either the Unexposed or the Exposed Category whom you would like to move to the next circle. For each contact, write down a series of actions you will take to begin this process. For example, you'll make sure to attend the upcoming panel

discussion or exhibition opening organized by the curator who stopped by your space during the open studio tour, and you'll briefly reintroduce yourself. You may slip a few digital prints of recent work into an envelope along with a personal note to reconnect with an old art professor, or update a gallery that included your work in a group show. These actions initiate or refresh a relationship and could lead to moving them closer to the center Core Support circle.

All too often artists are so focused on surging forward to make new connections that we forget about the wake of relationships we are leaving behind. You need to stay in touch with art professionals with whom you have already been in contact. Look through the lines of your résumé, and think carefully about the individual events. Do any forgotten names emerge? Search the Internet, or contact a mutual friend to see where they are now. Make a point of reconnecting with those art professionals in some way. Some may have dropped out of the art world entirely, but you just might find that the young curator at that little nonprofit space in no-man's-land now has her own gallery on the West Coast.

Another easy pitfall is not following up on a lead. Maybe someone asked you to send information about your work, and you were so overwhelmed with a big freelance job that you never got to it. A curator asked you to send images of your new piece, but you felt too unsure of that body of work, so you dropped the ball and didn't do it. Well, now's the time to do it. Don't worry that too much time has passed. Contact them in a straightforward manner without apologies. Let them know what you're doing, and reestablish a connection.

Not everyone you contact will move nicely into the innermost circle. The Core Support circle will always be the smallest in relation to the others. You want to make sure that it is a healthy mixture of family, friends *and* art professionals. Remember, you are gradually building an audience for your work comprised of relationships from all three circles of support. Contacts will move in and out of various levels.

Staying in Touch

Promoting your work requires that you consistently reach out to your audience by regularly being in contact with them. Slowly, many of them will gravitate to become core supporters. Besides your website, another great tool at your disposal is your contact list. When I lecture, I often ask groups of artists to raise their hands if they have more than a hundred people on a mailing list. Two or three hands may go up. I am shocked at how little attention artists give to collecting names and addresses of potential supporters. Today it is easy for you to be in touch with hundreds of people, simply by sending an email announcement. Just think about the amount of email you receive. One of the ways you will move people from the cold region of Unexposed into the warmer inner circles of support will be accomplished through careful development of contacts through email and postal mail. It isn't created by buying a generic mailing list of hundreds of galleries, curators, and art professionals nationwide, although there are plenty of people ready to sell you one. The best contact list you develop is built one name at a time.

Your contact list includes individuals reflecting three important parts of your life.

1. **Your past:** This is anyone who has shown interest in you or your work since you were born. Yes, that includes family, people from your hometown, former teachers, college roommates, your college alumni office, and art professionals with whom you have begun a connection, no matter how long ago. They have a long-standing interest in you and need to be updated periodically. You never know where they might end up. I never envisioned that my cousin, seven years younger than I, would grow up to become a banker in Ohio. Even though she has nothing to do with the art world, she and the curator of a major corporate art collection often attended the same business luncheons in her city. I was the only artist she knew to talk

People already have people who believe in them that may or may not have anything to do with the art world, and those people can be approached too. All of us have at least a couple of people who really support us.
—Jody Lee, Artist

about. Because my cousin is on my mailing list and has received my announcements for years, she knew just enough about my work to interest that curator, which resulted in my work being acquired for their collection. I have other cousins on my contact list who haven't done a thing for me, but they are part of my network, so I keep them informed. You never know.

2. **Your present:** What art professionals are you courting or connecting with today? Which registries have your work? Who attended your recent open studio or exhibition? Who just moved into town to take over the curator's position at the art center? Who did you meet this week, this month, this year? Think about who supports culture. Include all the professional people in your life: dentist, family doctor, dermatologist, gynecologist, lawyer, real estate agent, tax preparer, financial advisor, and banker. You want them to see you as more than an orifice or balance sheet.

3. **Your future:** What are your goals? Where are you headed? Who needs to know about you? Maybe you aren't quite ready for the most exclusive gallery in town or the contemporary art museum, but you intend to be. Maybe your immediate goal is to achieve representation locally, but ultimately you also want to be represented by a gallery in another city, state, or country. Placing those individuals with whom you wish to work in the future on your contact list today and sending them information from time to time will move them out of the Unexposed category into Exposed. Your goal will be to slowly move them in closer.

Everything is about relationships. I didn't know that basic fact when I was young. Quality of relationships is what it's all about: with oneself, one's art, and other people. Relationships develop organically over time.

—Morgan O'Hara, Artist

If you diligently collect names for your contact list, it will soon be a source of potential opportunities. Organize your list so that it can be sorted in various ways:

* By category, such as family, friends, artists, VIPs, art professionals, and others. You may wish to break art

professionals down further into curators, critics, and dealers. Some names may have more than one category.

- By location and alphabetically: zip code–sorted, local, regional, state, and international.

You may want to target some people mainly through email announcements, while you will want to send others printed exhibition invitations with a short note attached. This is especially true for curators, gallerists, critics, and art advisors, who often keep a file of interesting art information close at hand. From time to time they sift through this file looking for fresh work. Your card should be in that stack.

Treat every encounter and opportunity you have as a way to build upon and strengthen your circle of relationships. Use the networking tips we have already discussed, such as collecting business cards as you meet different art professionals, and make note of potential contacts as you research different venues. I keep a mailing list folder next to my computer on my desk. I drop in the business cards, announcements, and stray pieces of paper with someone's name and contact information. Every so often I pull it out and enter those names into my mailing list. That's how it grows, one by one.

Here are some tips for staying in touch:

- *Send email announcements.* Make sure you include all pertinent information about the show—title, dates, complete address, and opening reception—as regular text in the body of the email. Embed a low-resolution image of a work into the text. Make it attractive without sending too large a file. Try to keep any attachments to a minimum; many viewers will not bother to open them. I automatically delete any email announcement that arrives with the information only available as an attachment.
- *Personalize exhibition announcements.* Write a short note or a nice hello on your exhibition announcement. Go beyond highlighting or putting a star next to your name on a plain group show announcement by making your own. Use one of

the inexpensive postcard companies that advertise in the back of art magazines. Use an image of one of your works in the show on the front. Make sure that the layout of the card reflects that it is coming from you and not from the exhibition venue. Do not incorporate the venue's logo or other copyrighted material. Make sure your return address and contact information are on the postcard.

- *Send thank-you notes and other follow-up correspondence.* Have a stack of blank postcards or digital prints of your work on heavy stock always available on your desk. Use them for thank-you notes, invitations, follow-up, and other correspondence. I cannot overemphasize how much art professionals appreciate the simple gesture of a personal thank-you note. I have even sent thank-you notes for thoughtful rejections.

The contacts you develop have the potential to become supporters of your work. They will "get out of their chairs" and do something on your behalf. They will attend your exhibition, performance, event; promote you to others; refer your work; write letters of recommendation; fund your project by awarding you a grant or donating money; sell or buy your work; give you the commission; hire you as a freelancer, teacher, lecturer. Although you may work alone in the studio, the rest of the time you are teaming up or partnering with other individuals to help promote it. The assistance from these professional alliances is another stage of building your career. They need to be nurtured and cultivated. Always remember that it takes less energy to maintain a relationship than it does to create a new one.

How to Be a Good Partner

What does it mean to be a good partner? It means that besides doing your best studio work, you also assist the exhibition venue with the best possible presentation and promotion of your work. Many artists think their job ends once the work leaves their studio. They think the

I do save email of shows to see, but once the shows have passed, I can't keep saving all that email. But if I have a card that was interesting to me, I save it in a file. Every once in a while, when I'm in this thinking mode, I'll go through that file, and it will just trigger, "Oh my God, I need to reconnect with that person."
—Jennifer McGregor, director of arts and senior curator, Wave Hill, and former director, NYC Percent for Art Program

When I was a curator, I opened up every packet that came in. So as a critic I go to everything I can. I go to juried shows, I go to gallery shows, I go to museum shows, I go to solo shows at nonprofit spaces, at artist-run spaces, at restaurants, in beauty parlors—at all the places artists show before they have their foot firmly in the door. I write or talk about artists if the work interests me.
—Andrea Kirsh, art historian, art critic, and writer

I'd like to think that at some level, whether I'm working with a curator or gallery, we put the art first. But you know, their job is different than my job. They have something that is motivating them, and I have something that is motivating me. One has to be realistic. I have to protect the work and make sure that it's seen in the right way. That protection goes beyond the way it's made to the way it's shown and talked about. Curators and gallerists have skills that I don't have, and I want them to do their job. And I try to give them whatever tools help them represent me in the best possible way. Once this relationship is established, there needs to be trust on both sides.

—Janine Antoni, artist

responsibility to publicize, sell, and promote the work is up to the venue or sponsor, gallery, alternative space, museum, or organization. Those same artists are the first to be disappointed when the exhibition or event doesn't get the kind of coverage or sales they envisioned. Frustrated, they blame the venue.

Your responsibility to your work does not stop at the studio door or once you have been promised an opportunity. Early on, have a heart-to-heart talk with the venue or sponsor. Assess what they will need from you and what the staff can realistically do to promote your show. This applies to all opportunities, whether it is an artist-generated group show, a project room in an alternative space, a solo gallery exhibition, or a museum retrospective. Any way that you can support the venue's efforts will be appreciated and cements the partnership. Here is a list of what you should provide:

- *Fabulous work samples in exactly the size and format they can use.* These images will be used on the announcement, catalogue, advertising, press kit, fundraising proposals, and website. For press photos, make sure you have both horizontal and vertical image formats. Sometimes the only reason one artist's image is selected over another's is because the designer doing the layout needs a certain format to fit the space.
- *A well-written artist statement that speaks directly to the work exhibited.* Few organizations have a press office; publicity is usually part of the job of someone who is already juggling many other responsibilities. That harried staff member will deeply appreciate it if he can pull out a great paragraph from your artist statement and insert it into the press release. Not only have you made his job easier, but your ideas are accurately represented to the public. It is much easier for him to edit your artist statement than it is to start from scratch.

- *A one-paragraph biography and an updated résumé.*
- *Reviews and other writing about your work.* Include your press quotes sheet and a selection of important reviews and articles. You are the best archive of this information, and making it available to the venue helps their promotional efforts.
- *Your connections to others.* This is where you draw on your list of core supporters. Add to this list other art professionals, collectors, and writers who know your work or with whom you have had some contact. Go through this list one by one with your venue, and discuss which individuals might benefit from a personal approach, either from you or from someone on staff. The venue will also have their own list of supporters, and some of them may overlap with yours. Decide who will contact whom and how. This strategizing together is an important part of your partnership.
- *Your contact list.* Let them know how many announcements you will need for your mailing list. Since my own list is so large, I always ask for a thousand. If you let them know your needs early on, they can adjust their print run to include your request. I always offer to pay for the additional announcements, but so far no one has ever given me a bill. When the announcements are being run at the press, the cost of another thousand is minimal. When it comes time to mail them out, I do it myself. I am willing to invest in the first-class postage and time, as it allows me to write personal notes on many of them.

Your willingness to help promote the show is an important factor in its success. Being actively attentive to all aspects of the event in a positive, undemanding way will get you more staff attention. Doing your part to provide the essential promotional tools (work sample, statement, bio, and contacts) means your partners can do a better job for you.

Whether you are showing with a nonprofit alternative space, a commercial gallery, or a museum, ask yourself and/or the organization

with which you are working the questions below. The answers will help you map out a timeline of tasks to do, organize the things to have ready, and determine your budget for the show. Not all of these questions will apply to every opportunity, but most will. If issues arise as you ask these questions, you may need to negotiate or do some creative problem solving to resolve them satisfactorily for both you *and* the venue.

EXHIBITION CHECKLIST

Questions for all spaces:

1. What are the dates of the show?
2. What is the exhibition venue's production schedule?
 a. Deadlines for promotional materials: press release, exhibition announcement, catalogue
 b. Fundraising
 c. Dates for shipping work
3. What work is being shown? Is it ready, or do I need to develop a work schedule for its completion?

4. What needs to be done to the work to prepare it for exhibition (framing, mounting, etc.)? Who is paying for it?

5. What are my equipment needs? Who is responsible for supplying it?

6. What will be needed in the way of work samples and artist statements for promotion of the show (exhibition announcements, advertising, press kits, brochure/catalogue)?

7. Who pays for shipping? Does this cover to and from the exhibition?

8. Is the work insured during transit? Is it insured during the exhibition?

9. What is the sales commission? If a nonprofit, how are sales handled? Do they ask for a percentage of the sale as a donation?

10. Can we discuss/plan for some additional programming during the exhibition, such as a panel discussion, private opening, artist talk/lecture, closing party?

11. If the venue is out of town, will they cover my travel and lodging expenses?

12. Does the venue install the work, or should/can I be of assistance?

13. For installations, what kind of access to the space do I have? Twenty-four-hour access, or only during certain hours or days? Are there any other restrictions? Can I drill into the walls?

14. What kind of help will I have installing my work? What is their level of expertise? (Professionals? Students? Interns?)

15. How many exhibition announcements will I be given? Have I told them how many I will need?

Additional questions for nonprofit spaces:

1. Is there an artist's fee or an honorarium?

2. Is there a budget for the show that includes materials and production costs?

I thought getting into a gallery in NYC was the goal. And I got into one. I spent five years with the Steven Haller Gallery, a gallery whose aesthetic I adore, a dealer whom I adore and who I consider a friend and a mentor. I thought that once I got into that gallery, life would be [like] heaven, and—I don't know—somehow I would be able to pull out the lounge chair and sip lemonade, and life would be groovy. Wow, was I in for a shock. Everything became ten times more demanding and went ten times faster because then you needed to keep producing and you want to make the work that comes from your heart, but the work that comes from your heart has to be well-received, there has to be a market for it, you have to like it, your dealer has to like it. Suddenly, it was your art life to the tenth life power.

—Joanne Mattera, artist

3. How will I be reimbursed for these costs?
4. Can they help me with fundraising or act as a fiscal agent for equipment, materials, artist fee, production expenses, etc.? (See chapter 7.)
5. Will they accept in-kind donations of materials and services on my behalf? (See chapter 7.)

As you discuss the above questions with your venue, make sure you have been clear about your needs. They can't read your mind, so it's up to you to make your needs known. This doesn't mean you swagger in like a prima donna and treat everyone like your servants, but thoughtfully express what is best for you and your work. It is just as important that during any discussions you carefully listen and note their concerns.

Follow up all conversations with an email or letter clarifying what was discussed and how it was resolved. It's natural for everyone to hear and remember what is in his or her best interest. For example, if the venue has committed to shipping, framing, or other production costs, send them an email confirming their promise. This action eliminates misunderstandings later.

Make a production schedule for yourself. Include all deadlines for publicity materials, preparing the work for exhibition, packing, work installation, and documentation. The better you are at holding up your end of the partnership, the more they can help you.

Being in Charge Keeps You Connected

There are numerous ways to have an art career. The notion that you will have all aspects of your professional life managed by a gallery is unrealistic. Access to worldwide audiences is no longer controlled by a few galleries and museums. These days more and more artists are choosing to forego that tightly controlled environment and are managing themselves. They work with multiple partners

that span the museum, public art, nonprofit, and commercial worlds, affording them a robust career of their own design.

The fluidity of the art world is amazing. People don't stay in one place forever. In the space of a few years, everything can change. If you analyze your résumé, you'll notice that many of the items on it came about as a result of someone you know. In some way, someone helped connect you, gave you an important piece of information, directed you to a website or article, or sent someone to you. The contacts you make will benefit you over the long term, so make an effort to cultivate them. I find one of the biggest mistakes artists make is to think only in the short term. Artists expect something to come of the studio visit, exhibition, review, or email exchange right away. It may take many visits before someone includes your work in a show and several shows before people are familiar with your name. That's why developing and nurturing relationships is an important skill for the growth of your career. It helps you stay connected and is a powerful counterbalance to the isolation of a studio practice.

With all the different kinds of opportunities listed in these three chapters, you have many paths to engaging new audiences with your work. Begin with what feels most do-able, get feedback, make connections, and move on to more adventurous or difficult venues. Before approaching anyone, always do your research. Once you have canvassed your local area, move to other areas of the country. Given today's nomadic lifestyles, you are likely to have connections to artists and art professionals the world over. Always ask yourself, "Who is my best audience, and how do I connect with them?" With many possibilities to pursue, you need to figure out which ones are right for you.

Another mistake can be to spend your time waiting for the perfect gallery or situation in which to exhibit. I think it's very important to take whichever opportunity presents itself and to make the most of it. You can waste a lot of time waiting for Prince Charming.
—Ellen Harvey, artist

I chose to be open to any invitations that came, from wherever in the world they might come, and to say yes as often as I can. Since I made that decision, opportunities have grown exponentially.
—Morgan O'Hara, artist

Resources

International Association of Professional Art Advisors: http://www.iapaa.org
- An association of art advisors, curators, and art service professionals, they provide guidelines and standards for professionals working in the field.

American Association of Museums: http://www.aam-us.org
- A membership organization that represents museums and the professionals who work for and with them.

Americans for the Arts: http://www.artsusa.org

- A nonprofit membership organization dedicated to advancing the arts in America. Among their many programs is the Public Art Network (PAN), a professional network dedicated to the field of public art. PAN brings together artists, community members, and art and design professionals through online resources such as Resources for Public Artists and the annual *Year in Review,* which highlights innovative and exemplary examples of contemporary public art produced in the previous year.

Basa, Lynn. *The Artist's Guide to Public Art: How to Find and Win Commissions.* New York: Allworth Press, 2008.

- A comprehensive guide to the field of public art commissions.

The GSA Art in Architecture Program: http://www.gsa.gov

- The government office that commissions large-scale works of art for new federal buildings. At this site you can apply to the Art in Architecture National Artist Registry.

SUPPORTING YOUR WORK

As an artist, nothing else matters if you can't make the art you want. These chapters are about your artistic survival, which comes down to securing the materials, space, and time you need to make your work. Without these necessities, your ideas will never become tangible but only remain as stray thoughts in your head. This section provides information and skill-building exercises in financial management and legal issues as they apply to the unique issues of your art and your life.

It is true that money in the form of sales, awards, and grants is one of the most visible rewards for talent in our society. So if you aren't receiving money for your art in one of these ways, you can easily feel like a failure. Although money in itself is neutral, it gets easily entangled with your feelings of self-worth and entitlement. Like the other subjects covered so far— setting goals, writing about your art, promoting yourself—money is another tool to be used in service of your career.

This section will also touch on some of the legal issues artists face daily. Working from a broad base of knowledge will help you take the necessary steps to protect and defend your artistic rights. Knowing how

to negotiate and when to seek out professional help will save you from misery later.

The information in this section—securing the means to support yourself and protect your artistic rights—flies in the face of society's image of the self-destructive, suffering artist. Decide today to end that myth once and for all. Supporting your work comes down to respecting and treasuring your talent enough to provide it the opportunity to thrive. When you overcome these issues, the deep feeling of accomplishment that radiates from you will appear to the rest of the world as success. Save your pain and suffering for the studio, for when you are birthing your ideas. That's where it does the most good.

chapter six

How to Earn and Manage Money

This chapter explores how you earn and manage money. You will be challenged to look broadly for a variety of sources of support. It will discuss the type of financial structure that best suits your needs and the benefits of securing multiple income streams to sustain your career over the long term. You will be asked to explore your interests and skills to develop freelance opportunities. This chapter will also show you how to construct and monitor an overall budget, beginning with a financial tracking exercise to help you analyze spending and evaluate needs. Finally, you will find guidelines for pricing your art. Facing your personal and artistic needs, as frightening as that picture may be, will provide the motivation you need to fully support them. That's the first step to financial maturity.

Tossing and turning at night over new ideas for your art is called dreaming. Tossing and turning over plans to fend off your creditors is called a nightmare.

Money is the ten-ton elephant in the studio that most of us would like to ignore. If you are like me, you entered this profession full of passion, hope, and excitement. While you're in school, the connection between art and money is suspended. Instead you are learning art history, exploring your craft, and figuring out the steps of your creative process. School is a safe haven from those nagging voices inside your head or from your family about how you are going to make a living as an artist. Your escalating student loans are merely abstract numbers on a page to be reckoned with someday, not now. Maybe you have arrived at this profession later in life, having followed a circuitous route from another discipline or field. Overjoyed to finally pursue what your heart desires, you want to dream, to experiment, and to explore without attaching money to it. Yes, these wonderful moments of reprieve are appropriate *and* necessary to the creative life. Just like following your goals in chapter 1, the

creative process is to dream and scheme and plan as large as you can. Realizing your wildest artistic dreams is the reason why you became an artist. Visualizing your ideas is intoxicating, the healthy high that allows you to persevere when times are good *and* bad. You will always seek to prolong that delicate time when everything about your creative vision seems possible to achieve: sculpture that defies the laws of physics, paint that applies itself in astonishing layers, deeply psychological photographic portraits, video footage from the bottom of the ocean, installations that stretch for miles, or drawing an entire universe on the head of a pin. Ideas need to be envisioned before a price tag is attached.

Eventually reality intervenes. The day comes when you need to consider how to financially support the artist making that sensational art. Since the Impressionists, our society has mythologized stories of poor and suffering artists. Their creative life is portrayed as a triumph over pain and misery. Thus the adjective "starving" has attached itself to the noun "artist." We are taught that great art is not possible without anguish. Suffering in an unheated garret becomes a badge of honor, an essential ingredient to the creative equation. But let's analyze this notion for a moment.

Yes, the creative process can be frightening. We are always raising the bar in our work, challenging ourselves to push our ideas. And this process does bring with it some anguish and terror. What if my new idea doesn't work? What if no one understands or appreciates what I have created? No artist is immune to the feelings that arise from these questions. I'm sure you have your own list of terrifying moments in the studio as they touch your most vulnerable spots. They supply many sleepless nights. However, processing those powerful emotions through your work does not have to spill over into your financial life. Poverty is not an assurance of important art. Allow the rest of the world their romantic notion of *La Bohème*, complete with the cold-water flat and saltine-cracker diet.

In this chapter we are going to address how to put your art and your finances in their proper places so you can do more than simply survive as an artist—you can *thrive*.

It's true: in visual art earning a living follows its own path that differs from other fields. Many of your friends begin their professional lives in

medicine, law, business, or academia at entry-level positions that provide a steady income (with benefits) while moving up the ladder of success. You, the artist, are left at graduation with the same school loans and living expenses but without the means to pay them back. What's next? Do you prolong the escape from reality by heading off for graduate school? Are you now finishing graduate school and must finally face up to the next stage of your professional life? These are scary transitions. You are exhausted by the rigors of school and apprehensive over plunging into a practice on your own. You are painfully aware that your part-time job only covers art supplies. Now you have an entire life to support. Let go of the jealousy you feel when looking at artists you know with access to family or outside support. Right now, they appear to be at a distinct advantage, since they do not need to hustle for work. Jealousy is a waste of energy and only delays what you need to tackle within your reality. Instead, remind yourself that supporting your work will be an ongoing, evolving adventure. The same creative thinking you apply to you studio work will help you design a healthy financial life.

Let's face it, no one chooses to be an artist for the money, so supporting your practice can produce emotional knots difficult to untangle. Money is a delicate subject no matter what field you are in. Many people find it easier to talk about their sex lives than their bank accounts. If money were all you were after, there are many other professions with high income potential. If you are like me, you keep at it because you are driven to create and can't imagine doing anything else with your life. For better or for worse, you know this is where you belong. Being an artist shouldn't mean all or nothing financially. Unfortunately, the image promoted in the media focuses on art stars and their extravagant behavior. It's rare to find a profile about an artist who is just nicely chugging along. Thus we internalize a negative image of the art profession as one of extreme opposites—rich or poor, success or failure—without any vision of the middle path that most of us will find to be our reality. For the rest of this chapter you need to try to put that emotional baggage aside and face up to your financial responsibility. Ask yourself, "What is the best way I can fund my practice?"

Talent and money are two separate things; don't mix them up. In order to be free to strategize how you will support your work, you need to begin to separate any emotions that connect money to talent. Remind yourself that the same individuality you have established in your art practice will uncover a unique path to funding your art.

Let's start with defining what money is to your art practice. Money is a tool that provides the means to buy supplies, assistance, space to work, and most importantly time to develop and realize new ideas in your studio. It also covers your personal needs of food, shelter, and fun. How you acquire and manage your money to carry through your ideas, support your practice, and sustain your personal life while maintaining your integrity is vitally important to your sense of well-being.

I can guarantee you that dedicating the time and actions to organize your finances will free up wasted emotional energy fretting over the bills coming in. Van Gogh's letters to his brother are a poignant example of the time and energy spent on the quest for money. Nothing is free, not even handouts from your sympathetic brother. Yet, again and again, the saga of genius coupled with unremitting poverty underlies our view of an artist's life, Van Gogh's being the classic example. This myth is potent. For you to tackle it is courageous and psychologically essential to your health as an artist.

Most artists will not support themselves solely from their studio practice. It does not mean they or you are a failure. Consider this: If you are like most artists, you need to stretch every dollar to service multiple activities. Most likely you are juggling paid work to cover both your personal and artistic expenses. This means that you need to be *better than* the average person at managing it.

Let's start by looking at where money comes from. There are three main categories for funding your art and your life.

The first category is **earned income.** These are the wages, tips, and salaries you receive from employment. In addition to your salary, your employer pays half of your Social Security and Medicare taxes, provides unemployment and disability insurance, and withholds from your paycheck your estimated taxes, which they send to the government every quarter. They may also contribute to health insurance, life insurance,

Whether one likes it or not, the ability to function in this world depends in large part on one's ability to handle money and money flow.

—Susan Lee, tax and financial consultant

and pension plans. Your employment contract spells out how many vacation, sick, and personal days are available each year, as well as other benefits such as parental leave.

If you are self-employed, earned income is your net profit from business activities: art sales, royalties, licensing fees, lecture and workshop fees, freelance jobs, or commercial businesses you own such as an art moving service, a frame shop, a yoga studio, or any retail establishment. Self-employed artists, whether sole proprietors or incorporated entities, are responsible for maintaining accurate accounting records and filing the appropriate tax forms with the government, which include quarterly payments of estimated income tax and both the employer and employee contributions to Social Security and Medicare. You also provide your own insurance: health, liability, disability, and life. Work schedules, vacations, sick days, and parental leave are self-determined.

Unearned income is the next category, and it covers sources other than employment and profit from a business, such as interest from savings and money market accounts, stock dividends, capital gains from the sale of stocks and bonds, and lottery winnings. For artists, unearned income can also come in the form of project grants, fellowships, awards, and cash prizes. You are obligated to pay taxes on this income.

Other support is the third category and includes everything else. This means goods and services that don't include cash, such as living and studio accommodations during artist residencies, professional help and facilities provided in workspace programs, donations of materials and services, barter, and exchange. Also included in this category is support from your partner/spouse, friends, and family. Because money is not exchanged or is provided as a gift, you the recipient do not need to pay taxes on these sources of support.

Look at the three categories above. Where do you currently get your support? Does it come from several categories or only one? Are you regularly contributing to a savings account with part of your earned income and applying for grants and fellowships? Could you trade spaces with your childhood friend who lives in Paris to help subsidize a glorious month touring museums and galleries?

When fundraising is discussed during the Creative Capital Retreats, we use a simple exercise to demonstrate the advantages of multiple avenues of support, which I've modified here. The illustration below represents the means by which many artists fund their practice:

Now brainstorm all the other possible ways an artist can fund their practice:

- grants
- artist residencies
- teaching
- investments
- sales
- barter
- in-kind donations
- awards
- freelancing
- consulting
- partner/spouse

- family
- real estate

Now the illustration looks like this:

Illustration: Abby Manock

Precariously balancing yourself on one funding source, like the artist in the first illustration, subjects your life and your art to the mercy of whatever happens to that resource. Should you suddenly lose your day job, draw down the last bit of grant money, or find that your gallerist has abruptly gone out of business owing you for the last three sales, you are frantically scrambling for a new pole on which to perch. This is a precarious existence. However, if your financial picture is more like the artist illustrated in the image above, you are able to depend upon *multiple sources of support*. You operate from a stable platform generating a

steady steam of support. Should one funding source become imperiled or suddenly dry up, the aftershocks are easier to withstand. Artists who can access multiple sources of support will be better able to ride the financial ups and downs of a career or of the broader economy.

In this chapter we will be focused on the earned income category of support and will explore unearned and other funding sources in chapter 7.

Artists have to look at income from more than one income stream. You can't just hope to sell enough paintings to make a living. You also have to look at grants, you have to look at public art commissions, and you have to look at different ways you can earn money. Of course, not every artist is going to be a good grant writer. But they can earn money in other ways. Use the creativity they were born with to take advantage of a world that is increasingly interested in original art.

—Carolina O. Garcia, executive director of LegalArt

Earning Money

Besides making art, what other activities do you enjoy doing that you could turn into cash? Start by analyzing your skill set. Earning money outside of the studio shouldn't feel like after-school detention or, worse, a prison sentence. Your goal should be to earn money in a way compatible with your studio practice. Many artists work as assistants to other artists or find positions as administrators, curators, receptionists, installers, and handlers in galleries, museums, auction houses, private collections, and nonprofit art organizations. Others work for allied businesses, such as picture framing, art moving, art supply stores, or art conservation. Related disciplines such as advertising, illustration, graphic design, animation, film, theatre, publishing, and music also provide fruitful sources of employment where you can use your art training. Especially when you are just starting out, working in the arts is an excellent way for you to learn more about the business. What better way to learn how to organize and manage a thriving studio practice than by working for a successful artist? A job in an art gallery can help you evaluate the pros and cons of representation and understand how to approach and work with commercial art dealers.

All too often, the standard advice to visual artists is to find a full-time college teaching position. It has job security, great benefits, and summers off, all for only two to three days of work a week. If teaching is part of your skill set, this can be a good option. Many artists seamlessly combine their art practice with teaching. However, the reality is that

each teaching position posted by the College Art Association has between five hundred and eight hundred applicants, so the competition is tough. Many art departments fill a large chunk of their offerings with adjunct positions. Like seasonal migrant work harvesting fruit and vegetables, most adjunct teaching positions are offered on a class-by-class basis if enrollment holds and provide a meager income and no benefits. To make a living from adjunct teaching means working at several schools at once, thereby carrying double or triple the teaching load of a full-time position. But adjunct teaching isn't entirely bad. Working for a few years as an adjunct can build a résumé that can lead to a full-time job, or it can complement other sources of income. The first few years after I left the Rotunda Gallery, I taught studio and art history classes as an adjunct to supplement my studio income. Once I met my goals, I taught only the classes I loved most, Professional Practices and the Business of Art. Teaching a class or two a week is a welcome relief from my solitary studio practice; however, it's only a fraction of my income.

It used to be that people could manage as an adjunct art professor. Now I say if somebody wants to teach, great, but they need to make sure they have the credentials to get a full-time job. If you take stopgap jobs like art handling or being a waiter and have the idea that you'll only be doing it for a year or two before you break out as an artist, evaluate where you are after that year or two and see if that stopgap job works for you in the long run.

—Susan Lee, tax and financial consultant

There are lots of other teaching opportunities you can explore in public and private schools, museums, art centers, nonprofit galleries, after-school programs, and summer camps. In your studio, you can offer private art lessons or small classes for home-schooled children. Another way to use your teaching skills is to develop a topic or area of expertise and give lectures and demonstrations.

Art history is full of stories of artists supporting themselves by outside labor, which often translated into skills or ideas that benefited their studio practice. Looking at his massive Cor-ten steel sculptures, it's not hard to imagine Richard Serra as a steel worker in the West Coast mills and shipyards while putting himself through college. Likewise, it's easy to see how Jim Rosenquist's work was influenced by the years he supported himself painting huge outdoor billboards. Barbara Kruger worked as a graphic designer, art director, and photo editor at various magazines before she made a name for herself through her studio work. She used her design background to turn the tables on advertising culture

JAMES ROSENQUIST
President Elect, 1960–61/1964
Oil on Masonite
89 3/4 x 144 inches
Art © James
Rosenquist/Licensed by VAGA,
New York, NY

through her pithy text over layers of found photographs. Andy Warhol made a name for himself first as an illustrator. In fact, I treasure my old beat-up Amy Vanderbilt cookbook, not only for her fabulous brownie recipe, but for all the little line illustrations throughout, done by a young Andrew Warhol. Fred Wilson's installation work critiques the display of cultural and ethnographic objects in museum collections; his perspective comes out of his earlier jobs working in museums as a guard, educator, and curator.

Barbara Pollack in "Moonlighting Sonata" (*ARTnews*, June 2005), writes about a variety of younger artists following in the same footsteps. One such artist, Simone Shubuck, works as a floral designer for restaurateur Mario Batali; her work there meshes perfectly with the exquisite botanical drawings she produces in her studio. Video artist Paul Clay tests his ideas at his night job providing streaming-video shows for dance clubs.

FRED WILSON

Guarded View, 1991

Wood, paint, steel, and fabric; dimensions variable

© Fred Wilson, courtesy Pace Wildenstein, New York

Whitney Museum of American Art, New York

Gift of the Peter Norton Family Foundation

For some of you, the ultimate criterion of success is to establish a relationship with an influential dealer, patron, or collector ecstatic about your art. These connections will take your career concerns off your hands, providing all the financial and administrative support you need. You are left to concentrate only on making art. Sounds ideal doesn't it? But the reality is that few artists attain this kind of success. Only a few commercial galleries worldwide are able to position their artists in the market with prices high enough to provide lifelong comprehensive support. Achieving that position in your career is divine and can be part of your long-term plan, but it will take some—perhaps many—years to get there. In the meantime you will need to find other ways to support yourself. As for living off of a patron or collector or even your family, as helpful as they may be, they are unlikely to fund you year after year. Eventually, that source will dry up, and you will need to dip your bucket into other funding streams.

ART/WORK QUESTIONS TO CONSIDER

What financial structure best meets your comfort levels? Is it a regular pay-check or the ebb and flow of sales, freelancing or owning a separate business? What is your comfort zone with money? Is it easiest for you to budget your time and finances by having a regular work schedule, benefits, and a paycheck? Knowing each month that your basic expenses are covered can produce a sense of security even if the trade-off is working at a full-time job. You schedule your art life to occur before or after work and on weekends. You strategize vacation days to coincide with an artist residency. Art sales, grants, and awards feel like bonuses to spur you on. You use your personal days for important studio visits. Sometimes, after establishing herself with a company, an artist can negotiate a schedule that allows her to squeeze her work hours into three or four days a week, or establish some tasks to be done from home, giving her extra time for the studio without losing the regular paycheck. Many artists will begin working full-time in a related arts field, such as arts administration, grant writing, advertising, proofreading, or art conservation to develop references and contacts. In time they find a way to move out of full-time work into doing these tasks as skilled freelancers and consultants.

Not everyone is cut out for a regular job. Chances are if you experience "Sunday night dread" before the beginning of the work week, you may not be cut out for a 9 to 5 job. Maybe you require a more flexible work schedule or don't want to work for someone else. Consider developing a particular skill set of yours into a freelance business, also referred to as being an independent contractor. Freelancing takes many forms. In fact you could look at your art practice as one form of freelance activity and develop another. Many artists find freelancing the most compatible way to earn an income with their art-making lifestyle.

Besides making art, what else do you love to do? What would you do if money were no object? How can you get paid doing it? Start by analyzing your strengths. What do you love to do? What do you do better than others?

> *Art is a very strange business. A business where people buy things and then they sometimes don't pay for them. A business where everyone is pretending that there's no money involved, and yet in the end of course, as an artist, you do need money to survive and to continue making work and sometimes you can be very ill-served by all this pretending.*
>
> —Ellen Harvey, artist

If you want to work at a full-time job, make sure it's something you like to do. "In love with my telephone and enjoy meeting new people" could translate into working as a receptionist, a love for animals to working at an animal shelter or starting a doggie day care business. You are limited only by your ability to imagine what goods or services you can offer that someone else will pay for. Do you keep your friends in fashion advice and love shopping for just the right accessory or rummaging through thrift stores to discover cast-off classics or sleek designer wear? Can you translate those activities into styling on film or photo shoots? Or open your own retail shop? Sell your treasures on eBay? Are you incredible at organization? Do you automatically alphabetize lists? What small businesses could use your guiding hand? Are you in love with facts and figures? My college roommate went directly from art school to earn an accounting degree in graduate school. She works fourteen-hour days January through April, filing clients' taxes and earning most of her income, and has the rest of the year to make art with minimal responsibilities to her clients. Did your A's in English grammar lead to proofreading your roommate's research papers in college? Can you provide this service for a law firm or a scientific journal? Are you a good test taker, and do you like to teach? Can you develop a college entrance exam tutoring service or work for one of the national chains? What college classes did you deeply enjoy and excel in? Do you pick up foreign languages easily? Are you already multilingual? Can you work as an interpreter or organize art tours?

When I think of the people I employ as freelancers or independent contractors in my life—my web designer, framer, computer technician, photographer, yoga instructor, master printer, accountant, even my copy editor for this book—all of them are artists. If you are drawing a blank on what your special skills might be, ask people close to you what they think you are good at and what talents of yours they appreciate. Brainstorm with them how you might turn that talent into cold hard cash. Do you need some training or experience to get started? I have

I work full-time at NYFA [New York Foundation for the Arts] Monday through Friday, 9:30 to 5:00, I do studio work, and I do MINUS SPACE. So I do three jobs at once. The answer is that I am working all of the time, like 24/7. That may sound like a bad thing, but it is actually a tremendously good thing because I am thoroughly engaged in what I am doing. I think it is a much better situation to be overly busy to the point of being overwhelmed than the alternative, which is to do nothing and complain that there is nothing going on. So I'm always working on something, but it's all one big project. If I'm working in an office, curating on a show, updating a website, or painting, I see it all as artwork. It's all part of my creative practice.

—Matthew Deleget,
artist and cofounder, MINUS SPACE

artist friends who have taken a few accounting and bookkeeping classes at the local community college and work part-time doing the books for other small businesses. Others have returned for graduate degrees in social work to establish part-time therapy practices that provide a good income and time for their studio work.

When are the optimum times for you to make art? What work schedule dovetails well with them? When are your creative energies at their peak? Do you do your best work in the morning, afternoon, or evening, or late at night? Another way to connect the right job to your practice is to do outside work when you aren't bursting with creative ideas and energy. Save it for the studio. So if you like to do studio work at night, tending bar may not be a good choice for you, as you have to work when you really need to be making art. But even bad work schedules can be managed. For example, I'm a morning person. I like to get up and get to the studio while still transitioning from my unconscious night-thinking to more concrete daydreams. When I first moved to New York City, I worked full-time at a large art supply store, Pearl Paint Company. After a few months, I felt droopy and sad. I had created very little art, as I was too worn out each evening to do much of anything. It was only when I changed my studio schedule to work from 4 A.M. to 8 A.M. before going to work at Pearl Paint that I began to cheer up. For me, it wasn't hard going to bed early when I had a good reason.

What can you do (or what skill can you develop) that will provide the most money with the fewest number of hours and stress? Ah yes, the punch line. Always treasure and protect your creativity. Everyone has different financial needs and stress points. Know what yours are, and avoid locking yourself into work situations outside the studio that do not contribute to your creative well-being. Look for work that's rewarding but also pays well enough to help you with your artistic goals. If your job or freelance business is so stressful that you spend more time doing "retail therapy" than art, maybe you should look for a more serene way to earn an income.

Do you know freelancers doing the kind of work you are interested in developing? Offer to take them out to lunch and interview them

about how they manage. What are the pros and cons of their business? If they could begin all over again, what would they do differently? What mistakes did they make that you should avoid? What other advice do they have for you? Don't be shy. It may be that some will see you as a potential competitor and not want to share any information, and others will be generous with their advice. Try speaking with freelancers outside of your community, in another town or location where they won't feel as threatened. If someone provides a bleak picture to discourage you, interview a few others to get a more rounded point of view.

Because of the irregularity of your freelance income, one month you may be flush, while the next one money barely trickles in. You need to be comfortable managing your time and finances with a steady hand amid the ups and downs. Running your own businesses—you may separate your freelance business from your fine art sales—also requires you to be your own human resources department. That means researching and selecting health insurance policies, pension plans, paying quarterly taxes, etc. Planning for all of these expenses is important.

No matter what avenue you choose, the goal is to assemble the right mixture of activities that result in a lifestyle in which you are doing more than surviving. Many artists seek to earn just enough to scrape by, working at marginal positions or for cash "off the books" year after year. They neglect their finances because they hope a solution will come when they make it big and finally achieve fame and fortune with their art. I'm not trying to puncture anyone's big dream, as I'm all for dreaming big. However, laying a more secure financial base, developing many income streams, paying taxes, and using your creative energies to live well will not diminish striving for that goal.

In retrospect one of the best experiences I had during my undergraduate education was to have to pay for it myself. I didn't have family support, so my college education was funded by student loans and part-time jobs. I was on a strict budget. In order to manage my meager finances and buy art supplies, I kept an expense diary. Every purchase, no matter how small, was recorded and balanced against my earnings. It was the only way I could work as little as necessary at my part-time job and still pay my bills. For me, taking a peanut butter sandwich to class instead of

Develop a long haul plan. Basically, if you have a day job, you should have a day job that pays you as much money as you can possibly make in the shortest amount of time, so you have maximum energy for the studio. That's actually the most critical thing. Anything else is wasting your time.

—Kurt Perschke, artist

How to Earn and Manage Money

buying the turkey wrap meant I didn't have to skimp on art supplies or work an extra hour at my part-time job. I had to keep track of every purchase I made. In time I internalized the process so that I didn't need to follow it so carefully. This habit has been a huge lifesaver for me over the years. I have found that my ability to track my finances has allowed me to stay solvent as an artist even when I've taken big risks.

Your Finances

Where does your money go? To be a good manager of your finances, you need to be mindful of where your money comes from and where it is going. Wherever you are right now in your career—in school, just starting out, or mid-career—is a good time to do some financial tracking. This will provide insight into your spending habits and a place to begin shaping your financial life.

MAKING A BUDGET

No business operates without one. You may not like the word "budget," as it conjures up a vision of Ebenezer Scrooge, pinching pennies, and never allowing yourself to splurge on something fun again. Let's take the emotion out of the word "budget." To design a budget is to create a set of spending parameters for your basic needs, responsibilities, and desires. Creating a budget is useful even if you make it once and never look at it again. Just calculating and writing everything down in one place can draw your eye to earning and spending patterns that need your attention. It can confirm what you suspected in your dark bill-paying moments, such as your need to establish another source of income or to leave your credit cards at home. Without a budget it is really hard to make financial goals, career decisions, and even short-term choices about whether or not you can afford those shoes, a new computer, or whatever you feel motivated to spend your money on.

When was the last time you analyzed your finances? If the answer to that question is years ago or never, don't feel bad. Simply call this "Day One: A New Beginning," and see it as an opportunity to move ahead.

There is no such thing as an income category called "off the books." Many people want to believe that if they don't have taxes taken out, . . . they don't have to pay on that income. Actually, both income and self-employment tax must be paid on this money.

—Susan Lee,
tax and financial consultant

THE ARTIST'S GUIDE

Start by looking at where you are now. This will take all the compassion and kindness you can find. Be honest with yourself. This as not an opportunity to agonize over misspent youth, the fifty pairs of shoes stacked in your bedroom closet, the Italian racing bike hanging on the wall, or the set of five hundred oil pastels of which you use only a dozen sticks. The point is to get a handle on the money you need to live and make art. Where does your money go? To answer this question, keep a financial journal that tracks every penny and dollar you spend for the next month or two. This will provide insight into your spending habits and a place to begin your analysis. If you have a partner, are married, and/or have a family, you can choose to do this exercise either with that person and include all the household expenses, or with just your share.

How much money are you making every month and every year? If you aren't sure, start with last year's tax returns, and make any adjustments for things you know have changed. (If you file a Schedule C, use your gross income.) Do you have any other money sitting around in an investment account? Do you collect interest or dividends? Try to think of every possible place you currently earn money.

I believe somebody who can be conscious of every single detail in a drawing show is also able to be conscious of their spending, earning, and income. Often, many artists feel inadequate about their money abilities or would rather not deal with it. But the art world is not a place that will take care of you just because you want it to. Artists must take care of themselves because usually no one else will. Just saying you're no good at something doesn't mean that you should avoid it. Because there is no avoiding it.

—Susan Lee, tax and financial consultant

FINANCIAL TRACKING EXERCISE

1. *Track your spending by keeping an Expense Diary.* No one likes to do this, but doing it well once means you won't have to do it again. Get a little notebook, and carry it with you everywhere you go. Or use your datebook or start an expense diary on your BlackBerry or iPhone, and keep track of everything you spend. Save your receipts and note what the purchase was for: coffee, subway/train/bus, drinks, bananas, cleaning supplies, art supplies, entertainment, cigarettes, automobile, underwear, gifts—absolutely everything, regardless of how you pay for it. Make a distinction between groceries and takeout food and restaurant meals. Don't forget to write

down any item for which you don't get a receipt, like soda and chips from a vending machine. Include the electronic payment transfers and checks you write for utilities, rent/mortgage, student loans, and credit cards. Keep a separate account of credit card interest, bank fees, and late payment fees. Make sure you have captured each item on a credit card. Do this for a minimum of one month, ideally for three months.

2. *At the end of the month tally your figures.* You can generate a spreadsheet on your computer using a program like Excel and a column for each spending and earning category. If you use Quicken or Quick Books, add a cash account to the ones you have for banking to cover out-of-pocket expenses. It will make adding it up easier by running a profit and loss report. Assign every item a category: Gas, Rent, Utilities, Clothing, Art Supplies, Food, Entertainment, Medical, Childcare, Local Travel (you may want to separate out subways from taxis), etc. You can make up humorous categories too. My favorite is "Self-Therapy," which makes me smile every time I record what I spent on a manicure or a massage, instead of feeling guilty. You can also use a big piece of graph paper and make yourself a spreadsheet. At the top of each column put the name of a category, and start listing those expenses in the lines below.

3. *Account for those items paid quarterly or yearly,* such as health insurance, life and auto insurance, real estate taxes, gym membership, summer camp, and quarterly federal, state, and local taxes by dividing each amount to get a monthly figure. Record those items under expenses. Even if you don't pay them every month, you need to anticipate their due dates.

4. *Tally all sources of income for the month in categories:* Salary, Freelance, Sales, Interest, Rental Income, etc.

5. *Analyze the figures.* Check to see if there is anything you forgot, such as automatic debits to Netflix or student loans. Is

THE ARTIST'S GUIDE

there something you are not currently paying for that you should? Do you need to replace an important piece of equipment soon? Do you need a new set of tires for the car? Does the cat need vaccinations? Put that stuff in. What will you need to earn next year to continue supporting and/or growing your studio practice?

At this point try not to be too judgmental. It's just information, a place to start.

Do any of the numbers surprise you? Are you spending more than you make? Do the figures support your life goals? If you are appalled by how much you spend on espresso, bottled water, mixed drinks, or cigarettes, decide how much you can scale back, or find other ways to entertain yourself without feeling deprived. Do more socializing at home. Invest in a snappy thermos, and fill it with fresh brewed coffee, tea, or ice water before stepping out in the morning. Would the resulting savings over a year's time allow you to splurge on art supplies, a bigger studio, or take time off to do a six-week artist residency? Can you barter for goods and services? What do you have to offer? Do you have a big project coming up? Make adjustments for that. Are you putting any money into savings? Can you move a few dollars from your clothing or vacation spending to a savings account or IRA?

Congratulate yourself! This has been a lot of hard work. It's not easy to look at what you earn and how you spend it. No one is going to make you do this every month. This is your money and your life, so be honest with yourself. If you are regularly spending more than you earn, you know you are courting disaster. How can you change that equation? You need to either earn more money or spend less. If you are already balancing the money in and money out, then it's a good checkup. Make sure you are where you want to be financially. Could some of the columns be rearranged to better serve your long-term goals? Always keep the figures real and relating to what you actually spend and make. Knowing what it *really* costs you to live and create your art and what you spend on disposable things will help you plan your next move.

If you take that full-time job to make ends meet, but are so miserable in it that you comfort yourself with eating out every evening and buying electronic gadgets, is that furthering your goals as an artist?

IMPROVING YOUR FINANCIAL PICTURE

Now that you have a comprehensive picture of your financial life, refer back to the illustrations on page 164 and 165. Are you funding your life by only one or two means of support? What are some other ways you could earn money? If you make money freelancing, it probably arrives in fits and starts. Are you making enough this month to tide you over the summer, when your clients go on vacation, so you can spend eighteen blissful hours each day in the studio worry-free? Take time today to take charge and set up your financial future. It will have huge consequences for sustaining your career over a lifetime.

Here are a few other financial tips:

- *Diversify.* Don't rely on one client or customer. Maybe you have plenty of work right now, but always look out for other opportunities. I depend upon a network of art professionals to represent my work. One of them may not have many sales of my work this year, but another one will. For lecturing and workshops, I also work with a variety of institutions.
- *Charge enough.* Clients know they get what they pay for. Remember no one will offer more money than discussed. If you charge too little for your freelance work, you will eventually resent the client and yourself. Keep up-to-date on art prices and freelance fees. Are your prices and services in line with your peers? If they are higher, do you have talking points ready to explain why your time or your work is worth more than others? Have the guts to walk away from someone who won't pay you your true value.
- *Make sure benefits are reflected in your pricing.* It's estimated by human resource professionals that benefits (health insurance,

pension, paid vacation, etc.) can add as much as 30 percent on top of an employee's base salary. If you are freelancing, you are funding your own benefits. Social Security taxes alone claim over 15 percent of your profits. Then there is life insurance, health insurance, liability insurance, pension, vacation, etc. Even if some of those expenses are covered by a partner or spouse, they should still be accounted for in your fees and prices.

- *Don't be shy about getting paid.* A direct, honest approach about money is your best bet with clients and galleries. More often than not, late payment is due to ineptness rather than bad faith. Just give the payer a call. Be sure to be clear up front about the terms of payment.

- *Barter.* You can barter crochet lessons for a massage, business card design for tax prep, an etching for teeth cleaning. There are so many ways to get what you need in life. Be sure to trade dollar for dollar, not hour for hour (you may charge $75 per hour, while the other person charges $35 per hour). In other words, don't trade a $5,000 sculpture for tax preparation.

- *Watch your overhead.* You have to spend money to make money, but if your business expenses aren't paying off on your bottom line, it's time to reevaluate your spending. Do you really need another lens for your camera? Will it make a difference for your next series of work? Will it allow you to add another skill set to your freelance photography business? Treat your art and business expenses like investments. Would you keep putting money in your savings account if it weren't earning you a return?

Now that you have a comprehensive picture of your financial life, you probably won't need to continue tracking it so carefully to maintain a healthy balance between what comes in and what goes out. For me, the sense of security I feel when that part of my life is under control sets me free to be adventurous with my creative life.

REPORTING YOUR ART INCOME

Once you have tracked how to support your life within your profession and have started to make some money at it, whether it is through sales or freelancing, you need to declare it to the IRS. This means filing one or more Schedule C's (Profit or Loss from Business or Profession), along with your Federal 1040 forms, each year. Cheer up! Making money is empowering. I know it's depressing to think that a piece of the big check you just received for an art sale will be making its way into the federal, state, and city treasuries. With so many other needs in your life, couldn't you just pretend that money didn't come in? Who's going to know the difference anyway? It's a tempting thought, but I look at it differently. Paying taxes from my creative earnings is a triumph, not a burden. No matter how I earned the money, taxes would have to be paid. I'm proud that my earnings come from art, even when I often don't approve of the way our government spends my tax money. I make sure I pay only my fair share. Instead of trying to fly under the radar of the IRS by resisting the inevitability of taxes, I see them as one more line on the budget.

Now is as good a time as any to talk about intention. What are your career goals? What kind of life did you imagine in chapter 1? Are you intending to support yourself from your work at some point in the future? If so, then use your intention as a powerful impetus to clear up your financial life. Your motivation will keep you on track, clarify decisions, and help you tackle the yucky tasks. Declaring your art income, from the very beginning of your career, is an important message to yourself of your intention to make this profession work for you. When you challenge yourself this way you will be surprised at what you can achieve.

As mentioned above, once you begin making money from your art, consulting, or freelancing, you need to prepare for the annual accounting with the IRS by filing a Schedule C. You need to keep good records and save your business-related receipts. I recommend that you do this from the beginning, even before you have made any art income, as these are important habits to instill early on. Then when you do get

The person who is sitting in his or her studio who says, "Oh, I'm not ready to sell," is not ready to file a Schedule C, because they are not in business. It's when that person is trying to make a profit. Trying to make a profit means not just making the work but actively selling it.

—Susan Lee, tax and financial consultant

your first sale or check from freelancing, even if it occurs in November, you will be ready for it.

What constitutes business-related expenses? The obvious ones are art supplies, studio rent, office supplies, photography, promotion, professional memberships, equipment, and software. You can get more information from Tad Crawford's book *Legal Guide for the Visual Artist*, 4th edition (New York: Allworth Press, 1999). Read this book to better understand how to keep records and receipts. Once you begin filing more complicated tax returns than the simple Form 1040, you may want to develop a relationship with an accountant or a tax professional. Some deductions, such as home studio expenses and depreciation on equipment, have complicated rules and schedules that warrant professional help. Ask other artists or a local nonprofit for referrals to tax professionals who understand the nuances of filing business taxes in the arts. Do this long before the April 15 deadline, preferably in December or January. By the middle of March, tax professionals are working long days taking care of their regular clients and may not have the time and patience for you. Make a preliminary appointment to discuss your needs and assess how you feel about working with this person. You may need to interview more than one to find the right fit.

I would ask the people who are referring, "What do you know about this person, and why do you like them?" and you can get a sense of their style. . . . It's like going to a doctor. It's like going to an attorney. What do you want in a professional? What are your standards? Ask yourself that. It's true for accountants as well. . . . For many people, it's the one time a year that they talk to somebody about money.
—Susan Lee, tax and financial consultant

I save my notated business purchase receipts and enter the numbers into different accounts set up in Quicken to keep them straight: checking, savings, tax savings, cash purchases, and receivables. Quicken is a personal finance software program that has a variety of features for small businesses. I like this system because I can run regular quarterly reports to see where I stand. My husband keeps his business records in a ledger and tracks his finances from his monthly bank statements. He stores his receipts in a dozen categories in an accordion file. Each January, he finds a quiet weekend to pull them out, sort into more subcategories, and add them up. Both systems work if you are diligent about saving receipts and writing notes on them to remind you what the purchase was for. Keep these original receipts for at least the three years the IRS has to audit you. Credit card statements alone are not sufficient; if

you are audited, you will need to back up every figure listed with a receipt. Don't think that because you are a small business the IRS won't select you for an audit.

Keep accurate records of any invoicing you have done as a freelancer and of every payment for a work of art. These payments will often show up again on 1099s. Companies file these forms with the IRS listing the amount of money they paid you for the calendar year. One copy goes to the IRS, one goes to you, and one is retained by the sender. Many galleries, private dealers, and art consultants send 1099s reporting art sales paid to the artist. I have found that often they do not send these forms to you by the February 28 deadline, but months later. Don't assume that if you haven't received a 1099 by the time you file your taxes in April that you are home free and don't have to report that income. You may be surprised by additional 1099s arriving in May and June.

With each 1099 you receive, check it against your records to make sure it is accurate. Many times I have had to report errors on the 1099s I've received. I have heard stories from fellow artists of 1099s that were supposed to be $1,000, but had been filed as $10,000. If this should happen to you, contact the organization, and make sure they file a corrected 1099, or you may come to regret it. The IRS has high-speed computers that add up all the 1099s they receive under your tax identification number and then against the gross figures on your Schedule C.

Once you begin to show a profit on your Schedule C, you must also begin to pay quarterly taxes to the IRS and any other governmental body that requires them. In New York City, I pay quarterly taxes to the IRS, New York State, and New York City. I file an annual New York State sales tax return as well. The easiest way to calculate these taxes is to divide what you owed the previous year into four quarterly payments. You then remit that amount on April 15, June 15, September 15, and January 15 to cover your tax commitment for that calendar year, unless

there is a dramatic change in your business income up or down. These tax payments are similar to withholding taxes that are automatically subtracted from your paycheck when you work for someone else. Basing it on last year's obligation is the easiest way to figure it out. Whether my art sales are up or down, I always pay my quarterly taxes without fail. I have found the easiest way to do this is to create a separate savings account in which I deposit 25 to 30 percent of every check I receive for sales, lecturing, workshops, grants, etc. I don't consider that money mine, and it is squirreled away, safe from monthly expenses. There it sits collecting interest until I transfer it to checking for quarterly tax payments. That way I always have the funds on hand to cover them. Once I've finalized my tax returns for that year, if there is money left over, I will leave it in the account for next year or send it to my retirement account. I highly recommend you develop a similar habit; I guarantee you will never regret doing this.

When you make a profit from your business, whether it is through freelancing or art sales or some combination of both, this is a joyous moment and calls for celebration. As for almost all important accomplishments, it also carries responsibilities. Don't rant and rail at the government for requesting their share of your profit. Don't waste your energy on anger; return to the feeling of euphoria. You are making money from your creative practice doing something you love.

If you want to start selling your work, you need to understand tax implications. Get that from the beginning. Consider everything you earn to be income as if you had a job. Deal with it like it is income, and your life will be easier down the road.

—Carolina O. Garcia, executive director of LegalArt

CREDIT CARDS

Speaking of good habits, let's continue down this road by tackling another insidious problem: credit card debt. It seems as if whole cable channels and twenty-four-hour talk radio shows are devoted to this one topic. Frightened callers are instructed to get control over their mounting debt, cut up the credit cards, consolidate payments, scale down their expenses, and change their bad habits. Credit card debt has become a national epidemic reaching far beyond the arts.

Because of the precarious nature of an artist's life, living on credit requires *extra*-careful management. Credit cards are a wonderful convenience but function as a double-edged sword. They allow you to operate

I think that a lot of times when you have to figure out a different and cheaper way of making work because of financial concerns, it is often better than if you had all the money in the world. It's similar to how the creative process works. Those points when we hit our head against the wall are actually opportunities. The piece is telling you that it doesn't want to be made that way.

—Janine Antoni, artist

without a wallet stuffed with cash and provide easy access to the bank's money. However, those features also make them treacherous. Falling prey to the ridiculously easy repayment terms will keep you in a state of indentured servitude forever, with 18 to 24 percent interest rates compounded *daily*! I have listened to too many tearful stories from artists who ran up every credit card they had in order to fund their upcoming project or show. They saw it as their big chance, threw caution to the wind, and went all out: taking a leave from their job, paying their rent from cash advances, and debt-financing escalating production expenses. After the project or show premiered, to their dismay all they had left was thousands of dollars of credit card debt. I have one close friend for whom it took over ten years to pay back her "make it" opportunity. The interest payments alone amounted to more than ten times her purchases. Using your credit cards this way is dangerous. It can jeopardize your creative life and your ability to fund future work for years to come.

We'll discuss better ways of funding project budgets, production, and exhibition expenses in the next chapter. For now, make it a goal to reduce or eliminate credit card interest from your monthly budget. Turn the tables around on the bank by enjoying the easy access to their money and then paying off the entire balance due each month. Shred the weekly solicitations you receive for new credit cards; sign up for only the two or three companies that have the most favorable terms for you, such as low interest, cash back, or airline miles. If you are easily tempted to overspend, keep the cards at home, and pay cash, or use your debit card. You will think twice about that impulse purchase when you have to seek out an ATM machine to pay for it. Save the credit cards for real emergencies.

You turn on TV and see a society and economy based on having people overspend and run themselves into credit card debt, so they can seem to be what they can't afford.

—Susan Lee, tax and financial consultant

Selling Your Art

In this section I'm going to switch gears to remind you that as an artist, you have a valuable resource that can contribute to your income stream: sales of your creative production. The sale of your art can pro-

duce a positive rush of emotion that is larger than the actual cash transaction. It represents a significant vote of confidence in your creativity.

My first experience with selling my work was while showing off a portfolio of watercolors to some friends during my senior year of college. My friends were graduate students in organic chemistry, so I was enthusiastically describing how my ideas for this series of paintings had developed, pointing out details, and feeling a terrific sense of accomplishment. My friend Hal casually asked if he could buy one of the pieces. I was momentarily stunned. The thought of someone owning my work hadn't occurred to me. In fact Hal had to ask me several times before I realized he wasn't joking. Stuttering, I pulled a price out of thin air. While my first sale was modest, that check seemed enormous. It was the equivalent of a whole week of work at my boring part-time job. This sale allowed me to envision the possibility of a different way to earn a living.

From my first sale, I've had to grapple with how to price my art. Among my friends and in my classes and workshops, I am often asked this question: "How do I price my art?" Determining a price for your work has no simple answer, and it is easy to entangle yourself in an emotional knot. When you are just beginning to exhibit, or have a new body of work, figuring out a "fair" price can be puzzling. The standard advice is start low and work your way higher. What does that mean? Is $100 too low and $1,000 too high? Choosing to say the work is not for sale doesn't avoid the subject, as you may need to place a value on it for insurance purposes. If you are further along in your career and have established prices and a record of sales, it is equally tricky to determine when to increase them and by how much.

Yes, it is hard to attach numbers to your art. The objects you make, although incredibly important culturally, are not crucial to survival like food and shelter. Pricing a work of art isn't like pricing a widget that comes off the assembly line, with well-established parameters based on cost of manufacturing, advertising, profit margin, and a bit of supply and demand thrown in. The uniqueness of creative work and our emotional attachment to it make placing a value on our production difficult.

This section will lay out how to make a reasoned decision about pricing instead of relying on a gut reaction. If you want the sale of your

work to be part of your income stream, your prices must be both logical and attractive. Gathering together pertinent facts will help quell the uneasy feeling that you are not being adequately compensated. You will avoid selling your work for less than it costs you to make it. Likewise, a reasoned approach that takes into account all of the factors that influence pricing will insure that yours aren't inexplicably higher or lower than all the other works in a group show. Just like the other tasks you have been asked to do so far, establishing a price for your work now will pay off later (no pun intended).

Let's begin with defining some terms that are commonplace in the art market. The first term you should know is "primary market." This indicates the first time a work of art is sold, whether you sell it directly from your studio or through an intermediary—an art dealer or consultant—who takes a commission from the transaction. If you have handled the sale, you receive the entire purchase price; if others are involved, you receive what is left after they have taken their commission, which is usually 50 percent of the selling price. "Secondary market" sales are when a work of art is resold either at auction or through an art dealer. In the case of secondary sales, the artist does not receive money from that sale, although the price it goes for at auction can be used to help determine the value of the artist's other work. The only exception to this is secondary-market transactions in California, which has a state law mandating a percentage of each resale be paid to the artist. It's called the Resale Royalty Act, which entitles the artist to 5 percent of the resale price if it is greater than the original purchase price.

That's how art is purchased, but it doesn't address how art gets priced. So now we need another term: fair market value. Let's go to the definitive source, the IRS. "Fair market value" is the price at which a property would change hands between a willing buyer and a willing seller, neither under any compulsion to buy nor sell and both having reasonable knowledge of relevant facts. That sounds sensible enough. It means that if your Aunt Polly writes you a $10,000 check for one of the sculptures in your BFA thesis show, that doesn't necessarily establish your prices. Her motivation to buy your work may not be based on her knowledge of the art market, but a vote of confidence and affection for you. This brings up

another term, "appraisal." An appraisal is conducted by a licensed professional, an art appraiser, who has undergone training to research and determine the value of a work of art. To do this he or she takes into consideration the following factors:

1. Other sales of your work.
2. Exhibition records and loan agreements that state insurance values for your work.
3. Prices of your work or similar objects quoted in dealer or auction catalogues.
4. The economic state of the marketplace and the current standing of the artist within his or her profession.

A sale you have made yourself can begin the process of establishing your prices. That figure is bolstered when it is echoed by similar prices for comparable examples of your work offered through art dealers, or listed in the loan agreements and consignment contracts you sign with galleries and museums.

HOW TO PRICE YOUR WORK

It's helpful to begin thinking of pricing by considering some concrete facts rather than how you feel about yourself and your art at this moment. Start by asking yourself what it costs to make your art. After all, how can you begin to set prices for your work if you don't know what it costs you in terms of supplies, space, administrative stuff, and time to make it? If you file a Schedule C, you probably have some idea of the numbers. I'm not suggesting that you price your work by the hour or divide your expenses by the number of works completed that year to get a figure. But having an overall picture of your expenditures gives you concrete information and a solid place to begin. The previous exercise of financial tracking can be of immense help here. You have collected accurate figures on what it costs you to live and make art.

There are many other factors that come into play when beginning to price works of art. Let's continue to avoid the emotional issues of art's

value and approach it the way an appraiser would. The first factors to consider are as follows:

- **Rarity.** Unique pieces are priced higher than multiples, which are works that are part of an edition: prints, sculpture, photographs, DVDs, and videos. The larger the edition, the lower the individual price. For instance, a photographic edition of three can be priced higher per piece than an edition of thirty. Individual objects from an installation may be considered multiples as well.
- **Permanence and/or cost of materials.** Paintings on canvas are priced higher than works on paper, cast bronze sculptures more than wood constructions, video installations more than a DVD.
- **Productivity.** An artist who completes only three to four artworks a year, if the work is more labor-intensive, can command higher prices per piece than one who produces twenty-five to thirty. It's parallel to the concept of supply and demand.

The next step is to do your own research to gather information on different approaches to pricing. Ask other artists who are regularly selling work, and look through the price lists when you visit galleries. Art fairs are also great places to do this research. You can compare prices among a wide variety of galleries and artists from all over the world. Look for the venues where you think your work would fit in. If you have a price list in your hands, look for works that are similar in style, media, and size to your own. Then check out the artist's résumé. His or her career should be at the same place as yours. If you haven't shown your work in a commercial gallery, then you need to look at works by artists who have their first or second shows in galleries that feature emerging artists. If you are mid-career, then the exhibitions and awards on the résumé should match up with your own. Realize that the prices listed include the gallery's commission, generally 50 percent of the selling price, with some allowances for discounting. I'll

discuss discounting more in chapter 8, when I go over consignment agreements.

Oftentimes a price list is not readily available. Many galleries want the focus on the art rather than the prices. If a price list isn't posted, ask for one at the desk. It's an opportunity to break the ice and begin communicating with gallery staff. Instead of handing over a price list, they might ask you which piece you are interested in. Don't let this question intimidate you. Point out a work and say, "That one," and then ask about another. If you have been doing your homework, you may notice that the price quoted seems higher or lower than you expected. Ask them about it. You may learn something interesting about the artist or his practice. The gallery may tell you someone important has recently collected this artist's work, or that it is so popular that they have a waiting list of collectors, so it now commands higher prices.

If you are working with a curator or a dealer, ask for her help in determining prices. If you have done your homework, you will already have a sense of what current market prices are and thus have a basis by which to judge her advice. If you differ widely from her suggestions, you can propose what you think is a valid price and support it by discussing your productivity, the cost of materials, production expenses, or the prices of other artists. Remember that when you are working with art professionals, you are also forging a partnership. Every art dealer has his own sales style often based on his personality. Some are cautious, setting prices low and raising them slowly, while others will take bold and risky positions. There are no hard or fast rules. Frank discussions about pricing are enlightening and give you insight into how someone thinks about his business.

In my experience, art dealers want to create a demand for your work with prices that are attractive to collectors (meaning high quality work that is a worthwhile investment) and make them some money. Selling six works at $2,000 creates a better impression with the dealer, collectors, and your audience than selling one or none at $3,500. If you are not working with an art dealer, make appointments or schedule studio visits with other art professionals you already know, and ask for their opinions.

Once you have this information in hand, go through an inventory of your work, and establish prices. *Do this when you are not under pressure.* The worst time to figure out a price is when you are taken by a surprise offer to buy a piece. Don't price your work a few minutes before your friend arrives at your studio with her wealthy collector uncle. Don't price your work when, in the midst of a studio conversation, the visitor offers to buy your favorite piece on the spot. If you haven't given this careful thought well in advance of situations like these, a spilt-second pricing decision may mean a ridiculous figure, low or high, comes out of your mouth. Either way you'll regret it. If the collector whips out his checkbook and walks away with your favorite piece at a fraction of its production costs, you'll be fuming. On the other hand, if you find the collector smiles at your naively high price, you can bet you'll kick yourself for missing an opportunity.

Make a complete inventory of all your works with prices attached to each piece long before it is needed. This doesn't mean that every work is for sale; certainly you may wish to hold on to some for yourself. But whether for sale or not, each work should have a specific value for insurance purposes. Print it out, and keep it handy. You do not need to show your price list to anyone, but you can refer to it when necessary. Even though I feel comfortable selling my work, I often find that when someone asks for a price, my mind freezes, and I can't remember the exact figure. Instead of blurting out a price that's incorrect, it helps to take a momentary pause and respond, "I'll look it up." While getting out my price list, I can center myself before answering.

There are different opinions about how artists should price their work when selling directly out of their studio. Even if you are not working with commercial venues, I believe that you should only have one set of prices, and those are what would be listed in an exhibition setting. Since I have a variety of art professionals selling my work—galleries, private dealers, art consultants, and print publishers—I have one set of prices

It's based on a combination of the artist, the market, and whether it is their first show. If he's not a kid, though—he's over thirty, he's been painting for a while, and he was one of my students—it's an instinctive thing. You try to figure it out. You don't want to make them too high. "Whoops, we priced them too high," and you make them cheaper the next show. . . . Collectors: assume they're astute; they compare your $500 painting with what else they can buy for $500.

—Fredric Snitzer, director of Fredric Snitzer Gallery

that they all use. These prices take into account any dealer commission, which in my experience varies from 30 percent to 50 percent. Thus, there is only one set of prices, and all dealer commissions are taken into consideration to my advantage. This means, if the dealer commission is only 35 percent, I get a bigger chunk of the selling price than if the commission is 50 percent. It also means that occasionally when I sell a work from my studio, I always quote the same price as my art professionals. If the sale does not conflict with the contractual agreements I have with my art dealers, I may offer a discount, which makes the buyer feel she is getting a bargain. When you are working with commercial galleries, make sure you discuss how to handle sales from your studio, so that you don't damage a carefully nurtured relationship by encroaching on the dealer's perceived territory. You don't ever want the word to get out that bargains are available by bypassing your gallery.

People are increasingly worried about what they usually call "investment values." That doesn't mean that they want their money to double in three years or four years. What it does mean is that they want to make sure that they're buying artwork that has a sort of "good housekeeping seal of approval" and that the artist isn't going to necessarily disappear next year.
—Cristin Tierney, art advisor

At the beginning of your career, you may feel as if your prices are so low that you are practically giving your work away. Make sure at the very least you are charging enough to cover the cost of the materials needed to make it. You may need to absorb the cost of your time. Once you have established a pattern of sales, you can begin edging prices up until you hit a more comfortable place. When I talk about pricing and selling with my students, I use the analogy that your recent body of work will evoke the same emotions as a litter of puppies or kittens. Newly made work seems so precious that your tendency is to want to hold on to it, much like those cute and cuddly puppies or kittens. However, puppies and kittens grow up to be dogs and cats, and unless you want to look like the crazy lady in apartment 4C with fifty cats, be open to letting go of your work. Find new homes for your art and your kittens. Almost every artist my age can pull out an old work and tell you a regretful story of how someone once offered to buy it, but the artist turned him down. For me, it is better to have the work out of my studio and placed with someone who takes care of it. That doesn't mean you shouldn't save some important pieces from every phase of

The root of the problem isn't getting paid for what you do. It's getting paid in such a way that it starts to affect what you do. Are you going to make this or are you going to make that because this one will sell and that one won't sell or because people are going to support this one financially in some way? That's where the problem starts, because you, as an artist, might have a pretty clear sense of what you need to do next in your gut, but it might not be marketable. And so, if your gallery is going, "Well, I can't sell this," it totally starts to mess with your head. It's like, "Is this really what I should be doing? Or am I wrong, and should I just do what I know is safe? Should I just make what I know will sell?"

As much as they want the new, [dealers] also want the comfortable. If the dealer knows that they've got collectors that love something you can make, that's great. I've actually had people go, "Oh can you just make a few more of those red ones," and I'm like, "No!"

—Jaq Chartier, artist and cofounder of Aqua Art Miami

your career, or keep a body of work intact for an upcoming show. That's a necessary habit. But you don't need to save everything. Selling work gives you a boost of energy and space in your studio to fill with new pieces. Selling also minimizes storage fees or the horrible task of loading up a dumpster with old work. Those collectors who took a chance on you at the beginning will brag to their friends as your work in their collection appreciates in value.

Financial Checklist

The last part of organizing your finances is to consider the support structures that surround you. Most financial experts recommend that you incorporate the following items into your life. Whether you are working at a job that provides benefits or running your own business, these items need to be included in your budget. Don't be alarmed if this seems too much for you to handle right now. Incorporating them one by one is an excellent long-term goal.

- **Rainy day fund:** a nest egg of readily accessible money (meaning not tied up in real estate or Wall Street) of at least three to six months of living expenses. The more months the better. Transitions, natural disasters, slow-downs, recessions, illness, and life's unexpected adventures can rarely be anticipated. You need to save yourself from the financial consequences that workers' compensation, unemployment insurance, sick days, and parental leave cover for the corporately employed. I wouldn't have had the guts to turn my life upside down and leave the Rotunda Gallery if I hadn't had six months of living expenses stashed away.
- **Risk protection:** life insurance, health insurance, disability insurance (expensive, but good if you can afford it), homeowners or renters insurance. Because there are so many

JUNE BISANTZ
True Life Story, 2008
South Street Seaport
Pier 17 Mall
New York City,
June 1–30, 2008

home-based businesses these days, there are now insurance policies that jointly cover home and business. Check with your insurance agent for the details, and see if one matches your needs. It may be less expensive than separate fine art insurance policies. Health insurance is a necessity, even if all you can afford is a high-deductible plan. For years, because my family was basically healthy, I had a plan with a $10,000 per person, per year deductible. Routine medical care expenses I negotiated with my family doctor, and we were covered for catastrophes.

- **Retirement funds:** maximize your contributions to any employer-sponsored plan offered at your job. This is a form of enforced savings, and most are matched with contributions from your employer. It's like a pay raise, even if you can't access it until later. Also consider putting some of your pretax money each year into an IRA (individual retirement account), which will lower your tax bill. Any income it produces grows tax-free until years later when you take the money out. You can add another type of account, a Roth IRA, to which you contribute after-tax money, and it too grows completely tax-free. If you are self-employed, talk with a financial advisor about setting up a pension plan for yourself, even if you can only afford to contribute small amounts of money to it. Putting away something starts to build security, and you will welcome these assets later on. Sometimes IRA funds can be accessed for special expenses, such as a down payment on a home or for more education.

- **An up-to-date will:** more about this in chapter 8.

It's far too easy to put off or ignore managing your financial landscape. It's an intimidating terrain, but if you don't walk into it, you will become a hostage of your bad finances. You need to be a nimble money manager at all stages of your career. The simple truth is that most of us will not support our lives solely from a studio practice. As crazy as it

Money is emotional because, if you let it, it signifies your place in society or your sense of self-worth. At a primal level, it signifies if you are going to be able to eat. It may signify that, because you have sold a lot of art, you are therefore an artist. People come to me who have sold very little art. Are they artists? I'd say they are artists.

—Susan Lee, tax and financial consultant

may seem, a variety of income sources actually promotes more financial stability over the long term. Too many artists operate from a scarcity model because they have never taken the time to adequately assess what it really costs them to live and work day to day. It leaves them overworked, underpaid, underfunded, and unable to understand exactly why this happened. Facing up to what it costs you to make your art and live your life will challenge you to explore creative and career-building ways of support.

Earning a living from our art is an excruciating topic for artists, since money represents power and security. When our work isn't supported economically, it is easy to feel like a failure. Marriage counselors report that money is one of the hardest subjects for a couple to discuss in their relationship. Just like deciding to get married, deciding to be an artist is something you choose to do out of love and passion, without consulting a profit and loss ledger. Eventually, concern over supporting your art—securing sufficient income, budgeting, pricing, and ensuring financial stability—will inevitably arise. What I am asking you to do is to slowly but surely face up to the reality of your choices and figure out a way to support your studio practice, without compromising your artistic integrity. Freelancing, developing a parallel business, or working at a job does not mean you are a failure, no more than does selling your art mean selling out. They are the means by which you provide the time, space, and supplies for your creative practice.

Resources

Abbing, Hans. *Why Are Artists Poor? The Exceptional Economy of the Arts*. Amsterdam: Amsterdam University Press, 2002.
- Abbing is both an artist and an economist based in the Netherlands. Although much of his discussion focuses on European-based artists, it is an excellent analysis of why artists struggle economically.

Crawford, Tad. *Legal Guide for the Visual Artist*. 4th edition. New York: Allworth Press, 1999.
- Besides presenting an overview of legal issues artists may face, this book includes four chapters on filing your taxes.

Orman, Suze. *The Road to Wealth: A Comprehensive Guide to Your Money: Everything You Need to Know in Good and Bad Times.* Revised and updated. New York: Riverhead Books, 2008.

- Almost any book by this ubiquitous source of financial advice seen on television is a good place to begin your education. Browse through her recent publications in your local bookstore, and begin with the one that speaks most to your situation.

THE ARTIST'S CAREER GUIDE

How to Find Even More Support: Grants, Residencies, Gifts

This chapter provides an overview of grants and awards and other means of support: residencies, workspace programs, individual gifts, and in-kind goods and services. It will discuss how to identify and broaden the funding opportunities that are available to you. This chapter takes you through the steps of researching and preparing a successful grant proposal. It doesn't matter if you are making one painting or sculpture at a time, or working on an extensive long-term project, you need to take advantage of the fundraising opportunities available to you.

Hide your credit cards, roll up your sleeves, and look far and wide for what you need.

Constantly asking for money is called "begging"; purposefully asking for support is an "empowered request."

I learned the mechanics of fundraising when I was director of the Rotunda Gallery. During the first two years, I immersed myself in a frantic grant-writing crash course. Through trial and error I learned how to develop a variety of program budgets, research grant opportunities, and cultivate future donors. I often reached out to more experienced colleagues, who generously answered my questions, shared their past grant proposals, and reviewed mine. In time I put together more persuasive proposals. Fundraising taught me that a "no" often meant "not right now" instead of a flat-out rejection. I made it a point to follow up and get feedback about why we were rejected so that I could improve my proposal the next time. When attending other exhibitions and events in the nonprofit world, I developed the habit of scanning the donor list to look for new prospects for the gallery before I'd look at the

show. While fundraising was my least favorite job, it consumed more of my time than any other task. Every exhibition season began with a tiny amount of money in the bank and a rapidly growing proposed budget to feed. I often lay awake at night fearful that I wouldn't be able to raise enough funds to cover the gallery's commitments. The process felt like a never-ending treadmill.

When I left the Rotunda Gallery and set out on my own, I thought my fundraising days were blissfully behind me. After all, I was going to make my living from the sale of my art. I didn't want to take the time to research and write grants. However, after six months, it became apparent that I was foolish to avoid support in this arena. I needed the money, but I also needed the peer recognition as an artist that a grant could provide. So I pulled out my old grant-writing folders and began the process again, this time for myself. I asked myself similar questions to the ones I asked when looking for funding for the gallery's programs. First, what did I need? That question was easy to answer; I needed funds to help cover my monthly expenses so I would be free to make art. Once I had established what I needed, I began to look for foundations whose mission met my needs. Who funds artists with work like mine? I researched former grant recipients and looked at their work to narrow the list even more. I then sent for the funders' application guidelines.

When I began to assemble the materials needed to apply to these grants, I plummeted into self-doubt. Who was going to fund an artist with two young children? Was it really okay to ask for living expenses? Would they pay for babysitters? Why should someone else support my decision to leave my job? Just who did I think I was? These negative feelings quickly escalated to encompass everything about my work. The slides of my paintings didn't do them justice. The ideas I discussed in my artist statement seemed dull and flat. I felt dejected and concluded that my proposal wouldn't stand a chance against those of other artists. Wouldn't it be better to wait and apply for a grant when I had better work?

Thankfully, a tiny part of me didn't fall for this line of reasoning. I was shocked into action by my irrational reaction and was determined to apply for grants in spite of my pessimism. After all, I was an experi-

enced grant writer who had raised tens of thousands of dollars for the Rotunda Gallery. I had supported lots of other artists and written glowing recommendations for their grant submissions. Why was I blocked when it came to asking for support for myself? How was this different?

Asking for help can bring up complicated emotional responses in all of us. It was a breeze to do it for everyone else, yet here I was making excuses about why I couldn't ask for help for myself. I could speak eloquently about the needs of visual artists when I raised funds for the gallery, yet it was uncomfortable to acknowledge my own. I remember looking around my studio with several grant submission guidelines on my lap. I felt powerless, and my work suddenly seemed insubstantial; certainly not important enough for someone else to fund it. Why couldn't someone just show up to rescue me?

Just like promoting yourself, fundraising takes your work out of the safety of the studio and exposes it to stress-inducing competitive situations. This process releases the same demons of insecurity and unworthiness that we, as artists, are so apt to experience. Grants won't magically find you—you need to actively pursue them.

No matter how insecure I felt, I realized that fundraising needed to remain in my life. I decided to apply to the Pollock-Krasner Foundation, founded by painter Lee Krasner. They funded ongoing studio work, which seemed liked a perfect match for my needs. I began to assemble the application materials. Preparing my annual expenses was easy, as I was already in the habit of keeping track of them. However, the emotional rollercoaster of fear and unworthiness returned when I had to compose a cover letter that detailed a funding request. It was as if I were learning to write grants all over again. Aware of my fragile state of mind, as I finished my draft, I showed all my materials to a colleague for feedback. It was a good thing I did. She read my three-page funding request and threw the first two pages in the wastebasket. "Let's eliminate the unnecessary neediness," she said as she handed me back the last page to revise. I realized that the first two pages foolishly described my needs as desperate and implied that I deserved a grant because I had done so much for other artists. Neither of these sentiments belonged in that grant proposal. I reworked the proposal, using a different tone, and

How to Find Even More Support

199

submitted my application. It was declined. I didn't even make it past the first round. The rejection letter explained that I could reapply to the foundation in one year. As dejected as I felt at that moment, I stubbornly managed to turn my disappointment into determination to try again. I circled the date I would be eligible to reapply.

A few weeks before that date, I revised my application so it could be dropped in the mail exactly one year after the first one. This time, my application was judged by a new panel, and it successfully passed through the rounds of the foundation's review process. Four months later, I received notification that I had been awarded a grant. It was enough to fund my home and studio expenses (including babysitters) for six months. I could work full-time in the studio and didn't have to scurry around looking for additional work besides teaching my two adjunct studio classes. I felt on top of the world. Someone had validated my work, and that boosted my self-esteem. That grant meant more to me than any I had received for the Rotunda Gallery.

How often are you missing out on support opportunities? Maybe it's the fellowship given each year by your state arts council or municipal art society that you consistently forget to apply to. Even though these grants ask for materials you already have on hand—images of recent work, your artist statement, and résumé—you justify your behavior with a weak excuse such as, "Hundreds of artists apply for that grant; they aren't going to give it to me." Maybe you know of an arts organization or foundation that funds artists, and have even printed out the application, but you procrastinate filling it out and miss the deadline. Now your excuse is that you are too busy to put all that information together. A curator visits your studio and suggests you contact the president of a local company to see if you can get a donation of a piece of equipment or a roll of that expensive space-age material you need for your project. You don't follow up on the lead because you don't know how to ask a commercial business to donate to your project. A friend receives a grant, and instead of sharing his happiness, you are filled with jealousy, even though you didn't bother to apply for it yourself. These are some of the most common self-defeating ways of thinking. At one time or another we've all fallen into these traps. If any of the above scenarios feel

uncomfortably true, then you need to make it a goal to follow through on your own fundraising. I realize there aren't enough hours in the day to pursue every funding opportunity. But by not applying to the most appropriate financial opportunities for your work, you are effectively rejecting yourself before you have even begun.

As we discussed in chapter 6, money is personal and hard to talk about, so we avoid the subject as much as possible. Having to look for support is uncomfortable. It can attack our feelings of self-worth and make the whole art enterprise seem too vulnerable to pursue. Think back to how much you may have resisted doing the financial tracking exercise in chapter 6. Laying out the pluses and minuses of your finances is almost worse than posing naked in front of your neighbors. Yes, money is a delicate subject. It's not easy to quantify what we do in the studio, so it's natural to resist doing it. Putting together a budget for your art and seeking funds brings up the same financial issues as those for your life. Like me, you will need to discover how to vocalize your needs clearly and professionally.

Learning how to determine and present your professional needs without becoming a "diva" is a skill that develops over time. With your first few exhibitions you will often be so grateful to have the opportunity that you will agree to almost any terms, such as funding a project entirely by yourself. You rally all your friends to help, and you beg and borrow as much as possible. It's an adventure. But you can't carry on for long with that as your model. *Continuing to avoid the realities of securing funds for your work will leave you in a debilitated state of poverty.* Friends and favors wear out, and so will you. Unfortunately, too many art organizations reinforce this scarcity model, with tiny project budgets and miniscule artist fees. They feel the value of the opportunity to the artist balances it all out. I can understand art organizations' reasoning. They too have skimpy budgets and overworked staff. They are delighted to offer an artist any financial help at all. They would rather not know how much your project costs beyond the artist fee they have offered. You don't really want to know the bottom line either, because to face the reality of it is too scary. However, as discussed in the previous chapter, to successfully sustain your art practice over a lifetime, you will eventually

need to face up to the costs of producing your art—a project, a new body of work, or a show. Someone somewhere will need to secure the funds to cover it. That someone is ultimately you.

This will require raising funds, and you can reach out to others to help you do it. For example, when preparing for a show, knowing what expenses you will incur to create the work and engaging the venue in a frank discussion about your financial needs early on in the planning process will allow you to elicit their advice and help on fundraising options. This isn't an opportunity to throw the funding responsibilities into their lap, but a way to open the conversation and explore potential resources you can follow. What might those resources be, and how can you access them? The rest of this chapter will explain this process.

Where to Look for Funding

Let's start with an obvious question. Why does someone give you money? Why do individuals, foundations, corporations, and the government give money to the arts? I love to ask this question in my classes and workshops. The answers start to flow: "Because the arts are a valuable part of our society." "The foundation believes in your project." "The individual receives a tax deduction for contributing to a nonprofit." "Corporations give money because it makes them look good."

All of those are correct answers. In fact in 2005, over $13 billion were given to cultural organizations in the United States. *But the primary reason all that money was given to the arts is because someone asked for it.* I know this seems like a silly point, but it is the crux of all fundraising. It is highly unlikely that anyone will give you money or support unless you know what you want and ask for it. Remember, for the foundation community, giving away money is their job. So help them do it well. Send in your requests.

Susan's story (sidebar) includes two valuable points concerning your fundraising activities. The first one is

It was a Saturday morning, and I was out to breakfast with a friend and his family. He asked about my work, and I mentioned that I was on my way to Italy the following week to give a lecture, and that an opportunity to teach and make work in Florence during the upcoming summer had just fallen through. I went on to say that I was trying to figure out how I could still go there to make my work without the teaching component. After breakfast we took a short walk, where he told me about a small foundation he had started. He said if I wrote up a proposal, the foundation would fund it.

—Susan Harbage Page, artist

SUSAN HARBAGE PAGE
Untitled (Toile), 2007
From the *Postcards from Home* series
Color digital photograph
30 x 30 inches
Photograph by Susan Harbage Page

that she was clear about her needs and open to talking about them. We often don't want anyone to know that we need support, so we struggle with it all by ourselves. Sharing your fundraising goals with others allows them to suggest ways to overcome the obstacles. You might find yourself surprised by the resources they can offer you. The second point is that a small, unknown family foundation expressed interest in helping her. I'm stressing these points because the foundation community is as diverse as the art world. It's easy to think your only option is to apply to the largest organizations such as the Rockefeller, Ford, or Guggenheim foundations and ignore the numerous other possibilities. It's true their resources allow them to fund hundreds of worthy projects each year. However, the Association of Small Foundations estimates that there are over sixty thousand foundations led by volunteer boards

or operated by just a few staff. These smaller organizations account for half of the country's total foundation grant dollars. Your project may not be fundable by the Ford Foundation, but with careful research you might find smaller organizations that are just right for you. They might even be connected to someone you already know. When I began to think about writing this book, I "tried out the idea" on some trusted friends. One of the people with whom I shared my plans was Mark Golden, the CEO of Golden Artist Colors. His enthusiasm for my project was indispensable in helping me make my final decision to move forward with it. When I needed additional resources during the book's early stages, his small family foundation, the Sam and Adele Golden Foundation for the Arts, was an early supporter.

Finding the right kind of funding for your work is part of the responsibility you have to your practice as an artist. You can't live off of grants alone, but you owe it to yourself to consider fundraising as one of the support columns in your art budget. In combination with other sources of funding, grants will help you realize your very best work. Attracting support from other organizations and individuals also creates new partnerships. In a sense they become an integral part of your project. They are invested in your success, and the resources they provide will help you make it happen. You are no longer alone.

Funding will come from either public or private sources. Public funding is the money budgeted for the arts at all levels of government. Much of it is passed on to artists through state and local arts councils or agencies. Because the source of the funds is taxpayer dollars, public funders are interested in distributing money to a wide variety of artists and projects. They shy away from supporting controversial, sexually explicit, and political work. Their granting process begins with widely published application guidelines, and selections are made through peer panel review.

The other source of funding is private. This encompasses foundations, art service organizations, art centers, corporations, and individual donors. Foundations are created for the purpose of giving money away. They maintain a reserve of funds called an "endowment," which is invested in stocks and bonds to grow and earn income for them. A foun-

dation is required to distribute a portion of their investment assets (generally 5 percent) each year in the form of grants. Thus, if Wall Street has a good year, they have more money to give. When Wall Street has a downturn, such as the recession and financial meltdown of 2008, there is less money available for everyone—artists and all nonprofit organizations alike.

Art service organizations and art centers may have an endowment to help finance their grants, but they also raise funds from other sources, such as government, foundation, and corporate and individual donors. Their ability to subsidize artists is based on their collective fundraising efforts. They will target corporations for program grants or to purchase blocks of tickets to benefit events. They also cultivate individual donors and send regular appeals for funds to their contact list. Contributions from individual donors can vary widely each year, depending on their overall financial health and interests. Some save most of their decisions for the end of the year, when they receive bonuses and feel most charitable. Ever notice how many fundraising letters you receive in December?

Government programs, large foundations, and art service organizations all follow a similar grant-making process: published application guidelines and peer panel review. Funding appeals to smaller foundations, corporations, and individual donors vary. Often it is a more informal process, requiring only a letter of request. Their funding decisions are made by the members of the board of directors, the CEO of the corporation, or simply the donor.

There is no single approach to seeking funds for your work, so you need to employ a flexible strategy, being mindful that every funder has a different mission and purpose. With careful research and planning you can find varied funding opportunities.

Types of Support

What kind of support are you looking for? Most artists quickly jump to the notion of "Show me the money." Actually, besides receiving money for your work, there are many other ways you can secure support. It's to your advantage to think broadly about your needs and to put together a

mix of options. Below I will define the categories you should consider and the benefits of each.

AWARDS AND FELLOWSHIPS

This category covers money that is given directly to individual artists to help them continue making their work.

Awards and fellowships may come from government agencies, such as the annual grants provided by your state or local arts council. Some foundations also provide these kinds of awards. In addition to the Pollock-Krasner Foundation, other examples are the Elizabeth Greenshields Foundation, the George Sugarman Foundation, and the Aaron Siskind Foundation. These awards are based on the quality of your work and your past achievements. Your use of the funds is relatively unrestricted.

Because of staff time and overhead required to administer large numbers of grant applications, increasingly foundation awards are open only by nomination. Some examples are the Joan Mitchell Foundation, the Louis Comfort Tiffany Foundation, and the most prestigious, the John D. and Catherine T. MacArthur Foundation (also referred to as the "genius awards"). Art professionals, such as curators, critics, and art administrators, are asked to nominate eligible artists for the award. The artists are contacted by the foundation and asked to submit materials, which are reviewed by another panel of art professionals. By working with a preselected pool of artists, a foundation needs less administrative staff, and more of their income can be distributed as grants. I know how frustrating it can feel to be unable to apply to these organizations. This is why your promotional efforts, discussed earlier in the book, are important. Making sure a variety of art professionals are kept informed of your work will increase your chances of being a nominated artist.

Fellowships and awards are important signifiers that you have achieved a new level of peer recognition. They are generally the easiest to apply for, as you already have most of the materials in hand: your artist statement, images of your work, work sample descriptions, and résumé. The hard part is selecting the right mix of images and words to accompany them that will present your work effectively in the few mo-

ments they are flashed before a panel. I'll say more about the panel process a little later in the chapter.

PROJECT GRANTS

These are grants given to an artist to support the creation and production of new work. The funds must be used for the purpose for which they were requested.

Initially, this grant category arose to meet the needs of artists making site-specific temporary installations and public projects and those working in new media. These kinds of grants are obtained from organizations oriented to project-based work, such as the Creative Capital Foundation, which funds artists of all disciplines nationally, or the Jerome Foundation, which supports artists living in Minnesota and New York City. Many state and local arts agencies also have project-based grants as part of their funding menu. Nonprofit galleries, museums, and arts organizations will mix public funding with private to offer artists grants for installations and commissions of new work. These grants seldom cover your entire project budget. In fact, most funders don't want to be the sole support for your project and expect that you will be seeking funds and services from other organizations as well. Knowing this upfront and plotting out a plan of multiple sources of support for your project from the beginning are crucial to your project's overall financial health. Think of it as seeking a team of partners to assist you.

Oftentimes painters, sculptors, and photographers do not consider their work project-based and immediately conclude that they are ineligible for these kinds of grants. Don't be so fast to count yourself out. Look carefully over the guidelines and then at your work. See if you can describe what you wish to accomplish over the next year or two in research and development terms, such as proposing a series of works investigating an idea, concept, or process. Once you identify those features, write a statement that describes them as a project. For example, "I will investigate [idea, concept] through a series of ten to twelve modular sculptures created by [process, materials, scale]." Then create a

project budget that covers the expenses of making these works. We'll discuss how to set up a project budget later in the chapter.

FISCAL SPONSORSHIP

Another option is to work with a nonprofit organization that sponsors your project and agrees to receive and disperse funds you have raised for it.

Tarzan Lopez is the second part in a trilogy of family projects done in collaboration with my father, Mario, and my younger brother Igal. Each component of the trilogy is presented as both a book and an exhibition. Through NYFA's Fiscal Sponsorship Program I was able to approach foundations that do not ordinarily allocate money for individual artist projects. I was then able to raise part of our publication budget in the United States. Subsequently, I used this capital as leverage to obtain additional funding for the project in Guatemala. The publication of Re-trato *paved the way for our second book, which also benefited from NYFA's sponsorship. The third and final part of our trilogy will be completed in 2010.*

—Jamie Permuth

This is not exactly another category of support, but rather a way to access many more fundraising opportunities for project-based work. Most foundations and corporations are set up so that they cannot give money directly to individual artists. Their grants are restricted to the nonprofit community. Having your project under the "umbrella" of a nonprofit organization will allow you to overcome this obstacle and open up many more funding possibilities. Performing artists and filmmakers have used fiscal sponsors to help them raise money for their work for years. It's a good tool that visual artists can use as well.

This is how it works. A nonprofit organization agrees to be the fiscal agent for your project. Using their 501(c)3 status, you do your own fundraising. Grants and awards do not come directly to you but are sent to them. They deposit your funds into their bank account for dispersal to cover only valid expenses for your project. In a sense, a fiscal agent is like a nonprofit bank. The nonprofit does the bookkeeping for the project and files any forms necessary with the government. This creates a fair amount of work for them on your behalf. They are legally responsible for the funds received and for ensuring that the artist uses them properly. To cover these expenses, fiscal agents will collect a fee, generally 5 to 10 percent from any funds raised.

The New York Foundation for the Arts (NYFA) has set up a fiscal sponsorship program open to artists anywhere in the United States. They are currently sponsoring over three hundred artists' projects; one of

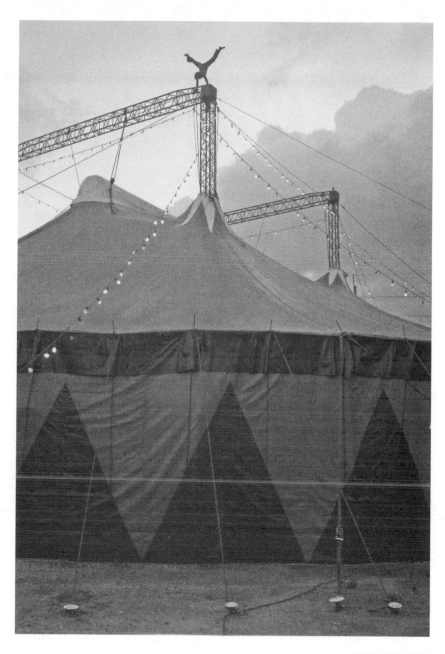

JAIME PERMUTH

Untitled

From the series *Tarzan Lopez*, 2005

Photographic project exploring
the life of Guatemala's largest
traveling family circus, Rey Gitano

13 x 9 inches

Photograph by Jaime Permuth

them was the development of this book. On the previous page is another NYFA sponsored project by photographer Jaime Permuth.

You don't always have to go to an organization with an established program of fiscal sponsorship. If you are already doing a project with a nonprofit organization, you can use their 501(c)3 status to raise funds and have them accept the grants on your behalf. Make a list of the foundations, corporations, and individuals to whom you want to send a request for funding or solicit donations of materials and services. Meet with your nonprofit venue, and see if they are willing to help you make these contacts and accept funds, materials, and services for your project. They will be able to advise you if your request overlaps with any funding they are seeking from the same organizations and individuals. They may also have already established a relationship with these funders and can help you make a connection or get an appointment to speed up the process.

INDIVIDUAL DONATIONS

Individuals account for more that 80 percent of charitable giving. That includes all donations, not just those to the arts. You can plan ways to attract individual donors. If you are working with a fiscal sponsor, you can send out a fundraising letter to friends and family asking for tax-deductible donations for your project. Suggest a range of donations—say, from $25 up to $1,000—so that even the most modest donor can participate. Their checks are made out to the organization acting as your fiscal agent, with a notation that the donation is for your project. The organization will then send them an acknowledgment of their tax-deductible contribution.

You can also solicit funds from private individuals without a fiscal sponsor. Many an artist has accepted donations from his core support group to help finance his work. When seeking individual donors, it helps to give them an overview of your project and then ask them to fund something specific from your budget, such as hiring a fishing boat to photograph seals in Nova Scotia, round-trip airfare for a three-month artist residency in France, archival framing for a series of pastels in an

upcoming show, crating and shipping of your show to Alabama, printing of a sixteen-page catalogue to accompany your installation/solo show/project, or the purchase of professional editing software. This list is limited only by your imagination. In your letter or meeting with a prospective donor, show how your request fits into and benefits your goals. Donors will be more inclined to contribute if they can see specifically how their donation helps them be a part of your project.

When artist Jody Lee needed to rent a large studio for a year to realize a new body of work, she decided to elicit help from her core support group to raise half of the monthly rent through their funding commitment. Jody began by considering why someone would support her proposal (sidebar).

She then gave her funding project a title, *Partisans of the Studio*. She thought long and hard about whom she could approach, what she could offer them in return, and how to pitch her request. She was uncomfortable asking for money from these private individuals without offering something tangible in return, so she decided to frame her request as follows: in exchange for their cash donations, they could choose art for their collection from a series of her drawings.

Through this project, Jody not only met her goal and accomplished a year of productive studio work, but forged a deeper bond with her core support network.

Remember that every donation doesn't need to be large. Small amounts of funding from a number of individuals can make a difference too. One way individuals and organizations are tapping into small donations is through online organizations set-up to collect donations for specific requests. One such organization is Fundable (http://www.fundable.com). You can post a description of your need and ask for donations within a specific time frame—say, two weeks. You send this information to everyone on your list, and they can respond by making pledges. If you meet your goal within the timeline, the pledges are collected by the Fundable staff and turned over to you,

I didn't want them to feel like they were helping bring something about so much as support something that is already fully there and would be taken further with their support. . . . So I made a booklet out of those studio photographs, printed them on Shutterfly, and put that in a portfolio, where I included my pitch letter. I wrote many drafts of that letter, and included whatever press I had and my c.v.

My idea was to ask them to parcel out their support by sending me money either quarterly or bi-annually, so it wasn't just, "I'm so deserving; send me your money." It was really like, "Let's make this alternative arrangement supporting the studio in its entirety as a field of inquiry." What I was asking of them was to support the whole endeavor of the studio in a wider sense than purchasing individual pieces from shows. . . . I thought that this would be a really interesting way to get the work to people. That turned out to be one of the best parts. . . . I could sense they were happy to be a part of it, because they were included in that process like important investors, which they were. Artists don't realize how valuable it is to people who are not artists to get close to the process.

—Jody Lee, artist

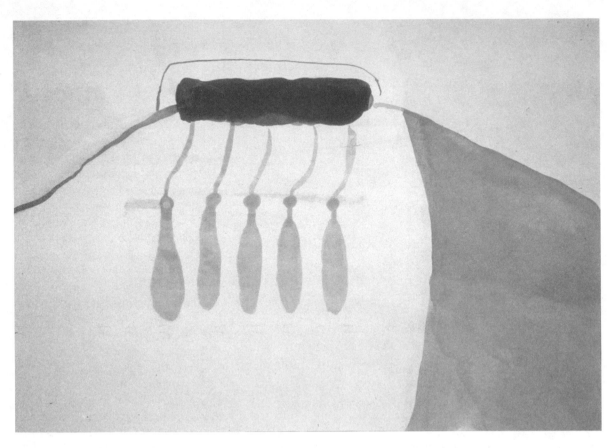

JODY LEE
Counting Your Chances in Sleep,
2007
Gouache, graphite on paper
9 x 12 inches

less their 7 percent administrative fee. If you don't make your goal, then the pledges are erased, and the donors owe nothing.

You can also throw yourself a benefit. Almost every nonprofit organization hosts benefit events each year. Benefits are festive galas, dinners, parties, and insider previews, designed to promote the organization and enlarge their circle of support by providing a pleasurable experience for contributors. You can throw your own benefit party. It can be similar to an open studio event but with something special thrown in, such as serving exotic cocktails or your grandmother's famous lobster bisque. You can use this opportunity to show off new work or a project in progress. Everyone attending buys a ticket to the party, and you watch your expenses to allow a profit from each ticket sold. For example, the benefit ticket is $45, while your expenses are $15 per person, which brings in $30

per person to your project. If twenty friends and family come to your benefit party, you have made $600 toward your project budget. You can offer different levels of support; for instance, donations of $100 or more might include a limited-edition digital print of your work. You may find that some of the people unable to attend will still send you a donation. Besides raising money, you will have attracted a lot of silent partners committed to your project. They have invested in you.

DAVID POLITZER
Storytelling: My DVD Intro, 2005
Color video with sound, 2 min.

ARTIST RESIDENCIES, STUDIO WORKSPACE PROGRAMS, TECHNICAL ASSISTANCE

These are organizations providing time, space, and assistance for you to do your work. They encompass get-away-from-it-all artist communities, such as a month in the New Hampshire countryside at the MacDowell Colony, where your only responsibility is to make art. Your lunch may even be delivered in a basket outside your studio door so your work isn't interrupted. Visual artists, writers, and composers intermingle, share ideas, and network in the evenings. Some residencies are even longer, such as the Provincetown Workshop on Cape Cod, in which artists are provided an apartment, a separate studio, and a monthly stipend for seven months, or the year-long program in Roswell, New Mexico.

There are workspace programs that provide facilities, access to special equipment, and technical assistance in addition to a place to stay, such as Sculpture Space in Utica, New York, or the J. Michael Kohler Center in Sheboygan, Wisconsin. Diana Al-Hadid was one artist who benefited from a residency at Sculpture Space. Commenting on her residency, Diana said,

I just finished the Roswell Artist in Residence, which provides a studio, a place to live, and a monthly stipend for a whole year. It isn't easy to pick up for a year and set aside the life you've created, but I had just gotten married, and my wife and I both really love the Southwest. So when they mentioned that they might have a studio for her too, we began to think of it as a year long honeymoon with the ability to dedicate almost all of our time to our work.

For me, it came at a good time. My money/job/rent situation was getting tight. I had no studio, and I had two shows to prepare for. So the idea of living expense-free for a year, in a nice new house with a large studio, was very appealing. Because of the facilities here, I was able to be much more ambitious about my work. My projects got bigger, and I was able to build sets for shooting video.

—David Politzer, artist

The combination of twenty-four-hour access, flexible workspace, and access to specialized equipment allowed me to complete three large-scale projects, a task which would have been virtually impossible to accomplish without the facilities, resources, and time made available to me. It is crucial for an artist to have time to make important mistakes, to work in the manner and the mess of their own choosing, to invent and expand their collection of artistic weaponry, and to feel generally unconstrained by space and time, so that their ideas can also have the same unobstructed freedom.

We have shop spaces with various types of equipment, from metalworking to woodworking, and a technology studio with computers and software, so artists can create their proposals. Even those [artists] with laptops still come down, because they can set up their own files and use our printers.

—Jeff Becker, artist and executive director of Arts Incubator, Kansas City

Your family or work obligations may be such that going away for weeks or months is out of the question. You may want to research nonresidential programs instead. These programs provide only space to work, access to special equipment, and technical assistance. Just a few examples in the New York area are Eyebeam, an art and technology center for digital research and experimentation; the Lower East Side Printshop, which provides printmaking facilities; and Harvestworks for electronic media projects. You will need to research similar facilities in your area. Many communities have set up free or below-market-rent artist studio programs, such as the Arts Incubator in Kansas City, which provides both studios and facilities.

The opportunity to work undisturbed at an artist residency can be of enormous benefit to your work. Receiving free technical assistance and use of equipment can replace the dollars in those categories on your budget line. The Alliance of Artists Communities (http://www.artist communities.org) estimates that these programs provide $36 million in direct support to artists each year in the form of stipends, travel, materials, room and board, and technical support. There are also international residency programs. For these, you can begin doing your research at Res Arts (http://www.resartis.org), which lists over two hundred programs in fifty countries. Check out what is available through your state art agency. Some states, such as Ohio and New Jersey, have provided funding to reserve spots exclusively for their artists in different residency programs in other parts of the country.

All artists at some point can benefit from getting away or having a "working vacation" at a residency. You can create, experiment, or just hunker down, removed from your regular schedule. Living and working within a community of other creative beings facilitates new friendships, develops your network of peers, and provides fresh feedback on your work. The great news is that this category of support has grown in the last decade. There have been fewer new sources of cash grants created, but many new sources of time, space, and technical support. In just two decades, the number of artist communities in the United States has expanded from less than 100 to over 250 today.

IN-KIND GOODS AND SERVICES

This category covers the donation of materials, supplies, equipment, or professional help. These contributions come from manufacturers, distributors, stores, and professional firms, such as accountants, engineers, and advertising agencies. In fact, New York City has a program, Materials for the Arts, devoted to collecting and distributing goods and equipment to nonprofit art organizations. Last year they collected $3.6 million worth of supplies from local businesses, schools, and theatre companies. Visual artists working with nonprofit organizations can search through their huge warehouse for art materials, picture frames, equipment, office supplies, and furniture.

If your project is being sponsored or presented by a nonprofit organization, go over your list of needed materials and equipment with them, as discussed in the section on fiscal sponsorship. As early as possible, make an appointment with the nonprofit to go over your budget and determine what you need and who might be approached to donate to it. Discuss which community resources they recommend you approach. Most nonprofits don't have the funds to cover the entire cost of your project, so this is a significant way they can be of assistance. It

DIANA AL-HADID
All the Stops, 2007
Cardboard, wood, metal, polymer gypsum, fiberglass, plastic, and paint
68 x 56 x 104 inches
Image courtesy of the artist and Perry Rubenstein Gallery, New York

I kept saying, "We have to raise more money, and whatever we don't raise, the participants share equally." So at every meeting I would say, "Okay, here is the list of what we need. Who is going to ask for this?" That part of it was really hard because none of them thought they could go out and ask for money. . . . We kept hearing "poor us," and we kept saying, "Get over it. You need to empower yourself by learning how to do it." The process was set up to be an inclusive one, where they could learn by doing or seeing how to put together a poster or a press release to promote the sales. . . . You have to get in there, get dirty, do the work, and that's how you learn. You learn from your mistakes, but you also learn by working with somebody.

—Susan Moldenhauer, artist and director/chief curator, University of Wyoming Art Museum

strengthens your request for funds and materials to have an organizational partner. The fact that a nonprofit is sponsoring you assures the corporation or business that your project is legitimate. When the items are donated directly to the nonprofit, the business can take a tax deduction for the cash value of materials and equipment. As a donor, the company also gets their name included in all the written materials associated with your project, which can increase their visibility. Think creatively: cans of paint, yards of fabric, dozens of aluminum tubes, six matching flat-screen monitors, the services of an experienced bricklayer, an airplane ticket to Timbuktu—all of these items could be secured as donations rather than cash outlays. Save your artist fee to pay yourself.

If you are not working with a nonprofit, don't despair. You can still approach suppliers on your own. You can't offer them the tax deduction, but frankly, few people donate just for that reason. They might be interested in donating to you because it's novel, a way to participate in something new and exciting. After all, on the surface the artist's life seems so much more exciting than their humdrum existence. Use the myths to your advantage. If they can't donate the goods outright, you may be able to negotiate for a wholesale price or a deep discount. Either way, you end up with more money in your pocket.

When Susan Moldenhauer and Wendy Bredehoft were organizing the Laramie Artists Art Fair discussed in chapter 3, in addition to each artist committing to a $100 contribution, they were encouraged to reach out to their contacts for additional support (see sidebar).

EARNING MONEY FOR SERVICES

Another way to extend your budget is to offer your services for an honorarium. You can do a lecture on your work, give a demonstration of your process, or develop another topic of interest. Scheduling these events

throughout your project or exhibition helps promote it, and you can use them to solicit volunteers or interns. If your project is being presented by a nonprofit organization, there is often a separate budget for artist talks, and it can help boost the artist or project fee they have already offered. Lecturing about your work enlarges your community of contacts.

The Fundraising Steps

Up until now we have identified the many ways you can find support for your work. The next section will walk you through the five steps of the fundraising process.

1. Clarify your fundraising goals.
2. Research potential funders.
3. Initiate contact through a query letter or request for guidelines.
4. Draft a proposal.
5. Seek feedback, revise, and follow through.

1. CLARIFY YOUR FUNDRAISING GOALS.

You need to regularly analyze what is happening in your art practice and what would help you make your very best work. Identifying the kind of support you need ensures that your time and energy spent raising money will produce meaningful results. Unfortunately, many artists only think about fundraising when a situation becomes dire. Grants, residencies, donations, and technical support don't show up immediately in response to an emergency. Yes, from time to time urgent situations may arise; no amount of planning protects you from that. But you want to minimize unnecessary emergencies by taking the time to determine your needs, set your fundraising goals, and then follow through with the plan.

To be able to create a competitive proposal and have it land on the appropriate funder's desk, you first need to know what you want to

accomplish. What is your goal? How does it connect with what you have done in the past and with your future plans? Then identify the intermediate steps and the resources needed. Now you are ready to determine what kind of help you are looking for. It might be a residency, technical assistance, and the funds to purchase an expensive piece of equipment. Decide where this support fits into the timeline of your project or studio practice.

If your work is installation and new media–based, most of it will revolve around a planned project. If you are engaged in painting, drawing, printmaking, photography, or sculpture, frame a project around a series of works to be completed within a particular span of time. Even if your tendency is to resist setting production-oriented goals to retain a more unstructured, experimental practice, identify what kind of help would support it. You want to be able to fold your current needs into those that are long-term. If you skipped the goal setting exercises in chapter 1 because you refuse to be tied down, it wouldn't hurt you to try them now. Allow yourself to think broadly and imaginatively. Talk your plan over with friends for additional advice and feedback.

2. RESEARCH POTENTIAL FUNDERS.

Now that you have a better understanding of what you are looking for in the way of support, you need to research and identify potential funders. The easiest place to begin your research is the "NYFA Source" section (under the tab "For Artists") on the website maintained by the New York Foundation for the Arts: http://www.nyfa.org. Don't let the name fool you; this organization isn't just about New York. They have spent years building a comprehensive database of opportunities throughout the United States for artists of all disciplines. You can do a search for funding based on many criteria, such as local and national awards to individual artists, project-based grants, artist residencies, and other forms of support. The most amazing fact about doing web-based research is that one organization can lead you to discovering others and direct you to opportunities you hadn't envisioned.

Another good online database is maintained by the Foundation Center (http://www.foundationcenter.org). It was set up to assist nonprofit organizations in all fields in their fundraising research. Besides providing guidelines on proposal writing, they also offer daylong seminars on fundraising topics at libraries throughout the United States. To help support this vast site, some of their services, such as their database of organizations that give money to individuals, require you to subscribe and pay a small fee. One way to circumvent the fees is to check with your local libraries, especially those at colleges and universities, and see if they are subscribers to the Foundation Center database. A librarian may be able to set you up at a computer terminal that gives you access to the entire range of tools and services the Foundation Center provides.

Free information on all foundations is also available on the Foundation Center's website. Most of it resides in the 990 forms that funders file each year with the IRS, which is scanned into this database. Don't be alarmed when you see your first 990. They can be the length of a short novel—I've seen ones over a hundred pages long. Just scroll through the pages to find the board of directors list, staff list, mission statement, and contact information. Skip over the operational expenses and investments to get to the pages that list every grant awarded that calendar year and the amounts. Many smaller foundations do not maintain a website or publish grant guidelines, so their 990 forms are where your initial research must take place.

You can also identify possible funders by doing a reverse search as well. Look at artists with needs and work like yours, and research who has supported them. You will see these supporters listed in exhibition programs, press releases, catalogues, websites, and artist résumés. When I was directing the Rotunda Gallery, I always checked out the funders of the other nonprofit spaces to find new foundations, corporations, and individuals interested in giving to the arts. Research the funder in more detail, as outlined above. If you know the artist, contact him, and ask for his advice about a particular funding source. He may have information that helps you get the grant, or be willing to let you read his successful proposal. He may even offer to introduce you to the

funder, to call or write a letter on your behalf. A letter of recommendation for your project from a previous grant recipient carries a lot of weight with a foundation.

Find out background information about the organization. While researching potential funders, make sure to carefully read their mission statement or statement of purpose. While reading, ask yourself these questions: Does it mesh with my goals? Do we have some common ground? Identify your project's strengths, and determine what you have going for you that would attract this funder. It is crucial to match up the interests of the funder with yours. This is another situation in which you should not attempt to fit your round art into their square mission. If you aren't a good fit, then don't apply; it's a waste of time. They aren't going to change their mission to suit your project, no matter how valuable it is.

Also, check out whom they have funded in the past. This information is often available on their website, or you can look up the 990 forms they must file each year with the IRS (also in the Foundation Center's database). Seeing who received a grant and how much they were awarded will help you determine if the funder is a good match for you and what would be an appropriate amount to ask for in your proposal.

Sometimes you do all this research to find that a funder isn't appropriate for you right now. If you feel that this is an organization that you may apply to in the future, begin building some visibility with them. Put them on your contact list so they can begin receiving information about you now. When you apply for a grant later on, they will already have some familiarity with your work.

3. INITIATE CONTACT THROUGH A QUERY LETTER OR REQUEST FOR GUIDELINES.

Once you have identified potential funders and have downloaded or received an application, make sure you sit down and *carefully read through the guidelines and directions*. I pull out a highlighter marker and isolate important passages. I write down questions that arise about the applica-

tion as I read through it. If the application guidelines are online, and increasingly they are, I suggest you print out all this information to ensure a careful reading. One of the biggest mistakes artists make is not to follow the instructions. It's easy to skip important information when reading off your computer screen. A grant proposal is not a place for a devil-may-care attitude. Not adhering to the instructions may disqualify your proposal from the outset.

A sloppy, poorly organized project description that does not follow the guidelines or a budget that doesn't add up will make the funder wonder if your project will also be slapdash and badly managed. Remember, once you make contact with a potential funder, everything you say, do, and write will reflect on how they see your project. Their initial and most lasting impression of you comes from your grant materials.

Another way to contact a funder is to send a letter of inquiry, or query letter. This is a brief letter of introduction no more than one or two pages in length. It includes the following information: who you are and what you have been doing, a brief proposal summary, total cost of the project, and your funding request, as well as a list of other sources of support and/or partners. At the close of the letter, offer to schedule a meeting or a telephone call to discuss your request further. The prospective funder will review it to decide if they are interested in considering a full proposal. This saves you from laboring over a hopeless funding request. If they are interested in receiving a full-blown proposal, their initial questions and comments will also help you tailor it to their specifications.

Sometimes you may wish to talk to a funder to determine if your request is a good match for them. Call or email to arrange a brief telephone conversation with a program director at the foundation. When you speak with him or her, be prepared to briefly summarize what you are doing and the funding you are seeking. Make sure you have done your homework and can relate your project to others they have funded. A conversation like this may provide you with good unpublished information that will help you determine whether to stress one aspect of your idea over another in your final proposal. It also shows that you are

doing serious research into finding the right funding partner for your project. Your finished proposal is thus preceded by a connection already established via your preliminary conversations.

Your proposal presents your project (or your request) clearly and compellingly in words and numbers.

—Aaron Landsman, theater artist

4. DRAFT A PROPOSAL.

Now you are ready to draft a proposal. A complete grant proposal is a package of information about you and your work. It contains some of the same elements as your artist package developed in chapter 4, which you use to introduce your current work to obtain exhibition opportunities. Where the proposal package differs is that the goal here is to propose something for the future. All of the information within it is designed to describe and support that project through the following documents.

- **Cover letter:** this has the "ask" right at the top and briefly summarizes the proposal contents.
- **Project description:** this is a one- or two-page description of what you are doing, why it's important, and your goals for the project.
- **Work samples:** these are images, drawings, and sketches of past work and the proposed project, with work sample descriptions.
- **Budget:** This is a list of proposed expenses and income.
- **Support materials:** These include your résumé, press clips, and recommendations.

While the list above addresses the order of documents to be arranged in your proposal package, it shouldn't be the order you create them. Although the cover letter will be the first item in your proposal, it is usually the last document you create. Below is a suggested order for you to follow to develop these elements in your proposal.

Write a project description. The project description is a written statement that will lay out the scope of your project and its importance. It should

be no more than one or two pages in length. Just like an artist statement, a well-written project description will encourage you to think thoroughly and deeply. It enhances your planning and builds a foundation for the passion you feel for your project.

To get started on a project description, brainstorm a list of all the points you could make to help describe what you wish to do and why it should be supported. Don't be alarmed if your mind goes blank and in despair you think what you want to do isn't important and doesn't deserve support. Calm down. Go back and read your artist statement. There may be parts of it you can cut and paste to help build your project description. Read through what others have written about you, and use their words to help generate yours. Go back to the writing exercises in chapter 2, and do them again for this proposal. Invite a few friends over to help you brainstorm additional information.

Make sure you use an active voice that states what you will accomplish with this project. Identify any confirmed partnerships, venues, and collaborators that will strengthen your request. Go back and review the funder's guidelines, convert their language into your own words, and, when appropriate, incorporate it into your proposal. This will help reinforce the link between your ideas and their funding mission. Below is a list of questions that your project description needs to answer. They are the questions the grants officer or panelists will be asking themselves as they read it over. Use the ones that best apply to your proposal.

What does this project mean to you and your work?
How does it respond to or address a current issue or need? How does it solve a problem?
What are your goals for this project?
What is most compelling about your art or your project?
How will it interact with or fill a need in the community?
What, in the broadest sense, would a donor be supporting in this project?

Below is the project summary for *HighWaterLine* that environmental artist Eve Mosher used to introduce her grant proposal. Notice how

EVE MOSHER
HighWaterLine, near Brooklyn Bridge, Brooklyn, New York, September 29, 2007

Photograph by Hose Cedeno

many of the above questions it answers in just one short paragraph. Creating a succinct project summary, just like writing an artist statement, requires a lot of messy drafts and significant time spent in careful editing. Eve worked on her project summary for six months, writing and refining with each grant application:

HighWaterLine is a public art performance and installation that will cover over 60 miles of the New York City waterfront. *HighWaterLine* creates a visible and local understanding of the threat of climate change. For *HighWaterLine,* I will walk along a 10-feet above sea level line, drawing a 4-inch wide blue chalk line, and interacting with community residents. I will trace the areas at risk to increased cycles of flooding and storm surge resulting from global warming. I will have an opportunity to discuss climate change with people whose neighborhoods (where they live, work and/or play) will be most affected. This personal interaction is the most powerful way to impact people's thinking about climate change.

Once you have composed a draft of your project description, test it by asking one or two people to read it over. Then have them orally summarize your project. Their synopsis will give you a good idea if your writing is clear and sufficiently specific in its description. Did their summary include your main points? If not, strengthen the description to make those points apparent. Show your test readers the mission and the criteria for selection from the funder's guidelines. Have them confirm that your project description satisfies the requirements and is a good fit with the funder's interests. Having another set of eyes look over your proposal will help you evaluate it from the point of view of the funder (the grant officer, program director, or funding panel). Based on their feedback, you will be in a better place to clear up any discrepancies.

THE ARTIST'S GUIDE

Compose a budget. Ah yes, the dreaded budget again. The budget represents your project as a list of anticipated expenses and income. A budget is just another planning tool, a numerical view of the proposal. A list of expenses will help you forecast what it will take to get the project done. As discussed in chapter 6, determining the actual costs of our practice can create fear and anxiety. These uncomfortable feelings in turn make us unwilling to confront them. Anxious to get going, many artists would rather skip creating a budget and recklessly proceed to the "pay as you go" model. This approach seldom results in a well-funded project. A list of income sources will encourage you to make a plan to raise the support needed. A funder needs to see how the expense and income figures relate to the project description. Their donation to you is an investment, and like any careful investor, they want to make sure you have clearly thought through the financial part of your project. If a funder is equally interested in two different artists' proposals and can only fund one, they will support the one that looks most likely to get done.

Knowing the financial reality, no matter how scary the bottom line, will help you commit to taking the necessary steps to meet the needs of your project. It may mean lengthening the project's timeline in order to raise sufficient funds to accomplish it well, instead of cobbling together what you have and going into debt just to meet your original schedule. The reality of the numbers will push you to do more funding research and consider alternatives to cash, such as donated technical assistance and in-kind goods and services. Just like setting goals, you can't get to "there" unless you know where "there" is. You then need to figure out how much it will cost and how you intend to pay for it.

If you begin this process by determining what you want, you stand a better chance of getting it. Aim high. Start by creating your dream budget. I refer to this as the "fairy godmother" budget. It encompasses all the resources you need to do this project well. What would your

When looking at your writing, see if it answers the following two questions: What it is (this can be on the most basic level, i.e., "It is a series of large-scale oil paintings based on Calder") and why are you making this work now? (This could be for political, personal, or other reasons.) Or what about this work keeps you up at night? Program officers who read many statements at once often say that artists write very intellectually about their work and forget to instill the reader with the passion for it. The "why" is the passion.

I think also [have] someone read the proposal who maybe doesn't know your work as well as you do, or doesn't know your work as well as your best friend. I sometimes show my wife my proposals when she is in a real hurry because she is not a huge reader. She doesn't enjoy reading the same way I do and doesn't sit on panels and read a lot of proposals like I do. So if she can read something in a couple of minutes and say here, here, and here are the problems or here's where I am really engaged, that helps me a lot.

—Aaron Landsman, theatre artist

budget look like if all you had to do was wave a magic wand and the resources were there? Your dream may encompass employing three full-time assistants, the consulting services of an engineer and a publicist, the rental of a cherry picker, professional documentation, and a beautifully designed, thirty-two-page catalogue.

You also need to know the hard numbers to be prepared and flexible if you end up getting only part of what you need for the project. At the same time that I prepare a fairy godmother budget, I also pencil in next to each of those figures Cinderella's numbers. These are the vital resources needed for this project to be accomplished well. What is so essential to the project that it can't progress without it? What is expendable? Look at each item, and think what the alternative might be. Some of the fairy godmother budget lines may go down to zero on Cinderella's side. Hiring a publicist, professional documentation, and those full-time assistants will happen only if you can raise enough money, but the project can't happen without the cherry picker and the engineer, so they stay, no matter what. Your alternative plan is to hire one assistant, use free interns, do the publicity and documentation yourself, and do a brochure instead of a catalogue. These penciled in numbers will calm any panicky feelings associated with the dream budget and provide a range of funding to shoot for.

Create an expense budget. Create an expense budget on a spreadsheet, beginning with a list of expenditure categories. Think through the steps of your project carefully, and ascertain at each point what will be needed, so you don't leave out something important. Some examples of these categories are below; each one could be broken down further if necessary.

> **Artist Fee:** See next page for how to determine this.
> **Assistance Fees:** Estimate the help you need and rate of pay (per day or per hour).
> **Materials:** Break out only big items, and group all the little ones together.
> **Equipment Rental/Purchase:** Note that some funders will not support equipment purchases.

Shipping: Get several estimates for crating and shipping, and use the middle figure.

Consultants: List engineers, technical advisers, etc.

Administrative/Overhead: This includes office supplies, postage, insurance, etc. This is often not included in an artist's budget. Whether you work out of your home or in a separate studio, figure out the value of your workspace (telephone, computer, printer, rent), and include it in the budget based on the percentage of the time and space devoted to the project. If you need to purchase additional liability or art insurance, list this as a separate line.

Travel Costs: Separate out air/train/car from lodging.

Documentation: This includes still photography and/or video supplies and services.

Advertising/Promotion: This includes a printed brochure, postcard, catalogue, website, paid ads, and the services of a publicist.

Contingencies: This should be 5 to 10 percent of the total budget. This is another often-forgotten budget line. It will provide a cushion to cover increased material costs and unexpected needs.

Figuring out an artist's fee—otherwise called "paying yourself." In every project you need to consider how to pay yourself. This is an artist's fee, with its own line on the budget. Feeding your project by starving yourself is a recipe for disaster. A funder expects to see this expense on your budget, so don't eliminate it thinking that they will reward your selfless commitment. Instead, they will see it as a sign that you do not think of yourself as professional. Be prepared to answer the funder's questions on how you arrived at your artist's fee.

How do you determine the value of your work on the project? For some grants the artist fee is already established, or there are suggested guidelines, but for most of them, you will need to figure it out yourself. The goal is to compensate yourself fairly for the time you commit to

your project. There are two ways to do this. The first way is to calculate your fee as 15 to 25 percent of the total project costs. Which side of the percentage range you use is determined by the size of your budget and the amount of work you will be doing. Big budgets may use 15 percent, while smaller ones, which contain a similar amount of work for you, may be closer to 25 percent. The other way to determine your artist fee is to calculate the time you spend on your project based as a percentage of your annual or monthly income. For example, if you estimate that you will work full-time for six months on this project, your artist's fee is one half of your "annual salary." It would be represented in your budget as: artist fee for six months ($35,000 x 50%) = $17,500. If you will be working on the project while maintaining an outside job or freelancing, you may want to calculate a day rate and figure what percentage of the week will be devoted to it. Artist fee: 2 days/week @ $250 per day x 20 weeks (2 x 250 x 20) = $10,000. Don't forget to include your time spent fundraising. That's part of the whole package.

Time is also the other thing artists need to consider. They think, "Well, I'm not going to ask for a fee on this project, because I want to do it so badly." And I think that that's a huge mistake. Your fee should be somewhere between 15 and 25 percent of the budget. Before you have to do a budget for a proposal, you should certainly find out what the program administrators consider admissible fees for the budget.

—Jennifer McGregor, director of arts and senior curator, Wave Hill, and former director, NYC Percent for Art Program

At this stage of the project, most of your figures are estimates. Do just enough work to feel comfortable with the numbers you are putting down. If you know that you'll need five thousand cement blocks, call the supplier to get a real figure. Calculate inflation into your numbers if the project will happen a year or two from now. When you are done, check to make sure you haven't left anything out, and then add up the expenses. The bottom line of the dream budget may make you want to run away and forget about this project. Hang in there; there's hope. Remember the Cinderella budget? Pencil in those bare bones figures, and add them up too. They will look reassuring.

Knowing the range of support you need to secure for your project will allow you to set funding goals. What you hope is that your fundraising efforts will allow you to proceed comfortably near the levels of your dream budget. At the same time, you have established a backup plan to raise enough funds to cover the essential parts. *Art doesn't materialize out of thin air. Someone somewhere is paying for it to happen.* You want

to avoid having that someone only be VISA, MasterCard, or American Express. As I have said many times before, if you don't know what you need, you can't ask for it, and you can't work toward it. Save the sense of mystery and surprise for your creative process; keep your budget firmly grounded in reality.

Figure out your income. The budget item "income" is a list of all the potential sources of revenue you will be targeting for your project, and demonstrates how you intend to cover the expenses. Make an inventory of whom you are planning to ask for funding and any promises of support you already have received. The income categories are below:

Artists often undervalue what they are doing in the studio, but then when they get to a point where they might hire somebody to help them and they figure out what they have to pay that person, it's like a shock. It's like, "You want to get paid this just to gesso my panels for an hour or two a day?" Then you start to get a sense of what it's really worth.

—Jaq Chartier, artist and cofounder of Aqua Art Miami

> **Earned Income:** This includes limited-edition print sales, ticket sales, lecture fees, DVD sales, etc.
>
> **Government Grants:** List all applications to national, state, and local government agencies.
>
> **Foundations:** List all foundations you plan to send a proposal and the amount requested.
>
> **Contributed:** These are cash contributions from individuals and corporations. If your venue has committed to an artist fee or project fee, list it here. You can choose to list your equipment purchases as money contributed to your project.
>
> **In-Kind Support:** This includes donations of materials, equipment, supplies, and services. Estimate the fair market value. Make sure it is accounted for on the expense side of your budget for the same amount. This may include your in-kind donations, such as covering the administrative expenses and studio rent yourself.

The income side of your budget will indicate the current status of each funding source. Grants you have applied for which have not yet been decided will be listed as "pending." Grants and contributions that have been approved or received are "committed." It will strengthen

Because the project crossed over some boundaries outside of the art world, one of the things I did was investigate organizations and arts organizations working on environmental issues. I emailed everybody that I talked to first. I would introduce myself, introduce the project, and then ask for a very specific follow-up. I was reaching out to community boards and arts organizations, environmental organizations, and city agencies. Usually, in the first initial email I would look at their schedule and say, "I would like to present at your upcoming meeting at such date." Sometimes they would respond to that, sometimes they wouldn't, and sometimes it took a follow-up call. The biggest things I credit for making the project happen were never taking no for an answer and [telling] everybody about the project. Frequently, I would get community boards that would say, "We're not interested in talking to you. We don't want to hear about it." It was terrible. It was no, no, no the whole time, and I never took no for an answer. And as far as telling everyone about the project (and I mean everyone), I've made some fantastic connections doing that. Sure, I probably could have done the project on my own, but it would have been a whole lot harder, and it wouldn't have reached such a huge audience, which was really the point!

The arts organization that I worked with provided absolutely everything they could. They helped produce the documentary [film], provided volunteers, and provided photographers to document the project. I also reached out to some photographers that I knew and offered to give them an opportunity to take photographs, with the guarantee that it would get picked up, reprinted, and published in press outlets.

—Eve Mosher, artist

your proposal to show that you are looking widely and appropriately for funding, or that you have already successfully secured some support.

Once you have completed your budget, the last step is to examine each line on the income column, and begin a separate list on how you plan to secure the funding. Do some additional research, and reach out to other art professionals for ideas. If you are working with a nonprofit organization, share your budget with them, and discuss resources they can help you obtain.

We artists have a tendency to think we can accomplish much more than is humanly possible within a period of time. Share your fundraising schedule with a more experienced art professional to get his or her feedback. You may realize that in order to solicit grants and make contact with donors you need to extend the timeline. It isn't a step backwards to recognize you can't adequately fund and present your project this year, even if it is disappointing. The ultimate goal is to have the resources to do your best work, so you want to make sure you give it adequate time and money. If needed, take an additional six months or a year to put the proper funding in place, and negotiate with your venue for a later spot on their calendar. It can make the difference between a great project or one disappointingly cobbled together. Remind yourself that it took Christo and Jeanne-Claude over twenty years to finally realize *The Gates* in Central Park.

Don't see it as a failure if you cannot raise all the funds for your dream budget. That's why you have been asked from the beginning to consider your options on what materials, equipment, and services could be substituted or eliminated and still make a good project.

The following is the budget for the *HighWaterLine* project described on page 224. Notice that Eve effectively used a variety of funding sources to satisfy her project's needs.

HIGH WATER LINE BUDGET

EXPENSES

ART MATERIALS / SUPPLIES			
Marker fabrication & materials (50 @ $75/each)		$	3,750
Chalk ($8 bag x 1,000)		$	8,000
Other materials		$	900
PERSONNEL			
Administrative assistant (40 days @ $120/day)		$	4,800
Assistant, chalkline, marker installations (40 days @ $200/day)		$	8,000
Design team for web and print		$	3,000
Artist's fee		$	15,000
MARKETING			
Printing (press kit)		$	2,000
Printing (promotional packet & action packet)		$	6,000
TECHNOLOGY			
Web hosting/domain registration		$	200
ADMINISTRATIVE			
Utilities (phone, fax, Internet)		$	800
Shipping, photocopy and postage		$	1,000
Office supplies		$	500
General liability insurance		$	2,500
Documentation (photography / video)		$	6,000
Administrative fees		$	5,000
SUBTOTAL		$	67,450
Contingency of 5%		$	3,550
TOTAL EXPENSES		$	71,000

INCOME

IN-KIND			
Web designer / developer	COMMITTED	$	1,500
Web hosting / domain registration	COMMITTED	$	200
Documentation (photographer's fee)		$	1,000
Marker fabrication & materials		$	4,000
Print & web designer		$	1,500
GOVERNMENT GRANTS			
New York State Arts Council	COMMITTED	$	1,800
Division of Cultural Affairs	COMMITTED	$	3,000
FOUNDATIONS			
Small Foundation Trust	PENDING	$	3,000
Local Utility Strategic Partnership Grant	PENDING	$	5,000
Large Foundation		$	20,000
OTHER FUNDING			
Individual donations	COMMITTED	$	2,500
Individual donations		$	3,000
Corporate grants/sponsorship	PENDING	$	7,000
SALES			
Markers (25 @ $100 per piece)		$	2,500
TOTAL INCOME		$	56,000

FUNDING REQUESTED

$	15,000

It should be also noted that Eve raised individual contributions by asking her contact list to sponsor essential materials needed for the project and in doing so raised $2,500. She sent an email to her contact list that briefly explained her project and how each contribution would play a role in it. Here's an excerpt from her email solicitation:

> I am drawing a blue chalk line around over 60 miles of New York City coastline. This is to demarcate areas that will be affected by increased storm surge due to climate change. I am drawing this line by pushing around a sports field marking device around the 10' above sea level contour line. Along the blue chalk line I will also be installing a series of lighted beacons in city parks. . . . This project will put me out in the very diverse neighborhoods of Lower Manhattan and Brooklyn. I will be (given the nature of my journey) having discussions with people regarding climate change and what they can do personally to have a positive affect. As you can imagine, drawing 60+ miles of chalk is going to take a lot of chalk. (1,000 bags in fact, at $8 per bag). So this is my first ever solicitation for donations for my artwork! A donation of $50 will buy almost 6 bags of chalk, providing almost 1000 feet of line. $100 donations will pay for the materials and fabrication of one beacon. Donations around $1,500 can help pay for the design of the materials to be handed out (action packets with tips on how to live a more sustainable life).

Assemble support materials. Support materials are your work samples (images or video clips of past work); project drawings, site photos, scale models, or mockups; and résumé, letters of support, and press quotes. A short written description is included with every image (see chapter 2 on writing work sample descriptions).

Don't include too many extraneous pieces of paper in this section of your proposal. A two-page résumé that highlights your career, and one or two good examples of the best press you have received, is plenty. Just like your artist packet, these documents are only the supporting players; the most important elements are your work samples. If you have had a

lot of favorable press, create a single-page quote sheet (see page 119). Keep this part of your proposal lean and focused.

If your images will be projected, make sure you understand how the panel will view them. Find out if the images will be projected one at a time, two at time, or four at a time. This is important information that will help you select the images so they support each other when projected. You want to see their presentation as an exhibition of your work. One image should logically follow another. If several are projected at once, think about how each image will relate to others on the wall. Print out the images you are planning to submit, and arrange them on a larger sheet of paper in the order they will be projected. Shuffle them around, subtract some, and add others until they work well together and present a cohesive statement. If you are including details, make sure they follow or are next to the full-image shots. I cannot emphasize enough the importance of your work samples in the panel process. Oftentimes the panelists will review over a hundred artists in one sitting, allowing only a minute or so for each projection. You want them to be able to scan your work and take away a clear impression of it. It will not serve you to include more than one medium or several series of works, unless doing so supports a specific aspect of your project proposal.

If you are submitting a time-based work sample, make sure you know how long the panel allows for viewing. Make a separate chapter on your DVD entitled "excerpt" that covers the time allotted, and include the entire work so it too can be viewed if time permits. Your excerpt should provide the panel with an overall sense of the larger piece.

Compose a cover letter. A cover letter is an introduction to your proposal. Only one page long, it is the last proposal document you write and the first one the funder reads. Your cover letter is the most important part of your package, as it introduces you to the grants officer and establishes his or her initial impression of your project. Now that you have assembled all the parts of your proposal, you should be able to summarize it clearly and concisely. The very first sentence of the cover letter is the "ask": "I am requesting a grant of $XXX to support my project . . . [project title or what the funds will be used for]." The body of the letter will include a brief

summary of the project and any important features or details that you want to bring to the funders' attention. Finally, you should close the letter thanking them for their time, offering to call and discuss the proposal further or to be of assistance if they have any questions or concerns.

Asking for recommendations. Some awards, fellowships, and artist residencies will ask you to include recommendations in your application. These may be several letters of support from other art professionals that are included in your application or sent separately to the funder. Or they may be a list of three to four names with title and contact information that the organization can communicate with if necessary.

Here are some tips:

- Never use someone's name without asking him or her first. This is good etiquette and important to maintaining long-term professional relationships. I have received recommendations to fill out from the Guggenheim Foundation on behalf of artists I barely knew. Not only was I annoyed, but I had to truthfully report that I wasn't very familiar with the artist's work. That's not the kind of recommendation you ever want a funder to receive.
- Check and confirm that you have the person's correct title and preferred contact information.
- Update your recommenders with current information about your work, and provide them with a copy of your proposal or application. Send them your current résumé and images of your work, or direct them to your website if it is up-to-date. That way, when they compose their recommendation or are contacted by the funder, they can describe your work accurately. It's harder to write or speak with conviction when all they may have to rely upon is fading memories of the work you did years ago.
- Always ask for written recommendations early. It is okay to follow up with a short email reminder a few days before the deadline to make sure they haven't forgotten to send it in.

5. SEEK FEEDBACK, REVISE, AND FOLLOW THROUGH.

Review your proposal with others to get feedback on the quality of your materials and the relevance of your proposal to the funder's guidelines. Keep track of any grant deadlines, and begin preparing your materials long before they are due. Developing a complete and persuasive grant proposal can take weeks. Try to do a little work on it every day or two. Review, revise, get feedback, and follow through on the suggested changes. These activities take time and can't be accomplished successfully when left to the night before a funding deadline. Completing a proposal doesn't mean you can now make twenty-five identical packages at the copy shop and slap a different cover letter on each. In the fundraising community this is called "spray and pray." The same proposal will not work for every funder. But once you have all the elements completed on one proposal, you do have the basic tools for many others. Look carefully at the other guidelines, make modifications here and there, and cut and paste parts of one proposal into another to tailor each proposal to a funder's interests. You may stress a different aspect of the project in your cover letter and project description, or you may highlight a specific part of your budget for which their grant will be used. The bottom line is: always personalize each grant proposal you send out.

The Panel Process

Grants and awards from most organizations are chosen through a panel process. This also holds true for public art commissions and other types of competitions. A panel is a group of knowledgeable individuals assembled by the sponsoring organization to review and make a selection from submitted applications or proposals. This group can also be referred to as a "peer panel." It is comprised of artists (often former grantees), curators, critics, gallerists, museum directors, and representatives of the organization. For public art commissions it may also include architects, city planners, and impacted community members.

The panel process generally goes like this: Applications and grant proposals are received by the organization and go through an initial review

by staff. Some may be declined immediately because they do not meet the criteria for the grant, award, or commission. Those that are complete and ready to go are prepared for the panel meeting. Staff thoroughly read all submissions to help answer questions from the panel. If they have time, they may contact the artist to ask for clarification on some aspect of the proposal. A master list of submissions is compiled for voting. The images, video clips, drawings, and maquettes are organized for viewing by the panel. If possible, the DVDs are tested to make sure they load properly on the organization's equipment. Proposals are photocopied and sorted into packages for each panelist. At the meeting the panelists are given instructions by the organization on the purpose of the grant (award, commission, etc.) and the criteria for selection. Then all the work is presented and discussed. Often the organization has someone there to keep accurate notes of the panel's discussion. Final selection is made through several rounds of voting. The first round eliminates those funding requests without strong panel support. Successive rounds of discussion and voting slowly whittle down the applications to the desired number the organization can award. It's a grueling process and often painful at the end, as each panelist has to make difficult decisions between equally favored projects.

In any sort of selection process, you are looking at hundreds, if not thousands of images. You are only going to have thirty seconds to make a decision about whether or not you want to keep this submission, this artist, in the pool. Maybe, if they do make it past that first round, the other materials are considered. The visuals are the most important material. Often that is the elimination round.

—Lydia Yee, curator,
Barbican Art Gallery, London

For most publicly funded grants, all applications are brought to panel review. To be a panelist for these grants can mean sitting in a darkened room for days viewing thousands of images flashed up on a screen for fifteen to thirty seconds each. It is the only way to get through the volume of applications. Many foundations and public art programs have developed a two-step process of review to bring only the most worthy proposals to the panel. Staff thoroughly review introductory material submitted by artists and make an initial selection to pare down hundreds or thousands of applications to a more manageable number. These artists are contacted and asked to provide a more specific proposal and/or additional information. Because fewer applications are

presented at the panel, each one can be given more time and attention and thoroughly discussed before moving on.

Handling Proposal/Application Rejection

Nobody likes to be rejected. It feels personal no matter how often you tell yourself it isn't. The fact is a door has been closed, and you feel shut out. Allow yourself a few moments to experience the terrible letdown, and *then move on.* It can help to remind yourself that "no" does not mean "never." It can mean lots of other things, such as: "not right now," "not the right project for us," "maybe next year," or "we ran out of money before we could fund all the worthy projects we liked, and yours was among them." If you have applied for a state arts council grant that processes hundreds of applications, you probably can't get feedback about why you were rejected. However, if you have applied to a smaller foundation or organization, you can call or email them and ask if you could get more information about why you were rejected. This is a delicate request that shouldn't be made when you are angry, hostile, or hurt. You don't want to put the funder on the defensive. Your purpose is to uncover any information that would help improve your application the next time you apply. If your funder understands that you are genuinely interested in hearing feedback, they can summarize the reasons why you were not funded or read back to you panelists' comments. Sometimes you may hear that you were very close to being funded, but that there just wasn't enough money to support all the worthy applications. Or you may learn the panel didn't think your proposal met the guidelines, or they were confused as to what you wanted the funding for. Remember that although you didn't get the grant, your work was seen and discussed by other art professionals. It's possible one of them may seek you out for a different opportunity. Even so, no matter why you were rejected, it never feels great. If you can get some insight or information

My experience of being a panelist for a couple of smaller grants is that it's agonizing work, because there are always [great projects that don't get funded]. At Creative Capital if they give out 20 grants out of 125 that have made it to panel, they could easily fund 50 artists and would love to. I can't stress that enough; that there are another 10 at the very least and probably 20 or 30 who haven't gotten funded whose work the panel feels is just as worthy. But for some, they don't quite have the popular support. And there are these hair-splitting decisions that happen and that often it just comes down to a vote: "Well, is it this one or that one?"

—Aaron Landsman, theatre artist

about your proposal, you can do better the next time. Rejection is discussed in more detail in chapter 10.

Final Thoughts

Your credit cards should not be your only funder. When an artist friend called me a few months ago, thrilled to have been awarded a Joan Mitchell Foundation grant, she ended the phone call with "Now I can pay off my credit cards." As happy as I was for her award, I also couldn't help but feel a little sad. I'm glad she's eliminating credit card debt—that's a good thing—but receiving a grant should be an opportunity to jump forward, not play catch-up.

If you still find this process daunting, yet you also know that a lack of funds is holding your work back, hire someone to help you fundraise. After all, that's just another budget line and could be absorbed into administrative costs or consultants. You will still need to do the work of identifying possible funders, articulating your project description, and assembling budget numbers. Doing it with an experienced fundraiser can speed up the process, and you will learn a lot watching him or her in action. There are many art professionals who work as freelance development personnel. To find someone to help you, ask around the nonprofit community for recommendations. Interview candidates about the clients they have served, and ask to see samples of successful proposals they have written. Make sure you feel comfortable working with them and with how your project will be represented. You'll find more information about working with a consultant in chapter 9.

You may think you don't need to apply for grants and fellowships. They are too much work, and you don't want to invest the time. You are foolish if you ignore fundraising. Assembling a grant proposal and budget at the very least facilitates your understanding of a project or a body of work. By submitting a proposal you are receiving much more than a yes or no result. Having your work reviewed by others is an im-

> *You can regurgitate guideline language in your proposal writing, and that is fine because panelists are often looking for a way to advocate for your work with the other panelists. If you have addressed the grant guidelines, then they have an easier time advocating for you because they can look at your application and say, "See, this is a catalytic moment for this artist." And that way anybody who is on that panel or anybody who works for the foundation can then say, "Oh, I see why they are applying for this grant." It lends validity to the argument that you should be given a grant.*
>
> —Aaron Landsman, theatre artist

portant feedback mechanism and circulates your ideas and images among art professionals. You may not get the grant, but you might end up making an important connection with one of the panelists. When you do find funding partners, you have established relationships with art professionals eager to see you succeed. The hardest funder to find is the first one; once someone commits others will be encouraged to support you too.

You probably already know at least one person or organization who could be contributing to your work but isn't. You haven't asked them. Keep the creative decisions about your work under your control, but open up and solicit help wherever else you need it. Remember, you aren't just asking for money; you are offering someone an opportunity to get involved with your work.

Make sure you are following through on fundraising opportunities. A few years back the New York State Lottery had a tagline for one of their advertising campaigns that I love to quote to myself and in my workshops: "If you aren't in it, you won't win it."

Resources

Alliance of Artist Communities: http://www.artistcommunities.org
- A comprehensive listing of national and international artists' communities, colonies, and residency programs.

The Foundation Center: http://foundationcenter.org
- A comprehensive database on U.S. grant makers and their grants. The website features two valuable tools: Foundation Finder, which you can use to search by name for basic information about private and community foundations, and the 990 Finder, which you can use to look up the IRS returns of private and community foundations.

Fundable: http://www.fundable.com
- A website organized to let "groups of people pool funds to make purchases or raise money." Go to their site and see current examples to get an idea of how you might be able to use this resource.

The International Association of Residential Arts Centers (Res Artis):
 http://www.resartis.org
- This organization is based in the Netherlands and maintains a website of international artist facilities with listings from fifty countries.

New York Foundation for the Arts (NYFA): http://www.nyfa.org

- NYFA maintains an extensive database of resources for artists. It is a good place to start your search for grants, fellowships, and residencies. They also have a fiscal sponsorship program available to artists throughout the United States.

How to Read and Work with the Fine Print: Contracts, Legal Issues, and the Art of Negotiation

Valuing and protecting what you have created is part of good art practice. This chapter summarizes your legal rights as an artist and provides basic information on copyright and contracts. It will introduce and familiarize you with some legal terms you will encounter. With this information, you will recognize when to consult with a legal professional. This chapter also introduces the process of negotiation, which will play a significant role in your day-to-day professional life. Negotiation will give you confidence to ask for what you need and promote a healthy artist–art professional partnership. The chapter is organized into two main sections: legal issues covered by federal and state law and how to mediate problems through negotiation.

Be prepared for your art to be bent, folded, spindled and mutilated, as well as copied, unpaid for, lost, and stolen.

Unlike the music or publishing industry, the visual art world still conducts much of its business with artists informally through oral contracts. This wasn't always the case. During the Renaissance, when work was primarily by commission, the relationship between artist and patron was direct and carefully spelled out—from how many figures needed to be included in the composition and the amount of expensive ground lapis lazuli pigment to be applied, down to the daily beer allowance for the assistants. An artist had to be entrepreneurial in order to attract commissions, negotiate contracts, manage budgets, and fulfill the expectations of the patron. It was during the nineteenth century, as patronage, guild, and art academy systems disappeared, that artists moved away from working primarily by commission and direct contact

with collectors. Sales were facilitated through a middle man, the art dealer. Contracts were replaced by written correspondence between the art dealer and the artist concerning pricing, payment, and placement of the work. There were some artists who still insisted on formal contracts. Because of his brief legal training, Matisse had extensive written agreements with his dealers, and this was true even when he was a struggling, impoverished artist. Picasso, once he discovered what Matisse was doing, began to insist on signed agreements with his agents as well.

Up until the mid-1960s, the art world was a smaller place than it is today. Artists made objects in the form of painting, sculptures, drawing, prints, and photographs, which were handled by a sprinkling of art dealers. As our culture gravitated away from communicating through letters to telephone conversations, more business decisions between artists and art professionals were conducted orally. Copyright protection was seldom thought about, as images of contemporary art were not instantly available worldwide in glorious, colorful detail. Today this has changed. Pandora's box is wide open. Artists challenge the very definition of art as an object, and explore ephemeral materials and processes. Images and concepts are released to the Internet seconds after conception. Art is exhibited in every kind of physical space imaginable, which provides artists with the opportunity to be in contact and work with varied art professionals, organizations, and communities. Now, more than ever before, it is imperative that you find firm footing in this uncertain new world and begin to take some basic steps to protect and defend your artistic rights.

Legal issues *will* arise during your career, and watching *Judge Judy* or reruns of the criminal cases in *Law and Order* isn't going to be much help in understanding your situation. What's perplexing is that legal matters aren't decided solely on the law as it is written, but more on how it is interpreted, applied, and enforced through our judicial system. The published case law concerning contracts, copyright, and fair use could fill a small library. Nothing is black and white. More often the law works in shades of grey. Determining if your copyright has been violated and then figuring out what to do about it is confusing. It is equally

baffling to establish how much of an image you are downloading from the Internet can be safely used without violating another artist's copyright. Besides, you don't want to be bothered with these inhibiting thoughts when eagerly creating new work. Worrying about legal issues you might face down the road is counterintuitive to the creative process and is, in a way, getting ahead of yourself.

Chances are you will also face disputes when working with other art professionals. A curator may have verbally agreed to cover certain expenses for your upcoming installation, but if you don't have it in writing, you might be left with a pocketful of unanticipated bills if each of you remembers that conversation differently. You might have an iron-clad consignment agreement with your gallery, but it is a meaningless piece of paper if you won't enforce it when they no longer abide by its terms. Valuing your legal rights is a form of respect for yourself and your work. It's all up to you; no one will do it for you.

I began my career with no information or experience with the legal aspects of my profession. I blithely accepted and signed whatever document came my way, and if one wasn't offered, I didn't give it too much thought. That casual attitude changed when I started the Rotunda Gallery. Suddenly, I was responsible for other artists' work as well as for protecting the gallery's interests. I had to draft loan agreements, commissions, and employment contracts. I had to address insurance and liability issues, and abide by the rules governing nonprofits. Running the gallery and making my share of mistakes taught me to put things in writing. I saw how necessary this step was to establish clarity and help resolve any differences of opinion that might arise later. I began to apply those same principles to my own practice.

That training came in handy a few years later when, reluctantly, I had to resort to legal muscle to get my work and my money from a gallery thousands of miles away from me. They had represented me for five years, and the dealer and I had developed a friendly long-distance relationship. She visited my studio on her New York trips, and we had regular talks on the telephone. I received payment promptly for the frequent sales of my work. Life was good. Then things slowly began to change. The first thing I noticed was that the checks stopped. I wasn't

too concerned, as I knew that sales can be unpredictable. She and I discussed how her business was a little slow at the moment and she assured me that I shouldn't worry about it. After that, it seemed she was never in when I called. It didn't dawn on me until a few months later that she had not returned any of my calls for a long time. Puzzled, I called repeatedly and each time reached voice mail. Next, I sent a letter saying it had been a long time since we had talked and to give me a call as soon as possible. No reply. I knew she was still in business, as I received exhibition announcements in the mail. I felt stymied. She was thousands of miles away, so I couldn't casually drop into the gallery to check on things. I sent another letter by registered mail. It stated that I didn't understand why communication between us had broken down and we needed to talk. Again, only silence from the gallery. I followed up a month later with another letter, this time stating that if we were not going to talk, I needed to have my work returned. It elicited the same lack of response. Now I was mad. Something was wrong, and my long-distance efforts weren't resolving it. I needed help. A good friend connected me to a lawyer in the same city as my gallery. He had me review my history with the gallery and the actions I had taken so far. I asked for his assistance to get my work returned. He was happy to call the gallery for me and would do it for free. I realized that once he made this call, my future with this gallery was over. I also reminded myself that I didn't want a relationship with someone if legal action was necessary to open up a conversation.

Assuming he was a collector, the gallery director took his call. I can only imagine the sour expression on her face when he identified himself as a lawyer representing my efforts to get my work returned. Contact by my lawyer prompted her to break months of silence. She immediately called me to say in a wounded voice, "Well, Jackie, if you wanted your work back, all you had to do was ask for it." I reminded her of my letters and phone calls over the past six months that had not been answered. Within two days, my work was back in my studio. It was beautifully packed, but there were seven missing pieces. Their absence confirmed my suspicions. The reason why the gallery had stopped communicating with me was because they owed me money. Fortunately, I had my signed

THE ARTIST'S GUIDE

consignment agreements, which provided a complete record of our history. It was easy to determine what had sold and which pieces were missing. At this point, I contacted my lawyer and explained how the case had expanded. Now I needed his help to collect the money they owed me for the missing works. Fortunately, I had the necessary documents to support my case. I faxed him twenty pages and an invoice for the missing works. He and the gallery negotiated for full payment to be paid through six monthly installments, as they didn't have the funds to pay it all up front. The director and I signed the payment agreement, and I collected the first installment. Even with that agreement, it was still like pulling teeth. Every month, it took multiple calls and faxes to make a check go into the mail. For the last payment due, instead of a check, I received notice that the gallery had filed for bankruptcy and closed. I was grateful that I had taken the necessary action when I did. With legal help, I had my art returned and had collected most of what was owed me. I'm sure that other artists in the gallery didn't fare as well.

If you have an active career you will run into all kinds of people: honest, deceitful, competent, inept, thoughtful, and eccentric. In good faith, promises will be made and sometimes broken. This isn't a problem confined to the arts. In all professions, there are good and bad people: those who will take advantage of you and those whose generosity will astonish you. Good people make mistakes and get themselves into difficult situations, which can affect you. Make it your practice to approach any business relationship carefully. I have had my fair share of legal problems and have learned how to take necessary steps to dodge others. I have signed contracts without fully considering their ramifications and waited impatiently to be free of their onerous terms. I have had my work altered without my permission and had to secure its removal from public view. I have used legal muscle only as a last resort, when negotiation failed. I've learned the necessity of keeping a paper trail for any work of art that leaves my possession. In over twenty years of my working with art professionals, involving hundreds of transactions, only a handful of problems have emerged. For the most part, the art professionals I have worked with have been honest and dependable. I deeply value our partnerships.

I'm not a lawyer and can't advise you on the specific problems that will arise in the course of your career, except to tell you that they are inevitable. What I can do is point out some of the issues you may face and provide some tools to help you protect the art you have worked so hard to create.

I confess: my eyes glaze over at even the thought of reading the fine print of a contract, and I don't enjoy having to discuss dreary business arrangements. It seems so tedious; I don't want to bother spending the time, and I'd much rather talk about my art. My first instinct is to give the contract a swift glance, sign it, and move on. I want to assume that the other person has my best interests at heart, so I don't need to be careful. I worry that if I ask too many questions, he will think I don't trust him. Unfortunately, it isn't until you have been wronged that you will realize that neglecting simple steps can have regrettable results. Everyday, artists are handing over precious work to art professionals without clarifying the exhibition, sales, payment, and insurance details. They sign documents that strip away their rights or have extremely unfavorable terms. Experience has shown me that when working with an art professional, there will be issues in which we will have opposing views. With that in mind, I have learned to override my discomfort and take the time necessary to read the tiny print, ask questions, and discuss my concerns. I don't sign anything until I have a clear understanding of how the document will define and affect our future business relationship.

As an artist, it's part of your job to be educated about the basic legal aspects of this profession. You need to be alert to possible problems, to be able to identify your risks, and to know when it's time to make an appointment with a lawyer or legal service organization. Start your education by adding a few books to your studio shelves, such as *Legal Guide for the Visual Artist* by Tad Crawford or *Art Law Conversations* by Elizabeth T. Russell. These resource books are written by lawyers for artists and cover most of the legal issues you will face. You also need to check out the legal service providers and nonprofit organizations in your area. In many communities, there are chapters of Volunteer Lawyers for the Arts (VLA) that provide education programs, including seminars and

If you are involved with a gallery that doesn't want to sign anything, that doesn't want to give out a name [of a collector], that is suspicious of you, then clearly that's not the gallery that you should be dealing with.

—Joanne Mattera, artist

publications for visual artists. In New York City, VLA lawyers and law students will meet with artists concerning individual legal issues as well as help match them up with free legal counsel if they cannot afford to pay for one.

Too often, artists approach a new relationship feeling the art world works against them. Disempowered by the knowledge that there are more artists than opportunities, they feel lucky to get whatever comes their way. Artists accept terms that are offered without a discussion of their concerns, expectations, and needs. They don't want to be seen as "difficult." They agree to exclusive representation with a dealer who has yet to prove they have a market for the work. They agree to incur expensive shipping and production expenses, hopeful that sales or the career boost will balance them out. With no thought about the long-term consequences, any opportunity seems too precious to let go.

It's not personal, Sonny. It's strictly business.

—Michael Corleone,
The Godfather

Artists frequently say to me, "I'm stuck in this lousy situation. What are the standards? Is what they are doing typical? Are there any rules to guide me?" Yes, there are some standards. Copyright and contracts are subject to federal or state laws. It may be that the art professional you are dealing with isn't aware of these laws or how they are applied to his business. His lack of knowledge doesn't let you off the hook. It is your responsibility to be informed and, if necessary, educate the gallery, curator, and collector too. Nowhere are the rules spelled out concerning professional relationships. Although most states have laws covering consignment of art (which we will get into later), the thorny issues of shipping, production expenses, artist fees, insurance, discounting, and the identity of buyers are up for grabs. Without universally accepted standards, each artist is on her own to set up the terms or to discuss and resolve problems with an art professional. The first time you stand up for yourself and negotiate an important issue, your knees may be shaking, but with experience you'll be able to enter into these difficult conversations with more confidence.

The rest of this chapter will provide an overview of the basic law that already protects you and provide some advice on negotiation and estate planning to help navigate potential serious problems. The laws covering issues that may arise in your career will be either federal or state laws.

The next section will cover intellectual property, which is a collection of legal statutes under jurisdiction of the federal government. These statutes apply uniformly across the nation and to other countries with which the United States has reciprocal agreements.

Intellectual Property

The good news is that the moment you put your creative thoughts into a fixed form—drawn, painted, sculpted, videotaped, pasted together, crafted, written—your creative activity is *automatically* copyright protected. That means you can envision an all-white painting, but you do not have a copyright to it until you actually paint an all-white painting. Here's the definition from the U.S. Copyright Office:

> Copyright is a form of protection provided by the laws of the United States to the authors of "original works of authorship," including "pictorial, graphic, and sculptural works." The owner of copyright in a work has the exclusive right to make copies, to prepare derivative works, to sell or distribute copies, and to display the work publicly. Anyone else wishing to use the work in these ways must have the permission of the author or someone who has derived rights through the author.

Copyright protection means that your work cannot be photographed, reproduced, or publicly exhibited in any way without your permission. Only you have the right to make derivative works (such as photo, pigment, or lithographic prints from it), document your work, and exhibit your work. This right remains with you even after your work is sold. The new owner has bought your art *but not your copyright*. This is true whether your work is acquired by a private collector, corporation, or museum. Your copyright can be transferred to someone else only via a written document you have signed. As of this publication, your copyright remains in effect for seventy years after your death and its ownership is part of your estate.

REGISTERING YOUR COPYRIGHT

For all works of art created after March 1, 1989, you do not even have to attach a copyright notice to the work, although it is recommended. Those created prior to that date must have a copyright symbol (©), the artist's name or initials, and the date somewhere on the work. It does not have to be on the front of the painting or drawing; the back is sufficient, and for sculpture, an unobtrusive area or underneath the work is okay. For DVDs and videotapes, the copyright notice is included after the credits and can be printed on the labels. You do not have to register your work with the U.S. Copyright Office to have this protection; however, there are some advantages if you do. If you were to pursue a copyright infringement case in federal court, your work must be registered before proceeding. If you win the case, you would be entitled to reimbursement of legal expenses, and damages can be awarded. As of this publication, the fee for registering your work electronically with the U.S. Copyright Office is only $35. To avoid paying this fee for individual works, which can feel pricey at $35 a pop, you can group works together as a collection. You could file an entire year of work in one medium, such as painting, under the title *The 2008 Painting Collection* by Sam Smith, under one registration fee, as long as you provide an image of each work, properly labeled with your name, date, and dimensions. A separate file and fee would cover a year's work in sculpture, drawings, or photography. Also, note that all the works in a collection must have been completed in the same calendar year; you cannot mix years. The U.S. Copyright Office website (http://www.copyright.gov), explains everything in detail, and it is easy to use. Forms can be downloaded from the site.

ALLOWING THE LIMITED USE OF YOUR COPYRIGHTED WORK

When posting images of your work on the Internet, you may wish to allow limited use of it. A Creative Commons license will allow you to post your images on your website, blog, and sites like Flickr and permit

others to use them. It changes your copyright terms from "all rights reserved" to "some rights reserved." You can specify what others can do, such as remix your work, and how you wish to be credited. To learn more and get started, you can visit http://creativecommons.org.

Art professionals who are working with you will want to incorporate images of your art on their websites, brochures, advertisements, and announcements. Because you are the copyright owner, technically they should ask for permission from you to do so, but many will assume the right to use your images in their marketing efforts. They may have a clause to this effect in their consignment or loan agreement. You will probably not mind this use of your images, but you should track how your art is presented to make sure you approve. You know better than anyone if the selected image best represents your work, if the color is accurate, or if it is upside-down or backwards. Don't laugh; I have had all of those problems. Someone at the gallery hands a bunch of scans to the web designer to post online. Without knowing the actual works, the designer can easily make mistakes.

As noted above, when your work is sold, only the physical object is owned by the collector; your copyright remains yours. If your work is acquired by a public collection, you may be asked to sign a document that provides them with limited, nonexclusive rights to exhibit and reproduce images of your work. Below is an excerpt of a limited rights agreement I assigned to a museum who had acquired my work.

> I, Jackie Battenfield, being the owner of the copyright in and to the following artwork created by me, . . . in consideration of the acquisition of the said work by the XX Art Museum, give my authorization to the XX Art Museum to reproduce the said work for all standard museum purposes in both analog and digital media (examples include but are not limited to slides, film and television).

This document provided the museum with the right to use images of my work in their collection for specifically defined activities such as promoting an exhibition, applying for funding, and including in reports, in catalogues, or on the museum's website. It would be too much trouble

if they had to contact me for permission every time they wanted to exhibit the work or use an image in their publications. This document does not grant them the right to reproduce the work on postcards, posters, calendars, stationary, coffee mugs, T-shirts, or any commercial product for sale in the gift shop. If they wanted to do that, they would need to contact me for permission and negotiate a separate contract that licensed use of my image for a particular commercial purpose.

Remember to always be careful whenever signing any agreement. It never hurts to consult a lawyer to make sure you understand the language of the document, the conditions it imposes, and how they may be carried out. A friend of mine had her work purchased by an important corporate collection through her gallery. She was separately contacted by the corporate lawyers and asked to sign an agreement that included the following paragraph:

> In consideration for the opportunity for broader exposure and publicity for the artist named below and the Artist's work described below, the Artist hereby grants to XXX Corporation a perpetual, irrevocable, royalty-free, right and license to use, reproduce, distribute and display all or portions of the Work and identify the Artist as the creator of the Work, in any medium (including, without limitation, in brochures, audio-visual presentations, promotional items, annual reports and Web sites) solely in order to promote XXX Corporation.

Some of the language used in this document, such as "perpetual, irrevocable, royalty-free, without limitation, promotional items," are dangerous words and should set off alarms whenever you encounter them. She needed to be aware that signing this agreement released a huge chunk of her copyright to this organization. Most importantly, she was under no obligation to sign it. Sure, the corporation had bought the work, and it was flattering to know they thought so highly of it that they may want to use it for promotional purposes. But the right to use an image of her work needed more clarification than was provided in this contract. With the advice of a lawyer, she could discuss her options

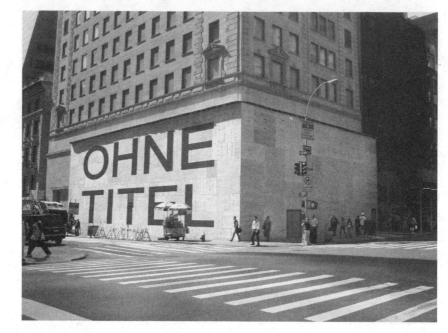

SERGIO MUÑOZ SARMIENTO

Image from *Ohne Titel*
(Untitled), 2008

Corner of Fifth Avenue and
54th Street, New York City

This temporary public
installation is an ongoing
project that merges the
discourses of art and law. It
addresses the financial
epidemic stemming from early
2000 to the present such as
the acquisition and ownership
of U.S. real estate by European
individuals and corporations.

and edit this document to specifically define when and how the image could be used, severely limiting the all-encompassing request proposed by the corporation. *Remember, in any situation, lawyers representing the other party are doing their job, which is to get you to agree to as much as possible that is to their advantage.* You need to do your job as well. Protect your rights, and give them only what is necessary and appropriate based on your needs and desires.

LICENSING AGREEMENTS

Intellectual property law covers more than your art as a physical object that can be bought and sold. Its commercial use creates another category of value. This is an additional reason why you need to protect and defend your copyright.

Your work could play a supporting "role" in film and video. You could be approached by an author, book publisher, or musician who wants to use your image in a book or on a CD cover. An image could be used in advertising and commercial products. Greeting card, poster and

calendar companies, advertising agencies, home products, and the hospitality industry comb the Internet looking for fresh ideas and images. You may be approached for permission to use your work for one of their products. This is called a "licensing agreement." It must be secured in writing from the copyright holder (you), and most often a fee for the use of your image will be negotiated as well.

You may be approached for the right to reproduce your work. It could be for a small, limited-edition print or thousands of posters. I have licensed small editions of less than twenty prints for hotel projects. In these cases, I ask the client to buy the original work and pay a fee for the right to reproduce it only for this project. The number of reproductions is specified. I insist that they buy the original work to be made into the edition, as I am not comfortable selling a copied work of art to a collector. So in addition to receiving payment for the original work, I receive a royalty for each print produced. Recently, I authorized the reproduction of a small section of one of my paintings as a print for a hotel chain remodeling all their rooms nationwide. Although the scope of the project was clearly defined, the exact size of the edition couldn't be determined at the time of contract negotiation. After consulting with my lawyer and my gallery, I felt comfortable with the royalty terms and signed the contract. Since the image the client was using was a tiny section of the painting, I did not insist that they buy it. Both the painting and the print were so different that each possessed a unique character. As it has turned out, I had no idea how many rooms this hotel chain had across the United States. Every week or two royalty checks arrive in the mail, signifying another completed hotel. In my studio we call this the "print that keeps on giving."

Make it a habit to consult with a legal professional when signing licensing agreements. Ask questions about any of the provisions you don't understand. Even if you are not represented by a gallery, reach out to other artists and art professionals you know, and draw upon their experience. If they can't help you, they may be able to connect you with someone who can. Find out the current standard range of fees for

Here's a short history of the world that explains intellectual property. We once had bananas and tomatoes, which was the agricultural age; we then had petroleum, . . . which was the industrial age. Intellectual property marks the third stage. The first two are finite and physical, but the last one is not. Anyone can come up with the next great design for a shoe brand, the next logo, the next Star Wars, or the next Madonna song, and that is not finite. Any person now can potentially own their own "oil field."

—Sergio Muñoz Sarmiento, artist and attorney for Volunteer Lawyers for the Arts

a print edition, use of a video clip, or the music video's request to use your installation as their backdrop. Remember that the other side's goal is to get the use of your image for the lowest fee possible. For print editions, a general rule of thumb is the smaller the edition, the larger the royalty payment per piece. You want to make sure you are being fairly compensated.

FAIR USE

In a free society, ideas and information need to be shared. The federal government has a series of regulations whereby the public has the right to freely use portions of copyrighted materials for a limited purpose— for example, to comment on, criticize, or parody. Their use does not require permission from the copyright owner. "Fair use" provides guidelines on the use of copyrighted work. It comprises a set of factors by which the reproduction of a copyrighted work may be considered "fair," such as criticism, comment, news reporting, teaching, scholarship, and research. For example, for your exhibition to be reviewed, images of your work need to be included in order to comment on or criticize what you have done. The reproduction of your work for this purpose is considered fair use.

INFRINGEMENT

If a copyrighted work is reproduced or publicly displayed outside the fair use doctrine above, its use is called an "infringement." The following four factors are considered by judges when determining whether or not a particular use is fair:

1. The purpose and character of the use, including whether such use is of a commercial nature or is for nonprofit educational purposes.
2. The nature of the copyrighted work.
3. The amount and substantiality of the portion used in relation to the copyrighted work as a whole.

4. The effect of the use upon the potential market for or value of the copyrighted work.

These four factors are guidelines that will help you navigate using copyrighted material in your work. If you are using images of art, a portion of a text, or a video clip in a lecture to your students, it's for an educational purpose, and this may be considered fair use. If you are using the same image or text in your art, it's considered a commercial purpose (even if you aren't selling it), and your use of it may be considered infringement when subject to the four factors above. In this day and age, when artists are appropriating images, referencing photographic source material, and incorporating trademarks and downloaded Internet files in their work, it is difficult to determine if you are swimming in the dangerous waters of copyright infringement.

For visual artists working with borrowed images, text, and music, the distinction between "fair use" and infringement is unclear and not easily defined. There is no specific number of words, lines, or notes, or percentage of another copyrighted image that may safely be used without permission. Acknowledging the source of the copyrighted material does not substitute for obtaining permission.

How you use other artists' images may put you in the middle of an infringement suit. Even after a careful reading through the literature on fair use, your desire to use copyrighted material in your art can easily persuade you that you are safely within the realm of fair use. Don't be shocked to find the copyright holder interprets fair use of his or her image differently from you. In 1992, Jeff Koons unsuccessfully used the parody defense to justify his use of photographer Art Rogers's copyrighted postcard image as the basis for his sculpture *String of Puppies*. The federal court sided with Rogers, as it determined that Koons could have constructed his parody without using that copyrighted image. Remember, should you be sued and end up in court, you will find yourself in foreign territory. Federal and state court judges are not up-to-date with contemporary art practice, and may not understand how appropriation fits into your work. Having art experts educate the judge during the trial is an expensive lesson indeed.

There are artists that are being sued for $19,000, $90,000, $200,000, all the time. It's pretty scary when you get a legal document in the mail that basically says, "Unless you show up to court, there will be a judgment against you."

—Sergio Muñoz Sarmiento, artist and attorney for Volunteer Lawyers for the Arts

I can't go into long explanations of the case law concerning infringement. The safest course is always to get permission from the owner before using any copyrighted material. The Copyright Office cannot give this permission. You might be surprised just how often the copyright owner will be happy to let you use their material with appropriate credit for free or for a small fee. Although we will never know for sure, it is possible that had Jeff Koons asked for permission or paid for the use of Rogers's image, he could have avoided an expensive court battle and judgment against him. If you have asked and the copyright holder doesn't give you permission, it means that you will have to work a little harder to find another way to achieve what you want. After all, you are a creative individual; use your resourcefulness. Sometimes artists rely on copyrighted material because it's easier than creating their own.

It's just as possible you will find yourself on the other side of this issue if your copyright has been infringed. Infringement hurts deeply when it is done to you, but you will think of a million justifications if you do it to someone else. Protecting and defending your copyright is part of your job.

Digital media heightens [the problems of intellectual property], because before, when you literally only had analog or material documents, it was limited in how they could be disseminated. Now, the minute you post something on your website in New York, someone in the Philippines or Brazil is reading it five minutes later, which is radical. If you turn the tables around, someone in the Philippines or Brazil is taking your images, words, and sounds and using them without your permission, which would have been much harder ten to twenty years ago. And that's from a purely intellectual property perspective.

—Sergio Muñoz Sarmiento, artist and attorney for Volunteer Lawyers for the Arts

The Internet has made all of these issues even more complicated. Posting your images online and sharing them through social networking spaces such as Flickr can create many unauthorized uses. Copyright law hasn't been able to catch up with this frontier, which is why the nonprofit Creative Commons has stepped in with different levels of licensing agreements. You may want your images to be freely used without onerous restrictions. If so, you should check out the information on the Creative Commons website to determine how you may want to apply it to your postings.

ORPHAN WORKS ACT

As of this writing, there is a bill going through Congress, The Orphan Works Act of 2008, which has alarmed many

in the art community, who fear they will no longer have comprehensive copyright protection. This bill is an attempt to create a system by which individuals creating new work can use orphan works material, which may be copyrighted, without fear of lawsuits. The U.S. Copyright Office defines "orphan works" as "copyrighted works whose owners are difficult or even impossible to locate." It requires that whoever uses the material demonstrate that she made a good faith effort to discover if what she is using is under copyright protection and has searched for the owner. They must file a "Notice of Use" before using the orphan work and provide attribution about the original copyright owner.

Your work will not be "orphaned" if you have registered it with the U.S. Copyright Office and have kept them up-to-date with your contact information. Even if you have not registered your work with the U.S. Copyright Office, your work is still protected, although you are not entitled to legal expenses and damages in an infringement suit. Make sure your name and date of creation are on all your artwork, and you have nothing to fear from this legislation. If your work exists in digital format, include your contact information in the file properties. Make sure you keep an archive of information and images of all your work. (More information about archiving is included in the next chapter.)

MORAL RIGHTS

Federal copyright law also incorporates moral rights legislation, which provides rights of attribution and integrity. It ensures that an artist is correctly identified with the works of art they create and that they are not identified with works created by other artists. It also allows artists to protect their works against modifications and destruction that would be harmful to the artist's honor or reputation. Like copyright, this right remains with the artist and can only be transferred by a written, signed document.

Before this 1991 addition to copyright law, artists had little recourse to protect their work from mutilation or outright destruction. For example, a 1,600-pound metal sculpture by Isamu Noguchi, owned by the Bank of Tokyo Trust Company, hung in the lobby of its headquarters in

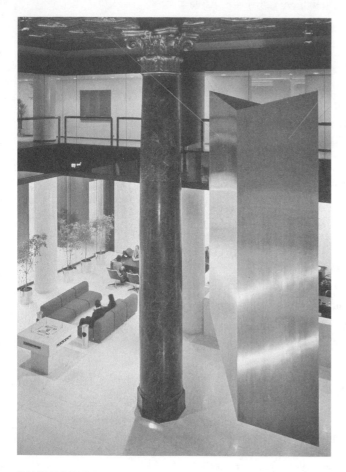

ISAMU NOGUCHI

Shinto, Bank of Tokyo Building, New York, 1974 (destroyed April 1980)

Aluminum, 17 feet

Photograph courtesy of the Isamu Noguchi Foundation and Garden Museum, New York

© 2008 The Isamu Noguchi Foundation and Garden Museum, New York / Artists Rights Society (ARS), New York

lower Manhattan. Here is an image of how it was installed. In 1980, the bank authorized its removal and had it chopped into pieces and put into storage without notifying the artist. Had the moral rights legislation been in place, the bank would have had to notify Noguchi of their intentions to remove and break up the sculpture and give him ninety days to remove it himself to prevent its destruction. For any artist, it is horrifying to have their work treated in a cavalier manner and destroyed.

OTHER COPYRIGHT ISSUES

The following two subsections of this chapter discuss other situations where copyright issues may arise. They cover circumstances in which you are doing creative work for someone else or when you are working collaboratively with other artists on a project. A lack of attention to copyright law in these cases can cause you a lot of distress later on.

Copyright issues when you are hired to do creative work. When you are hired to work for another individual or company, what you create may come under work-for-hire provisions, which means the copyright holder is the person or company that has hired you. This can easily become a gray area, unless the person or entity that owns the copyright of any creative work you do is clearly negotiated and written down *before* you get started. Both parties need to sign this agreement. The courts make a distinction between fine art and commercial art, so it is to your advantage to study the differences to protect yourself. If you regularly do freelance work as a photographer or graphic designer, I hope you have

already settled this issue with your clients and have a release for them to sign if you wish to retain your copyright for the work you do for them. However, even if you don't regularly do freelance work, you may be commissioned to create a painting, sculpture, or video projection for the set of a dance company or make original elements for another artist's installation. Clarify who owns the copyright, so you don't innocently encounter an infringement suit later when using something you have created while working for someone else.

Copyright issues when you collaborate with other artists. When you work collaboratively with other artists, each person in the group is considered a coauthor and has equal, undivided interests in the completed work, no matter who did what, when, where, or how much. This means that each member of the collaboration has the right to exhibit, sell, license, and reproduce the work without consulting the other member(s) of the group. Because each collaborator has all the rights of copyright, each can independently reproduce, publicly display, perform, reproduce, and make derivative works from the original without consulting the others. Imagine the snarl of arguments, hurt feelings, anger, and dismay when this happens.

The wonderful part of collaboration is the synergy of shared ideas and the melding of the best of them together. At the beginning, everyone involved has good intentions, and it is hard to imagine that disagreements may happen later on. To protect the working partnership and avoid future problems, discuss personal and group project goals and individual roles. Devise a plan for future decisions concerning documentation, storage, exhibition, sales, etc. It may be that each collaborator does not have an equal share in the project. Have these discussions right at the beginning, even if it feels premature and you can't imagine anyone ever wanting to exhibit or sell the work outside of the group. Once you have come to agreement over duties and responsibilities, put them in writing, and have everyone sign it and receive a copy. Clarity in these details will protect the individuals and the project, and help keep the collaborative relationship healthy.

Contracts: An Overview

Other legal issues for artists, such as those relating to property and contracts, are generally governed by state law. Each state establishes statutes, referred to as "common law," which vary from state to state.

Common laws . . . are the law of the community, the communitas, *and it comes from England. Because what makes sense in New York State may not make sense in California, Texas, or Florida. [That's] why obscenity laws are more lenient in California and New York than they are in Iowa and Nebraska.*

—Sergio Muñoz Sarmiento, artist and attorney for Volunteer Lawyers for the Arts

A contract is a verbal or written agreement between two or more parties that sets out the terms of how they will be working together. In essence it is a blueprint of a relationship and establishes the conditions, rights, and duties of each party. In visual arts, oral agreements predominate. Discussions about individual expectations and responsibilities are often assumed or not thoroughly discussed. It is often implied that having a contract means you don't trust your partners or collaborators. But a *written document that sets out the terms of how individuals will work together establishes the ground rules and forms the foundation of a good relationship.* Whenever two people begin to work together, each will have unexpressed expectations of each other, will hear and remember different details of a conversation, and assume that certain rights and responsibilities will be covered by the other party. It is to everyone's advantage to have all important issues discussed, agreed to, and written down. Written documents prevent a "he said/she said" situation.

All too often artists approach their relationship with either a nonprofit or a commercial gallery as supplicants, with the hope of remaining in favor and thus receiving good treatment. I hear over and over again the complaints of anguished artists who feel powerless in situations with art professionals. Intimidated and anxious to grab an opportunity and against their better instincts, they agree to whatever oral or written terms are offered. Asking questions and promoting their interests will make them be seen as "a difficult artist." They fear if they don't agree to the terms offered, they will be pushed aside in favor of the fifty artists lined up behind them ready to jump on board. Sound familiar?

Usually, problems don't arise during the "honeymoon" or early phase of a relationship. The gallery or nonprofit venue is eager to include your work. Your dream of having a platform from which to vault your

career to the next level finally seems within reach. Life is wonderful. The real test of your relationship comes when things don't go so well. Regrettably, in spite of everyone's hard work, the show isn't received as expected. Promises are broken or ignored. Excuses are plentiful: it's a bad time of year; the economy has taken a nose dive; collectors are hesitant to purchase your work. The nonprofit has had their funding cut, and the catalogue has been removed from the budget. Increased visibility of your work hasn't translated into other invitations. You wait and hope the situation will improve, but year after year, all you receive is a pittance. Your gallery isn't as welcoming as they were in the beginning, conversations are strained, and a cloud of disappointment hovers overhead. Your resentment builds as the relationship sours.

Ironically, people tend to respect other people in the art world when they are upfront with what they want. Just like in a personal relationship, if the other person is not able to give you something that is fundamentally valuable to you, maybe that is not a relationship that you want to be engaged in.

—Sergio Muñoz Sarmiento, artist and attorney for Volunteer Lawyers for the Arts

When working with a nonprofit organization, you can recover faster from a bad situation, as the most intensive stage of your partnership will be generally limited to an exhibition or project. Most artists will do what they can to retain a healthy relationship, mindful that they may be recommended for other opportunities. When an artist begins a longer partnership with a commercial gallery, there are more occasions when difficult situations and disagreements arise. Now it is even more important to clarify the terms of the relationship, as they have long-lasting consequences.

[Be] clear about what you want. Do you want sole representation? Do you want to just be one of their artists? Do you want career advice? What do you want from that dealer? Do you want them to help you with pricing? Do you want them to take you to an art fair? Do you want them to introduce you to galleries that they know? What are your goals? Be clear because we are working on this together. So [among] the artists with whom I work the best are the ones who are clear with me what their goals are.

—Julie Baker, president of Julie Baker Fine Art and partner of Garson Baker Fine Art

Most art galleries are reluctant to enter into long-term contracts with artists for exhibition and representation. A good relationship builds over time, and until both parties are sure that it is a mutually satisfying partnership, most issues can be decided on a short-term basis. Gallerists represent artists whose work they respect and want to place it in collections that will enhance their reputation and that of the artist. If the artist's work goes in a direction they aren't as committed to, they don't want to feel obligated to an exhibition of that work. The gallery wants to maintain control and flexibility in their programming. A gallery is more likely to offer you a contract once

your relationship has matured. For the same reasons, an artist who is doing well may be equally reluctant to enter into a contract for representation with a gallery. They too want the flexibility to entertain multiple opportunities.

With any arts organization, nonprofit or commercial, and no matter how long you will be working together, one show or project or for decades, some terms of your relationship should be written down. Below I will discuss consignment agreements, loan forms, commission agreements, and licensing contracts. These are documents that you will encounter at some time in your professional life.

THE "DROP DEAD" PRINCIPLE

A great deal of business in the art world is conducted informally. As long as both parties are alive, have similar memories, and do not have any disagreements, you can be lured into a false sense of security. A cardinal rule to follow is that whenever a work of art leaves your hands, it *must have a paper trail.* I'm shocked to find that many of my friends have worked with their galleries for years without ever receiving an adequate consignment document. I can guarantee that one day, something will happen to make them realize they have been standing on shaky ground. Creating a solid paper trail rather than relying on a path of bread crumbs is your protection when something is amiss or goes wrong. Just consider for a moment the following scenarios:

- The good news is that your prints are in the hands of a dozen art professionals across the country and are providing a portion of your income. You have been too busy to keep records of who has what. The bad news is you are in a fatal car accident. Your family realizes a great deal of your work is missing from the studio but can't figure out where it went.
- A collector has commissioned a piece from you as a present for his wife. Your work incorporates expensive materials and processes, so you orally agree that he will send you the

production expenses before you get started. He leaves the country on a jungle safari with his family, neglecting to send you the promised check. Nevertheless, you complete the project anyway, thinking it will be a great "welcome home" surprise. You are nearly finished with it when you are shocked to read the couple's obituaries in the newspaper.

- You have been working for years with a gallery and have a solid relationship built on trust. Work is sent and returned without paperwork. A terrible fire breaks out in the gallery, and the owner has died fighting it. All your work has gone up in smoke, as have the gallery's own records. You work with the heirs to help put together an insurance claim for the loss of your work. The insurance company pays only a tiny part of it, as there is no physical proof to support your claim.

I know the scenarios above sound far fetched, but any one of them can happen. Here's what they have in common: first, the artist did not possess a document clearly outlining the terms by which his art was lent or commissioned; second, the other party to the transaction was unavailable to confirm these terms, and lastly, a third party will make a final decision with no solid information to go on. We live our lives with the expectation that nothing will go wrong. But unforeseen events can and do happen everyday.

Never let your work leave your possession without a document attached to it. Make it a habit. Think of it as a path connecting you, the maker, with whoever has physical possession of the art at any moment in time. It records the journey of your art from your studio to a shipper (art mover, FedEx, U.S. Post Office, a man with a van) to an exhibition space or art professional and back again, until it is sold and becomes the property of a collector. This document is a signed agreement between you and whoever is responsible for the work at all points until it reaches its destination.

I think you have to be very clear in your mind about your relationship with your gallery. You have to understand that they have other artists, so not all their resources will go to you, and that they will devote the most resources to whichever artist they consider the most successful. There's no point resenting that. Galleries have limited resources, they need to survive, and you have to be realistic about what they can do. And you have to set clear goals for them. You need to tell them what you want or need; they can't read your mind.

—Ellen Harvey, artist

CONTRACT BASICS

For any contract you encounter keep the following steps in mind. It will help you slow down the process and thoughtfully consider your options.

- Read it through carefully.
- Ask questions of anything you don't understand.
- Seek legal and professional advice about the terms and the fees offered.
- Negotiate to cover your needs and goals.

The following section provides further discussion of some of the most common contracts you will be encountering and a template from which to start creating a paper trail.

CONSIGNMENT AGREEMENTS

A consignment agreement is one of the most common documents you will be using in your practice. It covers the terms of consigning your work to another art professional who will be acting as your agent to sell it. In over twenty years of working with dozens of art professionals, seldom have I been offered a well-written agreement that adequately addresses consignment issues. Most of them are inadequate—usually a list of the work with the amount due the artist if the work is sold. This is insufficient, and on the following page I'll show you what needs to be included and why.

On pages 265–266 is a model agreement from one of my galleries. It helped that this gallerist is married to a lawyer, because the agreement is better than most. It succinctly lays out many of the issues that will be encountered when someone else is representing your work. Having an agreement like this with any art professional is the first step to establishing a good paper trail.

As good as it is, there are questions in this agreement that aren't covered. I would initiate a discussion with the gallerist about them and have them clarified in writing. These questions can be addressed

You want a written agreement in such a language where any person on the street could pick it up and figure out who owns what and who gets what.

—Sergio Muñoz Sarmiento, artist and attorney for Volunteer Lawyers for the Arts

THE ARTIST'S GUIDE

CONSIGNMENT AGREEMENT

_____ (hereinafter "the Artist") and Good Gallery Fine Art LLC (hereinafter "the Gallery") enter into a consignment agreement with respect to the following artworks, which the Artist reaffirms, she/he owns free and clear.

Title of Work:

Retail Price:

Size:

Medium:

The works described above are hereinafter collectively called "the art." The Artist hereby consigns to the Gallery the artworks subject to the following terms and conditions:

1. The purpose is to allow the Gallery to continue to endeavor to sell the artworks and it will use its best efforts to do so.

2. The Gallery will promptly notify the Artist of the sale of a work of art. The Gallery will pay the Artist fifty (50) percent of the price of any of the artworks sold, which shall be payable thirty (30) days from the date that the Gallery receives payment of the purchase price, free and clear. The balance of fifty (50) percent of the price received shall be retained by the Gallery as its agreed commission for being instrumental in closing the sale. The Gallery will be responsible to collect and remit the sales tax.

3. Until the artworks are sold and the Artist's entire share of purchase price paid to the Artist, the right, title and interest in and to the artwork will remain vested in Artist. Upon completion of the sale of a work, title will pass directly from the Artist to the purchaser.

4. The Gallery will be responsible for safekeeping of the artwork. If any of the works of art are lost, destroyed or stolen, it will notify the Artist immediately; and the Gallery will pay the Artist the one half of the consignment price thereof within thirty [30] days after receipt of the insurance proceeds.

5. The Gallery will insure the artwork against all risks while they are in its possession. Such insurance will be in an amount not less than one half of the aggregate of the retail prices stated above.

6. For the purposes of any liability of the Gallery, the value of the artwork shall be deemed to be one half of the aggregate of the retail prices stated above. Upon payment of any compensation

The introduction and point 1 describe the relationship between the parties, and the works consigned. A longer list of works could be printed out and "see attached list" entered here. (Note that the retail price is listed. If you list the artist's price and the dealer sells the work for three or four times that amount, the dealer is not obliged to give more than the amount listed.)

In point 2 payment terms are clearly spelled out. This is important. You want to know how quickly you will receive payment. Some galleries only pay quarterly, which means if they receive payment January 2, they have no obligation to send you the money until April. Note that the gallery remits to the artist 50 percent of the price at which the art was sold. This is a discussion point. What happens if the gallery gives a discount of 10 to 20 percent? Talk this over with the gallery, and note what you have agreed to concerning discounts in the margins, and initial them.

Point 3 states that the artist is the owner of the work, not the gallery, and that ownership passes directly to the purchaser. If the gallery goes bankrupt, your work cannot be sold to pay off their debts, as they do not own it.

Points 4, 5, and 6 describe the insurance provisions. Note that the art is insured for the artist's share of the price. It cannot be insured for the retail price, as the insurance company will only cover the gallery's financial obligation to the artist, not their commission. Also note that damaged work for which the gallery reimburses the artist becomes their property. This is another discussion point. You may wish additional terms specifying restoration of damaged work and the harvesting of materials or parts.

continued on page 266

Point 7 describes the length of the relationship and the exit terms. This is important. It shows that the gallery has use of the art for a limited period of time, which can be extended longer without signing another consignment agreement. It also provides the artist with the ability to remove his or her work if needed after the original term has lapsed.

Point 8 states that, if a disagreement between the parties ends up in court, the winning party is reimbursed for legal fees, with the amount to be determined by the court. This clause protects both parties from unreasonable legal actions.

Point 9 states that the agreement will be adjudicated under the State of New York statutes. Different states have different consignment laws, and if you live in one with more favorable terms for the artist, you may wish to have any disputes settled there, rather than in the other jurisdiction. It also means if you live far away from the state listed in the agreement, it could be costly to pursue legal action.

to the Artist for the loss of or damage to any artwork, such artwork shall become the exclusive property of the Gallery.

7. This consignment will continue for a period of [X] months from the date hereof. Upon the expiration of the aforesaid period the Gallery will return the artworks to the Artist in good condition; but if the Gallery should so desire, may thereafter continue to hold them on consignment on the terms and conditions set forth herein, except that the Artist will have the right to terminate the consignment at any time on ten [X] days written notice to the Gallery.

8. In the event of legal proceedings arising from this agreement (including on appeal) the prevailing party shall be entitled to such attorney's fees, costs, and disbursements as are deemed reasonable by the court.

9. This agreement shall be interpreted and construed in accordance with the laws of the State of New York.

10. All notices in connection with this Agreement shall be in writing and mailed or hand delivered to the parties respective addresses stated below, postage prepaid or by facsimile transmission to the numbers given hereunder. Notice shall be deemed received two (2) days after the date of mailing or the day after it is faxed or hand delivered.

11. This Agreement may be executed in two (2) or more counterparts, each of which shall be deemed an original but all of which together shall constitute one and the same agreement.

12. This is the entire agreement between the parties and it supersedes all prior agreements between them. No modifications, variations or additions hereto will be of any force or effect unless reduced to writing and signed by both parties.

Signed and Executed by the parties.
The Artist:_____ Date:_____
Print Name: _____
SSN: _____
Address:_____
Phone: (_____) _____
Fax: (_____) _____
Email: _____

The Gallery:
Good Gallery Fine Art LLC
By: _____Date: _____
 (Gallery owner or director)

in a friendly conversation by posing a few "what if" scenarios, writing down the guidelines agreed to, and attaching them to the consignment document.

Here are some questions I would have about the sample agreement:

- Who is responsible for shipping charges of the work to and from the studio? Don't assume they are covered by the gallery. Some art professionals will insist that the artist cover all shipping expenses, while others will have a policy that the artist pays for shipping of the work to them, and they cover return shipping.
- How are buyer discounts handled by the gallery? Find out if the gallery absorbs them into their commission or if they expect you to split the discount with them. It's unclear in this agreement. You can discuss with the gallerist how often and under what circumstances discounts are given to a buyer. You'll want to know if they are available to everyone who walks through the door or only given in special circumstances. It's helpful to understand how your gallery does business.
- What information about the buyer does the gallery release to the artist? Again, you want to be able to track your work. Acquiring the names of collectors is important for your record keeping. Many galleries are fearful that the collector and artist will exclude them in future business dealings. I find their paranoia puzzling. The gallery wants you to trust them with your work, but if they won't provide this information, they show that they don't trust you. Remind them that trust works both ways. Use this discussion as an opportunity to reassure the gallery why you need this information to complete your records and that you have no intention of contacting these people without their permission.

Since most of the art professionals I work with do not have consignment agreements as comprehensive as the one illustrated here, I have

For my artist clients I always insist that the gallery share information about the collector. I put in "I swear to God that I'm not going to tell anybody" clauses. I have the artist remind the gallery that they are in charge of record keeping and while alive, it is the artist that ultimately will be called upon to verify provenance, therefore they have to find out who the collector is. Most galleries, after a while of screaming and hollering, will say okay.

—David A. Dorsky, attorney and director of Dorsky Gallery Curatorial Programs

them sign my own which is similar to the one shown but also specifies shipping and discounting terms. Only once has a dealer refused to sign my agreement. His reply was "In over twenty years of business, I have never signed anything." I chose to walk away from that opportunity. I could not comfortably send my work hundreds of miles away without a written agreement between us.

A recurring problem for artists is this: "Gallery X owes me so much money. Everyone tells me to call a lawyer and get my money, but I don't want to do that. I don't want to ruin the relationship." And I say, "Well, isn't that relationship already ruined?" At which point they look at me with this stunned look, as if I said something they knew all along. But I think that's what we are talking about, that power dynamic, that sense that they fear not only burning that bridge, which is not paying them, but burning more potential bridges.
—Sergio Muñoz Sarmiento, artist and attorney for Volunteer Lawyers for the Arts

If you are unwilling to create your own document, create a check list of items that should be included in any consignment agreement. As you go over their document, make a list of what is missing, discuss it with them, and add it to their agreement. Whenever you begin to work with someone, discuss the terms of your relationship. Commission structures, shipping, and production expenses may vary from one art professional to another.

Every state has its own provisions that apply to works on consignment. Statutes and regulations applied in Maine will be different from those in New Mexico and adjudicated according to the local statutes unless otherwise specified in your contract. Become aware of the specific regulations concerning consignment in your home state and the others to which you have consigned your work. *The Artist-Gallery Partnership: A Practical Guide to Consigning Art* by Tad Crawford and Susan Mellon provides a comprehensive overview of consignment law and shows how it differs in each state. It is another good reference book to have on your studio shelf.

OTHER CONTRACTS YOU MAY ENCOUNTER

Loan forms. This is an agreement provided by a nonprofit organization when your work is included in their exhibitions. It covers the dates of the exhibition, insurance coverage, a limited right to use your image in promotion, and any other provisions the alternative space, community gallery, or museum deems necessary. You will be asked for specific information about your work, title, size, medium, and price. Carefully read

through this document, ask questions about any terms you do not understand, and provide accurate information about your work. For insurance value, list the price the work would sell for in a commercial setting—i.e., the gallery price, not a studio price. If shipping, framing, and production expenses are not covered in this loan form, have a discussion with the venue about your needs, and get any decisions made in writing (refer back to the Exhibition Checklist in chapter 5). Most nonprofits will not engage in any activity concerning the sale of your work, but others may have a paragraph that outlines their policies if this situation arises. Some may request a percentage of the sale as a donation; others will not want to be involved.

Commission contracts. This is a contract between you and a gallery, museum, collector, or corporation to create a new work of art within specific guidelines. It can be applied to both permanent works and temporary installations. Commissions can be a wonderful opportunity for you to stretch your ideas and expand your practice. There is a wide range of commission contracts, from a few simply worded lines that describe the commissioned work to thick documents of legal text for permanent public art works. Included in most commission contracts are a schedule of payments, a listing of the artist's responsibilities (models, drawings, professional assistance such as engineers, architects, etc.), and a budget. Again, I can't overstate the importance of establishing a complete budget and a reasonable timeline for completion for any commission, so you have the best opportunity to live up to the terms of the contract. Be on the lookout for any clauses that chip away at your copyright protection, as they are easily slipped into these documents. I strongly suggest that you seek out professional advice and run these contracts by a legal professional to make sure you have not inadvertently signed away your copyright to the work.

A lot of times, I don't think the galleries understand that a consignment agreement can protect them as much as it protects the artists. There are many issues that are not even thought of when a gallery and artist agree to have an exhibition, and these issues can be addressed in a consignment agreement. I am asked to review gallery consignment agreements from artists that are two paragraphs long. I ask them, for instance, "You are delivering work that is going to be mounted and framed. Who is paying for the mounting and framing? What happens to the mounted and framed pieces that don't sell? Who does [the frame] belong to? Who is insuring the work?"

I can tell you, because I speak with gallery owners, that a lot of galleries don't have adequate insurance, if any. What happens if there is a fire and the owner of the gallery dies in the fire and you don't have a consignment agreement? Artists should address these types of issues, and any others, and have a letter confirming the conversation, including insurance. There are many galleries who do things professionally, but by and large most don't.

— David A. Dorsky, attorney and director of Dorsky Gallery Curatorial Programs

Licensing Contracts and Work-for-Hire Contracts. As I discussed under "Intellectual Property," you may be approached to allow limited use of your copyrighted work for commercial purposes or be hired to work creatively on a project. Most companies have developed in-house boilerplate agreements for these purposes. When you are presented with these contracts, slow down the process, and make sure to follow the basic rules from page 264: read, ask questions, seek legal and professional advice, and negotiate. Familiarize yourself with the next section on negotiation to walk away with your best deal. Remember, the job of the other side is to have you sign over the widest possible array of rights for the lowest possible price. With a little work on your part, you can do better than that.

Now that we have visited many of the legal issues that may crop up during your professional life, the next section provides some advice for navigating and resolving disputes.

Negotiation

Every time you connect with another person, you each bring to that association your expectations, needs, opinions, and past history. These are the unspoken and often unconscious thoughts that hover over any interaction, whether it is a fleeting conversation with a stranger on the street, dinner with a friend, or the daily interactions you have with your family. It is also inevitable that differences between you and others will arise and need to be resolved. The art of negotiation is your ability to engage in a process that results in agreements that everyone involved consents to willingly. It is sometimes referred to as a "win-win" solution. When done well, it is a problem-solving method that will help you avoid hard feelings and on-the-spot demands, and it results in healthier long-term relationships based on mutual trust and understanding.

Negotiation is a valuable skill to cultivate and absolutely essential to all your professional relationships. I often get S.O.S. calls from artists unable to engage in discussions concerning their needs with a curator, gallerist, or art administrator. They are too fearful of "making waves." They allow themselves to be subject to the terms offered and go

through their art life feeling vulnerable and bitter that their needs are not met. I have watched other artists resort to demanding and confrontational behavior to get what they want. Blinded by their desire to win, they are deaf to anyone's needs but their own and oblivious to what winning has cost everyone.

Few issues are black and white, and most artists are not complete wimps or entirely belligerent. I believe that many artists simply don't understand the process by which they can speak up for their interests and get more of what they want from their relationships with the art world. I like to visualize negotiation as an arm-wrestling match. Each side exercises his options back and forth as he promotes his own interests. However in this case, the best outcome is to have a tie declared. No one has been wrestled to the table. Each party walks away without hard feelings, respecting the other, and having had an opportunity to build up a little muscle.

In other areas of your life you negotiate all the time. It's a natural part of the give and take of your everyday life and the way you go about getting what you want. You negotiate who does which chores around the house, the decibel level of the music played in the studio next door to you, even what movie you'll see with a friend on a Saturday night. Having raised two sons through their teenage years, I frequently had to call upon all my negotiation skills—to carefully pick my fights, to let some things pass, and to be firm on others. My goal was to keep our lines of communication open and maintain a loving relationship. We assume the right to negotiate to make our daily life more comfortable and suit our needs. You need to assume the same right of negotiation in your professional life. There is a lot of power in sticking up for yourself, but you want to do it skillfully so that it gets you more of what you need and want *without* leaving behind a series of burned bridges.

The process of resolving any issue involves two major steps: the first involves your preparation, and the second step is the actual negotiation. Both steps are necessary. All too often your need to establish closure will make you want to jump right to the negotiation step. Seldom does a decision need to be made immediately. Take sufficient time to do the preparation necessary to be at your best in the negotiation phase.

I see this emotional obstacle that artists have. I see it with collecting money, which I consider wage theft. I try to make it black and white for artists. Someone is stealing from you. If they owe you $3,000 for a painting, you have to go after them, and this is the way you do it. You can't feel bad because they are a collector or feel bad because you think now they won't buy work from you.

—Carolina O. Garcia, executive director of LegalArt

How to Read and Work with the Fine Print

STEP ONE: PREPARATION

- *Collect information about your situation.* Consult with other art professionals to gather facts about the circumstances and others like them. For example, if you are setting fees for freelance work, find out what's the going rate. If you are asking for more, define what you bring to the situation that warrants a higher fee. Look at other consignment, exhibition, and commission agreements. Identify terms you would like added to yours. Research what statutes already apply under current state law.

- *Clarify your objectives.* Identify what you want to get out of this arrangement, relationship, contract, or commission. Make sure it aligns with your goals.

- *Look at the situation objectively.* In any dispute there are two points of view. Begin by acknowledging your emotions in this situation. You may feel vulnerable, scared, or intimidated. Analyze why you feel this way. You may be desperate for the opportunity or believe that it is too good to pass up. Maybe you carry bad feelings from a previous experience into this one. It's hard to be objective about the situation. Get some outside advice. Describe it to a colleague, and listen to his or her opinion. Notice where it differs from your own. I like to seek out someone who has a similar job or responsibilities to those of the person I'll be negotiating with. For example, if it is a curatorial issue, I talk with another curator; with art dealer issues, another dealer. This is not the time to complain about the other person or an attempt to win sympathy for your situation. Rather, it is an opportunity to look at the circumstances from another point of view. A curator can explain what a colleague is thinking in this situation and may provide alternative solutions you hadn't imagined.

- *Make a list of what you would like to accomplish.* Brainstorm the things you want to achieve in this situation. Don't censor

yourself; let it flow. Go back through this list, and prioritize and divide it into the things that are most important to you and those you can live without. Lastly, determine for yourself which items are absolutely nonnegotiable.

- *Look through this list, and figure out where you both agree and where you differ.* Behind opposed positions lie shared and compatible interests as well as conflicting ones. Look at what is at stake for the other party, and then identify where his or her interests mesh with or diverge from yours. For example, an artist's position on exhibiting his or her work (attracting an audience, building a career, community status, potential sales, and reviews) is different from the position of the gallerist (making a profit; building a collector base of support; community status; staff, space, and budget concerns). These two positions illustrate similar and conflicting expectations and needs.

- *Practice the discussion.* Instead of stumbling around, get your thoughts clarified before any meeting. Try out different options. I'll call up a friend, describe the scenario, and ask him or her to play the other side's role. My friends can really get into their "new personalities." They are often more obstinate than the person with whom I'll be doing the real negotiation. They challenge everything and make me think through my approach. It helps me practice what I want to say, and their feedback identifies my best arguments. They may even come up with novel solutions that meet everyone's needs and interests.

- *Prepare a list of talking points.* You have done your homework, clarified what you want, and identified where you are flexible and where you are not. You have practiced your case. Now write up a list of talking points to have with you when you enter into active negotiation with the other party. It may happen in person, over the telephone, or through a series of emails.

How to Read and Work with the Fine Print

STEP TWO: THE NEGOTIATION

- *Encourage the other side to talk first.* Listen carefully to what they have to say without interrupting. This will help center you and identify the areas where you are already in agreement and what needs to be further hashed out.

- *Don't absorb the other side's problems.* The other side will have great reasons why they can't give you what you want and may try to disarm you by pulling you into their troubles. Don't let them hijack you. Yes, you need to be sensitive to their needs, but as the problems come up, try to solve them together. What solution can you offer them that they can say yes to?

- *Reason, and be open to reason.* Allow room to barter. You should be prepared to make concessions and plan in advance what they might be. Go back to the brainstormed list of what you wanted, and note which ones are expendable and which ones are not. How does giving in on one or two points balance against getting what you want? You want to avoid ultimatums from either side.

- *Don't be in a hurry to settle.* Stay with the issues most important to you until they are resolved. You may need to go back and forth many times with different offers over several sessions before agreement is reached. Always remember that their first offer is generally not their best offer, even if they say it is.

- *Never yield to pressure.* Many artists settle for extremely inequitable situations because they feel "this is my only opportunity." If the solution leaves you bruised, the ill will you feel eventually poisons the relationship or opportunity. The converse is true as well. Winning at the expense of the other party may only advance your situation on a short-term basis instead of creating a long-term partnership.

- *Maintain your integrity.* If after considering your well-prepared arguments, the other side is not open to negotiation on those

areas most important to you, then this may be a deal or a relationship you should live without.

- *Put the details of any agreement in writing.* Write any changes to a contract in the margins, and have all parties initial them. For oral negotiations, write down the points covered at the end of the meeting or conversation. Follow up with appropriate letters or emails.

- *Never sign anything you don't understand.* Ask questions about any words or phrases, and consult with a legal professional until you are clear on what you are signing.

- *Follow the twenty-four-hour rule.* Always allow yourself time to mull over a situation, contract, or a problem before responding. Never send threatening emails or letters without allowing some time to pass. The heat of emotion or the psychological pressure for closure will make you think otherwise. Seldom does a decision need to be made on the spot. Collect your thoughts, highlight issues that need discussion, and set up another meeting to ask questions and to propose modifications or additions for what you want. The next morning you might better understand your situation or feel differently about it. You never want to corner the other party or find yourself equally boxed in.

I was at a dinner party with a very talented painter that is being represented by a local gallery. But he just doesn't feel like the gallery is doing what they should for him and feels that his career should be going further along when he compares himself to other artists in the city. And I agreed with him. I was talking with him about the protocol for changing galleries. What was the most appropriate way to make the leap without burning too many bridges? He was very scared about hurting the gallerist's feelings and going too soon. He was making it an emotional issue as opposed to a professional business issue. He wasn't seeing himself as a business. By just seeing himself as a person that has to maintain this friendship he could, ultimately, really hamper his career by staying there. Because I bet you that the friendship from the gallery's standpoint isn't really the kind of friendship he thinks it is. It often isn't.

—Carolina O. Garcia, executive director of LegalArt

Know your limits. Continuing to participate in a relationship where you feel bullied, taken advantage of, or unappreciated will only sap your energy for everything else. I've seen artists so full of grief or rage about a situation that it affects their art practice and personal life. It's easy for bitterness to replace creativity. It's good to know when to pull the plug and walk away from a bad situation. Even with careful planning, mistakes will happen. Chalk up bad situations to a difficult learning experience, and move on.

The purpose of negotiation is to have you slow down your decision-making process and proceed with knowledge and clarity to help protect you from jumping into bad situations that you may come to regret. You may begin your first attempt at negotiation with a trembling voice. You'll get better and more confident in your negotiations with practice. Follow through the steps outlined, and you will be better prepared and will find a stronger voice.

Estate Planning

I don't like to think about death, and it may not be a topic on which you wish to dwell either. You may have skipped over the exercise of writing your obituary in chapter 1, saying you'll get back to it later. However, death is a fact of life, and what will happen to your assets and your artistic legacy is an important item to be included in your planning. Artists have special needs when it comes to the care and distribution of their estates after death. You need to identify how your work will be treated and who will negotiate on your behalf. It's not just the collection of art objects you leave behind, but their copyright as well. Copyright protection extends to seventy years after your death, and so do issues of infringement and licensing opportunities.

It is never too early to begin to plan for the inevitable. An estate plan has four components:

1. A will
2. A legal power of attorney
3. A health care proxy
4. An executor of your estate

Artists have special needs when drafting a will. How do you want your work dispersed? Are there particular works that you want to give to institutions and individuals? Your will covers these gifts. There are also financial issues. Adding up the dollar value of the inventory of un-

Everybody should think about it. . . . If you don't, the state, not you, is going to decide who administers your assets. Those assets will be distributed in accordance with state law. Absent a will, there are specific legal dispositive beneficiaries. There is a statutory tree for the distribution of your assets. . . . So some stranger who is going to get a 5 percent fee on the total value of your assets for acting as the fiduciary, and who is appointed by a judge who doesn't know you or your wishes, is going to be in charge.

—David A. Dorsky, attorney and director of Dorsky Gallery Curatorial Programs

THE ARTIST'S GUIDE

sold work at your studio and with other art professionals can quickly make you a millionaire on paper, even if in actuality you don't have the money to pay your monthly electric bill.

You may be surprised to find that once the value of your art is added to your other assets, in death you are a multimillionaire, and your heirs are faced with debilitating estate taxes. Make sure you work with a lawyer experienced in the issues of estate planning for creative individuals.

Most people are worth more dead than they are alive; they just don't realize it. . . . Artists have two things that most other people don't have and are probably the most important things in terms of our culture when you think about it. They have their art, which has to be conserved, preserved, and protected way beyond their lifetime, and their artistic integrity, the reputation they build up over the years.

— David A. Dorsky, attorney and director of Dorsky Gallery Curatorial Programs

Finding and Selecting a Lawyer

Throughout this chapter you have been advised to contact a legal professional to help with issues as they arise in your career. If you live in a large metropolitan area, you can begin to seek qualified legal advice by contacting a chapter of Volunteer Lawyers for the Arts. If a VLA chapter does not exist near you, or your practice is in a more rural setting, there are other options. Every state and city has a Bar Association you can contact for a list of lawyers. If you qualify as low income, look for the nearest Legal Aid organization. Another resource is law schools. Most law schools offer legal aid clinics where students work on cases under faculty supervision. For free or at low cost you may get not only an eager student but also the benefits of a nationally known law professor overseeing the case. Contact local art organizations and other artists to get referrals. If you are paying full fees for the services of a lawyer, it is best to find one that has experience in the arts.

A lawyer is an advocate for your interests. She can help you clarify and understand your position as it relates to legal precedent. She can determine if you have a case, present a range of scenarios, and negotiate on your behalf. When choosing a lawyer, interview more than one. Make sure you feel comfortable with whomever you select. You want to be sure that she understands your situation and will be able to promote your case. You should feel comfortable asking questions without being rushed. Notice how many questions she asks you. This is one way to

evaluate a professional and establish she is taking the time to really understand your position. You will also need to discuss fees. Depending on the kind of case, some lawyers will work on contingency, their payment being a percentage of any settlement, and others bill on an hourly basis. Ask questions about how she accounts for her time. You don't want to be shocked to find that the first ten minutes catching up on current events before discussing your problem are included in the quarter-hourly bill.

To be pragmatic and frugal, look for someone who has experience in that particular area of law. For intellectual property, you definitely want someone who has a lot of experience in this. I would say the same thing for free speech. Why? Because, although lawyers who practice are licensed to do so, you don't want to be paying a lawyer to do research about something they are not well versed in. They could certainly catch up to that point, but the client is paying them to do that.

—Sergio Muñoz Sarmiento, artist and attorney for Volunteer Lawyers for the Arts

Most lawyers don't quite understand the implications of taking care of the art and your reputation [when drawing up your will]. They understand the black and white, but they don't understand art . . . in the art world . . . the ins and outs of how artists show their work, how they get reputations, and how they preserve their reputations in an economic environment.

— David A. Dorsky, attorney and director of Dorsky Gallery Curatorial Programs

The Bottom Line

If someone came into your studio, picked up one of your works, and walked out the door, you would stop them. If a burglar stole your work, you'd call the police, file a report, and do everything in your power to recover it. If you aren't paid for sold work, if an image of yours is reproduced without permission, or a designer has recreated your installation as his window display, that is another form of stealing. If you are not compensated, or flattered, you need to pursue these thefts. As long as you allow individuals and companies to take advantage of you in this way, you perpetuate the myth of the non–business-savvy artist. It's not easy to stand up for yourself or to be the first to blow the whistle, but if we all blow it loud enough, the field will get the message.

Along with protecting your interests you need to be a responsible citizen of the art world. It is easy to be trapped by your emotions surrounding your art career. Making art is about exploring deeply personal ideas and desires. The emotional state you inhabit when making art is not the same mind-set you want for conducting business. In these matters you need to operate with a cooler state of mind. I guarantee you will come to appreciate the benefits of separating your studio passion from the pragmatic negotiation you may conduct with a curator during the installation of your show, a gallery on

the terms of a consignment agreement, or a Fortune 500 company on the royalty fee to license your work. To obtain payment for sold art from an overextended dealer will require a composed and committed effort on your part. Doing this well might also preserve your long-standing relationship.

Don't be afraid to ask for what you want. You may just get it. If you don't ask for something, make sure that it is a conscious choice and something you can live without. Sometimes getting the job or the opportunity may be more important to you than getting credit, compensation, or copyright. It takes practice to develop good negotiation skills, but they will ferret out the bad situations and people from reputable ones.

Don't be afraid to walk away from something that is less than you can live with. Always consider your priorities regarding your desires and which ones you are willing to compromise on or forgo in order to make a relationship work. You don't need to go through your career feeling powerless. Good people appreciate a strong partner.

The lawyers have usually helped me point out areas that I'm either not getting paid for or things that I could be liable for that I don't want to be liable for. If you're working with a city, they usually want to write the contract, which means they write a contract that's all about them and not about you. So lawyers are useful. Besides a peace of mind thing, it's about negotiation and liability. Now I'm more aware of where my imagery is going and how I control it.

—Kurt Perschke, public installation artist

Resources

Crawford, Tad. *Business and Legal Forms for Fine Arts*. 3rd edition. New York: Allworth Press, 2005.
- Includes twenty-two business and legal forms, from consignment and exhibition agreements to a model release ready for you to use. Also includes a negotiation checklist.

Crawford, Tad. *Legal Guide for the Visual Artist*. 4th edition. New York: Allworth Press, 1999.
- This book includes discussions on copyright and contracts and estate issues.

Crawford, Tad, and Susan Mellon. *The Artist-Gallery Partnership: A Practical Guide to Consigning Art*. New York: Allworth Press, 1998.
- A state-by-state guide to the statutes concerning art consignment.

Creative Commons: http://creativecommons.org
- A nonprofit corporation dedicated to making it easier for people to share and build upon the work of others, consistent with the rules of copyright.

In legal terms, artists regardless of what they are doing, their medium, or their practice, should have a lawyer to talk to about what they are doing to spot issues, problem solve, or raise red flags that are both positive and negative about that artist's practice. For example, "Look, I'm doing these paintings, borrowing images from here, have a studio, don't have insurance." Right there, the attorney would be able to tell you what the good and bad things are about what you are doing—the artist's liabilities.

—Sergio Muñoz Sarmiento, artist and attorney for Volunteer Lawyers for the Arts

They provide free licenses and other legal tools to mark creative work with the freedom the creator wants it to carry.

Fisher, Roger, and William Ury. *Getting to Yes: Negotiating Agreement Without Giving In*. New York: Penguin Books, 1992.

- Based on the work of the Harvard Negotiation Project. The authors walk you through the process of negotiation and conflict resolution. This book is a classic.

Russell, Elizabeth T. *Art Law Conversations: A Surprisingly Readable Guide for Visual Artists*. Madison, WI: Ruly Press, 2005.

- Witty and sometime hilarious "conversations" that discuss the legal troubles artists encounter.

U.S. Copyright Office: http://www.copyright.gov

- All the information you need on copyright law. You can search the Office's registry of works and documents registered since 1978. Forms for registering your work are also available through this site.

MAINTAINING YOUR PRACTICE

Look around you at what needs to be done to manage your practice. As I've said before, these tasks embrace every job description of a small business: creative director, marketing director, bookkeeper, facilities manager, secretary, janitor, technician, and publicist. It would be nice to have a staff to oversee them, but for most of us, managing our practice requires doing jobs we'd like to ignore, put off, and forget about. It's hard to get motivated to tackle those tasks that aren't primarily fun or creative. Because you have so much to do and so little time to do it, this section provides suggestions and tips to help you manage the daily activities that will support your career over the long haul. Chapter 9, "How to Structure Day-to-Day Operations," will show you how to analyze and develop organizational tools to help juggle studio work, outside jobs, and your personal life. Efficient handling of the practical stuff will free you up for more time to be creative. Chapter 10, "How to Build Community to Survive Being Alone," discusses one of the most pressing issues you will confront: the inherent aloneness of a studio practice. You shouldn't have to do everything yourself. You can reach out and embrace your community in productive and mutually beneficial ways to help sustain you over the long term.

chapter nine

How to Structure Your Day-to-Day Operations

This chapter discusses how to bring order to your professional life and develop an organizational structure for sustained effort. It will help you implement the activities mapped out in previous chapters and fuse the component parts. It builds upon the planning exercises from chapter 1 to reinforce their importance in establishing and prioritizing your administrative tasks. This chapter outlines essential record-keeping skills and shows you how to create an archive for your work. It introduces time management fundamentals as an opportunity to help you learn how to do the work you need to do and still have enough time for art and fun.

Sustained minimal effort brings bigger and better results than occasional bursts of activity.

An inconvenient truth (to borrow a phrase) that appears again and again in this book is that no one is coming to save you. No one cares about your art as much as you do. Your creativity needs to be nurtured and protected. It is your most valuable asset. Even if you can't imagine making a living from your art practice, you are still the sole proprietor of a small enterprise. You need to think and get organized like one. The tasks you will undertake in this chapter—finding your ideal work schedule, organizing your business records, creating an archive, accessing information, and getting help—create the necessary support systems that tie everything together and are vital to your work.

You need to be mentally and physically free to meet the hardest challenge of your professional life, which is to make the finest art you can. You have already devoted a great deal of time and money to creating a body of work and finding opportunities for it out in the wider world. Now is the time to take care of your investment. Gather the loose ends

together, and weave some organization into your creative life. This assignment is easier than promoting yourself. It doesn't require talent or putting your ego on the line, and most importantly it's under your control. There are so many other aspects of your career that are out of your control—rejections, sales, favorable reviews, panel decisions—the list can feel endless. When your organizational house is in order, you can exert more influence in some of these areas. You have superb materials ready to respond to an opportunity. You have scheduled time to research and compile a thoughtful presentation of your work. These "little things" add up and increase your odds to achieve what you want.

Even if studio chaos is your creative style, that doesn't mean your personality is completely incompatible with organizing a few pieces of paper, sending off a fabulous jpeg image, or updating an archive record. You *do* have the ability to accomplish these tasks. They just require the set-up of systems that make sense to you and the development of new habits to manage them.

In order to handle my daily activities and work consistently toward my goals, I have had to make sure that my professional life is organized. I have created systems to help streamline activities I need to do over and over again. A day seldom goes by without someone, somewhere, inquiring about new and old work. I need to access information on hundreds of artworks, pinpoint their location, and determine if they have been sold, are currently on exhibition, are consigned, or are stored somewhere in my studio. I need to access jpegs saved at different resolutions and current pricing. Paintings, prints, and works on paper regularly leave my studio. They need to be packed and shipped with the proper paperwork included. Works that are returned need to be unpacked, inspected, and put away. The records of these transactions need to be updated and new works documented and entered into the database. Like you, whenever I sign on to my email program, there is a cascade of messages that require sorting and response. I need to schedule time to prepare and organize materials for upcoming workshops and classes. Everything—studio work, speaking invitations, meetings, workshops, classes, and exhibitions—needs to be coordinated in my calendar.

I don't particularly enjoy doing these chores, but I do them because I understand how vital they are to the smooth running of my life and work. Being able to efficiently grab a jpeg and a price, refer to the terms of a contract or consignment agreement, apply for an opportunity that has come up, and send off an already developed workshop description frees up hours for me in the studio. Quickly referring to my calendar to make sure I don't double-book an appointment or unnecessarily disrupt a studio day protects time I need to spend with my art. *Years ago, I assessed my needs and organized systems to handle them, because I didn't want to spend one minute more than absolutely necessary on these mundane tasks.* These habits of organization were all learned out of necessity and allowed me to be more productive in the studio.

I love the Grimms' fairy tale in which little elves appear at night while the shoemaker's family is sleeping. They stitch the cut-out leather shoes together and clean up the shop so that, on awakening, the shoemaker finds all the laborious tasks have been done and the beautifully finished shoes have been lined up to wait for customers. In the story, the shoemaker went from poverty to prosperity. I thought about that fairytale a lot when I was building my practice, caring for two small children, and working part-time to keep up with the rent. I was overwhelmed trying to juggle it all and envious of families with live-in housekeepers and nannies. If I had that kind of help, it would be so easy to be a good artist and a good mother. As I sat in the park watching my children play, I was churning with anxiety, as I knew no elf was coming to rescue me. Obsessed with thoughts of what needed to be done in the studio and how to move my career forward, I imagined how wonderful it would be to have an assistant who would cater to my needs. While my assistant was doing all the elfin tasks in the studio, I could relax and enjoy my time in the park. The only way I would be in a position to afford help—a babysitter a few mornings a week or an assistant to do administrative chores—was to generate a more active career. For now, my time had to shift from only studio work to encompass more administrative tasks. I possessed good organizational skills and a strong desire to succeed at my goals. I addressed my anxiety by becoming more efficient. This would allow me

to follow up on more opportunities. Knowing these were tasks under my control helped refocus my envy into healthy energy.

Ask yourself these questions: What skills do I already have in place? How can I use them to support my studio practice and goals? When you apply and hone a skill you already have, you are taking action, which is a powerful counterpoint to unconstructive feelings of anxiety, envy, or frustration. As your skill set develops, you are motivated to tackle new ones.

No one and no system is perfect; rather, both are always in a state of development. From time to time, I still misplace papers, struggle to find the right jpeg, and overbook my calendar. But when that happens, I ask myself what could be done the next time to avoid that problem. Still, there are days and even weeks when everything is out of sync, and my planning and systems have fallen apart. There are times when I can't clear my head enough to begin exploring a new idea because I'm plagued with other issues. Instead of finishing a painting, I'm rushing down the street in my paint-splattered clothes to pick up a sick kid from school. I'm stuck in a three-hour meeting in a windowless office, instead of the afternoon I had planned cruising art shows. Unexpected stuff will come up. I adjust my schedule accordingly and steer myself back on track.

I realize you may be feeling overwhelmed by all that needs to be done in support of your art. You may be wondering how you will fit it in and still have time left for meaningful studio work. I empathize with your desire to devote what precious time is available to just making art. I feel the same way and struggle to contain any resentful feelings I have about mundane administrative tasks. I don't get up in the morning and think, "Yippee, I think I'll organize my files today," and certainly don't expect you will either. You don't have to drop everything and spend the next few months on organization. My suggestion is to carve out a few hours each week to gradually shape the administrative aspects of your practice. You want to shoot for consistent attention over a long period of time.

The hardest part is starting. You need to put together systems that work for you based on your needs, desires, likes, and dislikes. If you

have been making art for years and haven't consistently kept records, it will feel overwhelming to create an archive of information about every piece you have ever made. If your filing system has been to toss things into a corner of your studio or on the precarious pile next to your desk, your first thought might be to just shove it all into a gigantic bag for the next recycling pickup. Calm down, and make a commitment to schedule one afternoon to begin to tackle these tasks. One afternoon will lead to another, and once you get started and begin to reap the results, it is easier to continue.

One of our artists who is growing his business and career is trying to take the energy he has in his studio time and give that same kind of energy and approach to his business stuff. It makes it a lot more fun and doable for him to imagine it that way. It's exciting to watch how dramatically it's affecting his progress.

—Jeff Becker, artist and executive director of Arts Incubator, Kansas City

Figure out how to make it fun. Think of it as a conceptual art performance. Imagine you are being filmed as you do it, and come up with a funny commentary as you work. Pretend this is some other artist's stuff, and you are being paid $100 an hour to bring order to their life. Post a list of your career goals in your studio or office space to remind you why you are doing it. Your attitude will help get you through the job. If you approach it as a demeaning chore, it will feel onerous and take twice as long. Figure out a great reward for yourself at the end of each session. Once you are organized and experience how much it helps your studio practice, you will be more motivated to maintain the systems.

The following section contains some of the ways I've learned to organize myself.

Time Management

Your artistic imagination may be infinite, but your time is not. You can't make the day longer than twenty-four hours or a week longer than seven days, although you may have learned how to burn the midnight oil. Since you can't create more time, you need to learn how to restructure and use it more *gracefully*. Don't buy into the idea that because you are an artist, you are incapable of devising a schedule or that doing so will inhibit your creativity. If you think about what a chaotic or disorganized day keeps you from doing and achieving, you may be more motivated to work on managing your time.

These are your choices: You can allow anything and everything else to determine how you spend the few precious hours you have to devote to your studio practice. You can handle the administrative burden in response to crisis. Or you can begin to analyze how you currently spend your time and look for ways to organize it more efficiently. You want to free up time for the studio *while* taking care of business. The following suggestions will not get in the way of your creative practice. In fact, *bringing order to your schedule and your workspace is one of the most valuable gifts you can give to the artist within you.* Providing a supportive environment nourishes your creativity. One of the biggest myths concerning artists is that they live disorganized and chaotic lives. Walk into the studio of an artist managing an active practice, and you will see nothing could be further from the truth. We artists may work in a way that seems peculiar to the rest of the world, but there is a structure and process to what we do.

Some people say they work best under pressure, but working under pressure is a bit of a fallacy. It's not waiting till the last minute that gives you the good work; it's the focus that is required when you wait till the last minute that brings about the good work. So think of it this way: Your focus is the center of your brilliance; why not avail yourself of that brilliance on a regular basis? Everyone has her own rhythm, but if you don't like the fact that you procrastinate, one way to get out of it is to think of what the alternative is. The alternative is, instead of trying to do a month's work in a few intense days in the studio, to give yourself the pleasure of yourself in flow, in focus, on a regular basis.

—Anna Deavere Smith, *Letters to a Young Artist: Straight-up Advice on Making a Life in the Arts: For Actors, Performers, Writers, and Artists of Every Kind* (New York: Anchor Books, 2006), 48

The first thing you need in order to manage your time better is to analyze what you currently do each day. Similar to the process of assessing your finances in chapter 6, you need to keep a diary of all your activities both in and out of the studio for a few weeks. This exercise is *not* an opportunity to berate yourself for an inefficient, wastrel life. It is your chance to learn something about how you currently use your time.

1. *Track your time.* Use a notepad, planner, or computer to take notes about what you do every day. Record how you use your time in and out of the studio to provide a complete picture of your activities. Do this exercise for at least two weeks. Use notations as specific or general as you like: work, sleep, studio, relaxing, commuting, cooking, video gaming, email, web surfing. Track it as closely as you can. If you concentrate on one thing for a long time, block out a whole chunk; for example, "11–7: sleep." Write down everything without

judgment or cheating. No one else needs to know that you were mesmerized by YouTube for three hours. Think of yourself as an anthropologist collecting data.

2. *Go back and assign each activity a category:* work, family, friendship, romance, knowledge, health, finances, self, spiritual, art studio, art business, downtime, etc. Add up all the minutes and hours spent daily and weekly in each category—again without judgment. Your three hours on YouTube could be categorized as feeding your creativity, doing research, or relaxation. Maybe it was a little of all three. Part of this exercise is to be honest with yourself about which categories the activity belongs in. Remember: it's just information; don't turn it into an indictment of yourself.

3. *Analyze the information.* To do this you need to fearlessly examine how you are currently spending your time. Begin by adding up all the hours in each category and arrange them as a list in descending order on a piece of paper. The category with the highest number of hours is at the top and the one with the fewest hours at the bottom. On what categories do you spend the most time? Necessities like sleeping and earning money may top your list. Note what nonessential activities are toward the top of the list as well.

Are you surprised by any of the categories? You may be shocked at how much time you are spending on the Internet or commuting, or how little time you are devoting to exercise. Last time I did time tracking, I was surprised at how long it took me to correct jpegs. This realization prompted me to hire a photographer to get a refresher tutorial to shoot better images with my digital camera and to learn Photoshop shortcuts to enhance them. It dramatically cut down the amount of time I needed to spend on this activity.

Note how long it normally takes to do some tasks. This is an ongoing issue for me, so I really have to pay attention to this one. My tendency is to think things can be done in half the time they actually take. For example, preparing and packing artwork for shipping. What I think will

take fifteen minutes actually takes an hour and can ruin my day if I haven't adequately planned for it. When I acknowledge how much time it takes to do something well, I schedule tasks more realistically.

Search through your time-tracking notes for hidden pockets of time. You may spend an hour each day on mass transit or driving. Use commuting to catch up on your reading, compile and plan your studio to-do list, dictate notes into a digital recorder, or listen to audio books on your MP3 player. Always keep a notebook with you to sketch in new ideas, should you have an unexpected half hour to kill— sitting in the doctor's waiting room, waiting in the coffee shop for a friend running late, or finding out an appointment has been cancelled.

Go through the categories, and see if there are any activities you can delegate, reduce, streamline, or eliminate to free up space for more productive ones. For example, I keep a running list of needed images posted in the studio, so when I set up the photo equipment to do a shoot, I don't have to try to remember which ones need to be done. If you were surprised to discover how much time you spent on email or browsing the web, set limits for those activities, or move them to a part of the day when they won't interfere with your studio work.

Does your life reflect the balance you seek? Ask yourself what your art practice needs. You need time for research, reading, writing, making mistakes, production, documentation, and fooling around. Look to see if these activities currently show up in your time tracking. Check your freelance business, teaching responsibilities, or other paid work to determine if they take too much of your schedule. Can they be compressed into one less day a week, freeing it up for art? Review your priorities to ensure they are accounted for by the way you spend your time. Go back to the category list you made, which added up hours of each week in different activities. Imagine the changes you would like to have in place a year from now. Would the studio work category move up a few notches because you have freed up another six hours a week for it? Hopefully, the "art administration" category would now make an appearance on the list.

When I was working in a 9 to 5 job, I was rigorous about my studio time, but now that this is my full-time career, I can be more flexible, partly because I have the discipline that I need to go into the studio when I need to be in the studio. . . . There are whole days and weeks when I don't paint and I am doing other things. But when I am painting and getting ready for a show, I am totally focused on the painting, the drawing, whatever, and I do very little else.

—Joanne Mattera, artist

4. *Draft a new schedule.* Once you have analyzed how you currently spend your time, map out your new production schedule. Pencil in the standing appointments, first assigning them the optimum times for you or the time you can't control, such as your 9 to 5 day job. Fill in the rest of your schedule with other activities based on your priorities. There will likely be some overlap, or some activities you can't fit in, but don't worry—this is a just a first draft. It is a fluid document that will be constantly tweaked and revised. Use this schedule as you would a road map: it shows the possible routes available to navigate your day, week, or month.

 It may help to make your draft schedule color-coded. Collect different colored Post-it notepads, and assign them categories: yellow for work, pink for art, blue for family, etc. Post them on blocks of time on a weekly calendar. Step back to evaluate the color dynamic. Do you want to find an additional block or two for pink or blue? Post-its are easy to move around to try out different options, or to respond to changing work schedules.

Artists have to be able to identify a business structure. If you have a 9 o'clock appointment with the curator at the Museum of Modern Art about your exhibition and you arrive at three, you do that once, the buzz will go out that you're not somebody that they want to work with. It can damage you personally, no matter how good your work is.

—Fredric Snitzer, director of Fredric Snitzer Gallery

Don't forget to allow time to have fun, rest, and relax. The purpose of this exercise isn't to create a schedule that's all work and no play. Time off is also time well spent. It renews your imagination, balances stress, and prepares you for the next task. I always have to remind myself to take time off. Even if it is going outside for a walk around the block, it clears my head. Staring out the window and daydreaming is a necessary part of my creative process. What may be a chore for you is a pleasure for another. I often enjoy spending an hour or two cooking at the end of a work day. In the kitchen I can catch up with the daily news from the rest of my family while chopping, steaming, and sautéing. Curling up on the sofa to watch a movie is another welcome escape.

 Make it a goal to change your schedule gradually so that it becomes a healthy balance between what needs to be done and what you want to

do. The clarity that comes from time tracking is a good wake-up call about how much of your life does not reflect your goals and desires. During the years I worked full-time at other jobs, I had to remind myself over and over again that studio work was my priority. Besides my family, it was the most important part of my life, and I had to protect it. Even when I did not yet have an active career, I scheduled time each day to work on it. That point was driven home for me when I had my first job after graduate school working at Pearl Paint. My studio work had dropped off to "something I intend to do one of these days." At the end of a day's work, I was too exhausted and filled with the needs and complaints of customers to do much more than head home, eat dinner, and collapse in front of the TV. By the time my day off rolled around, I had lost the thread of what I had been doing in the studio and just vegetated. After a few months, I realized that I needed to come up with a new plan. I recalled that in graduate school, I'd roll out of bed at 7 A.M. full of fresh energy and head off to the studio hours before anyone else showed up. Now I was rolling out of bed and trudging off to Pearl Paint. I made a new commitment to give my art practice the best part of me and my day job whatever was left over. I started setting my alarm clock for 4 A.M., and, armed with strong coffee, I worked for three to four hours before heading off to my job. That also meant I was usually in bed, with the telephone turned off, by 9 P.M. All I was giving up was a few hours of TV, and the gains in the studio were amazing. At 4 A.M., the world was quiet, and I could work without interruption. It felt natural to go from the dreaminess of sleep to making art. I felt deliriously happy going off to work having first accomplished something important for myself. There were mornings when I couldn't pull myself out of bed, and the kindest thing I could do was hit the snooze alarm. But as I was drawn into a new body of work, most mornings I awoke with anticipation. I have used this schedule at other times in my life. When my children were small, I often got up before they did to start working in the studio, and I usually fell asleep reading to them at night.

It is crucial to discover when and how you are able to be the most productive in your art practice. How you approach it may be completely different from the way I have. Your creative energy could peak in the

Everyone needs total loser time during the day, doing something they would be embarrassed to tell anyone they were doing.

—Colleen Keegan, creator, Creative Capital Strategic Planning Program for Artists

afternoon or late evening. It might not be a particular time of day, but rather short bursts of activity throughout the day. You may benefit from a weekly agenda where each day is a different activity, such as Monday, Friday, and Saturday for studio time and Tuesday, Wednesday, and Thursday for other kinds of work, with Sunday as time off. Your studio day could be further divided between concentrated art making and art administrative tasks. You might arrange your freelance work to dedicate a week to full-time studio work every month. You may break down your tasks for an upcoming project and spread them over several months, using your teaching semester to accomplish the research and fundraising and the summer break to produce the work. Find a way to schedule your life around your studio practice, so you can give it your best effort.

Know what it takes for you to become deeply engaged. Many artists establish a ritual to get themselves into the frame of mind needed for the studio. My friend Carol segues from the outside world to the studio by writing in her journal or reading. She uses that time to download all the things she may be worried about and put them aside. Another artist I know begins by drawing something. It doesn't matter to him if it has any relationship to the other work going on in the studio; rather, he uses the activity of drawing as a way to get into the right mood. I start by cleaning up my mess from the day before while circling around the work, thinking about how I want to begin today.

If your studio is in your home, or a few steps away, make some rules for yourself about the separation of work and life. I've had studios both in and away from my home. I learned to ignore dirty dishes, dust bunnies, unmade beds, and piles of laundry. On my studio days, I delegated those tasks to another member of my family. It is easy for the people you live with to assume that because you are working at home, you have also signed up for all the housekeeping. I spent many hours training my sons to respect my studio time. They had to learn not to interrupt me with unnecessary requests when I was working in the studio or making business calls. They grew accustomed to my refrain, "I'm working. I'll help you later." I'll never forget when I was talking with a gallery director about my upcoming show and my boys suddenly broke

out in a loud argument in the next room. Over the cacophony she asked me anxiously if everything was okay. I could sense immediately that no one was in danger. Since we had played telephone tag for days, and this was an important conversation, I replied, "Oh it's nothing—ignore them." I was determined to protect my studio time as best I could. You may have good house rules, but it can be hard to get the other two- and four-legged members of your family to always cooperate. I know this is easier said than done, but it's worth a try.

As you go through your day, you might want to keep a notepad nearby with a running list of the tasks to be done. It can be a way to organize the limited time you have in the studio, and as you become deeply engaged in your work, you will naturally want to do the tasks that support it. Your to-do list becomes a must-do list and is woven into your practice. I go through the day happy to cross off an item from my to-do list. I also like to alternate something I like to do with something I don't, to make sure I don't leave all the worst tasks for last, when I am least motivated to do them. By the end of the day, the crossed out to-do list is a rewarding reminder of what I have accomplished. Anything leftover gets moved to a new list and another day. Make your studio a place you love to be in.

The purpose of time management is to create a plan that reflects your way of working, lifestyle, needs, and goals, whatever form it might take. If your schedule is still out of control after doing this exercise, check back to see if you have made some common errors, such as not setting aside a specific time to do an important activity, like paying your bills, updating your records, or running on the treadmill. Maybe you are unrealistic about what can be accomplished in a day or how long certain tasks take, so you consistently overbook your activities. I'm guilty of cramming too many "must do's" into a day and regretting it later. Other scheduling issues might be resolved by delegating the chore to someone else, breaking down a big job into smaller steps over several days or weeks, or organizing your space so that things can be done more efficiently.

I always feel like I am starting from scratch. So how does one carry the information from one experience to another? We just started a new system called "The Studio Rules." It's totally idiosyncratic, but, in general, every time we make a mistake, we write it down and try to make a rule out of it, so we don't make the same mistakes over again. Of course, we are always going to make mistakes. It's a hilarious list.

Prioritizing has become the most important skill. What are the things that need to be dealt with? I think the big challenge for all artists is not to let the administrative tasks take over. You could do them all day, feel very accomplished, and not make any art. So there is another list that is dedicated to just the studio works. I see whether I can move any of the works forward before the administrative stuff takes over.

—Janine Antoni, artist

Even the best schedule falls to pieces if it isn't coupled with organized systems. That is the subject we will tackle next.

Organization

A big factor in my ability to manage time effectively is determined by organization. If good time management has freed up several hours, nothing is more frustrating than wasting them searching for a wayward consignment agreement, by being late for an appointment because I misplaced my front door keys, or running out of canvas after the art supply store has closed for the holidays. All my organizational systems arose from a particular need or problem to be solved. I added an inbox on my desk, an orderly filing system, a hook next to the front door, and a supply list pinned up in the studio where I can't miss it. I have yet to solve the problem of pulling off my reading glasses and laying them in the most bizarre places, but I'm working on it.

Don't claim your personality is incompatible with being organized. You get up and dressed each day, which is a form of organization, even if your socks don't match. Actually, to create your art means you have already developed a complex organizational process. Organizing yourself frees up emotional space and rewards you by making your art life easier and more productive. Initially, it will require that you set aside time to develop systems that work for you. Look around, and choose a place to begin—the clutter in the studio or the pile of papers under your desk. Don't try to do it all at once. Once you decide which area to take on first, dedicate a few hours to get started. Don't forget to promise yourself something really wonderful when you have completed the job.

Clear a space on the floor or table, and sort things into piles. Start with the big categories that work for you: art supplies, tools, equipment, office supplies, paperwork, etc. After creating the big piles, tackle them one at

> *Successful organizing systems work long-term only if they're based around who you are. You can learn new skills and modify some behavior, but you can't really change your basic personality—and you shouldn't. Your likes, dislikes, needs, and desires must be the foundation of your time-management system. You come first; the system follows, not vice versa.*
> —Julie Morgenstern, *Time Management from the Inside Out: The Foolproof System for Taking Control of Your Schedule—and Your Life*, 2nd edition (New York: Henry Holt/Owl Books, 2004), 4

> *All of the successful artists I know are very disciplined and very organized. Even if they don't look organized, they have their own order.*
> —Anna Deavere Smith, *Letters to a Young Artist: Straight-up Advice on Making a Life in the Arts: For Actors, Performers, Writers, and Artists of Every Kind* (New York: Anchor Books, 2006), 35

a time by further sorting them into sub-piles. If you can't figure out where to put something, make a pile of miscellaneous things. By the end of your sorting, you will have a clearer idea of what to do with them. I have to be careful I don't get distracted from my sorting and hold off the irresistible urge to call a friend whose two-year-old exhibition announcement I just unearthed. I stay focused and make a pile of uncompleted projects, and a list of people to contact for later.

While you are sorting, divest yourself of anything that isn't going to help you achieve your goals or gets in your way at the studio. Recycle or give away things like old art magazines, out-of-date software programs, art materials you no longer use, stiff brushes, empty cans, and extra sets of slides beyond the ones safely archived. Put aside art books and catalogues you no longer reference. Consider selling or donating these items. While you are sorting, be dispassionate about the process. Pretend that this is someone else's clutter and that every little piece of paper, bent scrap of wire, or empty jar doesn't have some significance for you.

Remember the saying "A place for everything and everything in its place." Be generous with your possessions, and give over some real estate in your studio to an organizational center. Decide if you want to have your administrative things in the studio or in an office area where you live. Your decision will be based on how you do your best work in these two areas of your practice. Many artists choose a physical separation of those activities, so they can give their attention completely to either their studio work or their art business.

Look over your piles, divide them between art-making stuff and business stuff, and assign everything a home. The goal is that everything has a place where it belongs, and like belongs with like. If it is important enough to keep, it is important enough to have its very own place where it lives all the time. Think of the way you use and retrieve your supplies, tools, paperwork, and computer files to determine how they should be stored. These decisions should correspond to the way you use them in your practice. The things you use the most should be the easiest to reach. Your art should be stored like the valuable product it is, not in a pile

next to the door where it will get bonked all the time. Protect your art, equipment, and files from dust, dirt, and water.

Invest in the right kind of containers for your belongings: filing cabinets, shelves, drawers, utility carts, sturdy cardboard boxes, plastic storage containers, three-ring binders, and stacking letter trays. Look over each pile, and determine how best to house the items. Find containers to take care of the most pressing items, and add more as you go along. Four or five labeled plastic boxes on a shelf or a stack of letter trays separating out freelance projects, studio work, and bills can quickly bring order out of chaos.

Take the time to put everything you have used back in its home. It takes only a few minutes a day to save you from ever having to organize this whole mess again. Establish new habits to streamline the operation. For example, I usually open my mail at my desk, which has a paper recycling bin underneath it. Bills go into their own inbox, exhibition announcements go into a pile, and things to be looked at later go into another box. All the unwanted credit card offers and catalogues go directly into recycling. When it's time for me to pay my bills, they are where I want them, and at the end of each week I clear out the recycling bin. Some bad habits may be hard to break, so figure out a way to work with them. In the studio, I get so involved that I usually work up until the last possible moment and then run out the door to my next appointment, leaving a mess behind me. I find that I'm more motivated to put things away when I start working again the next day; this bad habit has become part of my beginning studio ritual.

GETTING HELP

Ask for help if things are still out of control. If you are stuck somewhere in the process above or have completed all of the steps and still haven't resolved your organization issues, you might need to get assistance. The helping hand of a good friend or hiring an intern will allow you to share the burden and delegate chores to someone who can do it dispassionately, or more efficiently than you can. Someone else can

bring in fresh eyes, give you new ideas on how to accomplish the task, or help you break down an overly complex job into smaller steps.

It is always easier for someone else to organize your possessions because he or she isn't attached to it. Last year, we moved our family and my studio from a loft where we had lived for twenty-nine years to a new one in Brooklyn; I was faced with a huge reorganization job. Thousands of decisions had to be made, from what kitchen cabinet to store coffee mugs in to reorganizing all my prints and drawings in the flat files. I spent the first week valiantly unpacking boxes and portfolios with my assistant and managed to get the studio in order. But when it came to figuring out my office, I was flummoxed. Suddenly it all seemed too much for me. I couldn't bear to open any more boxes or make one more decision. I called my sister and asked her to fly in for a long weekend to lend a helping hand. She infused the project with new energy and teased me about my extensive Post-it note collection; her good spirits kept me focused on the job. We took lots of leisurely breaks to explore cafés and shops in my new neighborhood. With her help, organizing my office stopped being a chore and became fun.

If you feel overwhelmed by your mess, get some help. Trade onerous jobs with a friend the way you would a studio visit. Your fresh perspective can help solve his organizational issue; his helping hand can keep you focused on your job until it is completed.

RECORD KEEPING

Oh, the dreaded record keeping. *If you do no other task outlined in this chapter but one, this is it.* While writing this book, I routinely asked my friends if they kept an accurate archive of their work. All but a few blanched at the question and confessed that they just never got around to doing it—and promptly changed the subject. *You must keep accurate records of your work.* No one is going to do this for you. Even if now or someday you are working with a trusted art dealer, you need to keep your own set of records. If you are just beginning your career, do it now while it is still a small list. If you have been making art for awhile

and haven't kept any records, it will feel as daunting as climbing Mt. Everest. Remind yourself of the many hours, days, weeks, months, and years you have devoted to your work. Don't shirk this last part of your responsibility to it. If you feel overwhelmed, break it down into a more manageable task by doing a few pieces at a time until you have a complete record of your art. Enter this information either into a database on your computer, in a notebook, or on three-by-five index cards.

An archive record is an important document that provides detailed information about a single work of art and its history. The following should be included in the archive record for each piece of work:

1. **Title of work:** Each work of art needs a unique designation. If you don't title your works, then give them numerical identifications, such as "1–09," which signifies the first work completed in 2009. If you make multiples, such as videos, photographs, prints, or sculptures, keep a separate record for each piece of the multiple, and add an additional number to the title indicating which piece it references in the edition, such as *Slip Stream 1, Slip Stream 2, Slip Stream a/p* (artist's proof), etc.

2. **Image(s):** Attach an image. It can be a jpeg, if that's doable in your computer program. If recording in a notebook, attach a small print, slide, or page of images if it is a more complicated piece or installation. Save archive images of this work in a secure location.

3. **Date:** List the year completed. You can be more specific on the date if needed, but generally just the year is enough.

4. **Size:** Follow the standard sizing format of height x width x depth (Happy Work Dimensions), and indicate whether inches or metric measurements. For works with borders, such as prints, photographs, and drawings, you may wish to

Artists are the absolute worst record keepers I have ever seen in my entire life. It is so easy in this day and age with digital cameras and computers to keep track of every single thing you make. It's the most basic thing in the world: size, date, medium, a picture. You should keep track of where it is going. If you do it all the time, then it's not a daunting situation when you're sixty years old and come to someone like me, and you've got an inventory of thousands of pieces laying around your studio, and I say to you, "What's the value?" and you look at me with a blank stare. I say, "Well, I can't help until you tell me if I am dealing with an estate that is worth $5 million or $150,000."

—David A. Dorsky, attorney and director of Dorsky Gallery Curatorial Programs

specify two sets of measurements: paper size and image size.

5. **Medium/Materials:** Be as descriptive as necessary. "Mixed media" may be enough for a wall label in an exhibition, but your records should spell it out, e.g., graphite, colored pencil, and mica.

6. **Price:** List the selling (or retail) price of the work, taking into consideration gallery commissions. This is the price listed when the work is exhibited or insured. Keep pricing information up-to-date.

7. **Installation requirements/instructions:** Record any information needed to install the work, such as special hooks, wall attachments, pedestal size/height, or wall arrangement. This entry may refer to installation plans and layouts attached as PDF files and/or installation sketches and diagrams in a file folder or notebook.

8. **Equipment needs and interfaces:** If your installation requires three flat-screen monitors and a Super 8 film projector, list the specifics here, including manufacturer and model number. Technology changes quickly. If your time-based work requires a specific version of a software program or style of monitor to capture its original essence, note it here.

9. **Location:** Enter the location of the work. Is it at the studio, in storage, on consignment, in a show, or sold? List the name and contact information of the art professional, gallery, museum, or collector where it can be found.

10. **History:** Record all events associated with this work, including where it has been exhibited and dealers to whom it has been consigned. If the work has been sold, donated to an auction, given away, or traded with another artist, record as much information as you can collect on the new owner as well as the date of the transaction.

Here is an example of one of my archive records:

BATTENFIELD, JACKIE

MIZU: Shito-Shito (Rain)
1992
6 x 24″ collage on paper
20 x 38″ sheet size
50.8 x 96.52 cm

Signature: Front, lower right

Description: Monoprint collage/dry mount

Condition: excellent

Retail: 900.00

Location: Sold

Categories: 4 Square Horizontal Collages

Collection: University of Richmond Museums

Exhibition notes: Exhibitions: University of Richmond 9/93; University of New Hampshire 1/94; Chicago Center for the Print 5/94; Erickson & Elins 9/94; Addison Ripley Gallery Ltd. 2/95

You can set up your own archive record-keeping system in a spreadsheet or in a data management program such as FileMaker Pro. You want a searchable database that will provide sort functions that will allow you to organize the information according to your current needs, such as a list of works by media, title, date, location, sold/available status. Set it up so each category has its own column. There are also art management software programs such as the one developed by GYST, an artist owned company (http://www.gyst-ink.com). Their program will sort your work according to your specifications, allow you to attach jpeg images, and help you keep track of where the work is and, if unsold, when it should be returned (image next page).

The information in your archive must be protected. Make sure you back it up to a secure location, such as an online data archive, external hard drive, or flash drive. Regularly back it up to a source different from your studio or home. Should a flood or fire destroy the records, they are reachable elsewhere.

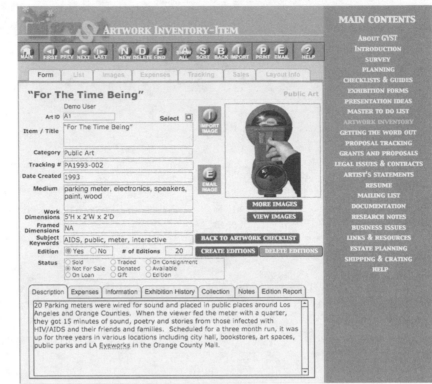

A screen image from the GYST (Getting Your Sh*t Together) software system. The program is a computer database that allows visual artists to keep track of artwork, consignments, sales, invoices, and more.

Don't rely on your galleries to keep records of where your work went. Galleries come and go, and you may never find any of that work again.

—Ellen Harvey, artist

Keep records of all correspondence, contacts approached, grant proposals, etc. Set up folders on your computer to store them away so they can be easily retrieved. List all attachments sent at the bottom of the letter: work samples (titles), résumé, catalogue, etc. When you follow up, you can note what they have already received. Make some decisions about what you wish to keep also as hard copies: important correspondence (including emails), contracts, signed consignment agreements, grant proposals, budgets, financial records, reviews, and freelance projects. If you get audited by the IRS, they will want to see actual invoices and receipts, even if the purchase was on your credit card.

Develop a filing system. Keep files on everything that happens in your business: clients, customers, galleries, exhibitions, projects, budgets, bills, etc. Filing isn't about where to save things, it's about how to find things.

How do you organize your things? As you sort and plan, think about how you will store the paperwork and information you wish to retain.

My habit is to store those sheets of paper in file folders. I am not ashamed to admit that one of the first pieces of furniture I bought after college was a filing cabinet, which I proceeded to fill with art correspondence, artist statements, project proposals, slide sheets, teaching syllabi, contracts, and financial records. Years later, when my husband entered my life, I cleared out one of my file drawers and organized and filed away all his papers. Over the years, I noticed that he stacked his paperwork on top of the files. He could still find what he wanted; it just wasn't in a file. That's when I realized that he wasn't a filer—he was a piler. When I reorganized our office space and ordered new furniture, I took his system into consideration and ordered a series of smaller drawers for him to store his piles and file drawers for me. According to the organizational solutions company Pendaflex, 48 percent of us are pilers. Figure out what system works best for you, filer or piler, and organize your space accordingly. I helped a good friend, another piler, with her organizational nightmare by suggesting a long narrow shelf above her desk to hold ten labeled inboxes, each storing the paperwork of a different project or job and one box for actionable items

What you file or pile must also be retrieved. Make sure your files and piles are labeled and organized in a way that makes sense to you when you need to refer to the information they contain. If you have a pet name for a project or organization and that's the name which comes to mind when you think about it, then use that label for the file rather than the one you think should be used. For example, I have a file called "Help" that contains information about different professional services I may need, such as art moving companies, installers, photographers, framers, grant writers, web designers. Some of them are people who have been referred to me and others are ones I have used.

All organizational systems need regular maintenance, or you'll be back where you started in a few weeks. Schedule a time to go through the accumulated items that are cluttering your desk or workspace: sort, throw out, file/pile, reshelve. I will retrieve something from a file but

I don't use a software program [for my archive records.] I work on a PC, and I create folders. I have a visual inventory. I have a folder for each gallery I work with, and within each folder I have folders that show me what they have now, what they have sold, what they have returned to me or I have retrieved from them, so I have a good visual record of my history with them. . . . I'm a visual person. I like to write, but I can't follow directions. I have a really hard time with Excel spreadsheets and stuff like that. I want to see it. As soon as I see it, I know everything about it. When I made it. What the day was like when I made it. Everything.

—Joanne Mattera, artist

neglect to put it back. Every few days I make myself go through the accumulated pile of paper that has been pulled from folders and return everything to its "home." Over the years, just knowing that the things I pull out will eventually need to go back has gradually helped me develop a more consistent habit of returning an item to its file when I'm finished, rather than waiting for it to pile up.

I needed to create a system that anyone could just step into, walk into, and take part in. That creates a certain mind-set. It was a matter of making a file for every piece I've ever done, splitting it up into installation instructions, provenance, various written texts about the work, conservation, and anything and everything else pertaining to each work. This way I could just go to the file and access everything I need.

—Janine Antoni, artist

Working with Assistants

Your studio is your sanctuary, and your records and files are personal too. Not all artists like to have someone watching them work in the studio or rummaging through their correspondence. However, you may find that as your career expands, doing everything yourself is not the best use of your time. You need more than the occasional helping hand from a friend. You need someone to show up regularly to tackle certain tasks you assign.

When my children were small and all I could afford was a few hours of babysitting each week, I would daydream about how much more I could accomplish if I had a personal assistant—someone who would diligently record and archive every work of art created, maintain my business receipts, balance my books, handle minor correspondence, order supplies, clean up the studio, run errands, and free me to pursue my projects. You too may be feeling overwhelmed with the responsibilities of managing your studio practice, job, and personal life. There are many ways you can get help.

STUDENT INTERNS

Help can be had for free or minimal cost by taking on an intern. When a student or emerging artist volunteers to work with you, it provides benefits for you both. He or she gets intimate and valuable knowledge about the daily functions of a professional practice, and you get a talented set of hands and legs. Many colleges support internship opportunities for school credit, so check out what's available to you locally.

A free internship will last only a few weeks or a semester at most, but it can help you tackle big projects, such as update your work archive, clear away the clutter and reorganize your studio, or assist with the construction phase of your project. Interns can possess proficiencies you don't have: Photoshop expertise, carpentry skills, or the ability to flawlessly gesso a canvas. Figure out what tasks you want to jettison from your to-do list, and search out a person to do them. You may need to train an intern to do it your way, but it will be worth it. After you have worked with a few interns, you will begin to understand what kind of personality and skill set works best with yours.

My current personal assistant started with me as an intern. Laura was a fine arts major, and the summer before her junior year she wanted to intern for a painter. Her aunt approached me, and I was reluctant to take her, as I already had a paid assistant to help me in the office two days a week. Besides, I never liked the idea of someone hanging out in my studio while I painted. However, as a favor to her aunt, I interviewed Laura. I was immediately charmed by her warm personality and eagerness to learn. I decided to give it a go. That summer, Laura worked with me in the studio two days a week. I provided her with subway fare and lunch. The first day I taught her how to stretch and gesso a canvas, and she rapidly became proficient. She worked hard and entered into the daily life of my home and studio with ease and grace. We had lengthy talks about art and the art business and occasionally escaped the studio on "field trips" to galleries and museums. By the end of the summer I was sorry to see her go. We kept in touch during her final two years of school. When she emailed me at graduation that she was looking for work, her timing was perfect. My long-time assistant was moving on to a fabulous new job. I had confidence that Laura would be able to take on the additional tasks I needed in my office. After a few days of training by my old assistant, the transition was easy. In fact, much to my delight, Laura brought a much-needed new skill to my practice. She was an incredible

With interns, you can't expect them to know anything. You can't just say, "Here straighten this out. Here, gesso this." They are working for free to learn something—that's how they are getting paid. I've learned the hard way the necessity of carefully explaining how to do everything I need them to do for me. I like to talk to interns about my thought process as we're working, because, usually, they have no idea why we're doing something. How am I thinking about creating a show? How do I keep a fairly organized inventory system? What do I expect my gallery to help with? Or whatever it is that I am trying to do. I find it helpful for me to think out loud, and they seem to find it helpful to hear me think things out. So that is the good side.

—Jane Dickson, Artist

JANE DICKSON
God Truck, 2003
Oil on Astroturf
37 x 73 inches
From the series *Traffic*

copy editor. As I was beginning to write this book, it was a skill for which she was very much in demand.

ARTIST ASSISTANTS

An artist assistant, unlike an intern, is someone whose services you pay for and use on a regular basis. Depending upon the nature of your practice, you may have an assistant who works a few hours or days every week, or one that works for you full-time during a project.

I resisted hiring an assistant for too long. I knew I needed help, but I didn't want to face the additional expense. An intern would be only a temporary solution. I didn't want to train someone and then have him or her leave after a few weeks. Finally, the pressure was too great. My to-do list was longer and longer and never done. I had fallen behind on everything and responded only to pressing situations. I was reacting instead of taking action. I couldn't put it off any longer, so I made a list of what I wanted an assistant to do. That was easy: office work and record keeping. I then asked around for recommendations of someone who might fit the bill. Along came Callie. She was an artist and a seasoned

professional assistant who juggled part-time work for several artist clients while developing her own projects. She started to work for me two afternoons a week, and immediately my life became more productive and calmer. Her fee more than paid for itself in the hours I could reclaim making art. It was invaluable to have someone I trusted to discuss issues, ideas, and decisions.

Figure out what your most pressing needs are, and invest in yourself by hiring help. A good assistant brings a set of skills that complement your own. Because you are paying her, you will be forced to organize yourself to utilize her time and skill set efficiently. It's painful to watch someone stand around with nothing to do when you are paying her by the hour. Since it is part of her job, an assistant will tackle tasks you may dislike, with much less angst. She can even help you think out loud and is a ready source of advice: "Which angle works best?" "What do you think of this color?" (See Jane Dickson's quote on the next page.)

Hiring an assistant brings with it responsibilities. You are obliged to be clear about her duties and to train and supervise her in those tasks until she does them as you wish. She wants to feel the satisfaction of a job well done. I initially hire an assistant for a three-month trial period, which is discussed at the interview. At the end of the three months, we review the person's performance and talk about any issues that need to be resolved. So far, I have never had to let anyone go at the end of three months, but having that system in place gives me an exit plan if it is not working out.

Kiki Smith retains two assistants to help her in her studio and one to run her office. "What I like is that, when people show up at a certain time of day, it kicks you out of your own subjectivity and forces you to think in an orderly fashion instead of drifting," she says. "For self-employed people, that's a big thing."
—Linda Yablonsky, "The Studio System," *Art & Auction* (November 2007)

CONSULTANTS

A consultant can provide essential services and expertise that you do not have, such as photography, accounting, graphic design, web design, proposal writing, and public relations strategies. They are not miracle workers; they cannot read your mind, nor solve your long-standing problems, but under your direction they will assist you with a particular part of your project. You may not need the services of a regular assistant or intern, but sometime in your career you will probably hire a consultant.

Hiring a consultant can help support your strengths and weaknesses. You may have a terrific project but need help writing and editing a grant

proposal. Your website needs a face-lift, and you don't want to learn a new software program, so you hand over your fabulous materials to a web designer who can add the bells and whistles you want on the site. Before you engage a consultant, identify your needs, and specify the expertise you want someone to bring to the task. You also need to consider your project's timeline. Timing is important; you don't want to engage a consultant prematurely, and bringing them in too late will be asking for a rushed job. Hiring a publicist in a panic the week before your show opens does not allow him or her to do a thorough job.

To find a consultant, ask for referrals from other artists, organizations, and professional associations in your field, and interview several candidates. Two consultants may have similar backgrounds and fees, but you may feel more comfortable with one style over another. Don't base your decision solely on the lowest fee. In the interviews discuss what you need to accomplish, and ask them what services they can offer. Always ask for references and examples of their past work. Check out their references, and look critically at examples of their work.

Once you have engaged a consultant, take the time to clarify the scope of your job and his fee. Together you can outline the next steps to be taken and an achievable time frame. Write up the details of the meeting, and make two copies, so you each have the same information.

Time is money! Make sure you do your homework and assemble any materials needed for your meetings. Make sure your consultant has the information he needs to do a good job for you. Get invoices for all work done. Invoices should include his Social Security number if your tax preparer wants you to file a 1099 for his services.

If you obey all the rules, you'll miss all the fun.
—KATHERINE HEPBURN

Running the day-to-day activities of your professional life doesn't take a degree in time management or a compulsive personality. It will require you to jettison a few bad habits and replace them with better ones. Again, I can't say it enough: you are the master of your studio, and if a chaotic system is the essence of your creative practice, so be it. However, chaos does not need to reign everywhere else. Organizing doesn't require talent; it requires steady commitment. There will come a day when you will need to retrieve an image, a contract, or the name of a collector who purchased work from your old gallery that closed their doors decades ago. You will appreciate the time you spent organizing if you can easily access that information. The suggestions in this chapter may seem like more work for you, but I guarantee that making a commitment to get this part of your life under control will actually free you up to be more productive in the studio. These organizational tasks are for your professional life, but you just might find they naturally carry over and favorably influence your personal life too.

If you are working with a publicist, I think it's important to find out what you can reasonably expect from them and the art community. A publicist can never promise a client what they are going to get, because we work at the whim of the media. It depends on what they want to cover.

—Nicole Straus, public relations consultant

Regularize some tasks so you don't need to overly think about them. If you have a hard time remembering the deadline for your credit card bill, sign up for an automatic withdrawal from your bank account or timely email reminders. Not only will it help bring down your debt, but you will avoid expensive late fees. If you assign a specific time to work on a task, you can more fully concentrate on what you are currently doing. I know I can be fully engaged in the studio if I've blocked out time later on to work on a pressing administrative chore. Schedule a few minutes every day to create a list of tasks and plan your schedule. Remember to allow room for the unanticipated. There will be days or weeks when your world is turned inside out. When things finally settle down, go back to your planning, and work your way forward again.

Given the complexity of our lives and the need to be self-directed, it's easy to fall into the trap of forgetting to acknowledge what you have accomplished. Make sure you aren't only focused on failure, what you didn't finish, or berating yourself for not working harder. It will adversely affect your motivation to create new work or tackle administrative jobs.

Tired, cranky, irritable individuals do not make the best decisions or art. Instead, let me suggest that you create a system of small and large rewards for yourself *whenever* you have tackled a tough task. Knowing you have planned a treat will help accomplish chores you don't like or want to do. Give yourself a bonus. Indulge in an afternoon trip to the local cinema, a pedicure, or an adventurous day kayaking.

I've learned the hard way that working all the time makes me crabby and resentful, which quickly dries up my creative juices. For me, the most luxurious gift I give myself is to attend a five- to eight-day silent meditation retreat. Sitting, walking, eating, and sleeping with one hundred other silent individuals doing likewise frees me from anyone else's expectations and allows me the liberty to compassionately and thoroughly clear my overstressed mind.

Resources

Morgenstern, Julie. *Organizing from the Inside Out: The Foolproof System for Organizing Your Home, Your Office, and Your Life.* 2nd edition. New York: Henry Holt, 2004.

Morgenstern, Julie. *Time Management from the Inside Out: The Foolproof System for Taking Control of Your Schedule—and Your Life.* 2nd edition. New York: Henry Holt/Owl Books, 2004.

- In these books Julie Morgenstern shows you how to organize and manage your life by "working with your personality, not against it."

chapter 10

How to Build Community to
Survive Being Alone

You need solitude to make your work and you need a support sys-
tem for all the other aspects of your practice. This chapter offers
practical ways to address your feelings of isolation and produc-
tively engage your community. It provides suggestions on how to
set up support, connect with other art professionals, and incorpo-
rate their help in your decision making. Sprinkled throughout are
examples of successful artist-organized groups. This chapter also
discusses the feelings prompted by rejection and how to work pro-
ductively with those emotions. Although you may feel competi-
tive and your instinct is to be withholding around other artists,
you have more to gain by adopting a cooperative stance and shar-
ing information.

*You may make the art by
yourself, but you'll need a
community for advice and
support.*

In the necessary solitude of art making, you may find yourself fluctuat-
ing between two extreme emotional states. The first one is the con-
tented state of aloneness needed to make and feel connected to your
work, and the second is the gloom of loneliness that descends when you
are feeling isolated and disconnected. Being a visual artist engages you in
creating new work and experiencing myriad emotions. As the outside
world recedes, you are left alone with your thoughts. For the most part
this is such a desirable experience that you want to return there again
and again. In this sublime state you are free and independent—no one
tells you what to do in your studio. Empowered, you only answer to
your inner vision, and your decisions are instinctual.

I remember when my oldest son was two and a half, we rented a sum-
mer cottage in the country for two months. I set up a studio in an old
chicken barn eight miles away and splurged on a part-time babysitter.

My first day in the studio, I realized that I hadn't been truly alone with my work since the baby was born. He wasn't napping nearby to unexpectedly awaken and disrupt what I was doing. There was no ringing phone to interrupt my thoughts. I relished having time to sit by myself and ponder what I wanted to do with my painting. I was grateful for this unstructured space to focus completely on my work.

The other end of the spectrum is when you move from a contented aloneness to a painful state of loneliness. The history of art is replete with despondent artists. I don't know of anyone who has not experienced a slump or some sort of paralysis. This discontented state is inevitable. You experience a sudden shift of emotion when the interior spaciousness of your creativity is reduced to claustrophobia. It seems as if the walls are closing in around you, and your studio resembles a cold prison cell rather than a warm hub of productive energy. Your inner conversation is stale and comes to a halt. The certainty that comes from feeling connected to your work shifts to uncertainty and fear. In this disconnected state, your inner critic takes over, and you are more vulnerable to doubt and despair. No longer feeling secure, the studio becomes a place to avoid, and you stop going.

Disconnection and insecurity lead to a profound loneliness, which is very different from the productive solitude you want in your studio. The first thing that happens is that you think no one really understands your problems. Instead of seeking engagement with the art community, you defensively withdraw from your peers and potential opportunities. From there you feel needy and out of touch, and find it increasingly difficult to talk with your friends. As you drop out of sight, a sense of desperation overtakes your self-esteem and public persona. You unconsciously project your diminished perceptions of yourself as an artist onto the way you believe other people and the art world perceive you. You have landed in a deep, dark rut. This is a fiction of your own creation, even though you experience it as if it were a reality.

Feeling alternately connected and disconnected from your work is a natural part of being an artist. The creative process embodies both states of being. Your ability to navigate these opposing parts is how you realize your creative vision—both inside and outside the studio. The challenge is

finding the right balance between the creator and the critic. There are no secrets in this chapter to avoid moments of loneliness; they are normal emotions every artist experiences. In fact, the more you try to avoid them, the more they gain momentum. That said, there are ways to manage and reduce periods of disconnection from your work. The remedy is to engage rather than disengage from yourself and your art community.

There are times in your life and available opportunities that are incubators for art communities. One place is art school, where you took a community of artist peers for granted. You had regular contact with other students and faculty. No matter what time of day or night, there were always three or four artists hanging out. After graduation, that easygoing camaraderie becomes impossible to maintain, when everyone scatters to face the challenges and responsibilities of life after school. Communities of artists also develop from shared workspaces or equipment, such as print and photo shops, ceramic studios, and electronic media labs. People come and go on their own schedule, but there is usually someone around to give advice or lend a helping hand. Art conversations spark over takeout pizza.

With few exceptions, having easy access to an art community isn't something you can take for granted. Even though I live in New York City, among thousands of visual artists, it is a constant effort to maintain my friendships in the art world. I wish that were not so. In spite of the fact that New York City contains more artists per square foot than most places, each artist is on a widely different schedule, holding down a job and managing his or her personal life. Artists rush to appointments, squeeze in studio time, and attempt to keep up with art events. They collapse into a heap whenever some free time appears. No matter where you live, you will need to have a strategy to develop the kind of community you need to sustain your practice.

Building a core group of artists and art professionals you can depend on to get advice is essential to your work. This group should reflect where you've been and where you want to go—people from art school, members of your immediate community, and contacts in other parts of the world. Optimally this group ranges in age, works in different media, and possesses a wealth of experience in diverse fields. You exchange contacts,

It was having a community that really helped keep me going. Having a community of artists when there was nothing happening, that kept the conversation going, even if it wasn't about art. It was about real estate most of the time, but just seeing each other's work, knowing each other, talking about work, and just being supportive in all ways was to me really the important thing.
—Fred Wilson, artist

How to Build Community to Survive Being Alone

information, feedback, and studio visits. They will give you advice and encouragement when you venture to new and daring places. They'll provide a sympathetic ear when you are stalled or a needed kick in the pants when you are procrastinating. The key is not to deprive yourself of this community. No matter what happens, art careers go through ups and downs. There will be times when you are incredibly productive and feel on top of the world as well as times when nothing seems to be jelling in or out of the studio. I don't know any artist whose career hasn't resembled a roller coaster ride. Your community will help you celebrate the good times as well as stand by you during the difficult moments. Your peers will understand the pain, frustration, and elation of your practice better than anyone else.

Over the years of conducting seminars, I have had the opportunity to interview dozens of successful artists about the early days of their careers. I quiz them on how they got started, what specific steps they took, and how they learned the ropes. A common denominator is that these artists developed a close-knit group of artist friends and maintained their alliances.

Your connections to other artists are what will keep you motivated, inspired, and committed. As you share information and opportunities with them, they'll do the same for you. As an artist, you need an outlet to celebrate good news, complain about problems, and receive a helping hand. I have found that scheduled activities are the best way for me to keep in touch with my community. The next section will explore four arenas of community building that will help you find your peers both locally and internationally.

The network that supported me was really my peers. We all moved [from Rhode Island] together. . . . It was quite an amazing group. And we all shared studios, living, got each other jobs and shows, helped each other install our work, and we helped each other make our work. So I came with a ready-made community that I already had a pretty rigorous dialogue with through school. And then, I think it was super important to meet other people, because we had all been taught by the same teachers. So we pretty much all had a similar approach, even though our work was very different. Meeting those other people was very important, because it really broadened my education and made me realize there were all these other ways of doing it.

—Janine Antoni, artist

Arenas of Community Building

THE WEB

The Internet is a stream of information and connectedness.

You already know this: the Internet links you to the diverse opportunities and practices of the art world. Right in your own home you are

connected to art news, trends, and happenings. Even if it isn't your cup of tea in terms of art, you need to be up-to-date and stay current on the issues. A steady stream of art news and information, grants, fellowships, and artist residencies is right there for you to research any time of day. Build a comprehensive email list to keep connected with art professionals all over the globe. Go back to chapter 4, and review your contact lists. Make sure you are regularly adding new names of artists, art professionals, and interested viewers. Learn and use networking programs such as MySpace, Facebook, and LinkedIn to stay connected.

Stay informed about what interests you and how it pertains to your work. There are blogs on almost every issue in the art world. You can start a conversation on your own blog, as Joanne Mattera did (see chapter 3). You can also bookmark other art discussion groups and add your own comments. Two of my favorite blogs are written by art dealers: edwardwinkleman.blogspot.com and badatsports.com. Edward Winkleman's blog with the catchy tagline "art/politics/gossip/tough love" discusses issues from a New York City dealer's point of view, while badatsports presents Chicago-based discussions by a former art dealer,

When I think about the people that I see that are happy with what they're doing, they are people that have good networks with other people.

—Jennifer McGregor, director of arts and senior curator, Wave Hill, and former director, NYC Percent for Art Program

Lisa Boyle. These art professionals have opened the "back rooms" of the art business through their personal candor. Other blogs such as Washington, DC–based Tyler Green's Modern Art Notes (http://www.arts journal.com/man/) provide fresh commentary on contemporary art happenings and people. Many blogs have RSS feeds, which will send a message to your inbox or blog tracking program when new posts or comments are added.

Sign up for the email list of any art organization you want to keep track of, so their openings, panel discussions, special events, and opportunities automatically land in your inbox. Subscribe to art newsletters. Some that routinely land in my mailbox are from artinfo.com, artdead-line.com, nyfa.org, and flavorpill.com. Most of the national and international art publications have online components. Choose one or two, and also subscribe to their magazines. Having a stack of art magazines in the studio to sift through is useful activity for those in-between moments of work. While you are reading reviews online or in magazines, keep track of those organizations, galleries, and critics with whom you share an

affinity and whose writing you enjoy. You will begin to notice the kind of art they support and, if appropriate, add them to your contact list.

As much as I recommend keeping abreast of art news and communities online, I also would warn you of its dangers. The Internet can consume vast amounts of your time and have a negative impact on your productivity. Like any powerful tool, you need to figure out how to manage it and make it serve you. Review your issues of time management, make sure you reserve your best energy for your studio work, and set limits for yourself.

Artists are developing their own online communities. In 2003, artists Matthew Deleget and Rossana Martínez developed an ambitious curatorial project, MINUS SPACE, which began as a modest website to encourage and revive a critical dialogue around the language and ideas of Minimalism.

MINUS SPACE has now grown to showcase the reductive art of fifty international artists and presents four exhibitions annually in its Brooklyn project space, as well as curatorial projects in other internationally recognized venues, such as the MoMA affiliate P.S.1. It publishes an online log, a directory of collaborating artists, a comprehensive chronology of events concerning the development of reductive art on the international level, and a comprehensive directory of links to related websites. Matthew Deleget describes the process below:

> We were making a specific kind of art that people could only explain by what went on forty years ago, which was Minimalism. . . .
> We realized that the curators organizing shows we were in were having a hard time formulating the language and the ideas correctly, so we had to work heavily with them. The venues didn't have a good understanding of what we were doing. Therefore, critics were not getting a clear message, so they couldn't write about our shows. Collectors weren't buying the work. So we were doing shows we felt good about, but clearly the message wasn't getting through.
>
> We began by collaborating with artists in our local Brooklyn community and put up online portfolios of their work . . . We

asked certain artists that we held in high regard to recommend other artists, and so on. We were interested in finding the best work out there. We have artists on our site that are in their eighties all the way down to their twenties . . . from all over the globe, different ethnic backgrounds, different conceptual standpoints and artistic strategies. It's pluralistic. . . . It's a community of practice.

We also needed to contextualize what it was we were doing. We started linking up to exhibitions that were relevant to our project. We have this huge comprehensive directory of links which brings a lot of traffic back to our site. [Through these links we have been invited] to do projects in spaces, participate in exhibitions that they've curated, included in print portfolios, and catalogues.

We have leveraged hundreds of exhibitions for people. We've had people's work go into many collections . . . Our project is about community and ideas. It was never about money. We started this project with $75, and we haven't spent much more on it. We have, however, spent the last five years of our lives on it, but it's a huge labor of love.

My main concern is my community. I have been able to meet fantastic, thoughtful people from around the globe who I feel like I've known my entire life. We share a common experience, value system, and an interest in the work we make . . . I feel like our project is somehow interrupting the natural progression of things by connecting an artist in NYC with an artist in Australia with someone in the Netherlands. I don't believe it would have happened naturally had it not been for MINUS SPACE.

MINUS SPACE is a model that could be followed when developing any online community. Not only does it connect the artists to other practitioners in their field, but it also provides a vehicle to help them challenge, critique, and expand their individual practice.

The Internet hasn't replaced the need for person-to-person contact. Below are other kinds of groups you can organize or be invited to join that provide a welcome escape from tackling the hurdles of your artistic life all alone.

CRITIQUE/SUPPORT GROUPS

Regularly meeting with a group of artists is a terrific way to stay connected to your community. Think about how you first became attached to your peers. Most likely it was at art school or in a shared work space after graduation. If you have come from another field and skipped formal art training, you may have been introduced to other artists in workshops or classes. You have met them at lectures, openings, and residency programs. Use these social opportunities to develop friendships. When I conduct a workshop, I often assign everyone the task of introducing himself to two new people in the room. That way, each person, no matter how shy, is encouraged to stretch his usual comfort zone to make new contacts. At a recent lecture I gave, I was delighted to hear from an artist who had attended a previous talk of mine thirteen years ago and who told me that she has remained close to another artist she met from that simple exercise. From any introduction a long-lasting friendship can grow.

If a senior artist says to me, "You should see so and so's work," I will see so and so's work. It is the best recommendation anyone can have. So to the extent that other colleagues of yours know and respect your work is really important. Those who support each other are the ones who are more likely to have more successful careers.

—Andrea Kirsh, art historian, art critic, and writer

If you feel the need for more regular interaction, think about organizing a critique/support group. Over the years I have been involved in different gatherings of artists. One began when I was invited to join a weekend-long discussion group comprised of mid-career women artists. It was wonderful to share this time with other women talking about issues I was trying to unravel on my own. One problem resolved itself in a way I hadn't expected. While discussing the noise and confusion of working around two rowdy children, I realized how distracted and "squeezed in" I was feeling in my home studio. It made me recall Virginia Wolfe's famous maxim, "A woman must have money and a room of her own if she is to write fiction." I too needed my own space. Within a month I had rented studio space a few blocks away.

A year later, the group reconvened, invited a few new artists to join, and hired a strategic planning facilitator to coach us on how to set individual short- and long-term goals and plan for the coming year. Although I had been using planning tools on my own for a long time, it

How to Build Community to Survive Being Alone

was invigorating to experience the process with the group. Over that early January weekend, while a blizzard raged, we worked intensively on the exercises. Every once in a while someone would look out the window and report on how much snow had fallen. From then on we affectionately called ourselves "The Blizzard Girls." After that weekend, we met monthly to check in on our progress. We also continued to organize a January weekend retreat to reset yearly goals. Part of the weekend fun was to meet in locations away from the city. One year we rented a house on the beach in Montauk, Long Island, and another year we found ourselves on the rocky coast of Connecticut. The core group of eight to ten Blizzard Girls continued to meet monthly for another six years. Sometimes there were shifts in the group, as someone might drop out and a new member joined. As all things have a natural life span, eventually the energy of the group waned, and our monthly meetings became quarterly and then ceased. But the connections didn't. Many of my closest friends today are former Blizzard Girls.

You can organize your own gathering. Go through your list of contacts, choose two or three artists, and propose the idea of creating a group. Discuss and clarify how it can address your needs. You may be looking to give and receive regular critiques on studio work, someone else may want to form a critical theory reading group, while a third person may need a career support group. Starting out, your group will have to choose one or two of the options. The most important point is to feel safe and comfortable with the artists you initially invite. Everyone's specific needs and interests may slightly differ, but the group should begin with a clear vision of why you are meeting. Once you have worked out the initial concept, each artist can invite one or two others to join, until it has reached a comfortable size. I've been a member of groups as small as four and as large as fourteen. Organize a meeting to discus the nature and structure of the group, the best time to meet, and how often. It is important that everyone jointly sets up the organization. A group can begin tentatively; people take a while to jell with each other, and there may be some dropouts as individual needs change.

Every group will develop its own personality and structure. If you need some guidelines to get started, I have found that the following

meeting organization works well. First, we select a regular time each month to meet and a rotation of spaces for the following months. It's nice if everyone has a turn being the host. The meeting begins with a quick round of three- to five-minute check-ins. We each report what's happened since the last meeting, describe any challenges we currently face, and share triumphs. Someone keeps track of time so that everyone stays within the limit. After the check-in, we may discuss pressing issues or the host's work, or delve into a topic or reading assignment.

Groups don't have to be as tightly organized as the ones I've described above. For example, the New York Artists Circle has been meeting over breakfast in a restaurant in lower Manhattan every fourth Thursday for years. There are times when over one hundred artists have converged there. They share information with each other, have a website featuring their work, and negotiate special member discounts on purchases at local art supply stores. Any community, large or small, could establish regular meetings at a coffee shop, diner, or community center to develop their own group. All it takes is for one artist to make the first move and invite others.

Every Monday night at 6:30, we gather at the Arts Incubator for "art stuff." It's not required, but we do a variety of things, from art demonstrations to business topics to going to other accomplished artists' studios, taking along pizza and beer, and having a relaxed time hearing their stories. This Monday, we have an inventor coming that has developed a product for artists. He is going to present it and see if any of us have any ideas on how we could use it. So we have a variety of things going on that help the artists get together and develop their relationships with each other.

—Jeff Becker, artist and executive director of Arts Incubator, Kansas City

Shared workspaces and technical facilities are also gathering opportunities for artists. In 2001, sculptor Jeff Becker took a huge leap of faith, renting a thirty-thousand-square foot building in a then-scruffy area of downtown Kansas City to start up a nonprofit resource, the Arts Incubator. The mission of the Arts Incubator was to provide affordable space, equipment, and support mechanisms for artists to create their work, understand the business side of the profession, and build relationships. Beginning with four artists, the Arts Incubator has grown to capacity, with fifty today. Artists are provided individual studios at below-market rents and access to common workspaces, shops and equipment, a library, and two galleries. Because the artists have widely different schedules for studio work, there is time set aside each week for community building.

WORK WITH A BUDDY

For over the last twenty years, as I have managed my art practice, family, and teaching, I have relied on an art buddy. Currently, I have a scheduled half-hour meeting with another artist one morning a week. It is an opportunity for me to "report in" to another person, and it keeps me on track with my planning. Currently these meetings take place over the telephone, although I have met over coffee in a café with others. During the half-hour conversation, we each take a fifteen-minute turn checking in about the past week and discuss our plans for the one upcoming. As I check in, I'll add to my to-do list for the week. Immediately afterwards, I'll pencil in tasks on my calendar.

I think having a writing buddy is also great—a proposal buddy, someone who is applying for some of the same things. You can work together on stuff. . . . I am a huge fan of people openly sharing information because I think if you both write your best proposal, the project that is most appropriate will get funded. I think generosity just yields more success than competition.

—Aaron Landsman, theatre artist

If I notice a task that never seems to get done, I use this meeting to discuss with my buddy the reasons why. What's getting in my way? Why am I avoiding it? Have I overscheduled too much for one week? What's my problem? While discussing these questions, I may realize that I have underestimated how long a task takes and need to allow for more time. Or it may be that I'm avoiding a difficult conversation, and I realize I don't know exactly what I want to say. That's why I'm not making the phone call or appointment. To get me started, we practice the conversation and come up with a list of talking points. Saying things out loud to another person is helpful, even if the solution isn't immediately apparent. I am often surprised by what I discover about myself. The challenges another person is facing frequently overlap with ones of my own that I hadn't acknowledged. Watching her resolve her issue helps me tackle them.

Working with a buddy is like the weekly staff meeting organizations conduct to discuss problems that have come up and to make plans for what needs to be done. Scheduling a regular meeting to work on your planning and to voice your intentions out loud will make you more accountable to the business details of your art practice. You are accomplishing two things: first of all, discussing the issues you are currently facing, and, second, planning your way through them. If you keep this

information all to yourself, it is easier not to follow through and to allow doubt to highjack your plans. It is important that the allotted time is equally divided between the two of you so that it doesn't become a session with you helping the other person but not getting help in return. With this weekly check-in, you now have someone who is a witness to the minute steps of your development—your willingness to take chances, your mistakes, and your successes.

Over the years, I've worked with a number of buddies, some for years and others for just a month or two to work on a specific task. If you are in a group or forming one, this may be a good place to identify a person to work with. It's best if he is as committed and serious about his career as you are about yours. There have been times when for one reason or another, my buddy and I have skipped a few weeks of meetings and have had to rescue the partnership from the hiatus. In other instances we have naturally drifted apart.

The person you choose to work with does not need to be a visual artist. Trust, reliability, and common sense are much more important traits. People's goals and availability change, and you may have to try out a few different prospects to find a good long-term match.

COLLECTIVES

Another way to fight isolation is to form or join a collective. A collective is a group organized around mutual artistic goals or social action. Collectives can exist locally, nationally, or internationally on the Internet.

Artists have engaged in the collective spirit for centuries. There are long-established collectives that have been passed down from one generation to another, such as American Abstract Artists (AAA). Organized in 1936, it was founded to promote the understanding of abstract and nonobjective art. Other collectives have been established to promote

Basically, art collectives do away with the one-artist-one-object model. They come in various sizes and formats: couples, quartets, teams, tribes, and amorphous cyberspace communities. Sometimes a group of artists assumes the identity of a single person; sometimes, a single artist assumes the identity of many. Membership may be official, or casual, or even accidental: friends brainstorming in an apartment or strangers collaborating on the Internet from continents away. And they may or may not refer to their activities as art. Research, archiving and creative hacking are just as likely to produce objects, experiences, information that is politically didactic or end-in-itself beautiful, or both. One way or another, joint production among parties of equal standing—we're not talking about master artist and studio assistants here—scrambles existing aesthetic formulas. It may undermine the cult of the artist as media star, dislodge the supremacy of the precious object and unsettle the economic structures that make the art world a mirror image of the inequities of American culture at large. In short, it confuses how we think about art and assign value to it. This can only be good.

—Holland Cotter, "The Collective Conscious,"
New York Times, March 5, 2006

GUERRILLA GIRLS

Do Women Have to Be Naked to Get into US Museums? 2007

Copyright © by Guerrilla Girls, Inc.

Courtesy http://www.guerrillagirls.com

This is one of four posters we made for the project "Public Viewing" organized by Littman Kulturprojeket, Basel/Switzerland. Posters were placed on sandwich boards and carried around the Shanghai Contemporary 07 New International Contemporary Art Fair in September.

—Guerilla Girls

artists' rights, such as the Chicago Artists' Coalition, founded in 1974 to act as a communication and advocacy network to encourage group action on health insurance for self-employed artists and a Percent for Art bill. Their arts advocacy helped establish the Chicago Department of Cultural Affairs, which has a terrific resource website, http://www.chicagoartistsresource.org. In New York City, Collaborative Projects or Colab, was a group of over forty artists who worked together for over ten years on collaborative works in new media. (Chapter 3 mentioned their breakthrough exhibition, *The Times Square Show.*)

Artist collectives can also be organized as multimedia art productions around social issues. Visual AIDS (http://visualaids.org) is focused on AIDS activism and has been instrumental in mobilizing the arts community, raising money, and providing services to visual artists living with HIV/AIDS. They have taken the initiative on estate planning and archiving for artists and their heirs. On December 1, 1989, they initiated a national day of action and mourning, *A Day Without Art,* in which over eight hundred arts organizations and AIDS groups darkened their exhibitions or presented shows of work about AIDS. They continue to collaborate with museums, galleries, art centers, and art organizations everywhere. A California-based artist collective, the Center for Land Use Interpretation (http://www.clui.org), is a research organization that explores the use and misuse of public land in the United States. To stimulate public discussion and interest in the contemporary landscape, they produce traveling exhibitions, public tours, and book discussions. They have also created a comprehensive photographic archive, containing thousands of images taken by CLUI representatives, covering all types of land use sites.

A collective may engage in street tactics to expose issues in the art world, such as the Guerilla Girls feminist collective, organized in 1985 to "creatively complain" about the paltry number of women and artists of color exhibited in museums or galleries or critically reviewed. Ap-

THE ARTIST'S GUIDE

pearing in public wearing gorilla masks (a playful misspelling of the word "guerilla") and assuming the names of famous women artists such as Frida Kahlo and Georgia O'Keefe, while maintaining their own anonymity, the Guerrilla Girls continue to this day to protest sexism and racism in the art world through public actions, posters, billboards, and books. In these organizations, artists maintain their individual studio practices while doing work with the collective.

Public Address is an artist collective begun in 2000 by Nina Karavasilcs, Anne Mudge, and other artists working in the field of public art in San Diego, California. They wanted to organize an art advocacy group that would overcome some of the issues of working alone. They saw a particular need to work together to strengthen the community of public art artists by sharing resources, providing professional development, and organizing to take collective action on issues that arose when dealing with city and governmental entities on permanent art projects. Through monthly meetings and a yearly retreat, this collective has effectively addressed the needs of their members and has educated and influenced public art commissioning agencies concerning all artists' rights. They have created guidelines such as the "Ten Commandments" for happy and successful public art projects and have a website (http://www.publicaddress.us) and blog with links and discussions for artists anywhere.

Public art is such a competitive field. These were artists who only saw each other in adversarial roles, meeting only when they were actually giving presentations and competing on projects. This was an opportunity for them to get together and discuss what was going on in the public art arena: part organization and part commiseration.

Several of us may compete for the same public art project, but the whole idea of noncompetition is that we support the artists who win the project and, in the process, share vital information so we raise the quality of the projects submitted, and each success is heightened. We also go to the community meetings and support one another whenever we can.

The collective actions often point toward advocacy. We've worked to get those contracts in better shape and worked to protect VARA [Visual Artists Rights Act]. We sometimes do things for fun, like a field trip together to an interesting art site, and then other times we sit down and hammer out the legal words to use in those contractual agreements. Information comes in the form of sharing professional standards, vendor suggestions, and even ideas.

—Debby and Larry Kline, artists and members of Public Address

The R-Word: Rejection

A hard fact of your professional life is that you are going to face rejection. I've struggled with searching for a graceful way to segue to this subject. I realize it's awkward in the middle of a section about community and networking to shift gears and discuss rejection and competition. These emotional states will often drive you to shun other artists

LARRY AND DEBBY KLINE

Forty Acres, 2006

Bonneville Salt Flats, Utah

Electric mobility scooter, mahogany, whitewash, water-based colorant

Tank dimension: 45 x 105 x 44 inches; overall dimension: 40 acres

rather than embrace them. Nevertheless, coping with these emotions is vital to your life as an artist. It will determine how you shape your community and your ability to stay engaged with it.

I remember dreading the days I had to write rejection letters when I was running the Rotunda Gallery. Each time I had to compose a letter took me back to my own painful experiences of receiving one. I know how disheartening and disabling reading such a letter is. As gallery director, no matter what I said or how many hopeful words I included, I knew my words would come across as bitter arrows puncturing an artist's dream. The most valuable lesson I learned sending these letters was that rejection most often is not a personal indictment of the art or

the artist. For instance, there were artists whose work I admired and wanted to show, but their timing was off, or I didn't have the right opportunity for them. This insight helped change my outlook on what rejection meant to my own work. Just knowing that it was often for reasons out of my control and not related to the quality of my art helped me develop a healthier attitude. This is such an important concept that I am compelled to write it again: **rejection is not a personal indictment of your work.**

No matter how renowned, well-connected, or talented, everyone will get rejected from opportunities they want. It is important to realize this, even if knowing the famous get rebuffed is of little comfort when you are holding that dreaded letter in your hand. You must find a way to work through your disappointment and despair that arise at that moment. Your ability to bounce back from defeat will play an important role in how you continue to interact with other artists and in your ability to promote your work and seek out new opportunities throughout your career. It's heartbreaking that some of us will face the word "no" more than others. What I've realized is that rejection is so much a part of an artist's life: **if I'm not being regularly rejected, it means I'm not pursuing opportunities.** I've also learned that one success erases many no's. I know an artist who created a ritual out of rejection. For every positive response—a grant, show, review, any yes he received—he would take five rejection letters from his stack and burn them. His purging ceremony celebrated his success rather than dwelled on failure. A ritual may not be your thing, but you can find some action that will help you cope with rejection.

Another way to take the sting out of rejection is to learn what you can about it on a case-by-case basis. When the Rotunda Gallery was selecting artists for a yearly outdoor sculpture project, one artist was a runner-up for three years in a row. Frustrated, she called me and asked, "Should I keep on applying, or is this a waste of my time?" I was impressed that she wasn't afraid to talk about it and was open to hearing positive and negative panel comments about her proposals. She used the information from our conversation to develop her proposal the following year. In the next round she was one of the artists selected. Some

When people come in and think that they are a great fit for the gallery and I have to explain to them that they're not, that's a tough thing to do. . . . I can't explain it. I think it's the same with collecting. I mean, why do you like something? It's sort of a gut feeling.
—Julie Baker, president of Julie Baker Fine Art and partner of Garson Baker Fine Art

[Artists] have to understand that all of us are seeing more work than we can handle. It can't be seen as personal rejection.
—Andrea Kirsh, art historian, art critic, and writer

of the artists I have taught in the highly competitive Artist in the Marketplace Program at the Bronx Museum of the Arts have applied six times before they were admitted. Their work matured, or they finally seemed to be a good match. Continuing to reapply is not a guarantee that you will eventually get it. But it is an indication that you are not allowing rejection to get in your way and you are willing to risk it again. If it is an important opportunity, each time you reapply you must research and gather all the information you can. The advice and feedback will help improve your future chances. If after all of this work it still doesn't happen, let it go, and look elsewhere.

Artists are vulnerable to complicating the high that accompanies success and to getting drowned by the profound disappointment that accompanies failure (or, better said, expectations that are not met). We can confuse those highs and lows with a general estimation of personal value—that is, by making a judgment about our value as human beings.
—Anna Deavere Smith, *Letters to a Young Artist: Straight-up Advice on Making a Life in the Arts: For Actors, Performers, Writers, and Artists of Every Kind* (New York: Anchor Books, 2006), 63

I've learned that a "no" is another piece of information to use. Anytime you discover why you were rejected, it is helpful. When seeking this information, you must be open to what you might learn, even if you don't like the reasons or disagree with them. It takes courage to seek out this information. Most rejection letters use broad generalizations and encouraging language to soften the blow. You don't know if you were really in the running or completely unsuitable for the opportunity. Sometimes you get an honest response. I once got a rejection letter from a gallery that in my opinion was a perfect match for my work. Instead of a form letter, the director took the time to state that he admired my gumption and resourcefulness but didn't feel the necessary attraction to my work. I sent him a thank-you note for his frankness, and I meant it. The gallery has remained on my contact list, and we've never worked together, but we parted as colleagues.

Over the years, I have interviewed gallerists, curators, grants officers, and other art professionals, and the one thing they say over and over again is how often the submissions they receive are inappropriate for the space or the opportunity. The artist has not done his or her homework properly and has wasted everyone's time. How often have you gone after something without checking it out carefully? All too often artists send out a "wide net" of packages and emails to galleries hoping they will catch a gallery or two. It's like the "spray and pray" approach with grant writing (see chapter 7). Always find out if the venue is the

right place for your work, and ask them if they are looking at new artists' work and for the submission guidelines.

You will also be rejected when you don't follow the guidelines or have submitted an incomplete, substandard application. Always allow enough time to have someone check your work samples and written information to make sure they are in excellent shape. Confusing, poorly done, or undecipherable materials make it easy for an art professional not to take you seriously and reject you immediately.

But the fundamental truth about rejection is even if you have done everything right, for every opportunity there are more qualified artists than can be handled. Many exhibition venues have prior commitments to other artists and can't make room for you. You may also find that your timing is off. The venue did a recent exhibition of work similar to yours and is looking at other kinds of art now. Even though your work is competitive and admired, there are more artists than can be supported. Every panel or jury runs out of awards, grants, or opportunities before they run out of first-rate artists. I realize how disheartening it is to learn you are the runner-up or wait-listed, or find that you missed by a hair, but you can't let it defeat you. Learning how to decipher rejection and take the appropriate action both psychologically and physically will be crucial to your moving forward.

We are in a field that is competitive by nature. Each year there are more and more artists contending for the available opportunities. You must acknowledge the competition and support your ambition without developing a bitter, defensive attitude toward the rest of the art community. You will always know someone who is receiving a show, a grant, an honor, or a job that you feel you deserve. My good friend Andrea calls it "compare and despair." This feeling will suck all the meaning out of your own past achievements and make them seem inconsequential. I have seen this crippling emotional state hijack many artists. This mindset is a form of self-loathing that leads you to blame others for your "bad luck," isolate yourself, and stop going after other opportunities. *In the end, if you don't apply for something that's right for you, you are effectively rejecting yourself before the funder, panel, gallery, or curator does.* Not applying is a form of self-sabotage and will have a negative impact on your

There are a number of reasons why galleries won't show work. It might not necessarily be that they don't like it, but that they have no audience or collector base for it. They might have an artist working in a very similar vein and not want to encroach on the relationship that they have established.

—Cris Worley,
director of PanAmerican
Art Projects, Dallas

You can't take it personally. If they're uninterested, it doesn't mean that you are a horrible person or that your work is awful. It's just not a good fit for the gallery.

—Jaq Chartier, artist and
cofounder of Aqua Art Miami

self-esteem and career. It's really not fair to all the hard work you have done so far.

You are only human and will face many disappointments in your professional life. It's okay to be bummed out for a while. I know you can find a way to handle these feelings responsibly, limit the blame, and find a process to move on. I can't give you a recipe for doing this; my ego is as bruised as yours when I'm rejected, but I have learned how to manage it. I just know that you can't give rejection that much "air time." *Everyone gets rejected; it never feels fair.* Remind yourself that the reasons you are being rejected are not petty or personal vendettas against you. Commiserate with your friends, and channel your feelings to more productive ends.

Using Your Community and Other Forms of Networking

When you are pursuing ambitious goals—looking for new opportunities, information, feedback, or advice—it is easy to fall into despair, thinking you don't know anyone who can help. That couldn't be further from the truth. Social scientists have proven in studies of human interaction that we are all a few degrees separated (they say six or less) from everyone on the planet. Your goal is to start closing that gap by strengthening your connections to the people you already know. We all have let relationships lapse. You could easily sit down and make a list of art professionals with whom you have lost contact because they moved or changed jobs, or you haven't thought about them lately. There are others with whom you neglected to follow up. If you spent the next six months reconnecting with those who have been interested in your work, something positive will come of that. It makes a difference. This next section is going to explore a few ways you can draw upon people you already know to help connect you to needed resources.

Every artist's career is different. The reasons why artists do things are very different. But I have found that jealousy is just useless. Being jealous of what somebody else has done or wanting what they have is completely useless, because you are on your own path. It's about how you live in the world best and how you work best. You can learn from other people, because they have done it the best way that it can work for them. You are doing your own thing the way you do it best.

—Fred Wilson, artist

DREAD SCOTT
Imagine a world without America, 2007
Screen print on canvas
75 x 75 inches
Photograph courtesy the artist

ASKING FOR ADVICE AND HELP FROM THE PROFESSIONAL COMMUNITY

This may seem counterintuitive, but those people already in your circle of contacts are your gateway to accomplishing your goals. They are already your allies; you simply need to develop a strategy to make the best use of them. People are more inclined to help you if you ask them for advice or for their opinion rather than asking them directly to do something for you. Asking for advice shifts the responsibility of the outcome from the advisor's shoulders and allows him or her to be of assistance without any binding expectation. I often think about the cliché "Ask for money, and you'll get advice; ask for advice, and you'll get money." I have found that even busy, important people are happy to make a little time available to help you, if you approach them with the right questions and

The Bad news is: it's who you know. The Good news is: you already know them.
 —Dread Scott, artist

demonstrate that you are open to the advice they offer. I refer to these networking opportunities as "investigative meetings."

An investigative meeting is a form of networking in which, instead of directly asking for an exhibition, grant, job, or funding, you ask for advice and expertise. It is your opportunity to gather information, gain insight, and make helpful connections to solve your problem. These meetings can be as casual as conversing with the person sitting at the gallery's front desk about submission and review policies for new artists, or as formal as an appointment with a curator, a director, an arts administrator, a grants officer, a writer, or another artist for advice.

Before you set up an investigative meeting, first you need to figure out what you want to accomplish. It should be based on one of your goals, such as securing gallery representation in another city, developing a successful grant proposal, producing a better website, developing a freelance business, or identifying other art professionals interested in the ideas of your work. You then need to select one or more people *you already know* who could be of help. They might have key information you need or provide feedback on your proposal. They can facilitate your access to resources, such as other people to contact, sources of funding, or technical assistance.

An investigative meeting with someone who already knows you or your work is a way to update or renew a dormant relationship. It may be an art professional with whom you have lost touch, or an artist you admire. Because you are asking for information or help, you are creating ample space for a dialogue about your work and an opportunity for a relaxed give-and-take conversation. It puts them in the comfortable position of not having to satisfy your expectations or solve your problem. They are providing feedback and advice. Most importantly, you are nurturing an ally and a deeper connection between the two of you.

In this kind of meeting, you can bring the person up-to-date with your work, and your questions may revolve around a technical part of a project, possible funders, or help in identifying others who may be interested in presenting it. You may also ask for her input on your idea and its feasibility. Other questions may revolve around proposal guidelines,

current standards in the field, or what's new on the horizon. It is an exciting way to expand your thinking and to focus on particular aspects of your work, while you and your "expert" participate in a comfortable discussion. It temporarily shifts what could be an awkward power dynamic between the two of you. It puts you on equal footing with the person you are meeting, so you are more relaxed and able to listen to her advice. Her feedback will help build your self-confidence. Just remember: if you are asking for her guidance, remain open to what she says.

Although it could be more intimidating, *you can also use an investigative meeting to launch a new relationship*. It may be someone you have been referred to from another meeting, or a person with whom you wish to establish a connection. This is your opportunity to introduce yourself, to get background information about her and her organization, or to learn more about an unfamiliar area of the art world. The same process described above applies: identify a person or organization who may have information or advice you can use, and ask if she could speak with you for no more than half an hour. With this meeting, don't expect to talk as much about yourself. Your goal is to elicit information about her and her area of expertise.

Whenever you set up an investigative meeting, be clear about its purpose, and put aside any hidden agendas. Even if this person is a good friend, respect her time by being punctual and checking with her about how long she can meet with you. Plan your questions in advance, take notes, and allow the meeting to take its course. If your meeting is with someone new, and a curiosity about your work arises naturally, taking a few moments to share it with her is fine. Always be open to her offers of assistance, but don't suddenly turn the tables on her by asking directly for it. By changing the terms or shifting the focus of the conversation, you will have undone all the meeting's good will. Any such offers must arise freely from the conversation. Remember, your purpose is to strengthen your connection and get information.

After any investigative meeting, always send a thank-you note, and report back to her if you have followed up on any suggestions. At the

meeting, ask for her business card to make sure you have her correct title and information. Even if she is your good friend, treat her professionally. By building strong rapport with career contacts, you help build relationships and the likelihood that they will offer assistance again in the future.

GROUP BRAINSTORMING

Another way to generate excitement and fresh thinking around an upcoming exhibition, project, grant proposal, or any kind of event looming in your professional life is to gather some friends around for a group brainstorming session. During the Creative Capital Weekend retreats I love to demonstrate the potential power of the group by doing an exercise we call "Targeted Marketing." It was developed by Creative Capital director Ruby Lerner when she ran an independent film program outside of Atlanta, Georgia. Every night she needed to fill a theatre with an audience in a community that didn't know they wanted to see independent film. So she developed a brainstorming method to think broadly on how to reach out and attract new audiences.

Whether your work is made strictly for conventional exhibition spaces or is pushing the boundaries, identifying new audiences or funders for your work is a crucial career development skill. You don't want to rely solely on the venue's regular contact list or your own. You want to figure out the most interesting aspects of your work that will attract funding partners, reviews, and news media stories, and generate a "buzz." New audiences will follow. For too long art audiences have been pulled from the same small group of people. Brainstorming is a way to help you become proactive and think strategically about how to connect with a wider world of potential.

To help generate a list of possible new audiences and the kind of programming that will attract them, host a brainstorming session six to nine months before your show, installation, performance, project deadline, etc. Invite six to ten people—artists, friends, family, and colleagues—for an evening of brainstorming about your project. For a few hours they become your partners. Follow the general rules of brain-

storming—all suggestions are welcome no matter how strange, silly, impossible, or obvious. Laughing is to be encouraged. Criticism is not. You want to elicit a flow of wide-ranging ideas, even those that initially seem goofy or improbable. Sometimes the most far-fetched idea turns out to be perfect further down the road. Write down all the ideas on large pieces of paper, and as one gets filled, hang it up on the wall, and begin another. As the evening proceeds, you want everyone to be able to refer back to all the information generated.

Start the brainstorming session by presenting information about your project, exhibition, or performance and where—or where you hope—it will be presented. Show visuals of your work, or sketches if it's still in the idea phase. Begin the brainstorming by asking the group to help you identify what is special or unique about your work: your approach, style, ideas, or references. Because you are too inside the process of creating the work, this information can be hard to identify by yourself. Others can often point out the distinguishing aspects and strengths of your work better than you. Their insights are the words and phrases that you may incorporate into your artist statement, project description, grant proposal, and press release.

Based on the concepts and ideas in your work, the next step is to continue brainstorming by making lists of individuals and groups outside an art audience who might be interested in some aspect of it or your particular approach to the material. Once you have identified these groups, do some further brainstorming on how best to approach them. List which organizations they belong to or publications they read. Make sure you cover both national and local organizations and online resources such as blogs, newsletters, and email lists. If you are looking for additional funding, use the group to list foundations, companies, and community resources you can approach.

In the next few months, as you work on your project, refer back to the material developed that evening. See which ideas continue to resonate. Pin all the brainstorming sheets on a wall where you can see them. Don't be alarmed by the quantity of suggestions. The purpose of brainstorming is to come up with far more information, contacts, and ideas than you could possibly use. As you develop your project or get

closer to various deadlines, you will continue to pick through all the information and pull out those ideas that make the most sense.

The result is that you may end up discussing with your exhibition space or project sponsor ideas for programs that could be targeted to a particular audience. This might be a special opening event, a topic-based panel discussion, youth and children's programming, or other activities that will bring new audiences to your work *and to the organization*. Don't forget that art organizations are always looking to expand their reach into a wider community. If you can help them do this, you have created a situation where you both win. Your partner will appreciate the fresh energy created around your work.

One thing we tend to do as artists is to think of the dealer or the curator or the critic as "the great other." We do it to ourselves. We create this Mount Olympus, and we put them on it, and then we are afraid to approach it. In fact, that mountain is all in our head. Thank someone as a follow-up to a nice gesture: to a critic for a review, to someone who has taken time to look at your work, or to another artist who has gone out of his or her way to do something for you or who has made a referral. Why would we not do that? And yet sometimes, because we have put certain art people up on such a pedestal, we are afraid to do the kinds of things that we would normally do with our relatives or friends—that kind of social courtesy.

—Joanne Mattera, artist

Identifying issues or interesting information about you and your work during the brainstorming process can also spark a fresh approach to media coverage. There are hundreds of niche magazines with national distribution looking for fresh ways to write about or illustrate their topic. People who subscribe to bird watching, sports, technology, science, history, psychology, and fashion magazines may also be interested in your work. An image of your work placed in *Harper's* magazine is instant national exposure. A brief article about your project in one of the airline magazines introduces it to buckled-in passengers everywhere. Over the next few months you can research these organizations, adding editors and writers to your contact list and developing a press release targeted to their interests.

The most important reason to engage your core support group in brainstorming is that they now have an intimate grasp of your upcoming project or show and what you hope to accomplish. They are your group of advisors. As they go about their daily activities, your project goes with them. During the following months, they may report back to you with new ideas and contacts. They will help promote your project to others. It's an ongoing process that will funnel information back to you. You aren't doing it alone anymore.

VOLUNTEERING

Generosity with your community is another important quality to cultivate. You can share information, lend a helping hand, or participate in a brainstorming session for another artist. You can give to a nonprofit organization. These are ways to nurture relationships, avoid isolation, and meet new people. An offer to ferry the visiting artist, critic, or curator to and from the airport and around to appointments will allow you to casually get to know him or her and share a bit of yourself too. When you volunteer to pick up or help install the art donated for a benefit auction, you are also introduced to the organization's staff. You may even score an invitation to the pricey pre-auction cocktail party filled with collectors and art patrons.

Donating a piece of your art for the auction is another way to support a nonprofit organization and be part of the festivities. I often hear artists complain about how frequently they are asked to donate their art. Because under current tax law they cannot take a deduction for the value of their work, they resent the idea of "giving it away." Maybe I look at art donations a little differently because I ran a nonprofit. I see my donation as an opportunity to entice someone to write a much bigger check than I could to support the organization and am pleased that my art is the vehicle for the transaction. I see it as a way to generate goodwill and make new connections. It's true that all art auctions are not alike, and many organizations see them as an easy way to generate income. Some do not seriously consider whether they can attract an audience able to make reasonable bids, so your work goes for a song. However, if you are approached by an organization you respect and they have a history of good support for their benefit art auctions, give something wonderful to them. Prepare the work so it's ready to hang. Inexpensively frame or mount works on paper, photography, and prints. You want the new owner to take it home and immediately put it up. You don't want it to languish unframed in the back of a closet. There are collectors who

Balance your need and desire to make art with the other things that you are doing in your life, so you're getting pleasure from all the things. It's not something that is going to be in sync for your whole life, and it's going to shift as you go through life. It's been interesting for me to watch how, for some people, the art is like 90 percent, and then it goes down to 10 percent, and then it goes back up again. . . . Take time to experiment. And I think that the art world right now doesn't put any premium on experimenting. I think that a lot of work really suffers [because of that].

—Jennifer McGregor, director of arts and senior curator, Wave Hill, and former director, NYC Percent for Art Program

regularly shop benefit art auctions looking for bargains and new artists. On the back of my donations, I affix information about the work along with my name, address, and website, so the new owner can be in contact with me if they wish, and sometimes they are.

Volunteering goes beyond getting something for you alone. When you give something to a person or a cause outside of your own immediate concerns, it is a graceful acknowledgement for help you have received along the way.

SAYING "THANK YOU"

I can't emphasize enough the importance of a simple thank-you. Acknowledging something someone has done for you is potent. It's astonishing how often people don't take the time to do it. Like volunteering, sending someone a thank-you note is an act of gratitude. I have a file of "fan mail" that I go through every once in a while. It's filled with notes from artists who have responded to something I've said, a workshop I've presented, and admirers of my art. My most precious piece of fan mail is a handwritten postcard from my future husband, with whom I did a studio visit right after starting the Rotunda Gallery. He thanked me and said he would like to visit my studio sometime. I've never dialed a telephone faster in my life. You just never know what a thank-you note might bring.

The Other R-Word: Relaxation

It's tough to be an artist in our culture. Funds and opportunities are limited, your desires limitless, and to reconcile the two into a cohesive career feels overwhelming. I realize that throughout this book I've asked you to add a lot of activities outside of your regular studio schedule to

help you put into place effective career management and promotion. Everything I have suggested is because I have experienced the benefit firsthand. These activities are all in the service of working "smarter, not harder," as Colleen Keegan, my Creative Capital Foundation colleague, is fond of saying. Along with establishing better systems, following through on opportunities, and networking, you also have to take time to replenish your well of creativity. Relax, and take time off. Whether it is in the studio or in the business of our profession, pushing yourself too hard will not allow you to do your best work and, moreover, will make it suffer.

No one is productive all the time. Careers and art production have normal ebbs and flows. Sometimes the best thing you can do for yourself is take time off to rest, relax, and renew. Allow an idea to percolate deep in your unconscious, to heal a stressed-out body, or to just have some fun.

The art world is a punishing culture. It never feels as if you have done enough, achieved enough, and networked enough. The wonderful aspect of a creative life is its open-ended nature, yet this lack of closure can drive you to exhaustion. All too often success is met with more stress. You expect more of yourself and push yourself even harder. Working like this will exhaust you physically, emotionally, and creatively.

You need to establish a system of rewards for small and big tasks completed. Nothing is too small to celebrate. Don't skimp with yourself. Take pleasure in a job well done. Sprinkle small rewards throughout a day. Take a restorative moment. Check to make sure you are taking time off from everything each week. I schedule a massage for the day after teaching the intensive Creative Capital weekend retreats. It's the greatest gift I can give myself; it not only realigns my insides but helps me transition back to my studio practice.

Vacations can be as exotic or esoteric as your budget and inclinations allow. I don't mean artist residencies, which are wonderful breaks from the usual studio practice but aren't technically a vacation. Schedule a few weeks off over a year's time to do nothing. Leave email and civilization behind. If your budget is tight, become a tourist in your own community. I lived in New York City for nearly ten years before I visited the

You aren't going to get a solo show because of it, but if someone is thinking of the many artists whose work they saw that they think are interesting and you are this wonderful person who follows through and says thank you, they would think of you first.
—Andrea Kirsh, art historian, art critic, and writer

Statue of Liberty. One summer, because we were on a tight budget, our vacation was seeing the sights at home. It was fun to hit all the tourist sites. A friend of mine gave himself a vacation by sending an email to all his friends and freelance clients that he was going to be out of town for a month. He then hung around home enjoying the solitude and allowing each day to unfold however it happened. His friends and clients managed to do just fine without him, and when he "returned" from his trip, everyone commented on how refreshed he looked.

There will be times when you will meet unpleasant people, suffer disrespect, and meet with disappointment. No one is protected from these situations. Everyone yearns for acceptance and rewards. The important thing to remember is that with every challenging encounter you have an opportunity. You can hold onto negative feelings or look for ways to manage them. Angry, bitter people do not attract community. It's not about pushing issues under the rug or ignoring them; it's about how to face them. **Every day you have the opportunity to make the art world a more generous place.**

Each chapter in this book is about nurturing and protecting your creative energies so you can make the best art possible. Your talent is tender and fragile. It's challenging enough to push yourself to the limits of your technical abilities. Taking on the business responsibilities on top of all of that can feel overwhelming. Any systems you build to protect that fragile connection to your creativity is paramount to sustaining your artistic life.

Resources

- Start collecting information and nurturing a community through any one of the websites and blogs listed throughout this book. Share them with others, and you'll begin to develop your own list of resources.

EPILOGUE

Writing this book has been a long voyage for me. It took nearly ten years for it to emerge as a pressing long-term goal. Initially, I resisted the idea, reluctant to shift my focus from making art. In spite of my reservations, the project kept percolating until it became a mission I couldn't ignore. I had been collecting anecdotes and filling notebooks with handouts from my lectures and workshops. I tried out the idea on good friends, and I noticed an upsurge of my energy whenever I discussed compiling this information into a sourcebook. Gradually it took shape in my imagination. I also noticed the more absorbed I became with the project, the less I could concentrate on making new work in the studio. Although it felt awkward to change my focus from art making, I had experienced short periods of time away from my studio. I trusted that when this project was completed, new ideas would again materialize, so I didn't feel overly threatened taking a hiatus.

Writing this book took longer, used more resources, and challenged me in ways I never could have imagined. I didn't realize pulling this material together would necessitate putting my studio practice on hold for over two years. I was on a steep learning curve with the publishing industry, and, thankfully, I discovered that the same principles of organization, promotion, and management that stood by me in my art practice now helped me with my book.

Everything I've written comes from my own experiences and has been tested and honed in my teaching and lectures. I have approached the content of each chapter by asking myself: Outside of making art, what skills are most useful for visual artists? What help is readily available? How can it best be understood and employed? To answer these questions I have drawn on the experiences that hundreds of artists have shared with me, and combined these stories with insights from art professionals.

To develop each chapter I have dredged the emotional terrain of my memories and how each one affected my practice. It was a struggle and terribly uncomfortable to dissect my thirty-year art career, relive old experiences, and revisit mistakes and places where I let myself down. I hated reviving bad feelings and being enmeshed in issues I had resolved years ago in order to re-create what steps helped me resolve them. On the other hand, I also savored the joy of turning my experiences into words, which I hope will resonate with you and make a difference in your life. Writing this book has challenged me to reexamine every aspect of my practice and to question what I do. I've had to confront whether I follow the advice I'm giving on these pages. Mostly I do, yet there are places where I fall short. I admit I'm not always as organized as I'd like to be, and I didn't start my own estate planning until writing the legal chapter. Finding the right lawyer to handle this issue for both my husband and me was a perpetual item on my to-do list. It never seemed to get checked off, but interviewing legal professionals and writing about it helped me begin the process.

Much of my advice is not secret information. It's readily available in other books, panel discussions, and websites. There are thousands of career seminars taking place throughout the world. Most of them correctly stress the importance of having compelling work samples of your art and carefully researching opportunities. What has always intrigued me was why so many artists find it difficult to follow this advice, so I explored what prevented me, my friends, and my students from doing what needed to be done. As a result, each topic in the book discusses the underlying emotional impediments—insecurity, guilt, fear, and shame—you will confront that may derail you.

I have made nearly every mistake discussed in this book. I had fuzzy work samples and incoherent artist statements that still make me flush beet-red every time I see them. I've bungled relationships and pulled them back together by the skin of my teeth. In some cases, they were beyond repair, and those losses have been some of my greatest learning experiences. You will also make mistakes, and I want to reassure you now that there is tremendous value in what you learn from them.

This book is a template for creating your own process. Find your own way to organize and experiment with the information and put it to use. Most of the topics address issues you can control. The moment when I realized how many

aspects of my career I could manage gave me the courage to resign my position at the Rotunda Gallery, and the freedom to pursue my studio practice full-time. It was an intoxicating feeling to know I had so many tools under my command. Ordering and structuring the business of your art buys you time and space so your ideas can flourish and gives you the freedom to be curious, break rules, take risks, and dream as large as you can. It allows you to stay on the leading edge of your creative practice.

As I write these lines, we are in a tumultuous time, economically and environmentally. Like all other fields, the art world will shift in unexpected ways and will judge artists and their work by unclear criteria. You need to find sound ways to stay engaged and search for new solutions. I encourage you to develop a structure whereby you continue to believe in yourself, ask questions, and get feedback and help as often as you need it. There is no one who knows your work as well as you, and you will always be its best advocate.

My Professional Practice class at Columbia University often ends with a discussion of an acronym I've developed to sum up my approach to promoting and defending an art career. The title of the discussion is "GAP," which stands for "Goals Attitude Perseverance." You need to know what you want to accomplish. Your *goals* will point you in a direction and motivate you to act. Taking purposeful action helps you sustain a healthy *attitude*. Your attitude, good or bad, is evident to the people surrounding you and helps you gracefully manage the issues you will confront daily. Your attitude is also reflected in whether you take rejection or success personally. I'm not suggesting you won't have strong feelings, only that you must find a way to make them work for your creative process and your ability to interact with other art professionals. *Perseverance* is a vital trait, as we are all challenged each day with having to push ourselves forward and create our work. Remember: your best ideas may be yet to come, so you need to stay engaged with your creative spark. Art history is full of artists whose work was ignored and then embraced at different stages of their lives. You can't predict when the art community will turn their attention to you. What you can control is how you continue to pursue your goals and the resilience of your attitude, which together strengthen you to persevere.

I understand we all wish to find a quick solution to our problems. However, I have neither heard nor found any secret shortcuts to a thriving art career.

Time and again my experience has shown that applying the simplest tools makes a difference: submitting a great image, making an impression in an introduction, knowing when to ask for help. While developing an administrative structure may initially feel antithetical to your creative process, learning how to manage basic business practices is a worthy investment of your time. These are the tools with which to weather a lifetime in the art world.

I know it is a Herculean task to sustain and support a studio practice, while juggling jobs and a personal life. I wrestle with these issues daily, and there are times when I feel challenged on every front. Throughout the book, my goal is to help you think about your responsibilities beyond creating art. Although I cannot address all the questions and issues that you will face, I hope that these pages reveal ways you can approach and tackle them on your own. These are life skills. Even if you just use one suggestion from each chapter, you will have multiple ways to begin the next phase of your career. I guarantee it will be a step in the right direction.

Without living artists there would not be contemporary art, and thousands of venues would be empty. Artists can reinvent the art world. As creative beings, artists have an important role in shaping the future, not only of the art world but also of global culture. You have a choice. If there are policies that do not support you, don't yield to them. Don't prop up a broken system or a relationship that can't be healed and isn't empowering you.

More than ever, the world needs brilliant, thought-provoking, and dazzlingly beautiful art. I believe in the importance of art to our lives and am committed to creating health and wealth in the artist community, where there is now an unquestioned subsistence mentality. I want you to succeed, and this book is my antidote to the misinformation and myths that hold artists back. As an artist I am filled with tremendous empathy and respect for your creative life and want to be part of the solution to make it better. I believe in your ability to apply a supportive process to your professional life once you understand how to do it and why it needs to be done. Over the years, it has thrilled me to watch artists I've worked with do exactly that.

With increasing excitement and fear, I am anticipating the moment when I will pack away piles of edited pages, return to my studio, and renew my connection to painting. I have a whole new perspective after writing this book and

look forward to making a new start. I plan to rewrite my artist statement, which is five years old. I want to begin a new body of work, and I have no idea how it will turn out. I'm viewing this moment as a precious opportunity to approach my work with fresh eyes, no restrictions, and no preconceived judgments. It feels scary, truly exciting, and the perfect place to be. I can't wait.

ACKNOWLEDGMENTS

Writing this book has been an all-consuming task. I have been blessed to have many mentors, colleagues, and friends who have contributed over the years to my understanding and development of the material in *The Artist's Guide*. The roots of the book grew from my positions at the Rotunda Gallery and the Bronx Museum of the Arts, and I am grateful to have worked with the dedicated staff at those organizations. I also want to thank my students at Columbia University for challenging me to think out of the box. The Professional Development Program at the Creative Capital Foundation has provided a community of colleagues and the opportunity to discover "reality checks" with artists all over the country, which has immeasurably added to my understanding. Thanks go to its visionary executive director, Ruby Lerner; associate director, Alyson Pou; and my most amazing co-leaders, Colleen Keegan and Aaron Landsman, as well as artist leaders Erika Blumenfeld, Chris Doyle, Jennifer Monson, Joanna Pristley, Sue Schaffner, Dread Scott, and Ela Troyano.

Development of my book proposal received crucial funding from the Sam and Adele Golden Foundation for the Arts. Thank you, Mark Golden, for your belief in me, and the board of directors for your early enthusiastic support. The Emily Hall Tremaine Foundation generously helped fund the writing of the book: thank you, Stuart Hudson, Nicole Chevalier, Ashley Sklar, and the board of directors. None of these grants could have made their way to me without the vital services of the fiscal sponsorship program at the New York Foundation for the Arts and the excellent guidance of the staff.

Thanks to Dolores Brien, Callie Janoff, and Eleanor Luger, who helped me jump start the project. The administrative and moral support of my patient assistant, Laura Rosenbaum, was invaluable. I owe a huge debt of gratitude to Carol Irving for her incisive editorial work. Carol's editorial assistance challenged me to dig deeper into my experiences and express them conceptually and practically.

Thank you to my agent, Erin Hosier, who immediately understood the potential of my book and how to pitch it to the publishing world. Thank you to the expert staff at Da Capo: Collin Tracy, Timm Bryson, Julia Hall, Lindsey Lochner Rudnickas, and, most of all, my editor Ben Schafer. Beth Wright copyedited with skill and precision.

Much heartfelt gratitude for the insights, feedback, and good humor of my dear artist community: Becca Albee, Andrea Callard, Linda Cummings, Judy Hoffman, Amy Holman, Gene Kraig, Rachel Loutsch, Rebecca Loyche, Joanne Mattera, Katy Martin, Eve Mosher, Melissa Potter, Judilee Reed, Sergio Sarmiento, Susan Schear, and Cristin Tierney. I deeply appreciate my friend Ellen Harris and my sister Reah Janise Kauffman, who went well beyond the bounds of sisterhood by volunteering additional rounds of thorough inspection of the manuscript and layout.

Most of all, to David Headley, my husband: you are the best supporter an artist could ever have.

Acknowledgments

BIOGRAPHIES

Below are short bios of the art professionals included in the book. During the writing of the book, the author conducted interviews with many of these art professionals, and excerpts appear throughout the book.

On the book's website (http://www.artistcareerguide.com) are transcripts of these interviews, indicated here with an asterisk.

Diana Al-Hadid is an artist born in Aleppo, Syria, and raised in Cleveland, Ohio. She constructs sculptural installations—combining materials such as polystyrene, plaster, and fiberglass—and sources religion, architecture, and physics in order to create a narrative object that is as haunting as it is enchanting. Past exhibitions include the Center for Arts and Culture, Montabaur, Germany; the Bronx Museum of Arts, New York; Michael Janssen, Berlin, Germany; and Tanya Bonakdar Gallery, New York. She currently lives and works in Brooklyn, New York (http://www.al-hadid.wsdla.com)

***Camilo Alvarez** is the director, owner, curator, and preparator of Samson Projects, Boston (http://www.samsonprojects.com). He has worked with organizations such as Exit Art/The First World, the Skowhegan School of Painting and Sculpture, and MIT's List Visual Arts Center with panelists Frank Gehry, Robert Venturi, James Ackerman, Kimberly Alexander, and Kyong Park.

***Janine Antoni** was born in Freeport, Bahamas. She is the recipient of a MacArthur Fellowship; the Joan Mitchell Foundation Painting and Sculpture Grant; and the Larry Aldrich Foundation Award. She has exhibited extensively in the United States and abroad at venues including Luhring Augustine Gallery (http://www.luhringaugustine.com), the Wadsworth Athenaeum; the Irish Museum of Modern Art; the Reina Sofia; the Los Angeles Museum

of Contemporary Art; the Whitney Museum of American Art; the Museum of Modern Art; the Guggenheim Museum; and the Aldrich Museum. Her work was included in the 1993 Venice Biennale; the 1993 Whitney Biennial; the 1995 Johannesburg Biennial; the 1997 Istanbul Biennial; the 2000 Kwangju Biennial in Korea; SITE Santa Fe in 2002; and Prospect.1 A Biennial for New Orleans.

*Julie Gerngross Baker**, born and raised in Manhattan, is the co-owner of Garson Baker Fine Art, a contemporary art gallery in Chelsea, New York (http://www.garsonbakerfineart.com), and owner of Julie Baker Fine Art, a contemporary art gallery in Nevada City, California (http://www.juliebaker fineart.com). She is the cofounder of *flow*, an invitational art fair, and former president of Gerngross and Company, an arts marketing firm in New York City, established by her father, Hans Gerngross, in 1946.

***Diane Barber** has been the visual arts curator of DiverseWorks (http://www.diverseworks.org) since 1997 and co-executive director of the organization since September 2006. During her tenure, she has curated more than sixty exhibitions for DiverseWorks, including Thought Crimes: The Art of Subversion, named Best Art Show in the Houston Press Best of Houston awards; Maria Elena Gonzalez: UnReal Estates, a collaboration with Art In General (New York) and the University of Memphis; and William Pope.L: eRacism, named Best Art Show in an Alternative Space by the International Association of Art Critics (AICA) in 2003. While at DiverseWorks, Barber has given particular emphasis to commissioning new works and site-specific installations and to developing programs with charged social, cultural, and political undertones.

Jeff Becker, as a former manufacturing business owner and 2000 graduate of the University of Kansas with a bachelor of fine arts degree in sculpture, identified the challenges artists face when working to build a business and career as an artist. Becker founded the Arts Incubator of Kansas City (http://www.artsincubator.org) in the fall of 2001 and currently serves as its executive director. He also serves on the board of directors for the Kansas City Art Commission and the Kansas City Crossroads Association.

***Wendy Bredehoft** is the education curator for the University of Wyoming Art Museum, a working visual artist with a national exhibition record, and consultant on arts, arts education, and nonprofit organizational issues. Bredehoft's current artwork reflects her interest in developing a visual vocabulary, rooted in color and line, that expresses a personal response to landscape. Bredehoft attained a master of fine arts in visual arts from Vermont College in 1996, and a bachelor of fine arts in visual arts from the University of Wyoming in 1984 (http://www.wlbart.com).

***Jaq Chartier** is a painter and cocreator of the art fair Aqua Art Miami. Her galleries include Ameringer Yohe, New York; Haines Gallery, San Francisco; Elizabeth Leach, Portland; and Platform Gallery, Seattle. Her work has recently been featured in exhibitions at Zentrum Paul Klee, Bern, Switzerland, and the Kunst-Museum Ahlen, Germany, and in collections including Microsoft and the Progressive Art Collection. Her awards include an Artist Trust/Washington State Arts Commission Fellowship, and a PONCHO Special Recognition Award from the Seattle Art Museum's Betty Bowan Committee. She was also a recent Creative Capital Grant finalist and a Joan Mitchell Foundation Award nominee (http://www.jaqbox.com).

Christo and Jeanne-Claude have created large-scale projects internationally for over forty years (http://www.christojeanneclaude.net).

***Matthew Deleget** is an abstract painter/curator and the cofounder of MINUS SPACE, a curatorial project based in Brooklyn, New York (http://www.minus space.com). His work has been exhibited nationally and internationally. Deleget has been the recipient of an American Academy of Arts & Letters Award, a Brooklyn Arts Council Award, and the Golden Rule Foundation Award. His work has been reviewed in the *New York Times*, *Flash Art*, *Artnet Magazine*, the *Philadelphia Inquirer*, and *Basler Zeitung*, among others. He is a member of the American Abstract Artists and the Marie Walsh Sharpe Art Foundation's Artist Advisory Committee, and he currently works at the New York Foundation for the Arts (http://www.matthewdeleget.com).

Jane Dickson is a painter living in New York City. She has been exhibiting her paintings, drawings, and prints in museums and galleries domestically and internationally for two decades. Most recently she has completed a mosaic for MTA in the Forty-Second Street Times Square subway station. She is represented by Marlborough Gallery in New York City (http://www.janedickson.com).

***David A. Dorsky** is an attorney specializing in art law and estate planning for artists and a member of the New York State Bar Association (http://www.dorsky.org). He is director of the Dorsky Foundation, Long Island City, and director of Dorsky Gallery Curatorial Programs. He is a member of the Foundation Board of the State University of New York, New Paltz, and a guest lecturer on estate planning, the business of art, and art law at such institutions as Parsons, Brooklyn College, State University of New York at New Paltz, Queens Council for the Arts, Fashion Institute of Technology, and PS1/MoMA.

Joe Fig is an artist living in Connecticut (http://www.joefig.com). Part craftsman, humorist, and historian, he creates intricate and realistic sculptures of artists and their studios, which reveal insights into their personality through their working style and practice. Fig's work has been exhibited extensively throughout the United States. He is the recipient of the Space Program, Marie Walsh Sharpe Foundation Grant; a Paula Rhodes Memorial Award, School of Visual Arts; a Lucille Blanch Award, Woodstock Artists Association; and a Francis Criss Award, School of Visual Arts. His book, *Inside the Painter's Studio*, containing interviews, photographs, and art, will be published in 2009 by Princeton Architectural Press.

***Carolina O. Garcia** is the cofounder and Executive Director of LegalArt, a nonprofit whose mission is to empower Miami's visual art community with legal and professional resources (http://www.legalartmiami.org). She was director of Literary Programs for the preeminent writers' organization PEN American Center and has been awarded the Innovative Service in the Public Interest Award. She received a Helping Others through Pro Bono fellowship, became a member of the Florida Bar, and completed the prestigious Miami Fellows Initiative, a two-year leadership program administered by the Dade Community Foundation, which cultivates Miami's future leaders.

***Ellen Harvey** is an artist who lives and works in Brooklyn, New York (http://www.ellenharvey.info). She has been the recipient of a Pennies from Heaven grant, a Philadelphia Exhibitions Initiative grant, a Rema Hort Mann Foundation grant, and a New York Foundation for the Arts fellowship. She has exhibited nationally and internationally and had solo exhibitions at the Luxe Gallery, New York; Magnus Müller, Berlin, Germany; Galerie Gebruder Lehmann, Dresden, Germany; Pennsylvania Academy, Philadelphia; the Center for Contemporary Art, Warsaw, Poland; and the Whitney Museum at Philip Morris, New York. Her first book, *The New York Beautification Project*, was published by Gregory Miller & Co. in 2005, and her catalogue, *Ellen Harvey: Mirror*, was published by the Pennsylvania Academy in 2006.

Valerie Hegarty is a visual artist who lives and works in Brooklyn, New York. She received her MFA from the School of the Art Institute of Chicago and has shown internationally in venues such as PS1/MoMA, New York; the Drawing Center, New York; the Museum of Contemporary Art, Chicago; Museum 52, London; and Museion, Bolzano, Italy. She has been the recipient of grants from the Tiffany Foundation, the Rema Hort Mann Foundation, and the Campari Commission. Hegarty is represented by Guild & Greyshkul in New York (http://www.guild greyshkul.com) and Museum 52 in London (http://www.museum52.com).

Jenny Holzer was born in Gallipolis, Ohio. She received a bachelor of arts degree from Ohio University in Athens and a master of fine arts degree from the Rhode Island School of Design. She has received many awards, including the Golden Lion from the Venice Biennale (1990), the Skowhegan Medal (1994), and the Diploma of Chevalier (2000) from the French government. Major exhibitions include the Neue Nationalgalerie, Berlin (2001); Contemporary Arts Museum, Houston (1997); Dia Art Foundation, New York (1989); and the Solomon R. Guggenheim Museum, New York (1989). Since 1996, Holzer has organized public light projections in cities worldwide. She was the first woman to represent the United States in the Venice Biennale (1990). She lives and works in Hoosick Falls, New York (http://www.jennyholzer.com).

***Colleen Keegan** is a partner in Keegan Fowler Companies, an equity investment and consulting firm specialized in providing strategic planning and business affairs

services for companies in the communications and entertainment industries. She developed the Creative Capital Strategic Planning Program for Artists.

*Andrea Kirsh is an art historian with a "very nonlinear career." In the '80s and '90s, she worked as a museum curator and administrator. She is the author of *Seeing through Paintings: Physical Examination in Art Historical Studies*, which introduces art historians, artists, museum docents, and others to what can be learned about paintings as they might be encountered on museum walls, by paying attention to materials and condition issues. Kirsh writes criticism for two web publications. One of them is the Fallon and Rosof Art Blog, which has been named one of the top art blogs in America (http://www.fallonandrosof.blogspot.com).

*Larry and Debby Kline work as a collaborative team, creating artworks that focus on social issues designed to question the status quo and effect change (http://www.jugglingklines.com). Elements of social interaction, participation, and performance are often present in these works, which use humor or surprising context to address serious and controversial issues.

*Aaron Landsman is a writer and actor. His plays, often presented in quotidian locations like homes, offices, and bars, have been produced in New York, Houston, and Minneapolis, and internationally in Sweden and Belarus. He is a member of Elevator Repair Service Theater, with whom he has performed all over the United States, Europe, and Australia. Landsman has taught at the Juilliard School and New York University. He lives in Brooklyn with his wife, Johanna S. Meyer (http:www.thinaar.com).

*Jody Lee is an artist and writer based in New York. She received Phi Beta Kappa with a bachelor of arts in German literature from Reed College, spending one year at the Universität Tübingen in Germany. She received a post-baccalaureate bachelor of fine arts degree from the University of Washington at Seattle, and her master of fine arts degree from Southern Methodist University in Dallas, Texas. You can view more about her work, exhibition record, press, and collections at http://www.jodyleestudio.com.

*Susan Lee, EA, CFP, is a tax and financial planner in New York City (http://www.freelancetaxation.com). She has prepared taxes for freelancers and artists for over twenty years. Her weekly personal finance radio show, *You and Money*, is on WBAI-FM in New York (http://www.wbai.org).

Joan Linder is best known for her labor-intensive drawings exploring themes such as the banality of mass-produced domestic artifacts, the politics of war, and sexual identity and power. Linder has exhibited nationally and internationally at venues including White Columns, New York; the Queens Museum of Art, New York; the Museum of Fine Arts, Boston; and the Gwanjgu Art Museum, Korea. She has been the recipient of the Lucas Fellowship at Montalvo, California; MacDowell Colony Residency; the Foundation of Jewish Culture's Ronnie Heyman Award; and a Pollock Krasner Foundation grant. She currently lives and works in Buffalo and New York City (http://www.joanlinder.com).

Robyn Love is an artist who works primarily with site-specific, mixed-media installations, usually involving community participation. She has exhibited her work internationally and has received numerous grants and commissions, including a major Percent for Art commission from the City of New York, completed in 2003, and a New York Foundation for the Arts Fellowship in 2005. She lives and works in Queens, New York, and in Gillams, Newfoundland, and Labrador (http://www.robynlove.com).

Abby Manock was born in Palo Alto, California. She moved to Burlington, Vermont, with her family at age eight, and has considered herself a Vermonter ever since. Her drawings have been included in exhibitions in New York, Washington, D.C., San Francisco, and Miami, and at the Museum of Fine Arts in Boston. Her performance work has been showcased by the Deitch Projects Art Parade in New York City, at concert festivals in Maine and Vermont, at Gallery Diet in Miami, and most recently at Performagia 2008 in Mexico City. Manock received her master of fine arts degree from Columbia University in 2007. She lives and works in Brooklyn, New York (http://www.abbymanock.com).

Christian Marclay was born in California, raised in Switzerland, and now lives in New York. He has explored the fusion of fine art and audio cultures through performance, collage, sculpture, installation, photography, and video for the past thirty years (http://www.paulacoopergallery.com; http://www.whitecube.com). Marclay has exhibited widely, including solo exhibitions at Moderna Museet, Stockholm, Sweden; Barbican Art Gallery, London; Seattle Art Museum, Seattle; Tate Modern, London; UCLA Hammer Museum, Los Angeles; and the SF-MoMA, San Francisco. Group exhibitions include SITE Santa Fe, New Mexico; Whitney Museum of American Art, New York; and Hayward Gallery, London.

Rossana Martínez was born in Mayagüez, Puerto Rico. She is an artist and the cofounder of MINUS SPACE, a curatorial/critical project based in Brooklyn, New York (http://www.rossanamartinez.com; http://www.minusspace.com). Her work has been exhibited nationally and internationally. Martínez has been a recipient of the Brooklyn Arts Council's Community Arts Regrant Program, the Artist in the Marketplace Program from the Bronx Museum of the Arts, and the Mujeres Destacadas Award by New York's daily *El Diario La Prensa*. Her work has been reviewed in the *New York Times*, the *Village Voice*, the *Brooklyn Rail*, the *New York Sun*, Flavorpill, and Artnet.

***Joanne Mattera** is an artist whose focus is lush color and reductive geometry, an esthetic she calls "lush minimalism" (http://www.joannemattera.com). She has exhibited extensively in New York at the Stephen Haller Gallery, the Elizabeth Harris Gallery, Thatcher Projects, the Heidi Cho Gallery, and at OK Harris. She is the writer of *The Art of Encaustic Painting*, and her reports on the annual Basel/Miami Art Fairs have attracted a following in the blogosphere. She is a visiting lecturer at Massachusetts College of Art, Boston, and Montserrat College of Art, Beverly, Massachusetts. Her most recent curatorial effort was Luxe, Calme et Volupte: A Meditation on Visual Pleasure for the Marcia Wood Gallery, Atlanta, where she is a represented artist.

***Jennifer McGregor** is the director of arts and senior curator at Wave Hill, Bronx, NY, a public garden and cultural center presenting artworks that engage the public in a dialogue with nature, culture, and site (http://www.wavehill.org). She has curated over fifty exhibitions and projects, and oversees the performing

arts program. She has served as director of the New York City Percent for Art Program; founded McGregor Consulting to work nationally on public art commissions, exhibitions, and planning projects; managed the design selection process for New York City's Flight 587 Memorial; advised the Freedom Park in Atlanta and the Abington Art Center in Jenkintown, Pennsylvania, on sculpture-park planning; and facilitated the start of the Public Art Network, a program of Americans for the Arts. She regularly serves on juries, panels, and selection committees.

***Susan Moldenhauer** is a photographer who lives and works in Wyoming. For twenty years, she has used the landscape of the American West as inspiration, seeking synchronistic, transformative moments when earth, sky, wind, and human presences are one. She is the director and chief curator at the University of Wyoming Art Museum (http://www.uwyo.edu/ArtMuseum) and co-founder of Touchstone Laramie Art Fair with the Laramie Artists Project.

***Eve Mosher** is an artist addressing environmental issues through public works (http://www.evemosher.com). Her project *HighWaterLine*, which created an immediate visual understanding of the effects of climate change in New York City, was profiled in the *New York Times*, on the Discovery Channel, and in *Le Monde*. She has received New York Foundation for the Arts fiscal sponsorship and grants from the New York State Council on the Arts and New York Department of Cultural Affairs, through the Brooklyn Arts Council.

***Morgan O'Hara** is an artist who shows and performs extensively in Europe, Asia, and the United States. Growing up in an international community in postwar Japan triggered her interest in examining the close relationships between East and West, creation and destruction, and life and art (http://www.morganohara.com).

Susan Harbage Page teaches photography and women's studies at the University of North Carolina at Chapel Hill and received her master of fine arts in photography from the San Francisco Art Institute. She has received grants from the Andy Warhol Foundation, the Fulbright Program (Council for the International Exchange of Scholars), and the Camargo Foundation, among others (http://www.susanharbagepage.com).

Jaime Permuth is a Guatemalan photographer living and working in New York City (http://www.jaimepermuth.net). He has exhibited his photographs at many venues, including the Museum of Modern Art, the Queens Museum of Art, the Bronx Museum of the Arts, the Museum of the City of New York, the Jewish Museum, El Museo del Barrio, and the Brooklyn Museum of Art.

***Kurt Perschke**, native of Chicago, is a public artist based in New York (http://www.redballproject.com). His projects have taken place in Barcelona, St. Louis, Portland, Sydney, and Arizona. He has participated in the Contemporary Art Projects 2006 Busan Biennale, worked with the Museum of Contemporary Art in Barcelona and the Contemporary Art Museum in St. Louis, and received an Americans for the Arts Public Art Network National Award.

David Politzer was born in Washington, DC. He currently lives and works in Youngstown, Ohio, but that is bound to change, so don't bother with the Yellow Pages (http://www.davideology.com). He holds a master of fine arts degree from Syracuse University and a bachelor's degree from Skidmore College. Politzer uses video, photography, performance, and sculpture to discuss how mass media representations further confuse the vagaries of contemporary social interaction.

Dirk Rathke was born in Potsdam, Germany in 1968 and received his master's degree from the Hochschule der Künste, Berlin, in 1997. He lives and works in Berlin (http://www.dirkrathke.de).

***Janet Riker** is director of the University Art Museum at the University at Albany, which features a changing exhibition program focused on contemporary art and a permanent collection of over three thousand works of art (http://www.albany.edu/museum). Previously she was director of the Rotunda Gallery in Brooklyn and assistant curator at the Drawing Center in New York City. Riker holds a master's degree in art history from Columbia University and a bachelor's degree from Alfred University. She has organized dozens of exhibitions of contemporary visual arts. She has served on numerous selection panels and commissioning bodies, and has lectured widely on contemporary art and artists' issues.

Gregory Sale is a multidisciplinary artist based in Phoenix, Arizona. The form and content of his work reflect a hybrid approach that incorporates the wry sensibility of Pop Art, along with the optimism of Yoko Ono, the provocation of the Happenings, and the raw intensity of art in the age of AIDS (http://www.love-buttons.com).

***Sergio Sarmiento** is an artist and writer interested in cultural production stemming from the discursive sites of art and law. He is currently a staff attorney and director of education with Volunteer Lawyers for the Arts in New York City (http://www.clancco.com).

Dread Scott makes revolutionary art to propel history forward. His work received national notice in 1989 over its use of the American flag, and he has since been exhibited at the Whitney Museum and other venues across the country (http://www.dreadscott.net).

Jean Shin is a painter and sculptor born in Seoul, South Korea. Her work has been widely exhibited in major national and international museums, and she has received numerous awards, including the New York Foundation for the Arts Fellowship in Architecture/Environmental Structures and Sculpture, Pollock-Krasner Foundation Grant, and Louis Comfort Tiffany Foundation Biennial Art Award. Shin currently lives and works in New York City (http://www.jeanshin.com).

Fredric Snitzer is director of the Fredric Snitzer Gallery in Miami, Florida (http://www.snitzer.com).

Allyson Strafella earned her bachelor of fine arts degree at Tufts University in Medford, Massachusetts, in partnership with the School of the Museum of Fine Arts, Boston. She participated in the Summer Program at the Skowhegan School of Art, Maine. She has received grants and fellowships from the Pollock-Krasner Foundation, the New York Foundation for the Arts, and the John Simon Guggenheim Memorial Foundation.

Nicole Straus is a public relations consultant in New York.

Julianne Swartz was born in Phoenix, Arizona. She is an artist who lives and works in Kingston, New York (http://www.julianneswartz.com).

Cristin Tierney is an advisor to a number of private collectors and institutions in the United States and is a doctoral candidate at the Institute of Fine Arts, New York University. Prior to founding Cristin Tierney Fine Art Advisory Services, she was a consultant for many years at Christie's auction house. She has taught graduate level seminars on the history of the art market at Christie's Education and undergraduate art history at New York University. Tierney also serves on the boards of several nonprofit organizations, including the Lower East Side Printshop and the National Advisory Council for Reynolda House Museum of American Art.

Jim Torok is a living artist who has exhibited all over the United States and Europe (http://www.jimtorok.com). He has been making a living doing his art for more than a decade, and has loved almost every second of it! He is represented by Pierogi Gallery in New York City.

***Fred Wilson** is an artist born in Bronx, New York. He has created site-specific works throughout North America, Europe, the Middle East, and Asia and exhibited in over a hundred group exhibitions, including the Fiftieth Venice Biennale, the Whitney Museum of American Art Biennial Exhibition, and the Fourth International Cairo Biennial. Wilson has been the recipient of numerous honors and awards, among them the MacArthur Foundation Genius Grant (1999); the New York State Council on the Arts and the National Endowment for the Arts awards (1990); and the New York Foundation for the Arts Fellowship in Sculpture (1987 and 1991). Wilson currently lives and works in New York City and is represented by Pacewildenstein (http://www.pacewildenstein.com).

***Letha Wilson** is a mixed-media artist whose work has been shown at many venues, including the Aldrich Museum of Contemporary Art, Bronx Museum of the Arts, Socrates Sculpture Park, Exit Art, Fredrieke Taylor Gallery, and White Box (http://www.lethaprojects.com). As a freelance web designer and consultant she has worked with artists and arts organizations including Artists Space, the Drawing Center, Sara Meltzer Gallery, and Visual Aids.

Biographies

*Cris Worley holds a master of arts in art history from Southern Methodist University and a bachelor of arts in art history from the University of the South. Since 2003, she has held the position of director at PanAmerican Art-Projects, Dallas, the first of now two galleries in Dallas and Miami (http://www.PanAmericanArt.com), following a directorship at Karen Mitchell Frank Gallery. She is a charter member and chairperson of the recently formed Contemporary Art Dealers of Dallas and is actively involved in supporting her local art community. The gallery represents artists in national and international art markets including Dallas; Miami; Los Angeles; Chicago; New York; Buenos Aires, Argentina; Milan, Italy; and Basel, Switzerland.

Lydia Yee is a curator at the Barbican Art Gallery, where she cocurated Martian Museum of Terrestrial Art (2008) with Francesco Manacorda. She has also organized projects by Huang Yong Ping (2008) and Shirana Shahbazi (2007) for the Barbican's Curve gallery. Previously, she was senior curator at the Bronx Museum of the Arts in New York and organized numerous exhibitions, including Collection Remixed (2005), Music/Video (2004), One Planet Under a Groove: Hip Hop and Contemporary Art (2001), and Urban Mythologies: The Bronx Represented Since the 1960s (1999). She was the 2003 Cassullo Fellow at the Whitney Museum of American Art Independent Study Program and the recipient of the 2004 Emily Hall Tremaine Exhibition Award for Street Art, Street Life (2008), which she guest curated for the Bronx Museum.

Heeseop Yoon was born and raised in Seoul, South Korea. She has exhibited in museums and galleries internationally, including MASS MoCA, North Adams, Massachusetts; Seoul Arts Center, Seoul; and Median Art Center, Beijing; and has participated in several residencies such as the Marie Walsh Sharpe, Skowhegan School of Painting, and Sculpture and Artist Alliance Inc. She currently lives and works in Brooklyn, New York (http://www.heeseopyoon.com).

Susan York's sculpture and drawings are in the Lannan Foundation and Panza di Biumo collections in the United States and Europe. A 2007 recipient of a Joan Mitchell Fellowship, York creates graphite sculpture, drawings, and installations (http://www.susanyork.com).

INDEX

Aaron Siskind Foundation, 206
Accentuate the Positive (Love), 91
Acconci, Vito, 140
Action plan
 on calendar, 18
 follow through, 18–19
 practice exercise, 14–16
 yearly, 16–18
Advocacy groups
 Americans for the Arts, 138, 156
 Chicago Artists' Coalition, 324
 Public Address artist collective,
 325
Agreements. *See* Contracts and
 agreements; Licensing
 agreements; Limited rights
 agreements
Ahearn, John, 88
AIDS activism shows, 105, 324
Aldrich Museum, 137
Al-Hadid, Diana, 213–214, 349
All the Stops (Al-Hadid), 215
Alliance of Artists Communities, 214
Alternative spaces/artist-run spaces
 and controversial, politically
 sensitive material, 105
 described, 104
 See also Nonprofit arts
 organizations
Alvarez, Camilo, 130, 349

 on artists' packages, 47
 on artists' studio visits, 80
 gallerists compared to art dealers,
 126
 on nonprofit alternative art
 spaces, 121
American Abstract Artists (AAA),
 323
Americans for the Arts, 138, 156
Antoni, Janine, 9, 19, 128, 349
 on filing systems, 304
 on gallery–artist communication,
 127, 262
 on having financial concerns, 184
 on knowing audience, venue, 99
 Lick & Lather (illus), 128
 on nonprofits, 107
 on peer support network, 314
 on prioritizing studio work, 294
 on relationships among artists,
 curators, gallerists, 150
Appraisal, term defined, 187
Archiving images
 as film, digitally, or on slides, 37
 importance of, 43
 sample record, 301
 See also Record keeping
Art & Community Landscapes (ACL),
 90, 94
Art advisors, 132

Art Basel Miami Beach art fair, 88,
134, 135
Art collectives. *See* Collectives,
coalitions
Art consultants. *See* Corporate art
consultants
Art dealers, 125–132
artists' relations with, 261
compared to gallerists, 125–126
and fairs, 133–135
and pricing approaches, 189
Art fairs, 133–135
community, in Laramie,
Wyoming, 88, 90
Art in Architecture, U.S. General
Services Administration, 139,
140, 156
Art Law Conversations book (Russell),
246, 280
Art management software programs,
301, 302
Art newsletters, 316
Art professionals
career paths, 123–124
defined as gallerists vs. art dealers,
125–126
long-standing connections, 111
networking with, to accomplish
goals, 121, 130, 330–334
Art service organizations, funding
source, 204–205
artdeadline.com, 316
artinfo.com, 316
Artist in the Marketplace (AIM)
program, Bronx Museum of
the Arts, 60, 328
Artist peers, connecting to, 101–102,
313–314
as a critique/support group,
319–321

for help facing rejection, 325–330
using the Internet, 314–318
working with a buddy, 322–323
Artist registries, 83–84
at nonprofits, 105
Artist residencies, 213–215
Artist statements, 46–49, 117
collecting information, 51–52
final product, 59–61
importance of, 25, 26–27, 119
questions to answer when editing,
54–58
support material for exhibition
venues, 150
testing, reading aloud by friends,
58–59
as useful for writing grant
proposal, 223
and writing/drafting process,
50–53, 54
*The Artist-Gallery Partnership: . . .
Consigning Art* book
(Crawford; Mellon), 268, 279
*The Artist's Guide to Public Art: . . . Find
and Win Commissions* book
(Basa), 141, 156
Artist's packages, 47, 60–61, 116–121
contents, 117
cover letter, 117–118
following guidelines for, 116
for grant proposals, 222–235
reviews, press quotes, 119
See also Artist statements;
Biographies; Résumés; Work
samples
Artists Space
open-admission artist registry, 84,
94
and Witnesses: Against Our
Vanishing show, 105

Artist-Venue Exhibition Checklist, 152–154

Arts Incubator, Kansas City, 214, 287, 321

Art/studio practice or business. *See* Earning a living as an artist; Organization of art/studio practice

Auctions, art benefit, 337-338

Audiences
 diverse, 91, 112
 researching, with venues, 97
 widening communities, 334, 335

Awards, 206–207

badatsports.com, 315

Baker, Julie, 59, 118, 125, 350
 on artists photographing their own work, 35
 on artists' relations with dealers, 131, 261

 on collectors and artists, 127
 on rejection, 327

Barber, Diane, 106, 350
 on community contacts, 102
 on importance of doing research, 98

Bartering, 177, 179
 in the negotiating process, 274

Basa, Lynn, 141, 156

Basquiat, Jean-Michael, 92

Batali, Mario, 168

Battenfield, Jackie
 Embrace (illus), 44
 Release (illus), 44

Becker, Jeff, 20, 214, 350
 on the artist as businessperson, 287
 on artists' get togethers, 321
 Arts Incubator, Kansas City, 321

Benefit fundraising parties, , 212–213

Biographies
 described, 61
 purpose, 66
 responsibility of artist to provide to exhibition venue, 151
 sample, 66–67

Bird by Bird: Some Instructions on Writing and Life book (Lamott), 54, 69

Bisantz, June, *True Life Story* (illus), 193

Blizzard Girls, 319–320

Blogs, 86–87, 315–316

Bloomberg, Michael, 107

Boneyard (Marclay), 30

Boone, Mary, 130–131

Boyle, Lisa, 315–316

Brainstorming
 funding sources, 164
 goals, 12
 rules/approaches for, 334–336
 to start writing project description, 223
 with supporters for fundraising, 171–172
 with supporters to promote project, 333–336

Bredehoft, Wendy, 88, 216, 351
 on Art Basel Miami Beach art fair, 137
 on a community exhibition, 89

Bronx Museum of the Arts, 60, 137, 328

Budgets
 calculating artist's fee, 227–228
 for grant proposals, 225–231
 for insurance (health, life, disability), 192–193
 for personal finances, 174–178

Budgets *(continued)*
 rainy day fund, 192
 for retirement funds, 194
 sample from grant application, 231

Center for Land Use Interpretation,
 www.clui.org, 324
Cezanne, Paul, 24
 The Large Bathers (illus), 26
Chartier, Jaq, 76, 229, 351
Infusion w/Magenta & Red (illus), 134
 on art fairs, 133, 134
 on day jobs, 172
 on galleries' relationships with
 artists, 129
 on making art that sells, 192
 on rejection, 329
 on setting deadlines, 83
Chicago Artists' Coalition, 324
Chicago Department of Cultural
 Affairs, www.chicagoartists
 resource.org, 324
Christo and Jeanne-Claude, 107, 141,
 230, 351
 Wrapped Trees project (illus), 39
Chuck Close (Joe Fig), 78
Ciel Rouge (Mattera), 152
Clay, Paul, 168
Close, Chuck, 77
Colab (Collaborative Projects) artists'
 collective, 87, 88, 324
Collectives, coalitions, 323–325
Collectors
 as clients of art advisors, 132, 133
 and pricing considerations, 189
 trying to avoid galleries'
 commissions, 129
 working through dealers, 131–132
College and university art galleries,
 109, 111-112

Commercial venues, 125–133
 See also Galleries
Commission contracts, 269
Common law, 260
Communities, groups
 advocacy, 138
 of collectives aiding artists'
 isolation, 323–325
 with nonprofits as liaisons with
 artists, 107 (*see also* Nonprofit
 arts organizations)
 online, 317–318
 of supportive friends, peers,
 101–102
 See also Artist peers, connecting to
Community exhibitions, 87, 88–90
Consignment agreements, 264–268,
 269
 sample, 265–266
Consultants, specialized services and
 expertise, 307–308, 309
 See also Corporate art consultants
Contacts
 building a list, 146–149
 business cards, 148
 following up with cards, thank
 you, 149
 responsibility of artist to provide
 to exhibition venue, 151
 tips for staying in touch, 148–149
 using email vs. cover letters, 121
Contracts and agreements, 250–252,
 260–270
 basic steps to follow, 264
 with commercial galleries, 261
 commission contracts, 269
 consignment agreements, 262,
 264–268, 269
 contracts described, 260
 historical use of, 241

importance of a paper trail, 245,
262–263, 264

loan forms, 268

negotiating, 270–276

with nonprofits, 261

questions to ask before signing, 267

sample, 265–266

Co-op galleries, 112

Copyright issues

with co-owners of a copyright, 259

copyright protection defined, 248

copyright registration, 249

Creative Commons license, 249

fair use, 254–256

infringement, 255–256

licensing agreements, 252–254

limited rights agreements, 249–252

and moral rights legislation, 257

and Orphan Works Act of 2008,
256–257

posting images on Internet, 249

work-for-hire provisions, 258

Core supporters, 101–102

as contacts, 146, 151

defined, 144

gathered for brainstorming, as
advisors, 171–172, 332–334, 335

as mix of family, friends, art
professionals, 145

as sources of donations,
assistance, 210, 211, 336

Corporate art consultants, 135–136

Cotter, Holland, 323

Counting Your Chances in Sleep (J. Lee),
212

Cover letter for the artist's package,
117–118

as part of grant proposal, 233–234

Crawford, Tad, 181, 195, 246, 268, 279

Creative Capital Foundation, 207, 237

Creative Capital Weekend retreats,
164, 334, 339

Creative Commons license, 249

Credit card debt, 183–184, 238

Criticism, 74–79

under fair use of copyrighted
materials, 254

heard from peers in studio visits,
76

reacting to negatives, positives, 79

readiness, preparation for, 74

Critique/support groups. See
Support/critique groups

Culture wars, 105

Dad's Basement (Yoon), 56

Dark Dawn (Wilson), 315

Deed of Gift records, 300

Deleget, Matthew, 85, 142, 351

on artwork as day job, 171

on having a community of artists,
317–318

Pink Nightmare (illus), 316

on planning, goal setting, 17

Descriptions. See Image descriptions

Dickson, Jane, 352

God Truck (illus) , 306

on paid assistants vs. interns, 308

on training interns, 305

Digital images, media

of artist registries, 83

used to safely store images for
archiving, 37

as work samples, 37, 42

Disconnectedness of artists

benefits of relaxing and rewards,
338–340

handling rejection, 325–330

and need to access communities
of artists, 312–314, 323

Disconnectedness of artists *(continued)*
 and volunteering as a quality to
 cultivate, 336–337
Do Women Have to Be Naked to Get into
 US Museums? (Guerrilla Girls),
 324
Documentation
 to archive, preserve art, 37
 as different perspectives of artists
 and institutions, 29–31
 digital technology vs.
 photographic film, 37
 of installations, 40
 photographing, 33–36
 See also Work samples
Donations (for support)
 from individuals, 210–213
 of materials, equipment,
 professional services, 215–216
Dorsky, David A., 352
 on artists'–galleries' obligations,
 154, 267
 on consignment agreements, 269
 on the Deed of Gift record, 300
 on finding an appropriate lawyer,
 278
 on having a will, 276, 277
 on the importance of record
 keeping, 299
 on networking, 82
Double Western still (Wilson), 42
Dress Code (Shin), 139
Duville, Matias, tornado (illus), 106

Earning a living as an artist, 159–194,
 343–344
 analyzing expenses and sources of
 income (exercise), 175–177
 and credit card debt, 183–184

earning money outside the studio,
 166–174
Financial Tracking Exercise,
 175–177
freelancing vs. regular day jobs,
 170–173
making a budget,
 174–178//managing time,
 287–294
organizing the practice (*see*
 Organization of art/studio
 practice)
overhead considerations, 179
paying taxes, tracking expenses,
 recording income, 180–183
questions to consider about
 money, jobs, 170–174
removing emotional baggage,
 negative images, 161–162
sources of financial support,
 162–166, 204
through selling artwork, 184–192
working for cash off the books,
 173, 174
See also Freelancing as an income-
 producing business
The Elements of Style book (Strunk;
 White), 58, 69
Elizabeth Greenshields Foundation,
 206
Embrace (Battenfield), 44
Environmental awareness, site-based
 public art, 90, 324
Estate planning, having a will, 276,
 277–278
Exercises
 action plan for short-term goal, 15
 for building connected
 relationships, 144–145

envisioning success, happiness, 9–10

financial tracking, 175–177

generate goals, 12–14

obituary, 10–12

promoting yourself to regional nonprofits, 114–115, 142–143

self-assessment of venues: questions to answer, 142

Exhibition Checklist, 152–154

Exhibitions

 artist–venue partnership relationship, 149–150, 151–152

 bypassed by art sold by dealers to collectors, 132

 community, 87, 87–90

 readiness to go public, 74–77

 as résumé category, 63, 64

 See also Juried exhibitions; Shows, multi-artist, collaborative; Venues for exhibitions

Expense Diary, 175

Eyebeam, 214

Fair market value, defined, 186

Fair use of copyrighted artwork, 254–256

 infringement factors, 255–256

Fellowships, 206

Fig, Joe, 352

 on artists' studios, 77, 79

 Chuck Close (illus), 78

Filing systems, 286–287, 302–304

Financial Support Structures Checklist, 192–194

Financial Tracking Exercise, 175–177

Financing an art profession. *See* Earning a living as an artist

Fischl, Eric, 140

Fitzgibbons, Coleen, 88

flavorpill.com, 316

For the City (Holzer), 92, 93

Form and Content (O'Hara), 103

Forty Acres (L. Kline; D. Kline), 326

Foundation Center, http://www.foundationcenter.org/, 219, 220, 239

Foundations, 198–202, 237

 awards by nomination, 206

 endowments described, 204–205

 small vs. large, 203–204

Freelancing as an income-producing business, 172–173

 charging enough, 178

 vs. regular work, 170, 171

 and work-for-hire contracts, 270

 and work-for-hire copyright issues, 258–259

 See also Earning a living as an artist

Freeze exhibition (1988), East London, 87

front bar (Linder), 67

Fundable, www.fundable.com, 211, 239

Fundraising, 197–202

 artist residencies, studio workspace programs, 213–215

 assistance from core supporters, 211

 with a benefit party, 212–213

 fellowships and awards, 206

 hiring a professional fundraiser, 238

 from individual donations, 210–213

 from in-kind goods and services donations, 215–216

Fundraising *(continued)*
 offering artist's services for
 honorarium, 216–217
 project grants, 207
 public and private sources
 described, 204–205
 from small foundations, 203–204
 through nonprofit fiscal
 sponsorship, 208, 210
 using the grant proposal budget,
 income list, 225–226, 228–229
Fundraising process (in order)
 set goals, identify support needed,
 217–218
 research, identify funders,
 218–220
 contact funders, follow guidelines,
 220–222
 draft proposal (*see* Grant proposal
 preparation)
 get feedback, revise proposal, 235
 follow through and personalize
 packages, 235

Galleries, 125–131
 and concept of territory, 129
 contracts, 127
 co-op, 112
 defines, 125
 guidelines for effective relations,
 128–131
 and obligations to/with artists,
 154, 267
 reasons for rejection, 329
 and reluctance to enter into long-
 term contracts, 261
 representation, benefits of, 126
 vanity, 131
 See also Gallerists
Gallerists, 130–131

vs. art dealers, 125–126
 and curators and artists, 155
 relationships to artists, 127, 261
GAP (Goals Attitude Perseverance),
 343
Garcia, Carolina O., 166, 352
 on artists selling art, 183
 on artists talking about
 themselves, 60
 on collecting money owed, 271
 on gallery–artist business
 relationships, 275
The Gates (Christo; Jeanne-Claude),
 107, 230
George Sugarman Foundation, 206
Glow (Martínez), 40–41
Goals
 brainstorming, 12–13
 compared to résumé, 68
 GAP (Goals Attitude
 Perseverance), 343
 long-term defined, 13–14
 matching art/studio practice with,
 142
 receiving art professionals' advice,
 help, 121, 330–334
 short-term defined, revised,
 13–14, 16–17
 and using proposal budget for
 fundraising, 227–228
 and yearly action plan, 16–18
God Truck (Dickson), 306
Golden, Mark, 204
Golden Artist Colors, 204
Graffiti, 92–93
Grant proposal preparation, 199,
 222–235
 artist's package attachment,
 232–233
 budget, 225–232

budget expenses, artist's fee calculated, 227–228

budget income calculated, 228–229

budget sample, 231

components described, 222

cover letter, 233–234

project description, 222–224

project summary sample, 223–224

proposal writing buddy, 322

recommendations, letters of support, 234–235

Grants

panel process described, 236–238

from private sources, 204–205

for project-based work, 207

proposal writing (*see* Grant proposal preparation)

from public, government sources, 204

Green, Tyler, 316

Green Roof Module (Mosher), 90

Guarded View (Wilson), 169

Guerilla art. *See* Street art, guerilla art

Guernica (Picasso), 24, 25

Guerrilla Girls feminist collective, 324

GYST, www.gyst-ink.com, 301, 302

Haring, Keith, 92

harvestworks, 214

Harvey, Ellen, 7, 31, 141, 353

on galleries–artists relationships, 130, 151, 263

on money, 170

New York Beautification Project, 92–93, 94(illus)

on record keeping, 302

on using opportunities, 155

Hegarty, Valerie, 44, 353

"Image Description List" (illus), 45

Hepburn, Katherine, 308

HighWaterLine (Mosher), 90, 224, 230

Hirst, Damien, 87

Holzer, Jenny, 92, 107, 353

For the City (illus), 93

Hotel Lobby Column, West Loop (Hegarty), 45, 46

The House Museum project (Love), 91

How Deep Is Your (Swartz), 31

"How Deep Is Your Love" song (Bee Gees), 31

Hudson River Museum, 137

"Image Description List" (Hegarty), 45

Image descriptions, 43–45, 117, 119

attached to grant proposals, 233

sample list, 45

Images or reproductions of art

as documentation of originals, 29

organizing and accessing, 284

and quality representing artist, 27

vs. viewing real works of art, 25–26

Imagine a world without America (Dread Scott), 331

Infusion w/Magenta & Red (Jaq Chartier), 134

Installations, 33

interactive artwork, 31

and performance media, 39–41

Intellectual property, 248–270

art used for promotional purposes discussed, 251–252

copyright protection defined, 248

limited rights agreements, 249–252

work-for-hire copyright issues and contracts, 258–259, 270

See also Copyright issues

Internet
 Minus Space as model for online
 community, 317
 posting images using Creative
 Commons license, 249, 256
 as tool for connecting to artists,
 communities, 314–318
Internships, 304–306
Isolation of studio practice. *See*
 Disconnectedness of artists

J. Michael Kohler Center, Sheboygan,
 Wisconsin, 213
Jackson Pollock (Namuth), 34
Jeanne-Claude. *See* Christo and
 Jeanne-Claude
Jerome Foundation, 207
Jersey City Museum, 137
Joan Mitchell Foundation, 206
John D. and Catherine T. MacArthur
 Foundation, 206
Juried exhibitions, 66, 112–113
 selection criteria, 113

Karavasiles, Nina, 325
Katonah Museum, 137
Keegan, Colleen, 6, 12, 292, 353
 on strategic planning, 13, 16
 on success and rewards for artists,
 338, 339
Kertess, Klaus, 131
Kirsh, Andrea, 149, 354
 on aggressive artists, 100
 on having supportive colleagues,
 319
 on rejection, 327
 on saying thank you, 339
Kline, Debby, 325, 354
 Forty Acres (illus), 326

Kline, Larry, 325, 354
 Forty Acres (illus), 326
Kohlhoffer, Christof, 88
Koons, Jeff, 255, 256
Krasner, Lee, 199
Kruger, Barbara, 167–168

Lamott, Anne, 54
Landsman, Aaron, 354
 on grant selection process, 237,
 238
 on proposal writing, 222, 225, 322
 on writing, 58
Laramie, Wyoming community art
 fair, 88, 90
The Large Bathers (Cezanne), 24–25, 26
Lee, Jody, 210, 354
 Counting Your Chances in Sleep
 (illus), 212
 on obtaining individual donations,
 211
 on supportive people, 146
Lee, Susan, 162, 167, 180, 181, 184,
 194, 355
 on artists needing to take care of
 money, 175
 on taxes, 174, 182
Legal Guide for the Visual Artist book
 (Crawford), 181, 195, 246, 279
Legal issues of the art profession,
 241–280
 consignment agreements, 264–268
 contracts, 260–264, 268–270
 copyright protection for the artist,
 248–252, 254–256
 estate planning, having a will,
 276–277
 fair use, 254
 intellectual property, 248–259

introduction, 241–248

licensing agreements, 252

negotiating contracts, 270–276

Orphan Works Act of 2008, 256–257

Lennon, John, 31

Lerner, Ruby, 334

Letters to a Young Artist book (A. D. Smith), 101, 122, 270, 288, 295, 328

Licensing agreements, 252–254

Lick & Lather (Antoni), 128

Limited rights agreements, 249–252

Linder, Joan, 355

biography, 66–67

front bar (illus), 67

resume: joan linder (illus), 65

Loneliness of artists. *See* Disconnectedness of artists

Louis Comfort Tiffany Foundation, 206

Love, Robyn, 91, 92, 355

Accentuate the Positive (illus), 91

Love Buttons (Sale), 107, 108

"Love" song (Lennon), 31

Lower East Side Printshop, 214

MacDowell Colony, 213

Manock, Abby, 164, 165, 355

Mapplethorpe, Robert, 105

Marclay, Christian, *Boneyard* (illus), 30, 356

Marketing. *See* Self-promotion

Martínez, Rossana, 17, 40–41, 44, 317, 356

Glow (illus), 40

Materials for the Arts, New York City, 215

Matisse, Henri, 242

Mattera, Joanne, 7, 119, 121, 246, 356

Ciel Rouge (illus), 152

on extending social courtesies to art people, 336

on goals vs. expectations, 153

on her website and blog, 86, 315

on studio time, 290

on visual inventories, folders, 303

McGregor, Jennifer, 149, 356

on artists' studio visits, 79

on balancing making art with life, 337

on networks and happiness, 315

on problem-solving public art commissions, 138

on proposal budgets, 228

Mellon, Susan, 268, 279

Metropolitan Transit Authority (MTA) Arts for Transit program, 140

Minus Space, 17, 171, 317–318

Modern Art Notes, www.artsjournal .com/man/, 316

Moldenhauer, Susan, 88, 357

on artist statements, 47

on asking for money, 216

Money and work questions, 170–174

"Moonlighting Sonata" (Pollack) in *ARTnews*, 168

Morgenstern, Julie, 295, 310

Mosher, Eve, 90, 357

on getting help from many sources, 230, 232

HighWaterLine (illus), 224

samples from grant application, 224, 231

Mudge, Anne, 325

Mural Arts Program, Philadelphia, 140

Murray, Elizabeth, 140
Museums, and permanent public art
 exhibitions, 136–137
 See also Specific named museums
Mushroom cloud (Wegner), 106
Myth of suffering artist, 20–22, 158,
 160, 162

Namuth, Hans, 33
 Jackson Pollock (illus), 34
Nassau County Museum, 137
National Endowment for the Arts
 (NEA), 90, 94, 105
National Museum of Women in the
 Arts registry, 84
Negotiating contracts, 270–276
 avoiding ultimatums, 274
 changes written, 275
 collecting information ahead of
 time, 272
 maintaining integrity, 274
 practicing talking points, 273
 preparing for, 272–273
Networking
 with art professionals to accomplish
 goals, 121, 130, 331–334
 to build self-promoting
 community, 99
 and contact list development, 148
 through art fairs, 134
New England Foundation for the
 Arts, 90, 91, 94
New York Artists Circle, 321
New York Beautification Project
 (Harvey), 92–93, 94
New York Foundation for the Arts
 (NYFA), www.nyfa.org, 208,
 210, 218, 240, 316
Noguchi, Isamu, 257–258
 Shinto (illus), 258

Nonprofit arts organizations, 102–121
 as agencies buying art for public
 spaces, 137–141
 clarifying terms of relationships,
 261
 co-op galleries, 112
 donating in-kind goods and
 services, 215–216
 educational institution venues,
 109, 111
 Exhibition Checklist (2nd section,
 items 1–5), 152–154
 as fiscal sponsors for artists'
 projects, 208, 210
 following up site visits, 116
 fundraising benefits for, 212
 as grant funded, 103
 as liaisons between community
 and artists, 107
 researching, visiting, venues in a
 region, 114–115
 as sponsors of free artist registries,
 83–84
 submitting work to, 116–121

Obituary writing exercise, 10–12
O'Hara, Morgan, 13, 104, 357
 on being open to all invitations,
 155
 Form and Content (illus), 103
 on relationships, 147
Ohne Titel [untitled] (Sarmiento), 252
Open Studio event, 82–83
Organization of art/studio practice,
 283–310
 assistance from student interns,
 artist assistants, 304–305,
 306–307
 exercise to analyze/schedule time,
 288–291

filing systems, 286–287, 302–304

hiring consultants, 307–308

questions to ask before starting, 286

record keeping, 298–304

rewarding accomplishments, 309–310

scheduling for productivity, 291–294

sorting, organizing clutter, 295–297, 303–304

system for accessing jpegs of images, 284

time management, 287–294

using an artist buddy for help, 322

Orphan Works Act of 2008, 256–257

Otterness, Tom, 88, 140

Overhead, 179

Page, Susan Harbage, 202, 357

 Untitled (Toile) (illus), 203

Panel reviews of grants, applications, 235–238

Peers, friends, colleagues

 criticism as preparation for going public, 76

 review self-promotion descriptive statement, 100

 studio visits from, 77, 81

 as two-way relationships, 102

Performance artwork work samples, 31, 33

Permuth, Jaime, 208, 210, 358

 Untitled from *Tarzan Lopez* series (illus), 209

Perschke, Kurt, 11, 107, 109, 358

 on the artist's liability, 279

 on community, 105

 on cultural programming, 111

 on day jobs, 173

 on documentation of work, 29

 RedBall project (illus), 110

Personal assistants, artist assistants, 306–307

 vs. interns, 308

Photography

 by artist vs. professional, 35–36

 film stock vs. digital media, 37

 labeling work samples, 38–39

 problems with digital files, 36–37

 of work samples, 33–34

Picasso, Pablo, 24, 242

 Guernica (illus), 25

Pink Nightmare (Deleget), 316

Planning process

 applications of, as path to success, 4–7

 calendar (year-long), 4

 calendar (short-term goals), 18

 developing, following through with action plan, 14–19

 generating goals, 12–14

 steps (1) envisioning success – (5) taking action, 9–19

 values defined by obituary-writing exercise, 10–12

 writing exercises, 9–20

Political, controversial art, 92, 105

Politzer, David, 213, 358

 Storytelling: My DVD Intro (illus), 213

Pollack, Barbara, 168

Pollock, Jackson, 33

Pollock-Krasner Foundation, 199, 206

President Elect (Rosenquist), 168

Price lists

 completed, always available, 190

 of other artists used for research, 188–189

Pricing. *See* Selling art

Primary market, defined, 186

Private dealers. *See* Art dealers

Process-based art, 33

Promotional tools, 24–69
 See also Artists' packages

Proposals (grant). *See* Grant proposal preparation

Provincetown Workshop on Cape Cod, 213

Public, 235–238

Public Address artist collective, www.publicaddress.us, 325

Public Art Network, 138, 156

Public art projects, 90–94, 137–140
 and advocacy group Public Address, 325
 diverse audiences, 91, 92–94
 environmental awareness, 90
 grants for, 207
 including site-specific art, 138, 140
 panel review process for grants, applications, 235–237
 problem-solving aspect of commissions, 138

Public commissioning agencies, 137–141
 See also Public art projects

Queens Museum of Art, 137

Rathke, Dirk, 358
 Curved Canvas series, 32
 Wall Objects (illus), 32

Recommendations, 234

Record keeping, 298–304
 as archiving, documentation, 37, 43
 backing up records, files, 301
 components of each record, 299–300
 Deed of Gift records, 300

filing systems, 302–304
 sample archive record, 301
 using a searchable database, 299, 301

RedBall project (Perschke), 107, 109, 110

Rejection, 325–330
 as information to use, 328
 not an indictment of artwork, 326–327
 reasons discussed, 116, 328–329

Relationships
 with art professionals, 333–334
 between artists and galleries, 130
 building core supporters, 145, 146–149, 313–314
 with "connected" peers, friends, 102, 143
 as counterbalance to artist's isolation, 154–155
 exercise for building, 144–145
 long-term, 143

Relaxation and rewards, 338–340

Release (Battenfield), 44

Res Arts, www.resartis.org, 214

Research
 of artist registries, 83
 importance of, 98
 of organizations, people, 101
 of pricing approaches, 188

resume: joan linder (Linder), 65

Résumés, 117, 234
 defined, 61
 as grant proposal attachments, 222, 232
 purpose, 62
 structure, format, 63–64

Reviews, press quotes, 119, 120
 as grant proposal attachments, 232

provided to exhibition venues by
 artists, 151
Riker, Janet, 112, 154, 358
Rogers, Art, 255, 256
Rosenquist, James, 167
 President Elect (illus), 168
Roswell Artist-in-Residence Program,
 New Mexico, 213
Rotunda Gallery, 83, 103–104, 197,
 243, 327
Russell, Elizabeth T., 246

Sale, Gregory, 107, 359
 Love Buttons, 2008 (illus), 108
Sam and Adele Golden Foundation
 for the Arts, 204
Sarmiento, Sergio Muñoz, 261, 359
 on the artist's liability, 279
 on common laws, 260
 on finding a lawyer, 278
 on intellectual property, 253, 255,
 256
 Ohne Titel [untitled] (illus), 252
 on power dynamics, 268
 on written agreements, 264
Scott, Dread, 59, 331, 359
Imagine a world without America (illus),
 331
Sculpture Space, Utica, New York, 213
Secondary market, defined, 186
Self-promotion
 artist–gallery guidelines, 128–131
 and assertiveness, aggressiveness,
 99, 100
 free artist registries, 83–84
 as marketing, 96
 as necessary for studio practice,
 98–99
 to nonprofit arts organizations
 nearby, 113

Open Studio event, 82–83
 to the professional art community,
 96
 self-esteem as issue, 96
 through networking, 99
 through websites and blogs, 85–87
 using descriptive statements,
 business cards, 100, 117
 using reviews, press quotes, 119
 See also Artist's package
Selling art
 appraisal described, 187
 being clear about payment terms,
 179
 charging enough, 178
 to earn a living, 184–192
 licensing agreements for, 252–254
 market terms defined, 186
 pricing, 178, 188
 pricing steps, 187–192
 studio sales vs. sales from
 galleries, 190–191
Serra, Richard, 167
Shin, Jean, 139–140, 359
 Dress Code (illus), 139
Shinto (Noguchi), 258
Shows, multi-artist, collaborative,
 87–89
Shubuck, Simone, 168
Smith, Anna Deavere, 101, 122, 295
 on contractual expectations, 270
 on procrastination, 288
 on success and failure for artists,
 328
Smith, Kiki, 307
Snitzer, Fredric, 182, 359
 on artists' business structures, 291
 on pricing art, 190
Storytelling: My DVD Intro (Politzer),
 213

Strafella, Allyson, 48–49, 359
 Untitled 4/19 (illus), 48
 Untitled 10/2 (illus), 49
Straus, Nicole, 61, 359
 on contacts with critics,
 journalists, reporters, 338
 on paid assistants, 308
 on publicists, 309
Street art, guerilla art, 91, 92, 93, 324
String of Puppies (Koons), 255
Studio visits
 art sales during, 190–191
 Joe Fig's perspective, 77–78
 from peers and colleagues, 76, 81
 tips for effective experiences, 77,
 79–81
 See also Visits, on-site
Success
 defined as relations with dealers
 or collectors, 169
 envisioning, in planning process,
 9–10
 judged on gallery representations,
 127
Support/critique groups, 319–321
Supporters. *See* Core supporters
Swartz, Julianne, 31, 360
 How Deep Is Your (illus), 31

Taxes
 business-related expenses,
 receipts, 181
 filing a Schedule C, 180–181, 182
 invoicing, recording income, and
 1099s, 182
Teaching as source of financial
 support, 166–167
Thank you notes, expressions, 116,
 149, 150, 328, 333, 338, 339
Things Could Be Worse (Torok), 21

3 columns, 2008 (York), 120
Tierney, Cristin, 126, 191, 360
 on art fairs, 134
 on balance of work and
 networking, 100
 on collectors, artists, galleries, 132
Time management, 287–294
 delegating housekeeping tasks, 293
 monitoring Internet time, 317
 scheduling for productivity,
 291–294
 through organization of clutter,
 295–297
 tracking, categorizing time,
 289–291
 using an artist buddy for help,
 322–323
Time Management from the Inside Out
 book (Morgenstern), 295
Time tracking/analysis exercise,
 288–291
Timeline. *See* Action plan
Times Square Show in 1980, 87, 88
Tornado (Duville), 106
Torok, Jim, 360
 Things Could Be Worse (illus), 21
Torres, Rigoberto, 88
Touchstone Laramie 2006 (Laramie
 Artists Project), 90
True Life Story (Bisantz), 193

United States, Copyright Office,
 www.copyright.gov, 249, 280
United States, General Services
 Administration (GSA), 140
Untitled (Toile) (Page), 203
Untitled 4/19 (Strafella), 48
Untitled 10/2 (Strafella), 49
Untitled from *Tarzan Lopez* series
 (Permuth), 209

Van Gogh Myth, 20–22, 162
Van Gogh, Vincent, 162
Vanderbilt, Amy, 168
Vanity galleries, 131
Venues for exhibitions
 artists' partnership responsibilities,
 149–150
 cultural, with installations in
 public, 106
 researching, 97, 114
 self-assessment questions, 142
 self-generated, 81–82
 unusual, diverse, less intimidating,
 89–90
 working in several at once, 141,
 154–155
 See also Exhibitions
Video and film media
 CD, DVD, VHS tape case cover
 designs, 41
 still images for work samples, 42
 work samples with written
 summaries, 41
Visits, on-site, 115–116
 See also Studio visits
Viso, Olga, 124
Visual AIDS, visualaids.org, 324
Volunteer Lawyers for the Arts
 (VLA), 246, 277
Volunteering, 337–338

Wall Objects (Rathke), 32
Warhol, Andy, 168
Washington Project for the Arts, 105
Websites, 85–86
 Holzer's Truisms, 92
 used for The House Museum, 91
Wegner, Dietrich, mushroom cloud
 (illus), 106
White Columns curated registry, 84, 94

Wilson, Fred, 168, 360
 Dark Dawn (illus), 315
 Guarded View (illus), 169
 on having a community of artists,
 313
 on jealousy, 330
Wilson, Letha, 37, 43, 85, 360
 on descriptive words in artist
 statements, 84
 Double Western still (illus), 42
 on photographing artist's
 installation, 41
Winkleman, Edward,
 edwardwinkleman.blogspot
 .com, 69, 94, 315
Winters, Robin, 88
Witnesses: Against Our Vanishing
 show, 105
Wooster Collective,
 woostercollective.com, 93, 94
Work samples, 31, 117, 119
 considerations for producing, 28–30
 digital images / files, 36–37, 42
 as grant proposal attachments, 232
 image descriptions (written),
 43–45
 images filed in artist registries,
 83–84
 importance of, 25, 26–27
 installation / performance
 photographs, 39–41
 labeling of images, 38–39
 photography by artist vs.
 professional, 33–34, 35–36
 responsibility of artist to provide
 to exhibition venue, 150
 video and film images, 41, 42
Work-for-hire
 contracts, 270
 copyright issues, 258–259

Workspace programs, 213–215

Worley, Cris, 361
 on introductions and follow-up, 131
 on reasons for galleries refusing
 art, 329

Wrapped Trees project (Christo;
 Jeanne-Claude), 39

Writing exercises. *See* Exercises

Writing process
 for artist statement, 51–54, 59–61
 benefits of, 68
 editing techniques, 54–58
 grant proposal steps, 222–235
 as part of planning process, 8
 using friends for test reads, 58–59

Written descriptions. *See* Artist
 statements; Image
 descriptions

Yablonsky, Linda, 307

Yee, Lydia, 361
 on artists' packages, submissions,
 60–61
 on the selection process, 236

Yoon, Heeseop, 361
 artist statement, 56
 Dad's Basement (illus), 56

York, Susan, 119–120, 361
 3 columns, 2008 (illus), 120